H. H. Bennett

Photographer

OTHER BOOKS BY SARA RATH

NOVELS

Night Sisters
Star Lake Saloon and Housekeeping Cottages

NONFICTION

The Complete Pig
The Complete Cow
About Cows
Pioneer Photographer: Wisconsin's H. H. Bennett
Easy Going: Madison and Dane County

POETRY

Dancing with a Cowboy
Remembering the Wilderness
The Cosmic Virgin
Whatever Happened to Fats Domino, and Other Poems

H. H. Bennett

Photographer

HIS AMERICAN LANDSCAPE

Sara Rath

Terrace Books

A TRADE IMPRINT OF THE UNIVERSITY OF WISCONSIN PRESS

Terrace Books, a trade imprint of the University of Wisconsin Press, takes its name from the Memorial Union Terrace, located at the University of Wisconsin–Madison. Since its inception in 1907, the Wisconsin Union has provided a venue for students, faculty, staff, and alumni to debate art, music, politics, and the issues of the day. It is a place where theater, music, drama, literature, dance, outdoor activities, and major speakers are made available to the campus and the community. To learn more about the Union, visit www.union.wisc.edu.

Terrace Books
A trade imprint of the University of Wisconsin Press
1930 Monroe Street, 3rd Floor
Madison, Wisconsin 53711-2059
uwpress.wisc.edu

3 Henrietta Street
London WC2E 8LU, England
eurospanbookstore.com

5 4 3 2 1

Printed in Canada

Library of Congress Cataloging-in-Publication Data
Rath, Sara.
 H. H. Bennett, photographer : his American landscape / Sara Rath.
 p. cm.
Includes bibliographical references and index.
 ISBN 978-0-299-23704-2 (pbk. : alk. paper)
 1. Bennett, H. H. (Henry Hamilton), 1843–1908. 2. Photographers—Wisconsin—Wisconsin Dells—Biography. 3. Wisconsin Dells (Wis.)—Biography. I. Bennett, H. H. (Henry Hamilton), 1843–1908. II. Title.
TR140.B443R36 2010
770.92—dc22
[B]
2010014292

An earlier version of the foreword appeared under the title "A Sense of Place" in *H. H. Bennett: A Sense of Place* (Milwaukee: Milwaukee Art Museum, 1992) and is reprinted here with permission.

For

Debbie Kinder,

great-granddaughter of H. H. Bennett, and

the Stewards of the Dells,

*working to protect and preserve
the natural beauty of the
Dells of the Wisconsin River.*

My energies for near a lifetime have been used almost entirely to win such prominence as I could in outdoor photography and in this effort I could not help falling in love with the Dells.

—HENRY HAMILTON BENNETT to JULIA LAPHAM,
Federated Women's Clubs of Wisconsin, March 2, 1906

Contents

Foreword / xi

Preface / xxi

Author's Note / xxv

1 Early Days: 1843–1864 / 3

2 Discovering the Landscape: 1864–1867 / 29

3 Picturing the Dells: 1868–1875 / 49

4 William Metcalf, Friend and Mentor: 1873–1881 / 71

5 Developments: 1882–1883 / 95

6 The Snapper: 1883–1888 / 113

7 Personal Views: 1888–1890 / 139

8 Urban Landscapes: 1890–1899 / 167

9 Change in the Wind: 1899–1904 / 199

10 Shadows: 1903–1908 / 219

11 Guardian Spirits: 1908–2010 / 235

Notes / 249

Bibliography / 259

Index / 263

Foreword

TOM BAMBERGER

I first saw Henry Hamilton Bennett's "Under the Overhanging Rock" (c. 1891) on the wall in John Szarkowski's office at the Museum of Modern Art in New York in the late 1980s. The river was just low enough so Bennett could find a place to stand in the small cave. The sun was right. A generous bend in the river left just enough space to frame the bluff and its reflection in the glassy, still water. The overhanging rock flowed across the top of the frame like a luminous night sky.

It was stunning. A photographer rarely just comes upon a picture like this. Bennett had been there many times before. He knew how his wide-angle lens would amplify the foreground, greatly enlarging the cave, as if seen from a child's point of view. The picture harmonized photography and nature into a masterpiece.

"Under the Overhanging Rock" is a photographer's picture. Bennett didn't need to get under a dark cloth to see the image glowing on the ground glass because he was, in essence, inside the camera. It was the perfect place and moment to realize a photograph by letting nature frame itself.

Four decades earlier, John Szarkowski hitchhiked from the University of Wisconsin in Madison to his home in Ashland, Wisconsin. His first ride often took him about fifty miles up the Wisconsin River to Wisconsin Dells. (Originally Kilbourn City, it was renamed Wisconsin Dells in the 1930s.) It's still a tourist town, nestled into a bend in the river by a beautiful expanse of sandstone cliffs.

Szarkowski arrived about ninety years after Bennett came to Kilbourn City from Vermont in 1857. Bennett died in 1908, but his studio was still on the main street just a few blocks from the river. And there, I suspect, Szarkowski saw "Under the Overhanging Rock," Bennett's panoramic masterpiece. Szarkowski graduated in 1947 with an art history degree. Two years later the first one-person exhibition of his photographs opened at the Walker Art Center in Minneapolis.

Szarkowski succeeded Edward Steichen as the curator of photography at the Museum of Modern Art in 1962. A year later, when Szarkowski mounted *The Photographer and the American*

Landscape, his first exhibition for MoMA, he included Bennett along with better-known photographers like Ansel Adams. "This work was the beginning of a continuing, inventive, indigenous tradition," Szarkowski wrote, "a tradition motivated by the desire to explore and understand the natural site." H. H. Bennett devoted his whole life to visually exploring the natural site just a few miles from his house.

Over the next ten years, Szarkowski's writings and exhibitions created a new canon of photographers and ideas, though I doubt he thought of it that way. Szarkowski believed photographers were the best critics of photography. He was an intellectual subversive who was contemptuous of big art ideas, especially when they displaced our patient engagement of the complexities of the world.

After Szarkowski retired from MoMA, he picked up his own photography right where he had left off. "I want to make pictures possessing the qualities of poise, clarity of purpose and natural beauty," Szarkowski wrote in 1958, "as these qualities were achieved in the work of the good wet-plate photographers," such as H. H. Bennett. Like Bennett, Szarkowski stayed close to home, photographing his barn, meadows, and apple trees in his own backyard until he died in 2007.

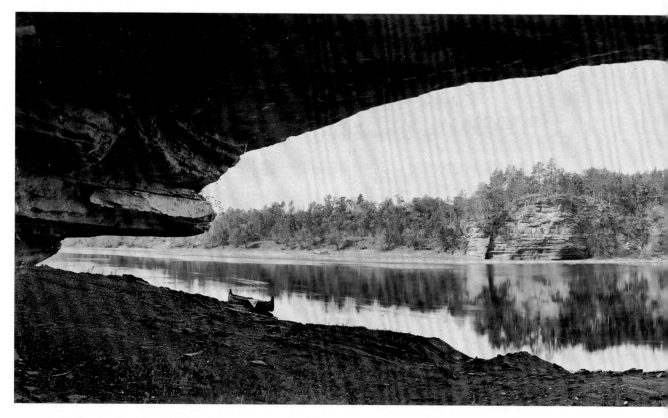

"Under the Overhanging Rock." H. H. Bennett seamlessly merged three separate negatives to create this panorama, which measured eighteen inches high by five feet wide. Several of his other panoramas are in the Library of Congress. (WHi-10914)

It is somewhat of a mystery how Bennett put "Under the Overhanging Rock" together. The albumen silver print is 17 inches high by nearly 5 feet wide. Today it's child's play on computer. At the time, sewing the three exposures into a seamless panorama was a daunting task of trial and error. But, as with any great work of art, the real mystery lies elsewhere.

Bennett was more worldly than we might expect of someone living in a small rural town. He subscribed to the leading photographic journals, like *Philadelphia Photographer*. In addition to providing photographers with formulary and other technical information, they instructed practitioners in precise detail about the correct way to compose a landscape photograph. Just twenty-five years after William Henry Fox Talbot perfected the first photographic printmaking process, photography was the fast-moving technological marvel of Bennett's time. It required a good understanding of chemistry, physics, and art. Bennett built his cameras and took his darkroom into the field, where he not only made his photo-sensitive plates but also developed them just minutes after exposure. He was a highly accomplished and inventive practitioner of his craft. When Bennett met Eadweard Muybridge, the infamous landscape and motion-studies photographer, the conversation went both ways.

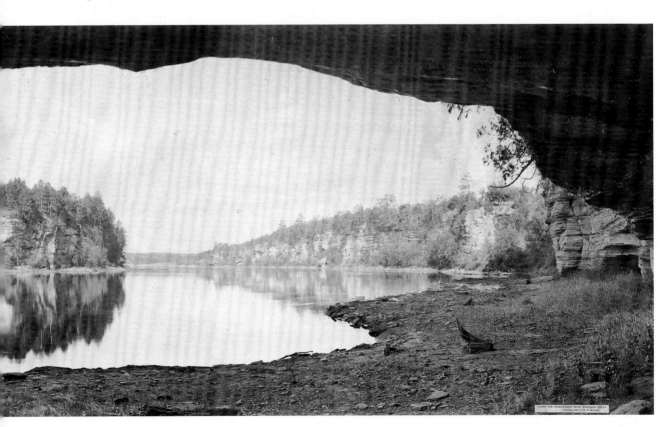

Bennett was commissioned by his admirer, William Metcalf, to document the collection of the Layton Art Gallery (the predecessor of the Milwaukee Art Museum). Metcalf was an amateur photographer, patron of the arts, and at the center of cultural life in Milwaukee. Ralph Waldo Emerson dropped by Metcalf's salon. Metcalf and Bennett were close friends. He loaned Bennett the money to build his studio in 1875.

In a highly mannered portrait of himself and his family in 1887 Bennett conspicuously included several works of art. His library included books on evolutionary theory. Charles Darwin's *On the Origin of Species by Means of Natural Selection*, published in 1859, was a best seller and in its fifth printing when Bennett started photographing in 1865.

It was a radical idea that science could explain what people saw around them. And doing science was an exciting counterculture activity. Victorians often went "geologizing," and Bennett photographed the product of this leisure activity—their rock collections.[1]

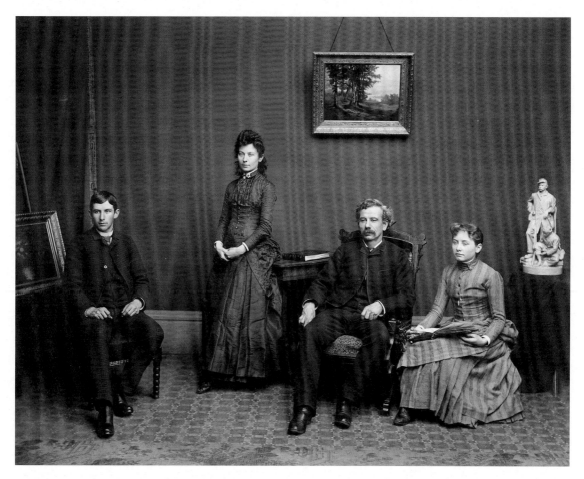

"Self Portrait with son Ashley and daughters Harriet and Nellie," 1887. Not long after his first wife's death, Henry Bennett arranged personal items in the studio for a series of family portraits. He often experimented with different photographic techniques using family members and called them "trying on the dog." (WHi-68922)

Photography was also a radical idea. The camera was the first machine that recorded the world. That feat itself was a natural wonder. Early photographers, like Bennett, were working at the frontier of imaging and would go on to change the way we see everything, including ourselves.

The results of the confluence of science and photography are represented in the great number of prosaic rocks, many not much larger than a person, that became the subject of Bennett's photographs. Looking at these photographs today, one wonders why anyone bought them. Yet the same rocks Bennett photographed were rephotographed by others and marketed in competing catalogs of stereo views.

Darwin's theory of evolution and Charles Lyell's geology demystified nature and shifted the idea of "wilderness" from something that was dark, scary, and fundamentally unknowable to something that could be lyrically enchanted. The technology and ideas of the time created Bennett's medium and his subject.

Bennett worked when America was defining itself, both physically and culturally, against a vastness no modern technological civilization had ever confronted.[2] Material progress was astoundingly vivid. Never had a wilderness been so efficiently reduced and civilized by transportation and industrialization. That wilderness evaporated in a generation. The railroad came to Kilbourn City just six months after Bennett arrived in 1857, putting Milwaukeeans less than half a day's ride away. Just eleven years later, railroads spanned the entire continent. In 1873 steamboats on the Wisconsin River greatly expanded Kilbourn City's river-tour business, making it easier to entertain large groups of people and dramatically increasing the potential of the Dells as a tourist attraction.

Bennett repeatedly emphasized the innate hospitality of nature. In one series of photographs his wife, children, and brother are shown picnicking in a rock formation, a Flintstones cartoon version of a parlor. The domestication of the wilderness made it possible to imagine that nature was designed for leisure.

Photography became part of the party. The famous Bennett photograph of his son—caught in midflight jumping between a precipice and a tall, flat-topped rock—is a hyperbolic dramatization of how nothing escaped photography's gaze, how human ambition could overcome nature's obstacles. Bennett made several companion pictures of a group of dapper Victorian men and women lounging atop the same rock, further underlining the ease and tranquility of just being there. Nature became the setting for an "outing." Sightseeing was born at about the same time photography arrived to record the sights, and the two have been bedfellows ever since.

Bennett frequently peopled his landscapes with well-dressed children and women, often members of his extended family, leaving the impression that this "wilderness" was a nice place for anyone's family. The geology of this part of the Wisconsin River, called the Dells, was also seen by other photographers and entrepreneurs as a vacation spot where nature was particularly formed to human scale, miraculously shrunk to playground size. Everything is small enough not to be too intimidating yet just big enough to inspire fun.

Photography was new in Bennett's day and was the most convincing form of modern visual communication. Simultaneously, advances in transportation and economic development gave people the means to travel more freely and enjoy life a little more. The photography of this

period, as Peter B. Hales has observed, "unified science, art, and capitalism; the sum of its work lay in drawing together and celebrating the divergent elements of an American culture undergoing the stresses of rapid change. More than reflecting the tensions surrounding it, the photographic view helped to resolve them—at least within the visual fiction of the photographic frame."[3]

Bennett was a man of his time and place. He became intimately involved in Kilbourn City, a community that was in the midst of inventing itself as a tourist attraction. His role was what we would think of today as a combination of public relations and advertising. He sold thousands of well-made pictures to support his family. And he made some transcendent images.

But to understand his artistic achievement, we have to wrestle Bennett away from his milieu. "Under the Overhanging Rock" is a timeless masterpiece that got better the farther it traveled from its time.

Bennett had just enough luck, it turned out, not to be entirely forgotten as an artist. If John Szarkowski hadn't been waylaid in a small Wisconsin tourist trap near his college, I wouldn't be writing this essay. Bennett would be just another regional photographer of historical interest. Happenstance brought Bennett to our attention, and the economic contingencies of his time complicated his artistic legacy.

In a letter to Eadweard Muybridge after they met in Philadelphia, Bennett bemoaned the fact that he had only a few prints to send, and those few were of questionable quality. "My attention has been given almost wholly to stereo work," he explained, "there being no sale here for any other class of views at the present time."

Stereo cards were the sensationally popular form of high-tech parlor amusement in Bennett's day. The photographic landscape print had not yet displaced nature paintings on the walls of Victorian homes, including Bennett's. In the nineteenth century people didn't generally buy the kind of photographs that were canonized in the twentieth century by American art museums. Just follow the money. Nineteenth-century landscape photography in America was financed by large organizations that were not interested in selling someone else's backyard. Civilizing the open spaces of the western territories was a development project. The great American West was the first vast landscape to be converted into real estate by photography. To promote economic development, the government and the railroads commissioned photographers to produce the voluminous folios of large prints that went on to dominate the twentieth century's art museum collections.

Though Bennett came west from Vermont to seek his fortune, he stopped short of the frontier and remained in Kilbourn City for the rest of his life. He did some traveling around the region on commissions, but he also made excuses not to leave his home and family for extended periods of time. Bennett turned down an offer to photograph the Yellowstone region because he didn't think there would be enough people—enough tourists—to buy the pictures. He declined commissions in Texas and Alaska because he thought he needed to know a place very well before he could photograph it successfully.[4]

Staying home, however, was difficult. Bennett's letters are consumed with practical matters—making a living, promoting civic issues, and raising a family. Photography in the nineteenth

century was a precarious profession. Photographers who started out as portraitists soon saturated the market of small towns like Kilbourn City and either went out of business or depended on government or railroad contracts.[5]

Being home was never the best career move. Most landscape photographers hit the road in one way or another. Though a few did some of their best work close to home (later Edward Weston) or looking out their window (Alfred Stieglitz), not many made a career out of it. Harry Callahan found his landscape subjects close by wherever he lived, but he moved around a lot. Aside from Bennett, it's hard to find American landscape photographers in the canon who made all their best photographs within just a few miles of their homes.

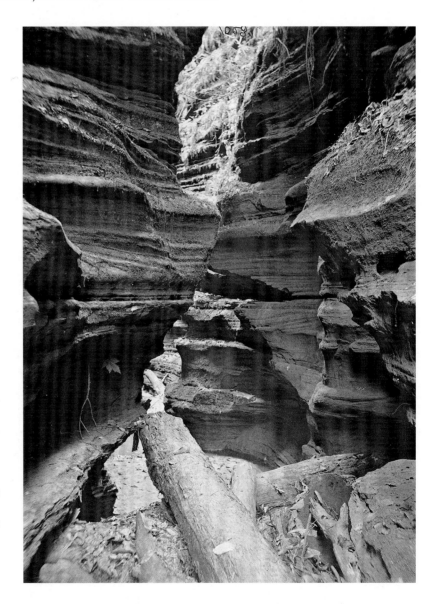

Viewed as a stereo image, this scene at Cold Water Canyon in the Upper Dells displays Bennett's genius for optimizing three-dimensional aspects. The play of light and shadow, the layering of sculpted sandstone, the log jutting out of the foreground—all combine to create a dramatic sense of depth. (WHi-7521)

Bennett's first catalog of stereo views, *Wanderings Among the Wonders and Beauties of Western Scenery* (1883), listed 528 views and was quite successful. The photographs Bennett made while traveling are unspectacular in comparison with his photographs of the Dells. Similarly, when Bennett's competitors came to the Dells, their images seemed more distant, more matter-of-fact, than Bennett's pictures of the same subjects.

For the rest of his life Bennett would revise these images by either rephotographing or reprinting them. It is difficult to follow the sequence of this process because Bennett used the original negative number to refer to the new and improved images. But time worked in his favor. Bennett's reluctance to leave Kilbourn City and his concentration on his stereo card business would shape his photographs into ever more refined expressions of the meaning of place.

After a short time it must have been apparent to Bennett that he had photographed every notable feature or view within a couple of miles of his house. Yet Bennett returned to the same view and photographed the same subjects again and again. For the most part, his reinterpretations were more successful than those of most photographers who rework their images.

Bennett moved forward. Part of his accomplishment came from fully understanding the stereo effect. His favorite subjects—cliffs that jutted out from the riverbank or caves that were sometimes no more than large holes in rock formations—became spatial dramas. The pictorial space Bennett created in his stereo cards then informed his prints and grand large panoramic photographs.

Bennett also had the time and proximity to his subject to tinker with his pictures. The Dells was his palette. He revised many of his favorite views, rearranged props, chose different models,

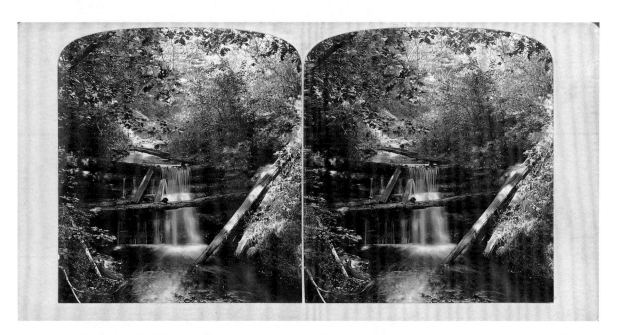

"Mirror Lake Dam and Mill." Henry did not have to venture far from home to encounter romantic settings similar to those painted by popular artists of his day. (WHi-68920)

and photographed at different times of the day and year. Bennett's most memorable pictures are from the heart of the Dells, a scant seven-mile stretch along the Wisconsin River. Here Bennett made essentially the same picture over and over again, expressing our desire for a place in nature that was no more foreign than his backyard, benevolently ordered and accommodating to our longing for comfort, beauty, and spiritual fulfillment.[6]

Bennett loved the Dells and the lyric possibilities of photography. "I have been whistling today and although it has been cloudy and hazy, the old inspiration has returned that brings out artistic beauties in bits of woodland and streams that could not be seen before, or, if seen, not appreciated," Bennett wrote in a letter to Evaline Marshall dated October 30, 1889. "Idealism has crept into the titles of the pictures I have made, and suggestions for other subjects that will have artistic merit, I think."

His business was selling the Dells of the Wisconsin River. After Bennett died, the studio continued selling his views to tourists. He was able to provide a comfortable life for his family, but he never escaped the box formed by economic necessity. Near the end of his life, a dam raised the river and flooded many of his favorite subjects. Today the community of Wisconsin Dells has morphed into the home of one of the largest concentrations of indoor water parks in the world.

Lost in the shuffle of commerce and history is that Bennett was Wisconsin's Henry David Thoreau and the Dells was his Walden Pond. That's why he never left. Bennett saw what Thoreau's friend Ralph Waldo Emerson called the "totality of nature" where he lived. That's why the heart of his work still resonates.

I suspect that Bennett was aware of Emerson and talked about him with his friend and patron, William Metcalf. "To the attentive eye, each moment of the year has its own beauty," Emerson wrote, "and in the same field, it beholds, every hour, a picture which was never seen before and which shall never be seen again."[7] Another Bennett contemporary, Peter H. Emerson, a British proponent of "naturalist" photography, wrote, "Art is not to be found by touring to Egypt, China, or Peru; if you cannot find it at your own door, you will never find it."[8] Bennett's "idealism" came out of the revelatory moments of a lifetime of patience and attention.

Preface

Much obliged for speaking highly of my work, but I am too modest to write my own biography for publication.

—H. H. BENNETT to his traveling agent, D. A. Kennedy, June 26, 1888

Humility—one of the reasons I find Henry Hamilton Bennett an appealing subject for a biography. Of course, there's also the dramatic arc of his life story, the passion he expressed in his art, his devotion to the landscape of the Dells, and the tenderness with which he cared for his family. Writing this new version of his biography has proven even more enlightening, given the tools available now to writers (the Internet, computers, and accessibility to further research materials). This is not merely, as Henry Bennett claimed when he revisited Brattleboro in October 1882, "The same old knife with several new blades and handles."

My research for *Pioneer Photographer* took place in the mid-1970s, when Wisconsin Dells only hinted at the colossal tourist mecca it has now become. You could walk across Broadway in winter without looking both ways. The Bennett Studio was still being run by Henry's granddaughter Jean Reese and her husband, Ollie. *Pioneer Photographer* was my first real book. Rick Smith, to whom I was then married, spent long afternoons in the Bennett Studio sifting through fragile photographs and glass negatives and making his selections. I sat in a warm corner in a back room of the museum, where I studied diaries and letters written in Henry's hand. Occasionally, I would glance up at a portrait of the photographer himself and wonder if he would approve. He had warned his agent, D. A. Kennedy, "If you should choose to have anything published about myself [I] do not desire any of my friends to say anything against any other artist in efforts to praise my work." I would keep that in mind.

Many pleasant memories linger when I look back on the writing and publication of *Pioneer Photographer*. Jean telephoned one evening to say they'd uncovered a packet of love letters written by Henry to Evaline Marshall during their courtship (before she became his second wife) in an old trunk in the attic, but they promised not to untie the pink ribbon until we arrived. Rick and I rushed to the Dells and shared the letters with Jean while seated on the attic floor, each of us reading passages aloud. Also in the trunk was Frank Marshall's diary—which recorded the entire romantic affair from his point of view as Evaline's ultra-protective brother.

We were privileged to meet Ruth Bennett Dyer, Henry's youngest daughter, who recalled her childhood for us one snowy evening as we listened to tunes on the elaborate music box that had been a wedding gift to Eva and Henry from William Metcalf. "We girls used to dance to that one," she'd venture once in a while.

The memoirs compiled by Ruth's older sister Miriam provided a sturdy framework upon which to construct our story. The entire Bennett family was affectionately and whole-heartedly supportive then, and they are still; I love them all.

I would like to acknowledge David Oskin and Eva Solcova of Big Earth Publishing, for generously transferring the rights to *Pioneer Photographer*, thereby enabling this edition to be pursued. Thanks to Rick Smith for selecting those prints used for *Pioneer Photographer* and for transferring his rights in that work. I am also grateful for the assistance of Dale Williams, Director of the H. H. Bennett Studio in the Dells, who supplied reference materials regarding the history of Kilbourn City and made certain that Henry's story was related with the utmost accuracy. Donald Wickman's research on George Houghton provided evidence regarding Henry's early days in Vermont and Wisconsin. I am also indebted to John Carnahan, at the Brattleboro Historical Society. Debbie Kinder, great-granddaughter of H. H. Bennett, and her mother, Jean Dyer Reese, spent long hours searching for further biographical information.

I appreciate the participation of Tom Bamberger, University of Wisconsin–Milwaukee, for his long-standing devotion to Henry Hamilton Bennett and for agreeing to write the foreword. His counsel regarding photographic reproduction has been most helpful.

I thank John Devereux, for his unflagging belief in the artistry of H. H. Bennett and for early financial assistance with my research.

Kathy Borkowski, Wisconsin Historical Society Press, was an enthusiastic advocate for this project. Andy Kraushaar and staff of the archives reading room at the Wisconsin Historical Society provided welcome aid in locating documents and photos in the H. H. Bennett Papers and Studio Collection. Lisa Marine's guidance and assistance were necessary for the scanning and transfer of photographs and I would have been lost without her reassurance and careful supervision.

Further recognition is due Constance J. Gordon, Chicago Public Library; Debbie Vaughn, Chicago Historical Society; and Kristi Finefield, Library of Congress, for finding and identifying copies of S. L. Stein's *Chicago* books. Appreciative thanks also to Steve Daily, Milwaukee County Historical Society; Rose Fortier, Milwaukee Public Library; Dan Vinson, UW–Milwaukee Libraries; and Bambi Grajek-Specter, Heather Winter, and Lisa Hostetler, at the Milwaukee Art Museum.

Stephen D. Hoelscher, University of Texas at Austin, offered information on Henry's relationship with the Ho-Chunk.

I am particularly indebted to Howard and Nancy Mead, with whom Jill Dean worked for fourteen years at Wisconsin Tales and Trails and Tamarack Press. In the 1960s, the Meads introduced Jill to the work of Henry Hamilton Bennett. In turn, Jill invited me to write his biography, and Tamarack Press published the first edition of *Pioneer Photographer* in 1979. Jill assisted with research and carefully selected many of the illustrations in this volume.

Pioneer Photographer was presented with an Award of Merit from the Wisconsin Historical Society in 1980. The documentary film *Views of a Cameraman*, based on the biography, was broadcast on the Wisconsin Educational Television Network in 1983 and won a silver medal at the New York International Film and Television Festival in that year.

Pioneer Photographer has been out of print for a very long time. But Henry Hamilton Bennett has arguably remained the finest little-known landscape photographer of the nineteenth century. With his compelling life story and these photographs I wish to help him acquire the critical respect he deserves.

I am indebted, as always, to the University of Wisconsin Press and to Sheila Leary and Raphael Kadushin for their continued support of my writing, especially in the publication of this new work. Terry Emmrich managed the reproduction of photographs and Adam Mehring's shrewd editing pulled it all together. They have my deepest gratitude.

Finally, my husband, Del Lamont, supported me during this arduous task. His strength, as always, holds me fast through the wildest storms.

Author's Note

The gift of the Bennett Studio to the Wisconsin Historical Society has assured the Bennett legacy and provides a means of safeguarding and cataloging his thousands of negatives as well as thirty-two cubic feet of personal papers (fifty archives boxes, thirty-seven file boxes, eight flat boxes, one tube, eight reels of microfilm, and one tape recording) for scholars and the general public to study and appreciate.

All letters and journal entries written by Henry and other family members and cited in the text are found in the H. H. Bennett Papers at the Wisconsin Historical Society in Madison. Most of the images used in this book come from the H. H. Bennett Studio Collection, which is also at the Wisconsin Historical Society. All illustrations from the Wisconsin Historical Society are identified in the captions with the initials WHi and an image number.

H. H. Bennett

Photographer

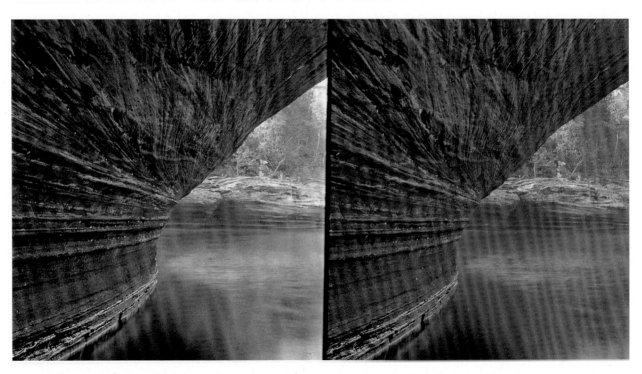

"Overhanging Rock at Black Hawk's Leap." Legend claims that in 1832, during the Black Hawk War, the famed Sauk chief leaped fifty-two feet across the Narrows on his pony while fleeing U.S. troops. (WHi-69014)

I

Early Days
1843–1864

Probably I shall never get a picture that I shall regard as all right in all respects. However, I shall always try for the best results attainable.

—Henry Hamilton Bennett, journal entry, October 7, 1888

THE MUSEUM OF MODERN ART DISPLAYED THE WORK of Henry Hamilton Bennett in its 1963 exhibit *The Photographer and the American Landscape.*[1] He was one of only nineteen selected photographers. Henry's work was admired for "the sweet, naïve, and sometimes vandalistic awakening to the poetic uses of the land [which he] recorded with great tenderness." The exhibit's catalog underscored the artist's singular vision:

> A contemporary of the frontier landscapists, Bennett worked a generation behind the frontier, in the vacation town of Wisconsin Dells. From 1865 through 1907 he made and remade, with variation and refinement, what was essentially the same picture. It showed a fairy-story landscape, rugged and wild in half-scale, with enchanted miniature mountains and cool dark caves; and in this landscape a human reference, most often a figure, neatly dressed, poised, superior to the site, but with friendly feelings toward it. It was a portrait of the American discovering an identity with the wild world.[2]

This perspective—discovering an identity with an untamed natural environment—could very well have represented Henry's own. But Henry Hamilton Bennett the photographer was an accomplished artist with far-ranging subjects in addition to his glorious landscapes.

The first of twelve children born to George Hamilton Bennett and his wife, Harriet Amanda Houghton, Henry was born on his paternal grandfather's farm near Farnham, Quebec, Canada, on January 15, 1843. He was named for his maternal grandfather, Henry Houghton, who lived in Brattleboro, Vermont.[3]

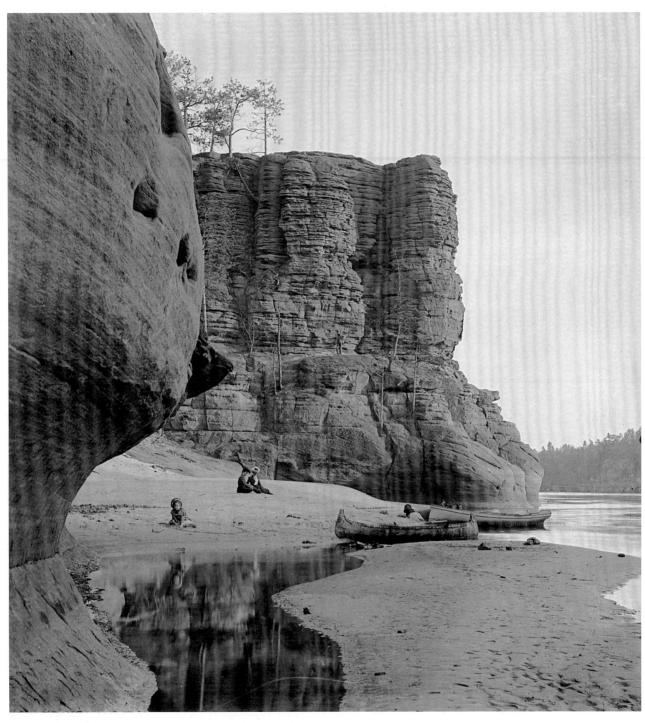

"High Rock." Members of Bennett's family posed to reveal a comfortable relationship with the wilderness and to add a sense of scale. (WHi-7300)

A year after Henry's birth George and Harriet Bennett moved their family from Canada to Brattleboro, where eight of their twelve children were born.[4] Dark-haired and shorter than most boys his age, Henry had what the family referred to as a "common school" education. The family was known for placing a high value on intellectual interests. Henry's father became one of the most prominent contractors and builders in the area of Brattleboro, a steadily growing town that was becoming a small industrial center in the upper Connecticut River Valley. However, Vermont's antebellum economy was not thriving, and like many Vermonters of the time Henry's uncle Albert Bennett migrated west, where more profitable opportunities beckoned. In turn, Albert encouraged George to join him in Kilbourn City, Wisconsin, touting the railroad line, which promised plenty of work and good wages.[5] The country on each side of the Wisconsin River resembled New Hampshire and Vermont; it was the best land the West had to offer for farming and was certain to double or triple in value. Carpenters, in demand, could make as much as $1.50 per day.

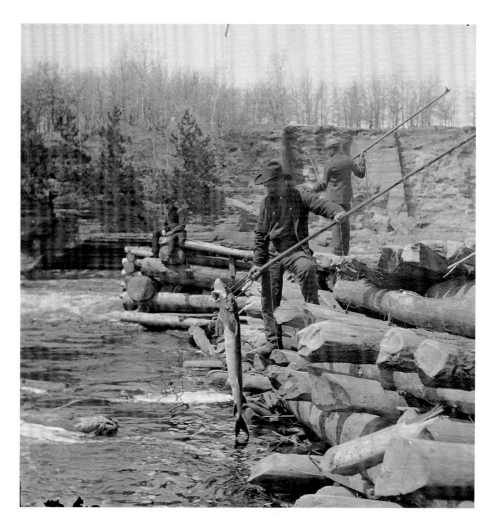

"Men Spearing Sturgeon" illustrates a popular Wisconsin sport when the sturgeon are running, which occurs on the river as soon as the ice breaks up. (WHi-7287)

Around 750,000 people had settled in Wisconsin by the time Albert Bennett convinced Henry's father to come there; a third of the population had been born in another state. Among these, 19,184 transplanted Vermonters constituted Wisconsin's fourth largest group.

In a family history Henry recalled: "In the spring of 1857, Father, with Uncle George Houghton and myself, came west to this place, Kilbourn City, Wisconsin, hoping to 'spy out a land' where there was better hope for prosperity than our eastern home gave." The men came by train to Portage, where they boarded a stagecoach. The pristine landscapes that bordered the Wisconsin River must have held enormous appeal for an adventurous boy of fourteen.

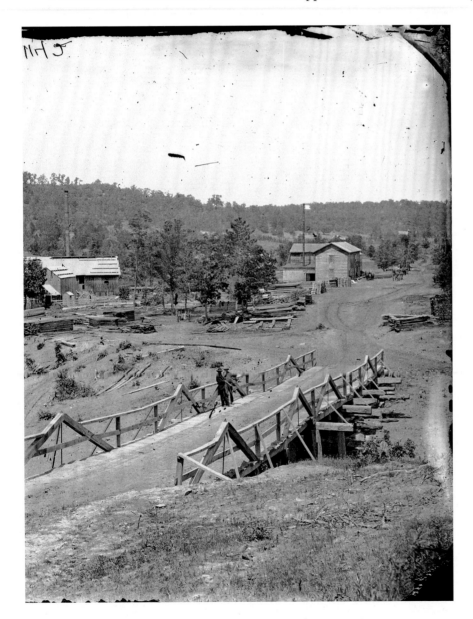

"Kilbourn, Superior Street Bridge." When Bennett arrived there, the town was only a year old. Perhaps the men on the bridge are saying, "I've got a feelin' this place is going to be somethin' someday!" "Aw, pshaw, you're always makin' a mountain out of a molehill!" (WHi-7569)

In Kilbourn City Albert Bennett was a partner with Joseph Bailey in furnishing ties for what would become the Chicago, Milwaukee and St. Paul Railroad. A bridge was currently being constructed over the Wisconsin River for the entrepreneur industrialist and owner of the railroad, Byron Kilbourn.[6] By 1857 track had been laid as far as the small village in the center of the state.

Henry's father hoped to buy his own farm in Wisconsin, but affordable farmland was not so easily acquired. Federal surveyors had already surveyed two-thirds of the state. North of their baseline lay a trackless forest. Speculators had already purchased huge tracts in south-central Wisconsin for $1.25 an acre, but good-quality farmland was $3 to $30 per acre, and that was beyond George Bennett's means. He and Henry took carpentry jobs to support themselves and pay rent on the modest log cabin they shared with George Houghton.

Another setback was the monetary panic that was sweeping the nation in 1857. The United States Treasury was empty. The depression that followed the panic was deeper and of longer duration in Wisconsin than in most states. The railroads especially found themselves in peril, as lines had been expanded too rapidly in comparatively undeveloped regions where settlers did not arrive in anticipated numbers. Land speculators were going bankrupt. Merchants and manufacturers had to barter with customers to stay in business. Lumber and wheat industries, both dominant in Wisconsin, suffered severe setbacks.

Kilbourn City had been in existence only a year when Henry Bennett and his father and uncle arrived. Streets were cut through the oak woods, and the first public lots had gone on sale in 1856. Tanner's St. Nicolas House and two other hotels already catered to travelers, and a new schoolhouse had been prepared for students. There were two dry goods stores, a cigar factory, hardware, clothing, grocery, drug, boot and shoe, book, and variety stores, livery stable, barbershop, blacksmith, meat market, carpentry shop, two millinery stores, one lawyer, one doctor, a newspaper—and one saloon.[7]

Brattleboro, a cultured and literary New England community by comparison, must then have seemed like a distant world. There the post office had been established in 1784. The first postal stamps in America were issued in Brattleboro in 1846. The town had had a bookstore since 1795, and now there was running water, courtesy of the Western Aqueduct Association, and even a model house complete with furnace and bathroom. Local factories turned out stoves, furniture, carriages, and sleighs. Citizens had access to a bank, multiple newspapers, doctors, lawyers, and churches to choose from, and a library society. The Esty Organ Works, founded in 1846, was famous for the reed and pipe organs it produced. A Cotillion Band formed when Henry was six years old, and the next year the Brattle Brass Band was organized.

Henry may have been concealing the extreme hardships of the Wisconsin wilderness when he wrote to his mother on May 17, 1857.

> I . . . feel first rate and like it here very well. We have got into our new house. I have been making a lock for the door today and I guess you would laugh to see it. . . . There is going to be a dam built across the Wisconsin River here. There is going to be lots of building here this summer. We are to work on a large building for Mr. Bailey, a man who is in company with Uncle Albert. This is going to be a large

place in a few years. It is only a year old and contains forty Houses. There is a place above here on the Wisconsin River called the Dells where the river is about fifty feet wide. . . . It is growing dark so I must close.

 Your much devoted son,

 Henry H. Bennett

The family back in Vermont naturally had misgivings about life on the rugged Wisconsin frontier. Henry's father wrote frequent letters to his wife, keeping her abreast of the news. Despite the financial crisis there seemed to be no shortage of carpentry work. He stressed the beautiful scenery and described their humble cabin:

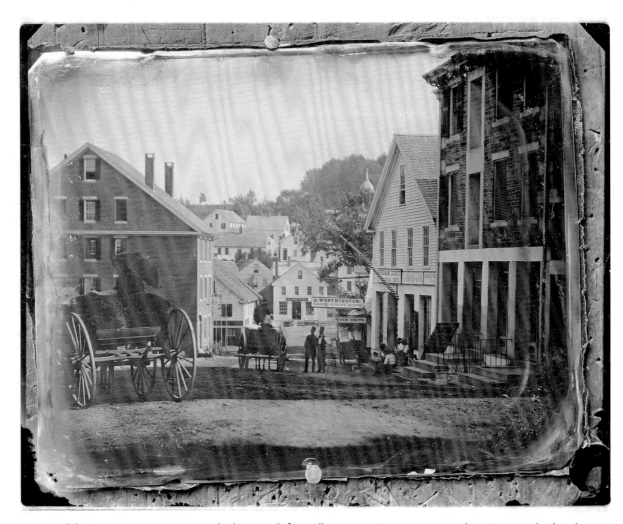

"Brattleboro, Vermont—Main Street, looking south from Elliot Street, 1853." Henry Hamilton Bennett's boyhood home. This daguerreotype was taken three years before Bennett left town by J. L. Lovell, a photographer who taught Bennett's uncle George Houghton the tricks of the trade. (courtesy of Brattleboro Historical Society)

June 14, 1857

. . . I think you would Laugh also to see us here in our little Cabin about as large as your Sitting Room with a Stove in one corner, our turn up Beds in another, table in another and our trunks in other places. A flour and meal chest and two arm Chairs make the sum total of our furniture, we have two windows that we open when it is too warm inside. George [Houghton] does the Cooking and Henry and I do the other housework. Tell Charlie that There is not any wolves about here to catch nor is there many Indians about here and what few there is are Good and friendly Indians.

A few weeks later Henry was excited to learn that his younger brother Edmund, thirteen, would be coming west with another family from Vermont. Most of all, it seems, he missed hearing and playing music. Stephen Foster's "Old Folks at Home," "Camptown Races," and "Oh! Susanna" were currently popular.

June 25, 1857

Dear Brother,

. . . I want you should be sure and bring my drum and drumsticks out with you if you possibly can, without paying extra on it. You could make a box large enough to put it in and take the heads out and put them in the box and then put the drum and sticks in and pack your things in around and inside the drum. We do not have much music out here and so I want it if I can have it . . .

Your brother,

Henry

P.S. Father wants you should bring out a knife and fork for yourself and Uncle Albert if Mother can spare them as he comes and stays with us sometimes. I wish you would bring my skates out if you can, handy.

Henry and his father soon journeyed up the Wisconsin River by boat to see the famed Dells, a locale a newspaper writer of the day described with alluring hyperbole as "a wondrous, witch-like tangle of cliffs, crags, caverns and gulches, or strange-shaped towering rocks, yawning chasms and roaring floods, all decked out with ferns and flowers and cataract form, all filled with the music of falling waters and winds sweeping through dark and labyrinthian halls."

The waterway had become an important north-south trade route for the state. Just above the southern boundary line of Juneau and Adams counties the river enters a constricted gorge which French explorers in the eighteenth century christened the "Dalles," meaning "the narrows of a river or between the cliffs." An early history of Sauk County referred to this part of the river as "seven miles of wonderland," and "the most remarkable bend in its whole length of 450 miles through the entire State of Wisconsin. Through the Dells [the river's] general course is southward, but it is now turned almost due east by a hard, sharp quartzite range, like a flint arrowhead, which stands for the union of the Baraboo Bluffs pushing themselves in from Sauk County. Rising some 400 feet above the river bottom, [the range] effectually turns the Wisconsin from its southerly course through the narrow Dells. The river then widens and naturally flows between low sand banks for seventeen miles to Portage."[8]

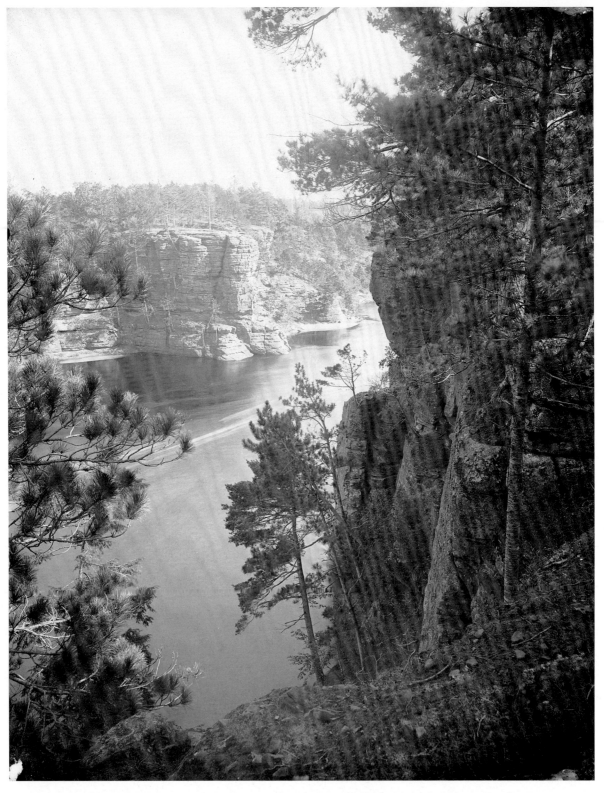

"High Rock from Romance Cliff." When Bennett and his father went upstream through the Dells in the summer of 1857, this would have been one of the impressive scenes they would have encountered. (WHi-7790)

Geologists say the extraordinary cliffs, chasms, and rock pillars of the Dells were the result of the river slicing through soft walls of Potsdam sandstone that, in Henry's day, rose 100 to 120 feet above the water. By 1857 few white men, except the lumber raftsmen— bawdy, colorful characters who rode thousands of lumber rafts drifting downriver from the pineries in the north—had witnessed this astonishing vista.

According to the Ho-Chunk Indians who lived in the area, this remarkable canyon was called Nee-a-ke-coonah-er-ah, meaning "Where the Rocks Strike Together."[9] They believed the Wisconsin River was formed by a manitou, an enormous serpent who lived in the northern forests. One day he left home in search of the sea and slithered southward, cutting a deep groove in the landscape with his scaly body. When the manitou reached the river near Kilbourn, he found a crack in the rocks and squeezed through, scraping the rocks into weird formations and leaving a contorted riverbed in his wake.

"Black Hawk's Cave." Where Chief Black Hawk was thought to have hidden from his pursuers (including Abraham Lincoln and Jefferson Davis) during the Black Hawk War of 1832. (WHi-7268)

The "Dalles" of the Wisconsin River appeared as an early reference point on maps of the Great Lakes region in the eighteenth century.

The last major Native American resistance to white settlement in Wisconsin, led by a Sauk chief known as Black Hawk and later referred to as the Black Hawk War, took place in 1832. U.S. troops, including a young Abraham Lincoln and Jefferson Davis, pursued the chief and his band across southern Wisconsin. According to local legend, after the bloody massacre at the Bad Axe River, the embattled Black Hawk hid in the Dells among the Ho-Chunk and was subsequently captured there—but not before he heroically leaped the Wisconsin River at its narrowest point. In 1867 the Wisconsin Historical Society described Black Hawk's cave as "the place where Black Hawk once secreted himself to avoid pursuers."[10]

The first written reference to the Dells appeared on August 28, 1832, in a report sent by the Indian agent at Prairie du Chien to the U.S. secretary of war: "The Black Hawk was taken about 40 miles above Portage on the Wiskinsin River, near a place called the Dalle."[11]

Although he could not have known it at the time, the afternoon in June when Henry Bennett went upriver to visit the Dells with his father, he encountered a landscape that would enchant and inspire him for the rest of his life. His father reported on their excursion to Harriet.

> July 26, 1857
> . . . We have just got back from a Ride up the River through the dells and it is quite a Prospect to Ride on the smooth surface of the River and look up to see the high cliffs and overhanging Rocks and in some places Caverns worn out by the water. Oh how I wish you were here with me now to see for yourselves and Enjoy the Beautiful and wild Scenery of the Wisconsin River, we saw the Cave where Black Hawk the Indian warrior hid himself when he was Pursued by the Soldiers and he was taken but a few miles from here.

Harriet Bennett was growing weary of lodging with relatives in Vermont. The older boys, Ed and George, had jobs, but they were only twelve and eleven years old. Daughter Sarah was nine, and sons Albert and Charles were six and four. Now she was pregnant again, and Baby Clarence was gravely ill. Her husband had fled to Wisconsin in search of a better life, but he was not forwarding much in the way of income.

Neighbors inquired with raised eyebrows, "When will you and the children be joining your husband, Mrs. Bennett?"

Harriet, exhausted, complained to her husband of her "cracked up nerves" and of a "monotony in daily family cares that is not vivifying and enlivening to the mind." She beseeched him to please come back home.

George Bennett replied that he wished he could help relieve her cares, but he was seventeen hundred miles away and had sent his wife all the money that he could; he needed the forty dollars he was due to pay small bills, including laundry and milk. "We have made a Great Sacrifice my Dear Harriet in separating ourselves for a time to better our worldly condition and now when the chance is almost within our grasp it seems hard to let it pass. But still if Little Clare continues to fail . . . I will try to get my money that is due and come home as soon as possible."

In August 1857, only a few months after he'd arrived in Wisconsin, Henry's father returned to Vermont. Henry, however, was reluctant to go back home. Boys his age were expected to work, and Henry Bennett would rather be whipped than be called a slacker. With his father's consent he remained in Kilbourn City with his uncles. Edmund had not yet arrived, so Henry, still fourteen, was on his own and expected to earn his keep. He was handy with carpentry and worked at lathing for $1.25 per day.

His mother, perhaps uncomfortable with the awkward situation, told him, "By the way, did you know that your name is getting to be quite illustrious in Brattleboro? Everybody is saying that you are a boy of resolute courage and that you stay there so contented without your family."

Henry replied stoically, "I am too much of a man to be homesick."

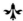

Although Henry shared the cabin with his uncles George Houghton and Albert Bennett, he received no financial help from the men. Instead, his father implored Henry to assist his family. "Be a good steady Boy and see how much you can earn and save for us by the time that we get there."

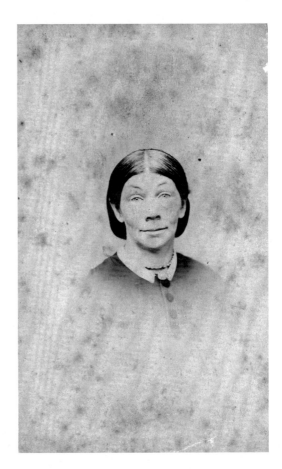

Harriet Amanda Houghton Bennett, Henry's mother. Her husband wrote to her in Brattleboro in 1857, "We have made a Great Sacrifice my dear Harriet in separating ourselves for a time to better our worldly condition." He brought her and the rest of the children to Wisconsin in 1858. (WHi-68897)

In September 1857 Henry was one of the passengers on the first train to cross Byron Kilbourn's one-hundred-thousand-dollar railroad bridge, which Henry had helped to construct. The bridge was 450 feet long and had two levels, a tin-roofed upper deck for trains and a lower deck for pedestrians and horse-drawn wagons. The local newspaper reported that a crowd of one hundred men, women, and children boarded the cars before the train began rumbling over the bridge, eighty-five feet above the water. They were cheered by the ringing bell, the screaming whistle, and the loud hurrahs of the crowd.

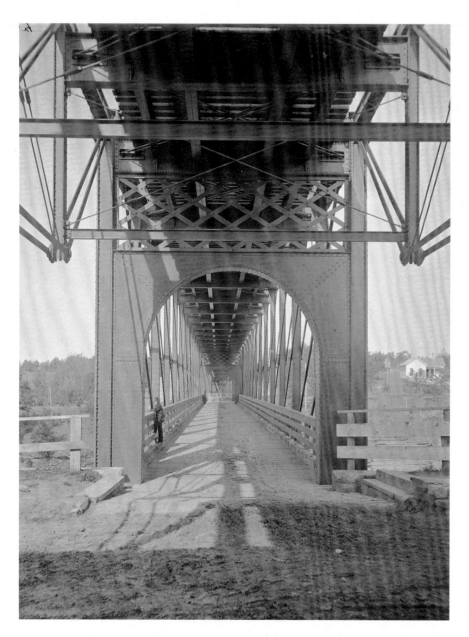

"Kilbourn, Interior of Railroad Bridge." The bridge built for Byron Kilbourn was completed with much hoopla in September 1857, but a spark from a locomotive set fire to the wooden span in 1866. This iron bridge, erected in 1877, similarly accommodated pedestrians and horse-drawn vehicles on one level and trains above. (WHi-7526)

"They have got the bridge all done all that they are going to this season," Henry reported to his father. "They have fixed it so that teams can cross and it is going to be a free bridge for awhile. I rode across it on the first train of cars that went across and there was most all of Kilbourn there to see it go."

His parents were naturally concerned for their son's welfare in the sometimes raucous river town and offered stern advice to avoid bad company and study his books in his spare time. "Associate only with the good and wise and may guardian angels watch over you and strew your path with flowers."[12]

With the country still in a depression, financial pressure was being felt across the land. Henry's father continued to plead for him to send money. Henry wrote:

> November 1, 1857
>
> . . . About the money . . . since you went away, I worked 4½ days on the depot, 10¾ for Mr. Avery, ½ day for Mr. Quincy, 9 days for Uncle George, 9 days for Mr. York, 8 days for Dr. Hooker lathing by the yard at 4 cents per yard and put on 190 yards, and 4 days for Ernst lathing by the yard at 4 cents per yard, and the rest of the time I have not had anything else to do. I have had $89.00 payed to me. Uncle George took $11.00 and I let Uncle Albert have $16.00 and I payed Mr. Tanner $5.00 for board on what you did not when you went away. . . . I hope this may find you enjoying good health as well as I am. Give my love to all the children . . . and give Mother a good smacking kiss for me . . .
>
> Your affectionate son,
> Henry H. Bennett

In the two months since his father left for Vermont young Henry had logged nearly forty-six days of work, the equivalent of full-time employment. But jobs in Kilbourn City were becoming even scarcer as winter descended. Henry had a falling out with George Houghton over some wages his uncle owed him. Then he found a job in a store that belonged to the Hydraulic Company, and his fourteen-year-old's desire for independence was satisfied.

George Bennett returned to Kilbourn City with Harriet and the remainder of his family in the spring of 1858. He built a small house near Kilbourn Hill, but due to hard times there were now few carpentry jobs, so George took up farming a few miles west of nearby Reedsburg. According to family yarns, times were so hard and food so scarce that the Bennetts had to eat basswood buds that summer.

Uncle George Houghton, a bit more enterprising than his brother-in-law, had possessed the foresight to purchase a planing mill in Kilbourn City when he'd arrived from Vermont in 1857. "Great Saving of Labor," he advertised, "ready to fill all orders in the line of preparing lumber for building."[13] Business boomed for a short while, but then the panic of 1857 hit Kilbourn City. Circumstances caused George Houghton to rely upon a particular skill to which he'd been introduced in Brattleboro.

Henry Hamilton Bennett probably would not have pursued a career in landscape photography had it not been for George Houghton's initial curiosity about the new process. The Vermont

Daguerrian Gallery had opened in Brattleboro in 1847, and veteran photographer J. L. Lovell, who had moved there from Ware, Massachusetts, instructed Houghton in the technique of taking daguerreotypes sometime after 1852.[14] Houghton's interest was only tepid at the time; he was more enthusiastic about rumors of new opportunities opening up in the West.

But a passion for photography must have been kindled in George. While he awaited the arrival of new equipment for his planing mill in Kilbourn City, George Houghton accompanied a photographer on an expedition to Reedsburg. He knew there was a photography studio fifteen miles away in Portage, but a photographic enterprise was a business that Kilbourn lacked.

In September 1858 George Houghton opened a "daguerrean saloon" in Kilbourn City and advertised that folks in the village ought to "call at the new Picture Gallery, where you can obtain correct likenesses of yourself and friends. . . . Pictures of every style and variety taken in cloudy as well as clear weather, at a great reduction from the usual prices."

The local newspaper sang Houghton's praises. "We are glad to have a Daguerrean Gallery in Kilbourn City. Our townsman, Mr. Houghton, a good artist, is fitting up rooms." Only a week later the editor asked, "Have you been there and seen his specimens? They say he 'can't be beat.' Those of his specimens we have seen are certainly excellent. And his prices are so low, that it would be a good economy, these pinching times, for a family to be used upon into likenesses altogether, and so wait for the rise of their property."

Houghton's gallery was successful, but his conscience and an ill-tempered second wife he'd left behind were pulling him back east.[15] On November 16, 1858, the Kilbourn paper stated, "Houghton tells us that since he gave notice last week that he should remain in this place but one week longer, his Gallery has been thronged with people wishing pictures and he has had to send many away, and many more are in want of Pictures. He therefore wishes to say that he will remain a few days more for the accommodation of those who have not been served."

To encourage procrastinators to purchase daguerreotypes before he left Kilbourn City, Houghton ran this advertisement in the *Wisconsin Mirror* the following week:

> Houghton's Gallery is the place
> to get a picture of your face,
> as perfect as you ever saw
> —without a spot, a blur or flaw.
>
> Thanksgiving is quite near at hand,
> come buy a picture for your friend;
> nor in your eagerness to eat,
> forget that Houghton's can't be beat.
>
> Pictures for friends or those to keep,
> you must obtain this very week.
> I've tarried with you quite too long;
> you'll believe I'm going when I'm gone.

True to his word, Houghton ran his final ad in the newspaper's next edition and promptly departed Kilbourn City, leaving brother-in-law George Bennett in town to look after the house and property he had purchased there. A year later a friend of the Bennett family in Brattleboro wrote to them in Wisconsin to report, "Your Uncle George is fixing up a Daguerrean room here." Houghton was now utilizing a new technology, the wet-plate, or collodion, process of photography, with a much larger camera and the opportunity to make duplicate copies from glass-plate negatives. George Houghton's son Fred wrote to the Bennetts in Kilbourn City that because of an increase in business his father was expanding his line of services in Brattleboro and had hired an artist to hand paint his photographs, rendering them even more lifelike.

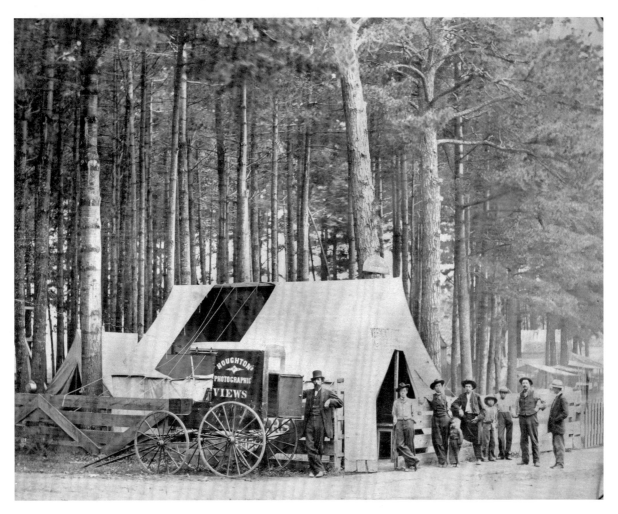

Henry's uncle George Houghton was operating Houghton's Photographic Hall above a furniture store in Brattleboro when the Civil War began. His health prevented his enlistment, but beginning in 1861 he documented Vermont's troops in battle with this custom-designed traveling photo-tent, which doubled as living quarters. (WHi-68635)

Back in Wisconsin, in 1861 George Bennett and his family moved from the farm in Reeds-burg to Kilbourn City, where they were to remain. He found a job as a carpenter for the railroad. Three more children—two sons and a daughter—would be born in Wisconsin. Henry's brother Ed helped build the house in which their parents lived for the rest of their lives, one block south and one block east from the school.

Henry Bennett was surely aware of the Underground Railroad. The lower Connecticut River Valley yielded a sufficient supply of fugitive slaves to sustain a vigorous transportation system in eastern Vermont. From Brattleboro the railroad went through Chester, Woodstock, and Randolf on the way to Montpelier, where it broke into three parts and then conveyed slaves into Canada. Because of its proximity to Canada, Henry's new home in Wisconsin also possessed a very active Underground Railroad line, and sympathy was expressed for fugitive slaves among the New Englanders who had migrated there.

In 1861, when the South seceded from the Union, economic prosperity came to Wisconsin. Rail-roads were inundated with trade when access to New Orleans was restricted on the lower Mis-sissippi River. Crop prices multiplied with the demand for wheat, Wisconsin's principal crop. An increased demand for agricultural products led to a boom in the mechanization of farming, an industry centered in the southeastern part of the state.

When Confederate forces fired upon the Union flag at Fort Sumter, South Carolina, on April 12, 1861, the Civil War—which Henry would always refer to as "the War of the Rebellion"—was under way. President Abraham Lincoln called for seventy-five thousand men to serve in the Union army. Enlistments were hastily arranged, and Wisconsin responded with valor. On April 15, 1861, Governor Alexander W. Randall received a telegram from Washington requesting one regiment of 780 men to serve the Union for three months. Within a week ten companies—from Kenosha, Beloit, Horicon, Fond du Lac, Madison, and Milwaukee—were ready. Governor Randall asked, "What is money, what is life, in the presence of such a crisis?" At the commencement of the war Wisconsin's inventory of military equipment consisted of 6 brass cannons, 135 flintlock muskets, 796 percussion muskets, and 811 rifles, all outdated. There were also 101 old pistols, 158 sabers, 44 swords, and 56 tents.[16]

Many of the volunteer companies that comprised the initial Wisconsin regiments were well trained for parades and celebrations but had little knowledge of the raw and violent circum-stances of war. On September 7, 1861, the Wisconsin River Volunteers was organized. Henry H. Bennett, age eighteen, presented himself for duty the very next day. Edmund Bennett, age sev-enteen, joined in October. Albert Irving Bennett, age twelve, tried to enlist but was refused. The brothers' loyalty to their country was a matter of family pride: great-grandfather Aaron Bennett had been an aide to General George Washington and had died at Valley Forge during the Revo-lutionary War.[17]

Company E of the Twelfth Wisconsin Volunteer Infantry was organized by Abraham Vander-poel of Newport, just across the river from Kilbourn City. The drillmaster was John Gillispie. Recruits were mostly between the ages of nineteen and twenty-two, although a few were as

young as sixteen. They were quartered in two hotels in the nearby village of Delton and marched for five to six hours each day, often in front of young ladies of the village who gathered to watch and admire. "The boys always got in their best work when they had a bevy of admiring maidens for spectators," one veteran recalled. "Boys just let loose from the school, the farm, and the shop, and put into the jolly, easy-going, free-from-care life of the soldier in camp, seemed to become possessed with the very spirit of mischief."[18] The grisly reality of what the boys were facing had not yet set in. Soon they would be informed that the life of the nation was at stake, and every fellow who enlisted could become a martyr to save his country. But the horrors of the war were still far away; right now they wanted to have a little fun.

The recruits slept in the ballroom of Freer's Tavern in two rows of ten beds that were meant to sleep forty boys, but they seldom slept. They invented an initiation ceremony that involved fights with boots, shoes, and pillows. They took to the dark village streets to go through ridiculous military drills clad only in their underwear. By the time the young men transferred to Madison in the late fall, not a bedstead was left standing; everyone was sleeping on the floor. The Bennett brothers were singled out as leaders in the merriment.

Henry's company enjoyed playing tricks on each other, but the local copperheads were treated with particular effrontery. One day an elderly copperhead was seized by the members of Company E, who attempted to make him cheer the flag. When he refused, he was tied to a knotty tamarack pole and carried into the village, where a harness line was draped around his neck. He was led, partially dragged, to a barn, where he was given another opportunity to cheer the flag. The old gentleman promptly declined, whereupon the line was thrown over a big beam and he was drawn up.

The captain watched all this closely. When the old man had grown black in the face, the captain ordered the recruits to let him down, still alive but fairly limp. Asked again whether he was ready to cheer the flag, the old man answered feebly, "No, I am not. But I want to ask that when you hang me again you leave me till I am dead. Don't let me down again!" The captain replied, "We shall hang you a dozen times before you are dead, unless you cheer this flag!" At this the old man weakened and said he would cheer the colors as well as he could. The flag was brought and held over him. He faintly hurrahed three times, swinging his old hat above his head.[19]

Not everyone in Wisconsin supported the Civil War. Some blamed the publication of *Uncle Tom's Cabin*. Some blamed the abolitionists. Democrats thought states' rights should prevail or that the country had been overtaken by Republican extremists. German Catholics did not support the war, since they had fled Germany to escape compulsory military service. On November 10, 1862, at least three hundred rioters attacked the draft office in Port Washington and vandalized the homes of Union supporters. A mob of protesters shut down the draft in Milwaukee that week, and in West Bend the draft commissioner was beaten bloody and chased from the scene by opponents of the draft. But Henry Bennett felt at the time that to be a soldier was to be "one of the merriest fellows on earth." That illusion would soon change as the days and months wore on and training eventually gave way to combat.

The recruits from Company E of the Twelfth Wisconsin were soon moved to Camp Randall in Madison, a mile and a half west of the Capitol Square. There, forty-two acres of what had been

the state fairgrounds were quickly adapted (and named to honor Governor Randall) for use as a drill ground for Union troops. Forty-five barracks, each measuring eighty by twenty feet and affording eating and sleeping accommodations for one hundred men, were constructed. Three tiers of bunks filled three sides of each building, and a kitchen with a cookstove was partitioned on the fourth side. Each bunk was filled with hay and covered with a coarse sheet. Generous ladies provided blankets and comforters. From the grounds of Camp Randall you could see the state capitol, Lake Monona, the state university, neat residences, farms, grassy meadows, rolling fields, and shady groves.

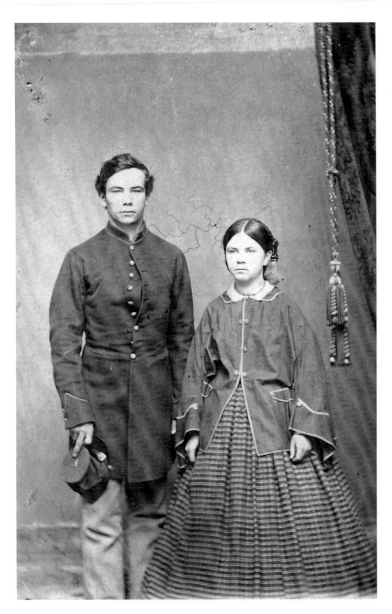

Henry Bennett with his younger sister Sarah Maria Bennett, the eldest daughter. Sarah's future husband, James McVey, served in Company E of the Twelfth Wisconsin Volunteer Infantry along with Henry and brother Ed. (WHi-68183)

One curious aspect of Company E was the presence of a bear cub, which joined the unit at Camp Randall. The bear was the pet of Harlan Squires, a sixteen-year-old recruit from Waterloo. To the young men the bear became as much a company member as were the soldiers. The bear marched along with them. Wrote one of the fellows:

> Such a soldier as the bear demanded an addition to the company quarters; accordingly, a dry-goods box was got, and a hole about the size of his bearship sawed out of it for a door. When this was turned upside down over a bit of straw for a bed, our young bear had decent and comfortable quarters. Close at hand, a twelve-foot post was set into the ground; on top of this a good-sized platform was built to which Bruin could climb for dress parade or to get a good view of the camp and his fellow soldiers. He seemed delighted with this plan, for he spent much of his time on this elevated perch viewing with evident satisfaction the military operations going on below him.[20]

The day came when Company E and the rest of the Twelfth Wisconsin Volunteer Infantry were to be moved out of Madison. On January 11, 1862, the soldiers marched to the train in a snowstorm. The bear marched along with the men and was given a bed in the corner of one of the cars. It slept all the way to Chicago, where the regiment marched from one railroad depot to another. One of the soldiers wrote, "All Chicago was out to see the sight. Chicago by gaslight, with windows, doors and balconies, as well as every foot of pavement, crowded with men, women and children clapping their hands and shouting all sorts of patriotic things, while a splendid band, leading a full regiment of soldiers [and a *bear*] through the enthusiastic crowd, [filled] the air with stirring music."[21]

The bear stayed with Company E awhile longer. Henry's brother Ed drew a sketch of it in a letter to their sister Sarah. The bear was finally sold for seventeen dollars in Leavenworth, Kansas.

Henry wrote in his diary from Leavenworth in May 1862, "I must confess there is something enticing about a soldier's life. The grass is six or seven inches high on the prairie and the trees are all leaved out. It looks quite romantic to see the tents pitched under the green forest trees." But it was not long before the monotonous business of marching back and forth across the country became wearisome.

From March until May 1862 Company E marched a total of 515 miles. Overall, during three years of war Company E of the Twelfth Wisconsin Volunteer Infantry walked 3,380 miles through twelve states, more miles than any other foot regiment. A soldier in Company E saw little combat, served a lot of picket duty, and wore his only uniform until it disintegrated.

Later excerpts from his Civil War diary indicate Henry finally admitted that life as a soldier was not as wonderful as he'd once thought.

> January 14, 1863
>
> It's a good thing for me that I learned in my childhood to swim, or I might have drowned this morning. In the night it rained very hard And . . . when I woke I had to put my swimming powers to use to get out of bed. . . . About an hour after we started for Moscow [Tennessee] the rain was pouring down in torrents and it has continued so all day without interruption. Added to that the mud is

2 or 3 feet deep. . . . We could not get into town so we had to camp 2 miles from the town, raining yet.
Had some whiskey rations.

January 15, 1863

 This morning woke up and found the ground covered with snow 5 inches deep and snowing yet.
This is my birthday. Not a very pleasant one outdoors but cheerful within and then I have been helped
with the best of health, hardly missing one tour of duty during the past year. Today I am twenty years
old. Just one year ago we were crossing the state of Missouri in battle. . . . Wonder where we shall be
a year from now—hope I shall be at home.

Back in Wisconsin any word from the troops was scarce and highly prized. It was not
unusual, when news of a large battle reached Kilbourn City, for silence to fall until someone
received a letter reporting that everyone was well: the battle of Shiloh, April 1862, the battle
of Gettysburg, July 1863. Often the anxiety would become so intense that while their children
slept wives and mothers would set out at night with a tallow candle in a tin can punched full
of holes, heading for the general store to ask for the latest news of the war and where their
menfolk might be.

In March 1863 Company E welcomed a visit from Cordelia Harvey, widow of Wisconsin gover-
nor Louis P. Harvey, who had drowned when he fell from a steamboat while returning from a
trip to distribute supplies to wounded Wisconsin soldiers in Tennessee following the Battle of
Shiloh the year before.[22] Mrs. Harvey took up her husband's work with wounded soldiers imme-
diately after his death, visiting hospitals and camps to distribute gifts and medical supplies.

March 4, 1863

 The expected visitor, Mrs. Harvey, came this morning, accompanied by Col. Howe and wife. They
stayed all day looking about amongst the regiment and went away on the train just at dark. . . . It is
so seldom that we see a Northern lady it almost makes us homesick. They are so different from the
Southern women that one cannot help but feel some yearning for home in the north but we must bide
our time.

During the spring of 1863 the Union army was engaged in an extended campaign to seize
control of Vicksburg, Mississippi, from the Confederate army. Located on a high bluff, the
city—nicknamed "The Gibraltar of the Confederacy"—was nearly impregnable and dominated
the last Confederate-controlled section of the Mississippi River. Eager to end the war, President
Lincoln wrote, "Vicksburg is the key. . . . The war can never be brought to a close until that key
is in our pocket."

Leading the assault on Vicksburg was General Ulysses S. Grant. Defending the city was
General John C. Pemberton, a Philadelphian who chose to fight for the South. In what is widely
regarded as one of the most brilliant campaigns of the war, Grant forced Pemberton to retreat

into Vicksburg and then laid siege to the city. After forty-seven days Pemberton's forces and the citizens of Vicksburg were starved into submission. On July 4, 1863, Pemberton surrendered to Grant his entire army—a total of 29,495 men.

With the fall of Vicksburg the Confederacy was cut in half. The day before, General Robert E. Lee's invasion of the North had been repulsed at Gettysburg. Combined, these two events marked the great turning point in the war.

Henry Bennett and his brother Ed were among the Union forces at Vicksburg. Henry described the fall of the city in his diary:

Bennett's Civil War diary, in which he meticulously documented his daily schedule. On Sunday May 24, 1863, he wrote of the shelling of Vicksburg by Union mortars. He would eventually celebrate the anniversary of the Union's victory at Vicksburg every year on the Fourth of July. (WHi-69555)

July 3, 1863, Vicksburg

Last night about 10 o'clock fighting commenced in the next division on the right of ours and kept up quite lively for an hour. It was mostly musketry. We have since heard that the Rebs tried to take some of our cannon, but did not succeed. How great the boys were I do not know, but hear the Rebs lost heavily. The remainder of the night remained uneasily quiet.

Firing commenced again at daylight and was kept up until 9 o'clock when the order came down the lines to cease firing and the Rebs began to tumble up on top of their works in plain sight. We were not backward in following their example. . . . We soon learned a flag of truce had gone out from the Rebs on the right to General Grant. Some said it was to bury the dead but just before we were relieved, we heard it was to negotiate for a surrender.

All this time we were out picking blackberries and the enemy doing the same. Lots of our boys went most over to their works and met them, shook hands, and had a good social time. When our boys come away, they told the Rebs to keep their heads low and take care of themselves.

It is now dark and has been quiet since morning except . . . when by some mistake there was some firing but when we left the pits both parties were sitting around in squads in plain sight of one another. It caused a curious train of reflection to see how men that a few moments ago were doing their best to kill one another would talk over things like old friends. I hope they can agree on terms of surrender. . . . Weather warm and cloudy.

When Vicksburg admitted defeat the next day, soldiers stripped leaves from the oak tree beneath which General Grant and General Pemberton had met to arrange the surrender. Henry came home with one of the oak leaves, which he preserved in a frame along with other relics of the war. For the rest of his life he led his family in an annual commemoration of the fall of Vicksburg on the Fourth of July. It had been one of the proudest moments of his life.

July 4, 1863

And a glorious old 4th it has been for us. We have double cause to celebrate. . . . Vicksburg surrendered about 10 o'clock they struck up white flags on their works opposite us and stacked their arms in front of their rifle pits. The boys began to flock over there and some regiments went over into town. Now our boys and the Rebs are all mixed up, talking over how they tried to kill one another a few hours ago. Thirty-one men including myself from our company are to go into their works tonight. Weather warm. Wrote letter home.

Most of the Confederate soldiers were paroled. However, surrendering on the Fourth of July was a bitter pill for the Confederates to swallow. Vicksburg refused to celebrate Independence Day for the next eighty-one years.

July 5, 1863

The night passed quietly. We done guard duty on their rifle pits. . . . We had quite a chat with them. Most of [the Confederate soldiers] are heartily sick of the war and if they can get home will stay there. Many of them say they are glad the place is given up as they were almost starving. As

near as we can find out, there is an army of twenty thousand. . . . This morning . . . about noon our regiment started up towards Black River. It is so hot I could not stand it to march. Some of our boys that started out have come back on account of the heat.

Indeed, the weather was unusually hot and sultry. Many soldiers became ill with chills and fever due to drinking bad water. Soon thereafter Henry Bennett was reported as a deserter. He contracted diphtheria in August 1863 and was sent to a Vicksburg hospital. He described his stay there in a letter to his family: "[T]he Doctor, bless him, gave me a physic and then went to dosing me for dysentery, and the Nurses, poor fellows, slept all night and let those of us that were able to sit up do the nursing. All they could do was bury those they killed." A fellow patient wrote: "The doctor's exact words were, 'Oh, you're a long ways from dying!' Perhaps I was more frightened than sick. But when a sick man is near a regular hospital and sees from three to six dead men carried out every day to the 'bone-yard,' as the boys used to say, it does not look very encouraging for him."[23]

Henry was given a thirty-day furlough, shipped off to Cairo, Illinois, and from there made his way back to Kilbourn City. His thirty-day furlough was extended to sixty days. On his way back to his regiment he again developed a fever at Fort Pickering in Memphis, Tennessee. He was detained there by a physician who refused to allow him to join his squad on a waiting boat. Henry nevertheless slipped away and rejoined his comrades in Company E. A month later he was reported as having deserted from the Fort Pickering hospital. Henry was not seriously reprimanded for his "desertion" and rather enjoyed all the fuss.

After he returned to camp Henry found the routine monotonous once again.

January 1, 1864

. . . I had a rather serious time last night from General J. Frost's attending us in front, rear, and all around. Camp R. Overcoat came to my support, but for all that . . . I had to withdraw to a breast-work of logs to which fire had been applied, causing clouds of sparks and smoke to ascend high in the Heavens. Even there our enemy would attack our rear, causing us to right about quite often, or, to express it more plain to one not accustomed to military terms, it was devilish cold and we were not disposed to stay longer away from the fire than duty compelled us to.

Two hours vidette [guard duty] on top of a hill where the wind had full sweep satisfied me in regard to the temperature of the air, but perhaps a little adventure I had on vidette . . . would . . . be interesting to some of you stay-at-homes . . .

Very near the exit of the old year and the birth of the new, I was standing with my back against a sturdy oak and my chin resting on the muzzle of my constant companion. Ruminating on . . . where I was on the first night of 1863—that was, doing similar duty at Harmony Hill and was on vidette duty the same hours in the night . . . I was consulting with myself the propriety of reenlisting. . . .

. . . [M]y reflections were brought to a close by the rustle of leaves as though someone was walking nearby. I quickly cast my eyes in the direction from whence the sound preceeded. I saw something which I first took for a stump. I still kept strict watch on it for about a minute, when I became sure it moved, and towards myself.

I did not like the style of its advancing, therefore brought the gun to bear on it and challenged. Was about to fire when my enemy appeared to halt and I asked who was there. Not getting any answer I about concluded again to fire and brought my gun up to do so but, on reflection, thought perhaps it would needlessly alarm the reserve and that I would reconnoiter a little.

Then commenced a series of creeping, crawling and dodging . . . that is not laid down in the tactics for war for skirmishes or any other drill. And whenever I could get a sight of the object . . . it seemed sometimes to move. . . . Finally, after various skulkings and laying down, I reached a big log close enough, I thought, to find out who or what had caused all this trouble. Accordingly, I raised my head cautiously above the log, and there not more than a rod from me, partly lying down, was a— what? Why, what I first took it to be, a rather short log.

Henry's good humor held out, even though news of fierce battles heavily burdened his thoughts. He seldom mentioned his experience in the Vicksburg hospital, when he and other soldiers were called upon to help tend to the wounded because the nurses were so exhausted. Nor did he share his knowledge of the field hospitals where arms and legs were sawed off and tossed aside into a bloody pile.

"Bennett's Wounded Hand." This photograph of his disabled hand was taken by Henry to accompany his application for a disability pension. (WHi-68895)

In quiet times there were moments of melancholy when he recalled the naïve young man who, in the early days of his enlistment, thought that a soldier must be "one of the merriest fellows on earth, leading a life of pleasure and devoid of care and trouble." After two years Henry's attitude had drastically changed. He was tired of the war. He was lonesome for his family. And, having recently returned to Kilbourn City for a furlough, he was deeply, painfully eager to go back home.

> January 8, 1864
> . . . The excitement of reenlisting has passed away and we have settled back into the old dull routine of camp life—get up in the morning—eat breakfast—sit around till noon—eat dinner—sit around till supper time—eat that. And so it goes day after day except when we are detailed for fatigue or picket duty.

Only three months after that entry, on April 17, 1864, Henry Bennett sustained a critical wound while on picket duty. During a rebel attack that night Henry climbed on a stump, and a defective half-catch on his gun loosed the trigger. Somehow his gun accidentally discharged, and the ball tore through his right hand. Chagrined, he said he would rather it had been his head.

His period of enlistment was nearly over, and for the remainder of that time plus an extra three months Henry was hospitalized, first in Paducah, Kentucky, and then at the Harvey Hospital in Madison, Wisconsin. The injury to his hand was described in an application for an invalid pension drawn up by Henry's physician: "The ball entered the hand at the knuckle joint, passing upward and across the hand, coming out at the wrist joint on the back of the hand, just above the thumb bone joint near the wrist joint, from the effects of which his right hand is rendered nearly useless from the bones having been fractured and the contraction of the hand."[24]

Henry successfully resisted surgeons' recommendations to amputate. He was mustered out of the service on November 8, 1864. He had served three years and two months as a private and said he had enjoyed everything about the army except the fighting. Anyone with access to his Civil War diary knows that statement is not entirely true. In fact, some have conjectured that his injury may have been self-inflicted.

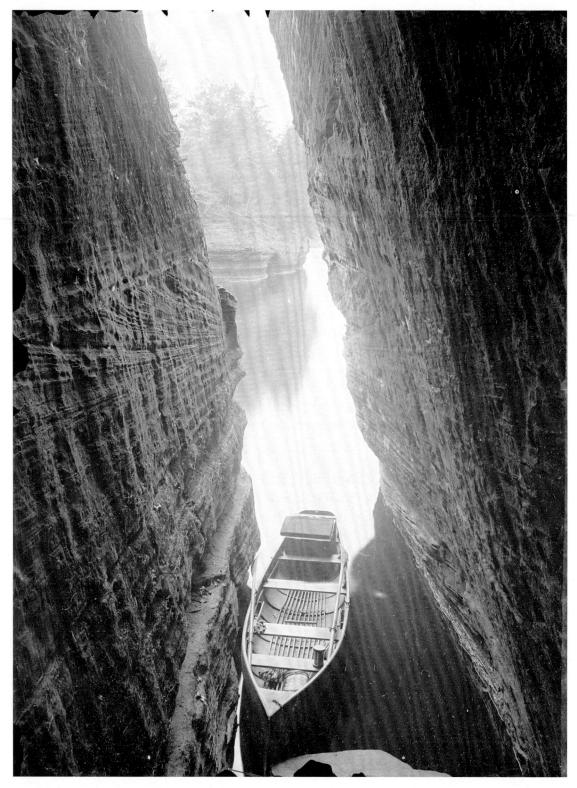

"Rowboat in Eaton Grotto." Bennett named most of the scenic highlights in the Dells, but the inspiration for this location has been lost in the haze of time. (WHi-7511)

2

Discovering the Landscape

1864–1867

Went to the Dells, water the highest its been for a great many years. Its Terrible, awfull, sublime, majestic and grand.

—H. H. Bennett, April 23, 1866

WHILE HENRY BENNETT WAS SERVING WITH COMPANY E of the Twelfth Wisconsin Volunteer Infantry, his younger brother Georgie journeyed to Vermont in 1864 "to learn the Picture business" as George Houghton's apprentice. After two weeks seventeen-year-old Georgie wrote back to his parents in Kilbourn, "I like it very well. I can Print, Make a Solution, Silver Paper, Tone etc etc." He enclosed a portrait of himself for his mother. When she wrote back, alarmed at his apparent unhealthy pallor, Georgie reassured her, "Now Mother, I'll tell you just what ailed that Picture. It was printed from a very weak negative (that is, one that is not very Opaque) so that the face has no shades or Highlights or Middletints to it, but prints nearly the same color all over it . . . That is the reason it appeared so to you," he assured her. "Nothing else."[1]

Uncle George Houghton had been prevented from enlisting in the Union army due to ill health, but as the only professional photographer from Vermont to follow the troops from that state, he did a brisk business capturing portraits of individual soldiers for seventy-five cents apiece and documenting images on the battlefield. Georgie accompanied his uncle as an assistant. They set up a custom-designed tent at Camp Griffen in Langley, Virginia, as a studio and darkroom.

During the Civil War it was the custom for families and their boys on the front to exchange tintypes.[2] Henry's brother Edmund had his tintype made while the brothers were in training at Camp Randall in Madison. Ed described the experience in a letter dated December 7, 1861: "Snowed this afternoon, was disagreeable drilling. . . . Went and had my picture taken but it was not a good one as it took 4 minutes to take it. It cost one dollar and a half."[3]

29

George Chapin Bennett, Henry's second youngest brother, born February 1, 1846, in Brattleboro. He learned photography at George Houghton's Brattleboro studio, and in 1865 Henry persuaded him to come west and join him in running a daguerreotype studio in Kilbourn: "Bennett's Gallery. Get the very best pictures of every style and variety. Come one, come all. None shall go away dissatisfied. Delays are dangerous so come immediately. Thankful to the public for their patronage, we shall do our best to merit it. H. H. Bennett and George C. Bennett, Photographic Artists." (WHi-68892)

In the spring of 1864 Henry Bennett returned to Kilbourn City. He was twenty-two years old. His right hand had healed from its war injury, but it was misshapen and painful, and he was left with the use of only his thumb and third finger. Before the war Henry had worked as a carpenter. He still possessed the skills and insights of a craftsman, but he no longer had the manual strength or dexterity for carpentry. He needed a new occupation, and Leroy Gates's tintype photography business was for sale. Photography seemed like a worthwhile gamble, since Henry already had connections in that business with his uncle George Houghton and his younger brother Georgie in Brattleboro.

Photographs were no longer a novelty in Kilbourn City, but the camera had not yet captured the Midwest as completely as it had the East. The 1860 census listed 3,154 photographers in the United States, but most of them were located in areas surrounding New York, Boston, and Philadelphia.

Harriet Bennett had written to her sons on the battlefield, "We should have tried to send you some pictures but cannot find an artist that suits us very much." About Gates's tintype studio, she continued, "The brave Leroy Gates we do not care to patronize."

In his defense, Gates was probably better suited as a river pilot than a tintype artist. He ran this ad in the Kilbourn newspaper: "For Recreation Resort to the Dells! Where depressed spirits can be alleviated, gloom and melancholy soon be dispelled, and the mind become greatly invigorated. LEROY GATES has purchased a pleasure boat for the purpose of penetrating the

numerous occult caves of the Dells." When guiding lumber rafts down the Wisconsin River, Gates adorned himself in a Prince Albert coat and patent leather shoes. He carved and painted onto a cliff in the Narrows the words "Leroy Gates, Dells and River Pilot, 1847–59." Perhaps he should have added "showman."

Gates was equally flamboyant as a photographer. Patrons of his tintype studio might find Gates surrounded by stuffed animals, one foot resting on the back of a wildcat, a sword in his hand. An ad in the 1860 *Wisconsin Mirror* for the Gates Picture Gallery stated his works were "almost as imperishable as the Rock of Ages. Ferrotypes, Papyrotypes, etc. On plates suitable for sending in a letter, 20c. In good sized and fine cases, .40 and upward. All above 3 years of age taken in cloudy weather with almost as good success as in good weather. Small children and infants taken best on clear days, in 2 seconds."

"The Narrows at Black Hawk's Leap." The colorful Leroy Gates, from whom Henry Bennett purchased his daguerreotype business, carved this graffiti on the far shore: "Leroy Gates, Dells and River Pilot, 1847–59." (WHi-7901)

With his uncle George as a role model and intrigued by the prospect of his own new career, Henry wrote to his brother Georgie in February 1865 proposing that Georgie leave Brattleboro and become a partner with him in the purchase and operation of Gates's photography business.

Georgie's ties to Brattleboro were not particularly strong. He was living with the Houghtons, and he had complained that the household was "not a very agreeable place to board. . . . Aunt Sarah is such a cussed old *Sour Kraut Bitch*," he grumbled. "They have no company once in a dogs age. And when they do have any the (little devils) young ones are climbing over them from head to foot in less than five minutes after they get into the house, so that if a person comes once they *don't* come again, and as for staying in the house no more than half an hour. Oh well, you can imagine the rest."[4]

Georgie was certainly game to return to Kilbourn City. Still, he questioned Henry's offer. "Now, not to take Leroy's word for it, do you think there is business enough in that little shop in that Godforsaken town to give us a decent living," he asked Henry.

Uncle George Houghton firmly opposed the idea and offered Henry a job working at his photo studio in Brattleboro instead. "If I were young and in good health I would give the business up & never touch it again for if your hands will let you work half way comfortable, you can earn double the money to work at carpenter work than you can making pictures unless the business is much better west than it is here. . . . But Henry I would leave the business [alone] for I tell you it will not give you a living."

Undeterred, Henry went ahead and made an arrangement with Gates in the spring of 1865 to buy Gates's business and rent his studio building. The times were changing. The Civil War ended with General Robert E. Lee's surrender to General Ulysses S. Grant at Appomattox, Virginia, on April 9, 1865. Milwaukee became, according to the newspapers, "one vast lunacy of joy, with festoons of red, white and blue bedecking the city by day and bonfires and fireworks brightening it by night."[5] Kilbourn City and other towns in the state celebrated by ringing church bells and holding festive celebrations, but they proved short-lived. Within a week all the bright colors were replaced with black crepe, and all flags were hung at half-mast: President Lincoln had been assassinated on April 14.

Wisconsin's Governor Fairchild may have been a model of sincerity when he made a point of personally welcoming the Wisconsin troops as they returned. But nearly half of the state's men of voting age had served in the war, and Fairchild's public greetings were politically shrewd.

With Kilbourn's soldiers coming home, Henry figured the demand for portraits would be brisk. Georgie remained skeptical, but he came to Wisconsin to work with his older brother anyway. Using the equipment they purchased from Leroy Gates, the Bennett brothers initially made tintypes, or ferrotypes, a name for tintypes that was popularized by a manufacturer of the iron plates used in the process. Capturing images via tintype was a clumsy and inefficient process. The photographer had to remove the lens cap from the camera and then replace it after a sufficient amount of time had elapsed, a matter of five or six seconds. The camera was easily jarred. The sitter had to be restrained with head clamps and supporting devices, and the slightest movement produced a blurred image.

Henry was often disappointed by the results of tintypes, so it wasn't long before he adapted both the camera and the studio to handle the newer wet-plate process, in which the photographic emulsion was spread on a glass plate instead of a metal one. Because the glass was transparent, the negative image that formed on the plate could be used to make multiple high-resolution positive prints from a single exposure.[6] Henry also refitted Gates's camera with a larger lens and placed the camera on a jack that could be raised and lowered.

Henry Hamilton Bennett diligently recorded his life and activities as a fledgling photographer in a small leather-bound journal. Starting in 1866, he included business transactions, guitar chords for many songs (including "Willy's on the Dark Blue Sea"), and a few additional revealing remarks. He and Georgie began the year with $8.75 in cash. They borrowed $10 from the banker, Mr. Bowman, on January 3. On January 6 Henry noted, "Made a negative of Mrs. S., didn't get a good one because she didn't keep still." On January 15, his birthday, he recorded spending fifteen cents for tobacco. On March 14 he documented recorded receipts of fifty cents and expenses of sixteen cents.

Henry also included more personal observations in his journal.

> January 15, 1866
>
> Snowed all day like Thunder and we didn't make a picture. This is my Birthday (23 years old) and one that has not passed without event; at least to me. Through the rest of my life this day will be remembered with pleasure by me and I hope by another.

The oblique reference to romance in the final line was significant.

> January 20
>
> Thermometer 14 deg. below. Had a lady victim this afternoon, brought a little baby to have its picture made; but the camera, chemicals and sun refused to make a sharp picture when the little one wouldn't sit still. The blame, of course, fell on the unlucky artist.

> January 22
> Rec'd Ferro[type] .50
> One cord dry wood 3.00
> I made two first class Negs of Miss E. Smith. Took all day to get things thawed out.

> February 14
>
> Snowing and Blowing this morning. This eve it's awful cold and the wind blows considerable if not more. I cleaned out the Darkroom this afternoon, forenoon mounted and finished up yesterday's Photos. Got a Valentine.

> February 15
>
> For all the very cold weather I had but one victim in the shape of a two-year-old boy brought in by its mother. The only way I could get a picture of it was to freeze it stiff and then it wouldn't stir. Temp 25 below this morning.

Despite his light-hearted tone, Henry could not help but be reminded of Uncle George's warnings about the wisdom of investing in a photographic enterprise in Kilbourn. His first months had proven to be very difficult indeed. The staple of the business, portrait photography, was a boring undertaking. Henry searched for more challenging outlets for his growing photographic skills, but the studio was not generating income and his family was unable to offer financial or practical help with his economic and creative desires.

Henry's brother Edmund, now a lumberjack in Wisconsin's pine forests, wrote to him in February and advised him to quit the dead-end business of photography in favor of the booming timber industry, which offered better opportunities. At this point Henry and Georgie were only a few dollars away from losing their business altogether.

In what must have been a last desperate move, Henry asked George Houghton for a loan. Houghton turned him down.

> February 24, 1866
>
> I made about 6 Doz. photos should made more but the wind blew everything sky high and as cold as . . . anything.

> February 27
>
> Made 4 or 5 Doz. prints. Nice day. George tried the albumen developer in making a ferrotype and it worked Bully.

In 1857, just after his initial arrival in Kilbourn, Henry had requested his brother Ed to bring his ice skates to Wisconsin. With the pause in his business, Henry could now indulge—perhaps overindulge—in one of his favorite winter pastimes. He sometimes skated for hours at a time on long winter nights. Bonfires made of dead branches and old stumps warmed the skaters, who relied upon the moon to illuminate the ice.

> March 5
>
> Everybody and their wives' relation went skating at the Newport Marsh tonight. Of course I went and have just got home before tomorrow.

> March 10
>
> I went skating this afternoon I guess for the last time this winter. About 4 o'clock it commenced snowing and directly drove us off the ice. Skating wound up the same way last winter.

> March 13
>
> Throat getting better. Business nothing extra. Had a gay time this morning trying to make a Neg. of C.K.R.'s little boy. He was determined not to keep still and succeeded admirably.

In 1862, to help fund the Civil War, Congress passed the Internal Revenue Act and began levying a tax on many small luxuries to raise additional revenue, most of which up until then had been garnered through customs duties and the sale of public lands. Now tax stamps were

Dixon's Canada Store was a major establishment in Kilbourn for women's fashions. In the mid-1860s it was reputed to be the finest dry-goods emporium west of Milwaukee. (WHi-68622)

"Kilbourn Fire Aftermath." A massive fire consumed Dixon's Canada Store on March 14, 1866, and destroyed that building plus eleven other businesses. Bennett photographed sightseers among the smoldering remains. (WHi-40714)

required on all photographs sold: a two-cent stamp had to be affixed to a photo that retailed for twenty-five cents or less, a three-cent stamp on a photo that cost between twenty-five and fifty cents, and a five-cent stamp on a photo that cost between fifty cents and a dollar. For each additional dollar or fraction thereof, another five-cent stamp was required. Like most of his colleagues, Henry usually passed the price of the stamp on to the consumer. Occasionally, the customer proposed an unorthodox method of payment for Henry's services, as Henry dutifully recorded:

> March 14
> Made a ferrotype of a young lady for which I was invited to tryst by her maternal parent. Upon my declining to comply with her invitation rec'd my regular payment in specie, postage and revenue stamps and scrip. About half past nine a fire broke out in Dixon's Store and was not stopped until the whole block was destroyed.

Dixon's Canada Store occupied an imposing three-story frame building. In 1866 it was reputedly the finest dry-goods emporium west of Milwaukee. The fire leveled the structure, destroying $100,000 worth of goods. The sensational flames were visible for twenty-five miles and consumed eleven other places of business. Henry photographed the smoldering ruins.

> March 20
> Axed a girl to write in here for me and she wouldn't. Gosh Daniel! Said she wouldn't again. Can't find words to express myself with.[7]

> March 29
> Bully day weatherly and businessly. Done about $25.15 worth of work. Bully for our side. I made 7 Doz. prints.

One of Henry's army buddies wrote to him that week, saying, "I pity you, Hank. It is so very difficult to find the matter whereof to manufacture *one* letter. Why law me, you might give a description of the young ladies you 'take,' in the course of the week, their good looks, rosey cheeks, soulish eyes, languishing manners, striking attitudes, well-developed b—s, etsetera."[8]

At the same time, a letter from Leroy Gates contained the following message:

> Dear Fellow: I've a few things that I wish you to do. . . . In the first place I wish you without fail to raise me $100 by the 11th of apr. and don't disappoint me . . . , you see I owe for hop poles nearly $200. . . . Now don't fail to raise this $100 and as much more as you can. Print me one doz. More of my pictures as before and take more pains toning.
> Truly, Leroy Gates.[9]

Henry was able to pay Gates the $100 in April, the same month Henry's brother Georgie returned to Vermont.

April 2

This morning George started for Brattleboro. For some days it has been thawing which makes it some dangerous traveling by rail but we hope he will get through all safe. He is going back to work for Uncle George. Thundershower last night. I made a Neg. view of Broadway from the side door of the Gallery. Bully one.

Georgie had been Henry's partner for less than a year, yet in that brief time he had taught his older brother the fundamentals of photography. But Henry was soon deeply discouraged by his brother's absence and the impending loss of the studio space he had been renting from Leroy Gates. He began exploring nearby communities, trying to find a place to relocate his business.

April 17

Here I am a houseless wanderer no where to go. Leroy sold out his Gallery Building to a man from Rockford by the name of Daniels. Makes things look some dubious to me but . . . "Fortune favors the brave."

Henry knew there was a photography studio in Portage owned by Mr. J. Jolley, and folks said a traveling photographer sometimes made a stop in nearby Reedsburg.[10] Of course, Madison, the capital city, had several photography studios, and there were other photographers who wandered from place to place. Henry knew he'd have to think of a way to be clever and competitive if he wanted to continue in the picturing business.

April 23

Went to the Dells, water the highest its been for a great many years. Its Terrible, awfull, sublime, majestic and grand.

May 4

Gay old day. Snowed most of the time. I cleaned my oilcloth carpet.

May 7

This evening finds me in Mauston out looking for someplace to open a gallery. Can't do anything until morning.

May 8

Didn't like the look of things at Mauston. Got onto a freight and made a short stay at Tomah. Liked the location of the town but didn't make any arrangements to go into business there. Got here into Sparta about 12 midnight.

May 9

Hotel bill 2.50
Gargle .20
Smokes .15

May 10

 Made a stop at Tomah and found a good chance.

May 19

 Leroy Gates gave me a receipt in full. Had a big fire today about noon or one o'clock. The railroad bridge took fire and in less than 15 minutes fell. Big loss for the railroad company.

 Later that month Henry and five other men from Kilbourn City went on an excursion that included a Ho-Chunk encampment and Stand Rock, a geological formation along the Wisconsin River that would become the subject of some of his best-known landscape views. A local guide ferried the men across the river. Bennett described their experiences in his diary entry for May 25, 1866: "After much wading through swamps we arrived where we started for, an Indian camp. Gained admittance to the 'Big Wigwam' and heard some splendid speeches I guess, any quantity of grunting and a little dancing. Got home at four o'clock."[11]

 Because he knew the Indians did not like to be photographed, Henry did not bring a camera on this 1866 outing. But the excursion marked the beginning of more than forty years of contact with the area's Ho-Chunk, whom he would eventually know personally and refer to as his friends.

 That spring of 1866 may also have seen Henry's first attempts at landscape photography. Again in May his diary recorded, "Went viewing this afternoon, didn't do the best in the world. Tried to get the bridge."[12]

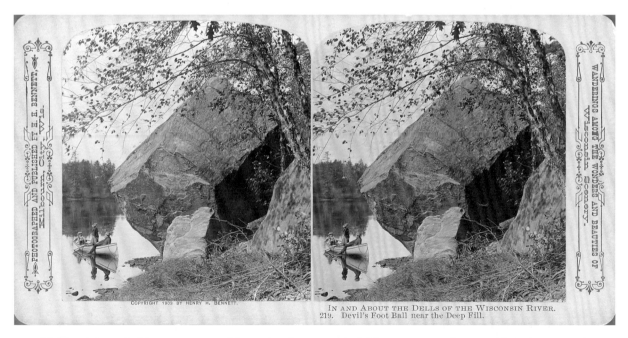

"The Devil's Foot Ball," an ominous rock located at the west end of Kilbourn, was easily accessible by Bennett and may have been the subject of one of his earliest nature photographs. (WHi-68891)

In the decades following the Civil War a romantic notion grew as the country stretched into new territory. Victorian America was feeling the shock of unparalleled change. The landscape was being inexorably transformed, but there remained a hope that while the wilderness was tamed, its beauty and primitive nature could somehow be preserved. Prominent landscape photographers were latching on to this idealistic concept. Carleton Watkins was already photographing Yosemite and the Columbia River in Oregon; Eadweard Muybridge was documenting contemporary landscapes in California. The Dells, like Yellowstone and the Rocky Mountains, was also appreciated as uniquely American.

Although the spring of 1866 marked the beginning of Henry Bennett's career as a landscape photographer, his earliest efforts did not meet with commercial success. As usual, he had dutifully summarized his accounts in his journal through the month of March, but the pages were virtually blank the rest of the spring and summer. In June he was forced to labor at lathing for several days, but the gap in his journal notations reflected a distraction other than a lack of customers.

His business was clearly languishing, but he found himself reluctant to move from Kilbourn City to Tomah, a distance of about fifty miles, where he had found the best location for his new business . A dark-haired girl named Frankie Douty had caught his eye.

Francis Irene Douty moved to Kilbourn City from Elmira, New York, in 1857, the same year that Henry Bennett moved there from Brattleboro with his father and uncle.[13] But Frankie was only eight years old in 1857. Fourteen-year-old Henry did not take much notice of the little girl until the rest of the Bennett family moved to Wisconsin the following year and Frankie became best friends with his sister Sarah.

The first mention of Frankie Douty in the papers of H. H. Bennett appears in a letter from Henry's brother Edmund to his parents on May 28, 1865. Ed's letter closes, "Love to Frankie Douty. See Hank scowl!" Ed's letter further inquired, "Is Hank married and settled down to a sober and steady fogy and don't calculate to write nor have any correspondence with wild, young, unmarried gents like me to influence him from the paths of his domestic matrimonial life?"

Frankie was then just sixteen, and Henry had only recently returned from the war. He was too busy trying to set up his Kilbourn photography business with his brother to think of courtship.

Henry *did* seem to have an eye for all the pretty girls of Kilbourn, and Frankie Douty was surely something special. They had paired off while skating the previous winter and gone sleighing together. As the summer of 1866 unfolded Henry spent more and more time with her. He rowed Frankie upriver in his boat, sharing the wild beauty of his favorite Dells scenery and leisurely hiking the cool, fern-lined paths of the ravines that rose from the water's edge. There was opportunity for romance in the privacy of that quiet setting, where berries and wildflowers were plentiful and the two of them seemed alone in their clandestine solitude.

Courtship in New England would have been more restrained and discreet than it was in rural Wisconsin. Back in Elmira, a "good" girl never went out alone with a man at night, which would have been scandalous. Even during the day she had to get her mother's permission merely to be

IN AND ABOUT THE DELLS OF THE WISCONSIN RIVER.
1095. Skylight Cave, in the Navy Yard.

"Skylight Cave." In the summer of 1866 Henry romanced his sister Sarah's friend Francis Irene Douty by showing her his favorite places in the Dells and searching for secluded, intimate settings. (WHi-68888)

with a man. Then, if a girl was fond of a young man, she was admonished not to show her true feelings so as not to appear too eager.

If Henry asked for her hand in marriage, Frankie anticipated spending months preparing for her wedding. She would hem delicate handkerchiefs, embroider chemises, and stitch bed linens, preparing her trousseau. In those days if a young woman said yes to a man's proposal, the man was expected to ask her father for her hand.

Couples were usually married by a minister in the bride's home. Even in practical Wisconsin the bride often wore a wreath of orange blossoms in her hair, but her wedding dress would be sewn of dove gray cambric or fawn silk—and it would serve as her best dress for several seasons after her marriage, perhaps until she was expecting her first child.

Frankie's wedding was hasty and not so graciously arranged. Henry's journal entry for Tuesday, January 22, 1867, included expenses for blacking his boots, hiring a horse and buggy, and paying a minister's fee. After that Henry wrote, "Got married" and "Come to Tomah."

The couple had eloped. They were married in the nearby village of Delton. Henry was twenty-four years old. Frankie was eighteen, but only Henry was aware that she was already six months pregnant. She had not even dared share her suspicions with her best friend, Sarah Bennett. Henry listed his occupation on the marriage record as "artist."[14]

Without informing their parents, the couple went directly from Delton to Tomah by train. Henry had quarreled with his parents and swore he would not write to any of his family members. Shortly after their train arrived in Tomah, however, he sent his parents a note asking them to ship his things to Tomah. And he wrote an impatient letter a week later, asking why his request had not been honored. "I am something in a hurry to get to keeping house," he told his folks. "Costs too much to board at a hotel." He told them Frankie's parents would be sending her things by train as well.

Tomah seemed to be an optimistic site for a photography business. Among other things, Henry reminded his parents to be sure to pack the photo chairs.

On February 11 the newlyweds each sent a letter to Henry's parents. Married life seemed to have softened the groom's quick temper:

Henry Hamilton Bennett and Francis Irene Douty. Henry and Frankie ran off to Delton to be married on January 22, 1867. The groom was twenty-four; the bride was eighteen and "in a family way." Immediately after the ceremony they left for Tomah, where Henry was determined to launch a photography business on his own. (WHi-66547, WHi-69032)

Before I come away I think I said I was not going to write to anyone but I got into a writing spell. . . . Don't know whether marrying brought it on or something else . . . if the truth be known it's because I did not want to be behind my wife. Want to be as dutiful as she is to her new Pa and Ma, as she tells me she has got a letter ready for you. . . . Suppose first I must touch on family matters. In relation to them can only say that there has nary cloud come up on the horizon of our domestic sky. The . . . mop hangs pendant on the wall, used only when the floor needs scouring. I think I wrote to Ed that "I am monarch of all I survey" (when I don't survey but little . . . we are keeping house and a more comfortable set you don't often see than this same Mr. and Mrs. H.H.B.).

His photography career in Kilbourn City had been lackluster at best, and his family had discouraged him from continuing in that venture. Nevertheless, Henry still saw himself as an artist and remained determined to pursue a similar business in Tomah. His November 11 letter to his parents concluded: "I have one small job of lathing to work at when it's warm enough so I can. When it's not, I saw wood for Mrs. B. . . . When it's so cold that I can't do that, I stay at home like a good husband. I think I shall do a very good thing here photographically in the spring. There's a prospect for it now, anyway."

Frankie's letter to her in-laws, George and Harriet Bennett, began sedately and then gained momentum. Her impression of domesticity was not quite as idyllic as Henry's:

Dear Father and Mother,

It is with pleasure I address a few lines to you. I am housekeeping for the first time and enjoy it very much. . . . I like the place a great deal better than I thought I should. I should like very much to have you come up and make us a visit. I suppose you are pretty well informed by this time who "us" is. If you're not, it means Mr. and Mrs. B.

I wanted to have come down and bid you goodbye before leaving but it so happened that I could not. I must close and write a few lines to Sarah. You will please excuse me for writing with a lead pencil, for Henry has run off with his pen. It hasn't struck him a bit by being up here away from the Kilbourn girls, he just runs all the time and when he gets hungry of course he will come then, scolding around if I have not sawed his right wood and brought in the water. Worst of all is to get him even to make a fire in the morning. Well, enough of this trash. . . . Write soon and accept this from your daughter.

F. I. Bennett

By 1867 twelve children had been born to Henry's parents (including baby William, who had died in 1855 at four months of age). Now the three oldest boys, Edmund, Henry, and George, had gone off on their own, and eight children were left at home. The youngest, Harriet, was only eighteen months old. Henry's father wrote to him in March of that year, once again to ask for money. Henry's Civil War injury qualified him for a disability pension, but he had not yet received his first payment. In addition, he had start-up costs for the photography business he expected to launch later in the spring. He responded to his father's request:

My pension does not amount to much. I am only allowed $2 2/5 [$2.40] per month which gives me only about $74 due since the time I was examined, then there is $5 due the agent yet which leaves it small considering the expense of getting it. I am real sorry that I cannot help you any now. Was blue this morning when I got your letter. Have plenty of use for more money than I shall have, getting the license [for photography] and rigging up the tent and paying expenses between now and the time I can get to operating. But if you are not through needing some by the time I get mine, will send you some and will always divide with you when you cannot get along. And I am in hopes it will not be long I can help considerable.

As March wore on the couple's meager assets were diminishing. The adventure of being on their own and the excitement of starting a new life in Tomah had become much less appealing. Bennett wrote to Kilbourn banker Perry Stroud on March 26, 1867:

Friend Stroud,

Yours was rec'd this morning. I've got my pension at the rate of $2 2/5 per month, got it last Saturday night. Have straightened up my accounts here and find myself with just $16 to live on and start my business with, if it ever comes spring. I was in hopes to pay you a part at least when I got the Pension, but Perry, it's just as I tell you and I can't pay money that I have not got. My Pension only comes to $74. Don't find but very little to do. Have sawed wood by the cord a little and put on 12 yds of lath. that is the extent of my income since I have been here. . . . Everything looks as if I should do a good thing, if I get at it, but I can't begin until spring opens.

Henry had the idea of setting up a studio in a custom-made tent similar to the one his uncle George Houghton had employed during the war. The tent had been utilized as a makeshift studio and living quarters. Henry had written to Georgie about it, and his brother had responded from Fort Monroe, Virginia, with particulars:

[It] was 14 × 28 feet, lined with a sort of blue drilling cloth, not exactly overall stuff but a little darker blue. The light was a hole, 7 × 9 or 8 × 10 feet cut in one side of the slope of the roof or top, about 3 or 4 feet from the back end. The canvas that came out of the hole was fastened at the top so as to roll down and cover the hole in stormy weather. The darkroom was a small concern stuck under the roof of the side, right opposite the light. We used only one side screen though I should think twould not be a bad idea to have two especially if the wall of your tent is not at least five feet high.

Finally, toward the end of April the always recalcitrant Wisconsin spring arrived, and Henry set up the tent he had obtained with Georgie's specifications. He was ready to open for business on April 22. "I believe I can make the best pictures in my cloth house," he wrote his parents. His father was concerned about lumber prices and wanted to build a home for his own family in Kilbourn, but Henry told him, "You must not get discouraged about a house, Father, something will turn up and everything will be alright. If your oldest son was anybody he would have been so situated that he could help you. Perhaps he will be, sometime."

A week later, on April 28, 1867, a baby girl was born to Henry and Frankie. They named her Hattie. Henry wrote to his parents that very same day to announce the news and to ask for the companionship of his sister (and Frankie's friend) Sarah:

> Dear Grandfather and Grandmother,
>
> There is a little girl come to see us. I cannot get anyone to do the work and take care of Frank. Are you well enough, Mother, so you can spare Sarah? And will she come for two or three weeks until Frank gets smart? I will be at the train tomorrow night and all trains after until she comes or I hear from you. If . . . she can come, let it be tomorrow night. Don't spare her if it's going to be hard for you, Mother.

Sarah eagerly took the next train out of Kilbourn City, delighted to help Frankie with the baby girl. "Henry is almost tickled to death over it," she wrote back to her folks. "Thinks it's the nicest baby in existence. Its nose is like its Pa's, has a very pretty mouth and the whitest, fairest skin I ever saw on so little a child. Its hair is very thick and as black as can be. Henry weighed it just a few days after I came up, weighed 9 pounds."

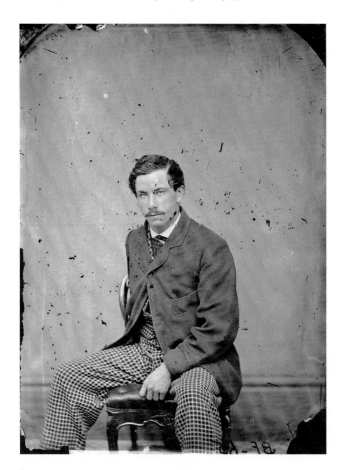

An early portrait of an earnest and handsome young man. This was probably after Henry's service in the Civil War, as he seems to be concealing his right hand. (WHi-68189)

Frankie's recovery was rapid. A week later she baked a cake, and Sarah said, "I think at this rate I'll be playing company before the week is out. But I am afraid she is getting smart too fast. I try to make her keep stiller but she won't, says she can't."

Sarah returned to Kilbourn City, and Henry began traveling around the countryside with his photo-tent, imitating Uncle George and the corps of tintype galleries that followed the army camps from battle to battle during the Civil War.

The camera that Henry had purchased from Leroy Gates was originally fitted with four lenses to make tintypes or ferrotypes. Four images of the same pose could be produced at one time on the metal plate and then cut up afterward with tin snips into four separate photographs. Henry and Georgie had discarded the tintype process back in Kilbourn, but he found the procedure was suitable for use in a traveling photo-tent where customers could be provided with quick results.

As he journeyed around the countryside, Henry carried with him a practical handbook on photography called *The Silver Sunbeam*, which gave these instructions to photographers: "Place the cap on the lens; let the eye of the sitter be directed to a given point; withdraw the ground-glass slide; insert the plate-holder; raise or remove its slide; Attention! One, two, three, four, five, six! (slowly and deliberately pronounced in as many seconds, either aloud or in spirit). Cover the lens. Down with the slide gently but with firmness. Withdraw the plate-holder and yourself into the darkroom and shut the door."[15]

It was a busy summer for Henry Bennett, and he was not the only traveling photographer in the neighborhood. He explained the situation in a letter to his parents posted from Tomah on August 7, 1867. The letter illustrates the young photographer's considerable flair for publicity. It also makes clear his choice to compete on grounds of quality, not price:

> When I am out of the gallery I can hardly think of anything else. Just now I am having some competition. I beat the fellow that was here so very bad that about two weeks ago he stuck out a card saying, "Photographs, $1.50 per dozen." The next morning I had out some big handbills saying, "Good photographs are worth $2 per dozen. I can be had for that at Gen. Photography's Tent."
>
> . . . And then in a few days the paper comes out with some puffs for me, and then he gets up a dialogue for the next issue. He's a Copperhead, and soldiers are [my] friends, consequently I found out about his dialogue and as soon as the first paper was struck off, got the editor to stop the press and put a few lines under his. But I send you the last two papers with the things and you can see how it is.
>
> I think I can beat him anyway. I have the good will of the people and I'll give him a hard pull. About all the work he's done since he's worked so cheap is to pay up old debts, can't buy stock that way and he's got not many [tax] stamps. Think you'll see his dialogue does me more good than hurt.

Henry was still hopeful and planned to make enough money during the rest of the summer to build a more permanent studio in Tomah in the fall. Sarah wrote to say that their grandparents had arrived in Kilbourn from Vermont and also reported, "Father has bought four lots on the knoll above where Taylor lives. He has paid for them and got the deed. He and mother say that they wish you'd come back here and run Daniels out, I think t'wouldn't take much to do it."[16]

Once summer ended, however, the photography business in Tomah plummeted along with the autumn temperatures. In October 1867 Henry was in the throes of what he called the "Bennett blues," a depression that surfaced periodically throughout his life. In marked contrast to his usually optimistic nature Henry wrote a gloomy letter to his parents:

> I've got the blues. . . . Frank is down sick today with a cold and the baby has got whooping cough. Happy time, ain't it? . . . I've worked hard this summer to get a start so I could put up a cheap building for a gallery this fall, but it's here and finds me without nary red. Have tried to borrow some $ and secure on my stock and tools, but can't do it. Everyone that has money to let can get 15 or 20% and that's more than I can pay.
>
> I've got friends here that will do anything for me that they can, but they are like myself, they haven't got any stamps. One of them told me that if I wanted lumber he'd see that I had it on most any time, another says he will let me have glass, . . . for which I'm very much obliged, but that won't buy a lot and do the work on a building.
>
> I'm discouraged, that's what's the matter. . . . If I had some stamps I could go off and perhaps find some good place, but there tis again. Well, let the thing run, I don't care much which end of the horn I come out of. . . . Frank is a good girl and does all that she can to help me, and more than she ought to. But Fate is against me and I'm beginning to think he's (Fate) the best man.

The following day, even more depressed, Bennett penned another note to his father—this time with tongue in cheek but despair in his heart:

> I heard Charlie speak of your trying to find a girl to do housework. I can send you an excellent one from here if you should want one now. She is married and has one child, about six months old. Will work for her board and clothes. She is a good, smart woman, but her husband is a worthless cuss and does not half take care of her and t'would be a blessing if she could find some place where she could work and not suffer for the necessaries of life. I think from her looks she will more than earn what she asks. Write me your mind as soon as you get this.

Actually, Frankie was not in much shape for housework just then. When the baby had fallen ill, Frankie had contracted whooping cough herself. Her mother was justifiably worried and sent her cough syrup by railroad express with instructions to take sixteen to twenty drops three times per day. She also suggested to Frankie, "If you would come home I could take care of you and it would not hinder Henry from his work." Frankie needed little encouragement to return to the warmth of her family. She and baby Hattie went back home to the Doutys almost immediately.

Left by himself in Tomah, Henry became even more despondent. The migraine headaches that had tormented him since childhood fell upon him with more frequency. He felt he had failed his new wife and that he was not a responsible father. He was of no help to his own parents, and, at the age of twenty-four, he had already failed in his chosen career. He could always pick up a few dollars by sawing wood or lathing or working on the new railroad line, but that did not satisfy his strong need for personal expression.

Brother Ed wrote to his parents in the autumn of 1867: "I really hope that Henry will conquer the blues and laugh at his own too sensitive nature. His natural pride and manliness need not suffer if he does not take reverses so keenly. And what is more, he need not think that his reverses in any way disgrace him or his relation and friends."

Henry was in such desperate straits that he even wrote to his uncle George Houghton in Brattleboro, asking if he might have a job in the photo studio out there. Uncle George wrote back that he had sold his studio that spring to a man named Gilmore with the thought of doing more outdoor work himself. Then Houghton had partnered with a Mr. Knowlton to complete a series of stereoscopic views of the Connecticut River Valley from Bellows Falls to Holyoke, Massachusetts, which were subsequently sold to train passengers. "There was a time when I made something at it but this last effort of mine . . . has proved a failure. I went in at Northampton & put in several Hundred dollars and worked hard all summer & did not get my living out of it & have finally been obliged to leave what I had there & go away or starve."[17]

It was too cold now to set up his photo-tent, so Henry sat in his room in Tomah alone. On the night of November 15, 1867, after drinking heavily, he wrote to his father in a nearly illegible scrawl:

> I'm played out, but what do you spose I care a cuss for, nobody or nothing. I'm owing some but that's nothing. . . . I am able to owe most anyone. Am going to Texas soon. Got a job manuring a plantation. How's Frank and the young one? Yours in much haste. Sousy cuss or any other man. Shit.
> Hank

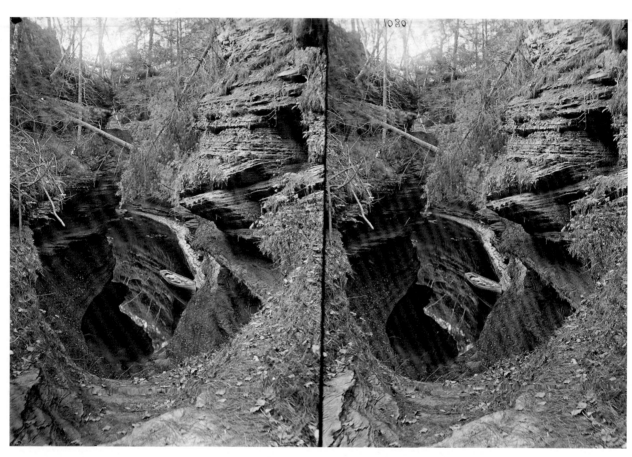

"Looking Down into Rood's Glen from the East End." An optical illusion in stereo, where the rowboat at the bottom of the gorge seems to float in space. (WHi-69025)

3

Picturing the Dells

1868–1875

My own pale one, our city comforts tire;
Come to the Dells of the Wisconsin River
And see the wild stream flowing on forever
And the fresh breath of heaven in joy respire!

—Author unknown

HIS SPIRIT BROKEN, HENRY BENNETT PACKED UP HIS THINGS in Tomah and went back to Kilbourn City, where he rejoined Frankie with their baby girl, Hattie. Although he was discouraged with photography just then, he was reluctant to abandon it altogether. By this time Frankie knew and understood Henry's moods. With her gentle encouragement, Henry agreed not to give up. Over the winter the couple agreed to collaborate in giving the photography business one last try.

Leroy Gates's sale of the gallery building to P. F. Daniels of Rockford had fallen through, so in the spring of 1868 Bennett arranged to lease the building from Gates for $12.50 per month. The Kilbourn newspaper announced that Henry was back—at "Gates' Old Stand"—with "photographs, vignettes, stereoscopic views and stereoscopes."

One pleasant spring day, as Henry lingered outside the front door of his gallery enjoying a smoke, Jonathan Bowman, a Kilbourn banker (though not the one with whom Henry dealt) came by and made a great show of peering in through the door of the vacant gallery. Leaning on his gold-headed cane, Bowman archly remarked to Henry, "Seems to me as if you ought to go back to lathing!"[1] Given Henry's financial circumstances at the time, Bowman could perhaps be forgiven for his comment. But the summer of 1868 was a turning point for both Henry and Frankie and the fledgling studio.

Kilbourn was beginning to draw more tourists during the summer. In 1857 the *Wisconsin Mirror* published an article entitled "Kilbourn and Its Advantages," praising the healthful and beautiful location at the foot of the Dells, "which, for wild grandeur and majestic beauty probably have nothing to equal them in the state . . . no place in the West will prove more attractive for pleasure seekers and lovers of nature."

Proprietors of the Tanner House provided a two-seated buggy and a large rowboat for tourists, who were driven by carriage to the head of the Dells and returned to the hotel by way of the river. One writer proclaimed, "There is nothing more pleasant or health inspiring than to take a boat on a good day and row up and down the river viewing the long rows of flowers of various colors that ornament the seams of perpendicular rocks, noticing the shrubs and even trees that grow out of some of these rocks." The desirability of a steamboat for sightseeing was mentioned. "Most visitors do not stay long enough to go to all the points because carriages cannot go among the ravines and none but the healthy have the courage to attempt to penetrate the depths or climb their heights."[2]

As the Kilbourn area began to draw more tourists during the summer months, Henry's studio photography business grew. But the conventional routines of portrait photography became increasingly more boring to Henry when he learned of Andrew Joseph Russell, an adventurous ex-army photographer who was spending that season photographing the advance of the Union

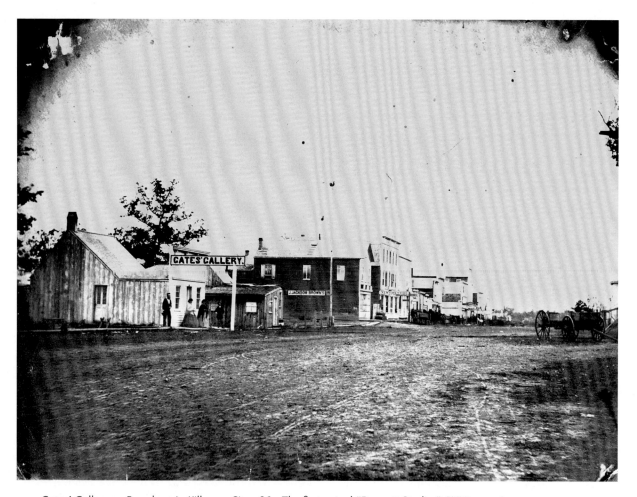

Gates' Gallery on Broadway in Kilbourn City, 1865. The first actual "Bennett Studio." (WHi-40713)

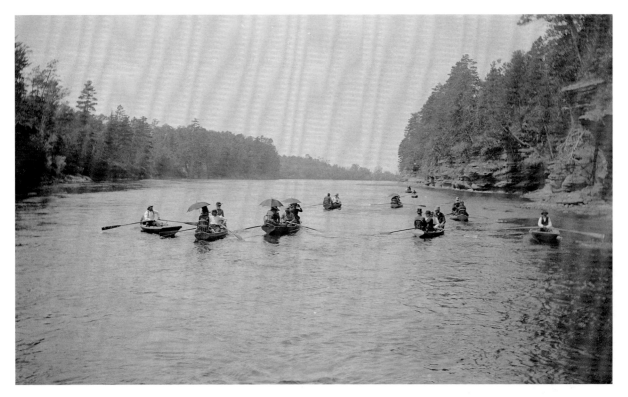

"On a Sunday Afternoon—Dells Guides—Rowboat Fleet," the earliest way for tourists to get a glimpse of the beauty of the Dells. Guides to row the boats and point out attractions could be hired for a reasonable fee. (WHi-2348)

Pacific Railroad from Nebraska to Utah's Promontory Point. That same year Carlton Watkins's photograph of the Golden Gate Bridge from Telegraph Hill caused a sensation. Henry longed to be doing something exciting and creative like those men instead of posing elderly couples in his studio and coaxing babies to sit still for a lengthy exposure.

Henry had a notion of photographing landscapes on a smaller scale than Russell, Watkins, and other prominent photographers of the day. The beauties of the Dells of the Wisconsin River had captivated him ever since he first saw them as a boy, more than a decade earlier, and he sensed there would be a ready market among tourists for such appealing scenic views.

Frankie proved to be Henry's partner in business as in life. Women photographers were not that rare anymore; in fact, they were entering the profession at an astonishing rate.[3] Frankie quickly learned how to use the camera. She was not deterred by the complicated wet-plate process. Henry trained his wife to assume the studio trade, making the portraits that supplied a steady income for their small family—even though customers often paid for their photographs in cords of wood or bushels of potatoes. This freed Henry to devote his time to pursuing his landscape work. "You don't have to pose nature," he observed wryly, "and it is less trouble to please."

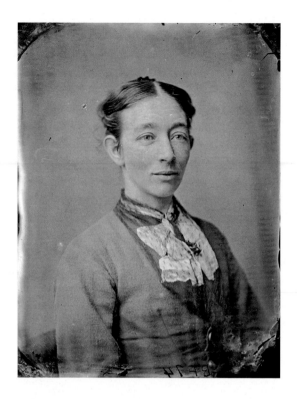

Frankie Douty's determination that her husband would succeed provided strong motivation for Henry when the young mother offered to help in the studio and take over the portrait trade. He was then free to pursue his fascination with photographing nature, "which was less trouble to please." (WHi-68887)

Freed from the confines of the studio, Henry was a happy man. With his camera in a flat-bottom boat, he began traveling up and down the Wisconsin River, seeking to capture the essence of the water-sculpted rock formations for stereo views by utilizing the same wet-plate process of photography that he had employed in his studio.[4]

A photographer using wet plates outdoors required strong incentive and the ability to carry a complete darkroom on his back—or in his boat. He also needed heavy glass plates, a bulky camera, and a fairly sophisticated understanding of chemistry.[5]

Stereographs were then at the peak of popularity. In 1859 Oliver Wendell Holmes, Sr., had written in the *Atlantic Monthly*, "Oh, infinite volumes of poems that I treasure in this small library of glass and pasteboard!"[6] Holmes was the inventor of the stereoscope, the light, inexpensive device for viewing stereographs in what seemed like three dimensions. His deceptively simple, handheld viewer consisted of a hooded eyepiece supported by a comfortably grasped handle. The stereo card rested on an adjustable frame opposite the eyepiece. The stereoscope became an American's passport to faraway places and fantasy lands, but it introduced the viewer to the wonders of this country as well—Niagara Falls, Yosemite, Washington, D.C., and soon the beautiful Dells of the Wisconsin River.

The stereograph was particularly effective in illustrating the Wisconsin landscape Henry chose to photograph. His stereo views portrayed the crags and chasms of the Dells with vivid naturalism, sometimes achieving spatial effects that were impossible to duplicate with the human eye.

Because we perceive space through a pair of eyes set about two and a half inches apart, each eye sees the world from a dissimilar vantage point. The two points are fused in the brain to create our perception of three-dimensional space. When two photographs of the same scene are made from two points the same distance apart as our eyes, the photographs—when seen through a stereoscope—also become fused in the mind and appear three-dimensional. Henry's first stereo camera had only one lens, so it was placed on a board that could be moved slightly from one side to the other to obtain the second image. Eventually, he constructed his own double-lensed camera to be used exclusively for photographing stereographs.

Henry's initial landscape outings required a dark-tent to be carried along. This proved uncomfortably bulky and he had to transport it on a cart or in his boat to almost inaccessible locations. Dark scenery needed lengthy exposures, sometimes as much as an hour and a half. Wet plates had to be kept wet during the exposure and finished promptly afterward, so Henry invented a system of placing wet sponges inside the camera to maintain the crucial moisture.[7]

George Houghton returned to Kilbourn City from Vermont in the autumn of 1868. The newspaper maintained that he had returned for his health, but he was also selling a patented "self-wringing mop, which seems to be entirely ahead of any thing in the line we have ever seen; as it is never necessary to touch the mop cloth in wringing."[8] Uncle George, with his Civil War photography experience, may have had some influence on Henry's landscape techniques.

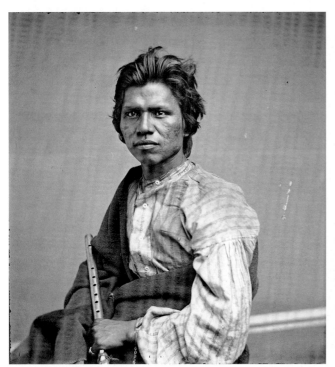 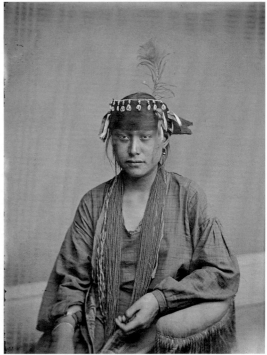

In the 1870s Ho-Con-Ja-Gah Moche-He (Thunder Cloud) and Nah-Ju-Ze-Gah (Brown Eyes) were invited to the Bennett Studio to have their portraits taken. (WHi-7356, WHi-7531)

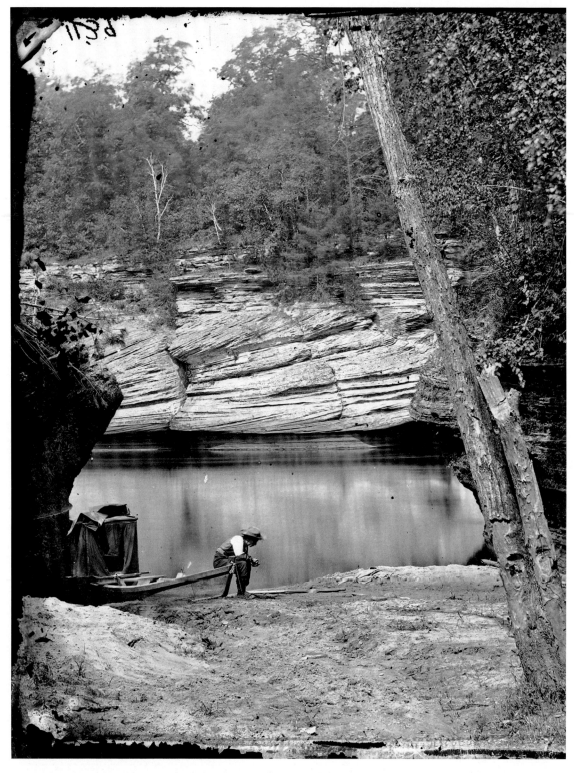

"H. H. Bennett and Dark Tent at Gates Ravine." A self-portrait of the artist deep in thought or catching his breath after a long row upriver hauling the traveling photo-tent. Stenciled on the canvas were the words "H. H. Bennett" and "Landscape Photographer." (WHi-7568)

After his initial season of outdoor photography, Henry Bennett used the winter of 1868–69 to modify and simplify the bulky contraptions he needed to lug around in the field. His skill with carpentry allowed him to build a portable dark-tent that featured a headpiece and hand-holds. The new apparatus could be carried on the boat and used there or carried on a cart and set on a tripod for use on dry land. He could also strap the dark-tent on his back, leaving his hands free for carrying his camera.

With his new and efficient dark-tent, Henry now had a self-contained, moveable photography studio. He could stow all the necessary chemicals for exposure and development of the plates, the glass plates themselves, plateholders, and a water bag in the dark-tent. A few improvements in equipment, some innovations in technique, and an assortment of new camera angles allowed Henry to enthusiastically pursue landscape photography in this fashion for the remainder of his career.

That same winter Henry earned a little money sharpening poles used in the area's hop industry. Hops, an ingredient necessary for beer, are produced on a twining vine that grows rapidly in

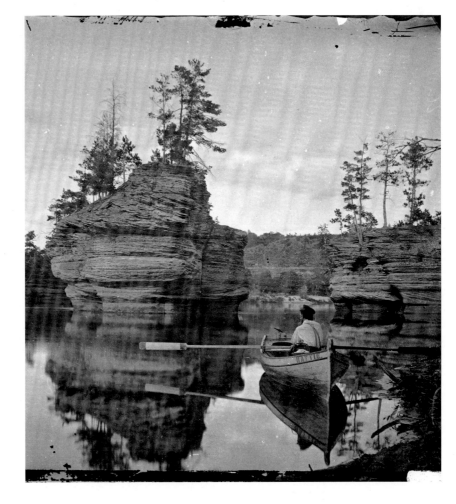

Former curator of photography at the Museum of Modern Art John Szarkowski commented on this scene of the Sugar Bowl in his *Looking at Photographs.* He was impressed that Bennett, who was primarily producing stereo cards, also managed to create some of the "boldest and least conventional compositions to be found in nineteenth-century photography" even when observed as a single image. (WHi-7365)

the direct sunlight of the summer months. They had been grown in Wisconsin since the 1840s, and after the Civil War demand for hops increased. The destruction of eastern hop fields by the hop louse inspired more Wisconsin farmers to try hop cultivation. The state's yield went up from 135,587 pounds in 1862 to nearly 7 million pounds in 1867. Sauk County accounted for one-fifth of the nation's entire crop, and farmers there realized over $1.5 million on hops alone.[9]

At harvest time in the late 1860s the ever-entrepreneurial Leroy Gates recruited thousands of young women for a festive "picking bee." One day in early September 1868 two thousand women spilled out of a twenty-six-coach train at the railroad station at Kilbourn City, carrying their umbrellas, satchels, baskets, bandboxes, bundles, and babies. There were twenty-five hundred pickers on the next day's train. Gates must have rejoiced in his success. Hop pickers were paid fifty cents for each box of hops they filled (about two dollars per day on average) plus board. They joined local Ho-Chunk and picked hop blossoms from vines supported on tamarack poles.

A newspaper article commented upon the lively scene:

> The railroad companies are utterly unable to furnish cars for the accommodation of the countless throngs who daily find their way to the depots to take cars for the hop fields. . . . Every passenger car is pressed into service, and freight and platform cars are fixed up as well as possible for the transportation of the pickers. Every train has the appearance of an excursion train, on some great gala day, loaded down as they are with the myriads of bright-faced young girls. . . . It broadens human feelings to know there are so many lively girls in the world, and beer will be none the worse for a view of the hands which pick the berries, that give it its bittersweet.[10]

Harvest season was a time for feasting, dancing, and fabulous profits. Henry traveled to the hop fields in 1868 and got a photo of the women at their work during what turned out to be the last of the booming hop harvests. Late that summer more than twenty-five thousand women worked in the hop yards. The next year, however, eastern fields came back into production, and the hop louse made an unwelcome appearance in Wisconsin. A glutted market forced the price down from thirty-five cents per pound to three cents per pound, and hundreds of Wisconsin farmers lost their savings.

Autumn 1869 found Henry having an unexpected encounter with another calamity involving a family member of Leroy Gates.

The area around Kilbourn City was still rather uncivilized. Various forms of frontier justice were still in existence, and vigilante movements were not uncommon, especially those involving the tracking down and discouragement of horse thieves. Just then the Wisconsin River Valley was being terrorized by a gang of cutthroats led by Pat Wildrick, a character newspapers referred to as a highway robber who was "the dread of travelers, the plague of sheriffs, and the torment of the entire region."

Leroy's father, Schuyler Gates, had built the first bridge to span the Wisconsin River at the Narrows in 1850, several years before Byron Kilbourn's railroad bridge. Gates Sr. was a respected

man in Kilbourn City. In May 1868 the elder Gates sold all his property and built a boat, planning to travel downriver to St. Louis with his new young wife. Their first night out they camped on an island near Arena, thinking it would be safer there than sleeping onshore. But around midnight robbers struck. They pistol-whipped Schuyler and left him bleeding and unconscious. Then they raped his wife, Mary Ann, whom they tied to a tree, and stole the old man's life savings before they took off. In the struggle over the money one of the robbers lost his mask. By the light of the full moon Schuyler Gates recognized Pat Wildrick. Mary Ann got free and brought her husband to a nearby farm. He recovered and testified before the grand jury that he had been attacked by the notorious Pat Wildrick and Wildrick's partners in crime.

Not long thereafter Wildrick was arrested and jailed in Iowa. Released on bail, he robbed a companion in Portage and was jailed once again.

Wildrick was in custody in Portage awaiting trial when, on an early September morning in 1869, Henry Bennett went on a picturing expedition in the country. Near the mouth of Hurlbut Creek Henry came across the body of "the venerable Schuyler Gates."[11] Henry's photograph of the scene shows Schuyler Gates's body lying between the ruts of a rugged dirt road.

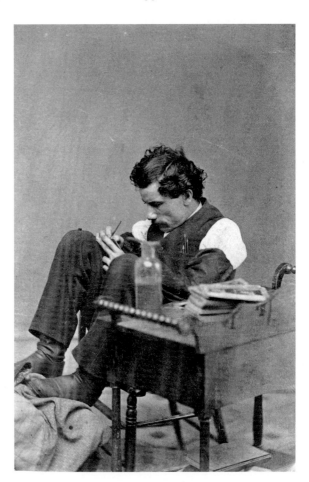

The young photographer at work. An early perfectionist, Henry Bennett is spotting some of his stereo views. (WHi-68539)

That month became known in Kilbourn City as "Bloody September." Locals felt Wildrick's men killed Gates to destroy the evidence against their comrade-in-crime. Feelings were high when Wildrick's attorney, William Spain of Portage, shot Barney Britt, a farmer who advocated Spain's death for his defense of Wildrick. To avenge Britt's death, a crowd broke into the Portage jail, took Spain outside, and hanged him from a tree.

According to Henry, on September 18, 1869, a remarkable number of prominent men of Kilbourn City casually climbed on board the evening train to Portage. The weather was warm, but all the men carried overcoats and wore their hats low over their eyes. Once in Portage, the crowd estimated at 125–150 men made their way to the jail, where they demanded that Wildrick be handed over to them. When the jailer refused, the men, who had brought along a heavy battering ram, broke their way inside.

Anticipating trouble, Wildrick smeared his body with lard so he could more easily slip away. But the angry men caught Wildrick and dragged him to an oak tree near the jail where he was promptly hanged. The limb over which the ropes were thrown was cut down, and the pieces were distributed as souvenirs. The businessmen from Kilbourn City returned on a later train and went quietly to their homes.[12] Henry Hamilton Bennett, who enjoyed relating the tale, may well have participated in this act of revenge.

The Wildrick incident became a favorite folk tale of the region. The press of the time approved the verdict and considered the task equitably performed.

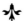

In August 1869 Henry and Frankie Bennett welcomed the birth of their only son, Ashley Clayton Bennett. Amazingly, Frankie continued to work in the studio, undeterred by the presence of a baby boy and a four-year-old daughter.

The late 1860s saw the Dells evolving into a place of summer resort in no small part because of Henry's beautifully composed stereographs, which depicted the wilderness area as tranquil and inviting. A later scholar of Henry's work would explain his popularity in this way: "The common man, who knew nature well as a constant and often cruel adversary, was not often captivated by her charm. Only after he had gained the upper hand, after the site had become something a little less awesome and a little gentler, did he take his family into the wild countryside for Sunday luncheon. There, after cold chicken, he would carve his initials into the walls of a fantastic grotto."[13]

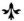

Uncle George Houghton was in failing health. He went to Rochester, Minnesota, where Dr. W. W. Mayo had settled in 1863 to treat Minnesota Civil War veterans. Then he spent the winter in Clear Lake, Iowa, but his illness worsened. He came back to Kilbourn City, where his family found him "in a very feeble state." He died several days later, July 7, 1870, at the age of forty-six. The *Wisconsin Mirror* printed an appropriate summary of his life and described Houghton as "a man of strict integrity and honorable principles . . . [who] had the good will and affection of our citizens."[14]

In the spring of 1871 visitors of another sort invaded Kilbourn. Bird lovers and hunters alike came to town to see vast numbers of passenger pigeons that roosted nearby. The pigeons moved in one great flock numbering millions of birds, darkening the heavens, blocking out the sun, and creating a fearsome roar with the beating of their wings. The roosting area, which began five miles north of Kilbourn City, was ten miles wide and extended north as far as Grand Rapids (now Wisconsin Rapids), a distance of forty-five miles. The *Kilbourn Mirror* reported on the scene:

> For the past 3 weeks [the pigeons] have been flying in countless flocks which no man could number. . . . Hardly a train arrives that does not bring hunters or trappers. Hotels are full, coopers are busy making barrels, and men, women and children are active in packing the birds or filling the barrels. They are shipped to all places on the railroad and to Milwaukee, Chicago, St. Louis, Cincinnati, Philadelphia, New York and Boston, being picked and packed in ice for the more distant points. In about two weeks the pigeon season will be over. Then look out for the squabs.

Henry Bennett admired the beauty of the docile pigeons, but the hunting and trapping disturbed his gentle nature. The nesting area was only a short distance from town. He walked

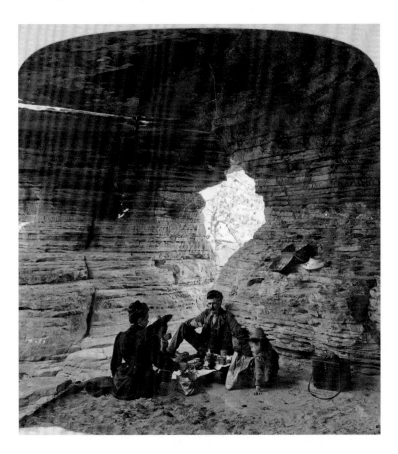

Photographs like this one promoted the Dells as a friendly area where a visitor could enter the "wilderness" yet remain safe and civilized. This cozy picnic scene, "Luncheon Hall, east of Stand Rock," was staged around 1900 with Henry's second wife, Evaline Marshall Bennett, brother John Bennett, and daughters Miriam and Ruth. (WHi-69030)

through it with a reporter for a Milwaukee newspaper. Eggshells whitened the hills and valleys and crunched underfoot. Every tree had from one to a dozen nests, and each nest held a squab, a little yellow pigeon about the size of a thumb. The reporter noted that the nests were "economically made" and then added, "Bennett, who says they are made of two sticks and a straw, exaggerated the simplicity less than one who knows him would suspect."[15]

The passenger pigeon migration of 1871 became a bloody slaughter. In Kilbourn City an old shed was set up as a pigeon-rendering factory. Although he had the equipment by now to do so, Henry never photographed the passenger pigeon massacre. He was sickened by the event and saw little reason to record the killing of the beautiful birds. Instead, in May 1871 he bought a new boat and took his time painting it, perhaps to avoid the loathsome business he knew was being conducted in the countryside. Also during 1871 Henry constructed a solar camera that could create enlargements from standard negatives. The ingenious device utilized the direct rays of the sun.

Business at the Bennett Studio was improving all the time. Even in winter, which was always the slowest period of the year, Frankie's bookkeeping showed a surplus on hand of $6.60 at the end of December. The surplus was welcome. In addition to handling the portrait work, some darkroom development, and the books, Frankie now had three children to care for; Nellie Irene Bennett was born on December 2, 1871.

Henry Bennett's landscape photographs were selling especially well. In 1872 he advertised more than two hundred stereographs of Devil's Lake, the Dells of the Wisconsin River, and the strangely shaped rocks of nearby Adams and Juneau counties. He won a silver medal at the Wisconsin State Fair for his views, and orders arrived from as far away as New Mexico and the East Coast. The Bennett Studio's account books for 1872 reflected the increase in trade. At the end of June there was a surplus of $43.80 on hand; at the end of July, $47.50; and by the end of August, $64.60.

Many who had observed Henry's stereo views of the Dells began traveling to the area to take in the scenery for themselves. A report in the August 24, 1872, *Wisconsin Mirror* said the "Lady in Black," Mary Todd Lincoln, had visited the Dells incognito that week and went away most impressed with the resort. Perhaps because of her visit, an attempt was made to clean up the village for tourists. In an editorial that autumn the newspaper spoke in favor of an ordinance to prohibit cattle from running at large on village streets.

Nevertheless, there was as yet no way to travel through the Dells other than by rowboat. Henry spent day after day rowing people up and down the river, giving each group a free personal tour of the scenes he had so passionately grown to love. Tourists could also hire Henry's brothers Charlie and Albert as river guides. Or they could rent a rowboat and explore on their own, as John Muir, the famous naturalist, had done ten years before during his last botanical excursion from Madison in July 1863:

> We took the train from here [Madison] Thursday morning for Kilbourn, a small town on the Wisconsin River towards LaCrosse, rambled all day among the glorious tangled valleys and lofty perpendicular rocks of the famous Dells. . . . The thousandth part of what we enjoyed was pleasure beyond telling.

At the Dells the river is squeezed between lofty frowning sandstone rocks. The invincible Wisconsin has been fighting for ages for a free passage to the Mississippi, and only this crooked and narrow slit has been granted or gained. . . . We travelled two miles in eight hours, and such scenery, such sweating, scrambling, climbing, and happy hunting and happy finding of dear plant beings we never before enjoyed. . . . We cannot remove such places to our homes, but they cut themselves into our memories and remain pictured in us forever.[16]

A decade later, in 1873, Henry was replicating those fantastic visions with his stereo views. Not only did Henry sell his cards at his studio, but he began using more aggressive marketing to compete with stereo views produced by photographers from other parts of the country such as those represented nationally by the American Stereoscopic Company of Philadelphia and Anthony and Company of New York. Henry understood that stereo views were not just art, they were a commercial entity. He hired a traveling salesman who represented a regional agency and sold door-to-door at homes and schools. Henry also sold stereo cards by the gross to Milwaukee bookstores Des Forges and Lawrence and to West Book & Stationery Store.

In the decade after their invention stereo views and the stereoscopes to view them were relatively expensive, but as the process of production became easier, the prices became more reasonable. Soon the viewing of stereo cards became a common pastime in middle- and upper-class parlors. The increased distribution of Henry's views was thought to account for the growing popularity of the Dells among sightseers and travelers.

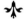

Winter months remained, as usual, lean, as they did in many northern tourist destinations. The end of February 1873 found Henry and Frankie with merely $2 to spare. Sales of eight-by-ten-inch prints soon picked up, and by the end of April they had $22.50 in the bank. With his camera and tripod planted safely on the shore, Henry took some interesting views that spring of lumber rafts going over the dam.

Then, in early June 1873, a flatboat—fifty feet long and twenty feet wide—came downriver from Quincy, Wisconsin. It had been converted into a rudimentary sightseeing craft with a side-mounted paddlewheel driven by a six-to-eight-horsepower steam engine. The arrival of the boat was a surprise to everyone. It was named the *Modocawanda*. The Kilbourn paper rejoiced: "Hurrah for the steamer and jolly excursions through the Dells!" The boat could carry seventy passengers, far surpassing the capacity of the flotilla of rowboats. It was a humble craft, but its appearance in Kilbourn City marked the beginning of the town's development as a destination for mass sightseeing adventures.

In August 1874 another steamer—the *Dell Queen*—was brought overland by train from Madison. Also that summer the Kilbourn paper announced enigmatically: "Henry Bennett and a friend went over the Kilbourn dam in a sailboat."

Henry continually sought new ways to depict his beloved scenes of the Dells and surrounding countryside. He knew fresh views would attract new visitors to his studio and, more importantly, could be sold to those who had already been drawn there by his previous views.

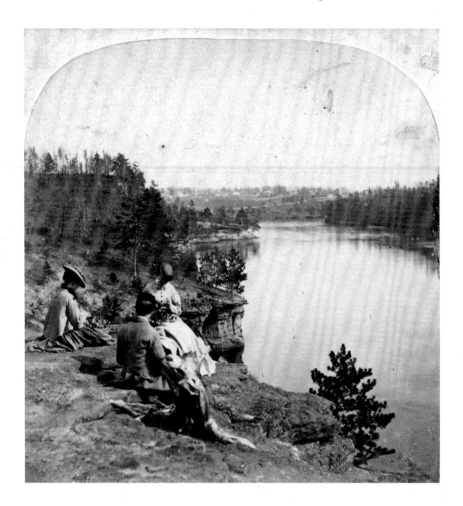

With the village of Kilbourn City in the distance, a gentleman and two ladies leisurely enjoy the "Sights at High Rock, Down the River," a stereo view published by the Bennett Studio in the late 1880s or early 1900s. (WHi-68556)

 With a strong understanding of the middle-class tourists who came to the area, Henry created images that would attract their attention. In his stereo "Sights at High Rock, Down the River" he posed a gentleman and two ladies (most likely members of his family) comfortably relaxing upon a high bluff overlooking the river. Kilbourn City can be seen in the distance. Leisure activities such as this, the stereo tells viewers, are available at the Dells to the robust and the genteel.

 By this time competitors had begun to produce and distribute stereographs of the same Dells subject matter that Henry was utilizing. This was inevitable, as buyers demanded views of the more distinctive or famous geologic features or vantage points described in guide books and pointed out during their tours of the river. Physical access to these elements and a limited number of optimum positions from which they could be documented created parameters in which the photographers had to work. Matthew Mould of Baraboo, for example, whom Henry undoubtedly knew, was part of the competition. So were Charles A. Tenney of Winona, Minnesota, J. C. Land of Waukesha, and Charles A. Zimmerman from St. Paul—a close friend of Henry's who

DEVIL'S LAKE AND VICINITY.
147. Across the Lake—Turk's Head in foreground.

CHARLES A. ZIMMERMAN, PHOTOGRAPHER.
THIRD STREET, ST. PAUL, MINNESOTA.
View at Devils Lake, Wis.

Bennett's stereo "Across the Lake—Turk's Head in Foreground" exemplifies his artistic skills. In views of the same subject by three different photographers, Bennett's view (top) clearly captures the most visual drama. The other photographers chose higher vantage points and failed to maximize the stereo effect, which relies on overlapping shapes and distance to enhance the illusion of three dimensions. (WHi-68637, WHi-68640, WHi-68644)

may have accompanied him on his outings. In their own studios they also focused on local scenery and were not loath to "borrow" from someone else's success.

Yet there was still room for a diversity of aesthetic choices. Henry wanted to capture the essence of a particular view as he envisioned it in his mind's eye. A consummate perfectionist, he often went to great lengths to obtain the best possible exposure. Sometimes he trimmed away the underbrush to improve the vista. At other times he would place a few old logs, a rowboat, or a canoe in the foreground for added interest.

Exposures took a long time, and if a cave was too dark to provide a good exposure, Henry would use a brush and a pail of whitewash to paint the walls of the cave and brighten the scene. Often he returned repeatedly to a specific spot, photographing it from different angles under different weather conditions and at various seasons of the year. The wind may have slightly disturbed the foliage in an earlier image; at the last minute a cloud may have obscured the sun; or contrasting shadows in the eventual print had not fallen just right. Some exposures—such as those made in dark caves in Cold Water Canyon—might last ninety minutes or more. It was not at all unusual for him to construct a wooden scaffold on a point of land in an attempt to reach an even more unique angle for yet another photograph of that sight.

IN AND ABOUT THE DELLS OF THE WISCONSIN RIVER.
1011. Cave of the Dark Waters, north entrance.

"Cave of the Dark Waters," near the Sugar Bowl in the Lower Dells. It was sometimes necessary in such dark spaces to whitewash the walls to reduce lengthy exposure times. Encouraged by his traveling agent, Bennett used this cave for several of his ill-advised trick pictures. (WHi-68833)

Once, in his quest for new places to record, Henry rowed deep into an opening off the main channel of the river. He then encountered another opening that looked intriguing, but he could not get into it by boat. He thought he heard a waterfall back among the rocks, so he waded and crawled and even swam farther into the gorge. Sure enough, there *was* a waterfall. Henry could not get over or around it, but he could not dismiss the challenge of finding out what lay beyond. The following winter Henry laced on his skates and glided back up the river and into the rock gorge, where the waterfall had frozen solid. He cut steps into the ice and succeeded in climbing up the face. From there he could reach the head of the ravine. Because of the unusually strange rock formations he found in this place he named it Witches Gulch. He was probably the first white man to traverse the ravine's entire length.

Late in 1874, after the maiden season of the *Dell Queen* had come to a close, Henry convinced the boat's captain to go back into Witches Gulch with him. The next spring, when the water was high, Henry and his brothers and the captain floated logs and boards into the gorge and made a walkway to enable tourists to disembark and spend time sightseeing there on their own.

The Dells "has become a place of great resort for invalids, tourists, artists and pleasure seekers," the Kilbourn paper gushed.

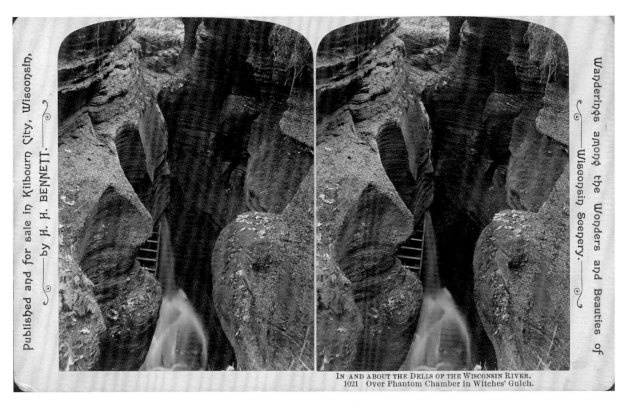

IN AND ABOUT THE DELLS OF THE WISCONSIN RIVER.
1021 Over Phantom Chamber in Witches' Gulch.

Witches Gulch, discovered by H. H. Bennett after wading, crawling, and swimming into the gorge in search of new places to picture. (WHi-68832)

Often during the summer Henry photographed the passengers on the *Dell Queen* before the daily morning excursion. With his rowboat on the lower deck of the steamer, he went along for part of the trip to take passengers' orders for prints. Then he would row back to Kilbourn, sometimes offering to take a party of tourists with him in the smaller craft, occasionally making a detour to the Stand Rock area, which could not then be reached by steamer. Pictures of the steamboat passengers would be printed and ready for them at his studio upon their return.

One story he liked to tell in later years was of a certain trip when no one ordered a single picture. In desperation he tried to find someone to hire him as a guide for the trip back so the trip would not be completely wasted. At this point, however, Henry discovered that his rowboat had gone adrift and floated away. He took this as a sign he was not meant to become a professional river guide.

In December 1874 Henry reported to the Kilbourn City newspaper that he had sold more than twenty thousand copies of stereos that year and was publishing forty new views.

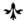

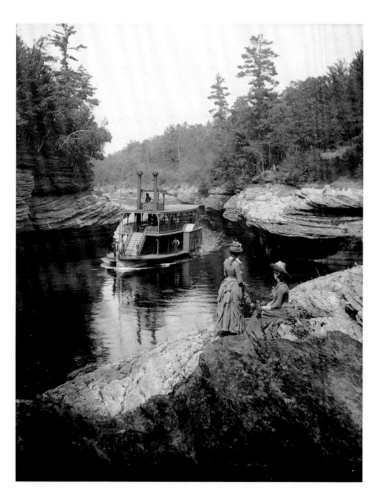

"*Dell Queen* Entering the Narrows." Sightseeing in the Dells underwent a vast transformation with the arrival of the first steamboats. Bennett's daughters Hattie and Nellie watch the *Dell Queen* navigate the Devil's Elbow. (WHi-3544)

After nearly ten years in the photography business, Henry and Frankie Bennett made a detailed inventory of their equipment and supplies at the studio. The gallery the couple rented from Leroy Gates consisted of five rooms plus a garret. Frankie made portraits in the "operating room," where a woolen cloth background, side screen, headrests, and position chair were located. Among the many pages of inventory (including a pipe and tobacco at zero value, a cake of soap at ten cents, and a box of matches at twenty-five cents), some of the items were labeled with the initials of Henry's uncle George Houghton.

INVOICE OF GALLERY STOCK—COMPLETE January 1, 1875

Reception Room: 1 stovepipe, 3 cane seat armchairs, 1 cottage parlor chair, 1 round table and cover, 3 frames of views, 1 large mirror, 1 case for views, 1 slat curtain . . .

Operating Room: 1 slat curtain, 1 cloth curtain, 2 headrests, 1 round top stand, 1 wash stand, 1 position chair, 1 8 × 10 camera box and holders, 1 woolen cloth background, 1 oilcloth carpet . . .

Darkroom: 1 blender, 8 lbs condemned col. [collodion], 1 col. Filter, one flowing bottle, 2 rubber dippers for bath, 1 drying rack, 2 ink rollers, 1 low stool, 1 bottle gold wastes, 2 lbs col., 1 barrel, 2 glass funnels, shelves and yellow glass . . .

Finishing Room: 1 5 × 8 Philadelphia stereo box, matches, envelopes, 2 lamps, 1 2 yr *Philadelphia Photographer* $12, 1 yr *Photographer's Friend* $2, 1 *Silver Sunbeam*, 1 *Photo Guide*, 200 business cards, 1 reducer's manual, 1 lb. Nit Silver Crys't $17.50 . . . locket cases, card mounts, negative varnish, shears, scales, Wedgewood mortar and pestle . . .

Garret: 20 feet backboard, old negative glass, 5 2 × 24 maple trays, 1 stereo camera box, 1 dark tent and legs, 1 keg, 1 16 × 20 rustic frame and glass . . .

Printing & Finishing Room: 1 box with tassels and screw eyes, 1 box 10 lbs Hypo soda, 1 box 10 lbs salt, 1 diamond, 1 glass cutter, 1 set scales and weights, 2 corkscrews, 1 filter stand, 1 brush broom, 1 stereo trimmer, 250 stereo prints not trimmed, 2 doz sheets plain paper, 2 cards with 2 doz views, wrapping paper, 1 alcohol lamp, 1 cutting board, poured silver in pails, 1 tin tank for dark tent, 1 dark tent, 1 dark tent's folding legs, 1 folding tripod, 8 × 10 photos not called for, 1 silver saving churn, 1 tin pipe from sink, 1 sink, one water bottle, one indicator, six lead pencils.

Outside: 1 woodshed, 3 cords sawed slabs, 1 solar camera, 1 trunk and bottles, 1 5 gal. jar of lye, 6 cords dry wood not sawed, 1 pump and fixtures, 1 tank, 1 trussle for tank, gutter on church, 1 table for mounting, 1 revolving showcase.

Total: Reception Room	273.25
Operating Room	264.00
Darkroom	78.90
Finishing Room	148.95
Printing & Finishing Room	2427.92
Garret	48.00
Outside	271.50
	$3512.52

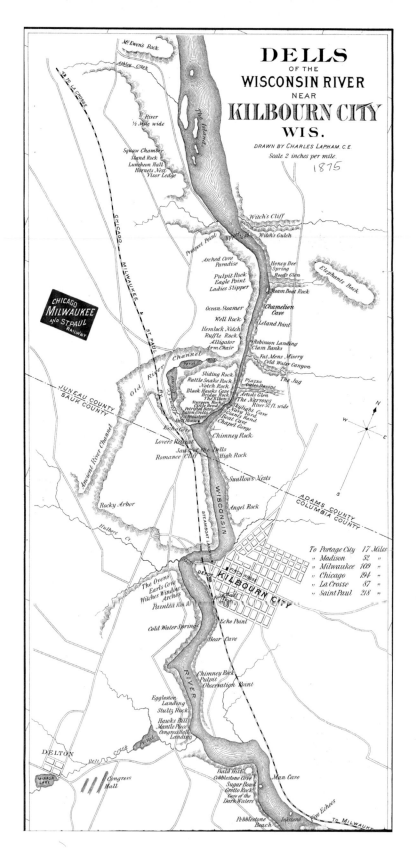

This map of the Dells of the Wisconsin River near Kilbourn City was issued in 1865 by the Chicago, Milwaukee and St. Paul Railway to entice tourists to the area: "Week end excursion tickets at reduced rates will be sold to Kilbourn City and Return every Friday and Saturday during the Season, good to return until the following Monday." (WHi-39790)

The Chicago, Milwaukee and St. Paul Railway issued a handbook in 1875 to help draw tourists to the Kilbourn City area by rail. It was illustrated with etchings made from Henry's photographs. Another 1875 guidebook to the Dells, *The Tourist's Guide to the Wisconsin Dells: An Illustrated Handbook, Embracing the Prose, Romance and Poetry of This Wonderful Region*, included an actual photograph by H. H. Bennett glued onto page 25. Elsewhere in this handbook was an advertisement for the Bennett Studio that offered "Views of the Curious in Lemonweir Valley" and "transparencies for the Sciopticon," a kind of magic lantern. A poem extolled the glories of the Dells in ten unbelievable verses, the last of which went like this:

> How were all those wondrous objects formed among the pond'rous rocks?
> Some primeval grand upheaval shook the land with frequent shocks;
> Caverns yawned and fissures widened; tempests strident filled the air,
> Madly urging foaming surges through the gorges opened there;
> With free motion toward the ocean rolling in impetuous course,
> Rushing, tumbling—crushing, crumbling rocks with their resistless force;
> And the roaring waters, pouring on in ever broad'ning swells,
> Eddying, twirling, seething, whirling, formed the wild Wisconsin Dells![17]

According to Henry, the poet was Frank O. Wisner, editor and publisher of Kilbourn's weekly newspaper, the *Wisconsin Mirror*. Wisner was so pleased with the genius of his own verses that he brought them into the studio as he composed them and read them aloud, line by line.

The summer of 1875 saw Kilbourn developing into a true resort town. Now that wandering cattle were under control, the newspaper called for improvements to be made to the walkways in the canyons and gulches. Two of the hotels, the Glen Cottage and the Tanner House, underwent remodeling. Additional amenities such as a cornet band were added at the Finch House to serenade moonlight excursions. Local entrepreneur Freeman Richards offered dinners at Cold Water Canyon with a menu that included fresh trout, lobster, lemonade, and ice cream. Most of the tourists came from the Midwest and the South, but the Dells bore a resemblance to Lake George and Watkins Glen, New York, so people from as far away as Boston, New York City, Philadelphia, and San Francisco were welcomed, too. Railroads offered special excursion rates. The trip from Milwaukee to Kilbourn City took only two and a half hours.

In June 1875 the little steamer *Champion* was built for navigating shallow water. The *Dell Queen* was fitted with gas lighting for leisurely pleasure trips during the evening, and musicians accompanied the travelers with harps and violins. A gala Fourth of July Rowing Regatta featured three rowboats racing the steamboat *Oriole* while the *Dell Queen* and a third steamboat carried spectators. The rowboats in the race were manned by the Bennett brothers, Henry, Charlie, and Al.

There was no way he could have known it then, but there were changes ahead for Henry Bennett as well as for the pleasant tourist destination his photographs were helping to shape. The year 1875 would be his last at "Gates' Old Stand."

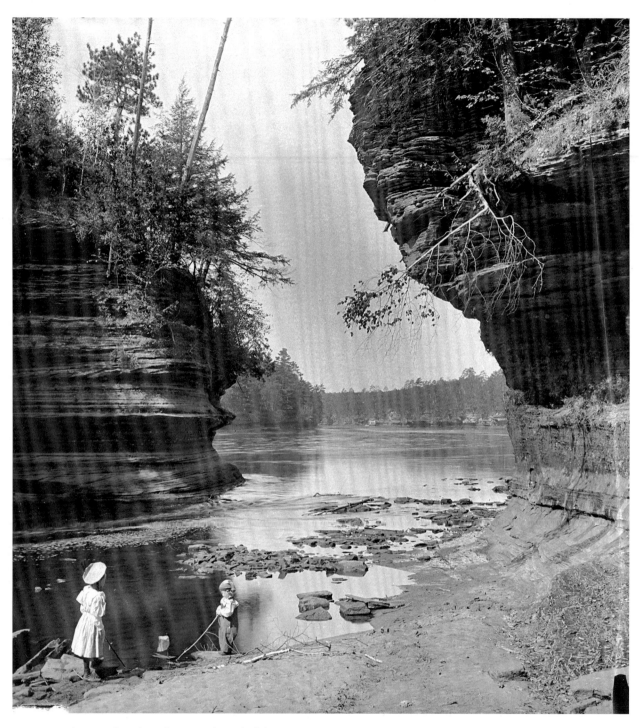

"Steamboat Rock," where the main channel of the Wisconsin River curves around Steamboat Rock, on the right. This was one of Bennett's favorite sites to photograph. (WHi-7308)

4

William Metcalf, Friend and Mentor
1873–1881

Joyously our hearts are beating, as the fleeting waters fled
Swiftly past her, as yet faster toward the Jaws the *Dell Queen* sped.
From the splashing paddles rolled the flashing waves in seething swells,
As she bore us where before us lay the wild Wisconsin Dells.

—John Clerke, "Through the Dells," from Wisner, *The Tourist's Guide to the Wisconsin Dells*

WILLIAM HENRY METCALF OF MILWAUKEE LED A DOUBLE LIFE. By day he was a partner in Bradley & Metcalf, a firm established by him and Charles T. Bradley in 1843 and now one of the largest boot and shoe manufacturers in the country.[1] But Metcalf was also a member of Milwaukee's aristocracy and spent much of his time as a patron of the arts. His spacious home on Cass Street was open to such guests as the inventor of the stereoscope, Oliver Wendell Holmes, the philosopher and author Ralph Waldo Emerson, the famed archaeologist Professor Edward S. Morse of Salem, antislavery speakers, and other notables who might be lecturing in the city.

William Metcalf's father, Eliab Metcalf, had been a highly recognized artist, a painter of still lifes and portraits, both life size and miniature, and a cutter of silhouettes. William naturally inherited a love of the fine arts from his father. He, too, painted portraits and on pleasant weekends escaped into the country around Milwaukee with a camp stool and a sketch box. Rainy days often found him in his studio at an easel.

But William Metcalf never attended college, a deprivation he worked diligently to overcome. In addition to his painting hobby he methodically pursued a self-directed education that included languages, general science, astronomy, chemistry, optics, and hydraulics. A waterwheel took the place of a grand piano in the back parlor.

The Unitarian Church of Milwaukee had its beginning in the Metcalf parlor. He led a Shakespeare class, during which local talent studied the English bard. His friends delighted in visiting his private gallery, where they were cordially welcomed on Sunday afternoons when Metcalf and his wife were "at home," and he delighted in showing and explaining his works of art. Visitors admired *L'étoile perdue* (The Lost Pleiad), a larger-than-life painting of a nude woman by

William-Adolphe Bouguereau (popular with wealthy Americans), and the bucolic landscape *Bay of Naples* by Achille Vertunni.

Metcalf's daughter Julia claimed her father was "witty and quick in repartee, gaining such a reputation for fun making that it was almost a trial to him. In company he was expected to be chief entertainer and keep the ball rolling, which he invariably did. At the dinner table he was at his best, full of fun, stories, graceful toasts and compliments, a merrymaking, indispensable guest who sang old English songs and ballads with spirit and success."

The shoe manufacturer was also an amateur photographer and had his own darkroom.[2] In 1873 he purchased by mail order $150 worth of stereo views from Kilbourn photographer Henry Hamilton Bennett. By that time Metcalf had been experimenting with the dry-plate process of photography for at least three years and had contributed articles to photographic journals in England and the United States, his success with dry plates having gained him some recognition. Metcalf had added a gallery on the first floor of his home, opening from the music room, that allowed adequate light to illuminate the photographs he had collected on his trips abroad.

"Camp Ne-Un-Gah Ah-Rue-Chu," also informally referred to as Camp Mosquito Bite by William Metcalf, helping himself here to the keg of rum. The wealthy Milwaukee industrialist joined Bennett and a few others in July 1873 to view the intriguing rock formations of Adams and Juneau counties. The expedition established a bond between the two men that resulted in personal and professional benefits to both. (WHi-7455)

The spiritual elegance of Henry's landscapes as well as his technique appealed to Metcalf. After admiring Henry's work, Metcalf wrote to ask if he might accompany the photographer on one of his picturing expeditions in the countryside. Henry liked the sound of the letter, and he agreed.

In July 1873 Henry Bennett, William Metcalf, George Bennett (Henry's brother, by then a photographer in Texas), a Chicago bookstore owner named Sheldon, Jack Davis (who acted as the party's guide), and a reporter for the Kilbourn paper traveled to Adams and Juneau counties to camp out among eye-catching rock formations. Rocky Rock, Lighthouse Rock, and Roche a Cri, about twenty-four miles north of Kilbourn, were accessible only by horse and buggy through tall grasses and "prickle weed" and over roads that were often deep with sand. The hardy group set up tents and named their bivouac Camp Mosquito Bite. They dined on boiled eggs, tea, sardines, cheese, and crackers. Around the evening campfires they read Dickens's *A Christmas Carol,* Tennyson, and "Bulwer's last novel with the unpronounceable name," probably *Kenelm Chillingly.*[3]

Henry and Metcalf entertained themselves by taking pictures. Except for guide Jack Davis, the other men were just along for the adventure. One of them reported with amusement on the activities of the two industrious photographers:

> Up and down, over and along the rugged cliffs they tugged and toiled with an enthusiastic devotion to their art, which seems madness to the uninitiated, but to them it was evidently keen enjoyment. Here and there some "good thing" was hidden among the trees, and forthwith Jack's stalwart arm was in requisition, and his lusty blows mocked the sentiment of "woodman spare that tree." Great and small, fragrant birch and whispering pine alike came groaning down, that the Camera might peep in upon the beauty they concealed. We drones of the party did a little climbing, till the sun grew hot, then stretching ourselves on the grass at the base of the bluff, made up for last night's loss of sleep.[4]

Too many hard-boiled eggs and the howls of wolves kept the men awake the first night. Then they were viciously attacked by mosquitoes and deerflies. One of their two horses died, and it rained for an entire day. Still, it must have proven a great adventure for the Milwaukee industrialist because the following October the Kilbourn paper reported, "Mr. Bennett, Mr. Metcalf of Milwaukee and a party of ladies are exploring the vicinity of Ableman and taking elegant stereos."[5]

This was an exciting departure from city life for William Metcalf, who was particularly excited about accompanying Henry to Ho-Chunk encampments. In the decades following the Civil War many Americans became intensely curious about the nation's original inhabitants.

The Ho-Chunk people Henry and Metcalf met during their expeditions were members of a transitional generation. Many had known life both before and after government policies attempted to eradicate Native American culture by breaking up tribal relationships and conforming Indians to the white man's ways, "peaceably if they will, or forcibly if they must." The last armed conflict between federal troops and Wisconsin's Indians ended in 1832 with the Black Hawk War, but it was government policy to move the Ho-Chunk—along with the Chippewa,

Georgie Bennett, Henry's brother and early partner, became a professional photographer in the West. He accompanied Metcalf and Bennett on their trip to Adams and Juneau counties and may be the figure with the eight-by-ten-inch camera in this view of Pillar Rock and Fort Danger. (WHi-7576)

Potawatomi, Stockbridge, and Huron—west of the Mississippi River. Many resisted removal, so federal troops were called into the state periodically between 1840 and 1871 to coerce recalcitrant Ho-Chunk into leaving the state.

During a removal in the mid-nineteenth century the Ho-Chunk were escorted by federal authorities, a marching band, and several banners decorated with the Stars and Stripes. But shortly after the tribe reached Nebraska, it was discovered that at least half of their members had slipped off along the way and returned to their old Wisconsin homes. The last major forced removal, in fact, took place in 1873. The Ho-Chunk were not harassed by the government after that, and they were generally taken for granted by the citizens of Kilbourn City, where the local newspaper once commented, "Our town, though dull, often looks gay, with the red, yellow, and blue blankets of the Indians flaunting in the wind as they pass from store to store."

The Ho-Chunk people gathered every year for a summer encampment near Kilbourn City, where Wah-con-ja-z-gah (Chief Yellow Thunder), a respected Ho-Chunk leader who had resisted all government attempts to uproot him, had a forty-acre homestead. Henry noted that when

Wah-con-ja-z-gah (Yellow Thunder), an elderly Ho-Chunk leader who enjoyed his summer homestead near Kilbourn City. Bennett made two dozen photographs of Native Americans, only a small percentage of his work, but they created a stir among his customers. A stereo series, *Among the Winnebago*, became a best seller. (WHi-4757)

he had arrived from Vermont in 1857 the Ho-Chunk, Ojibwe, and Menominee regularly came around to hunt and fish. But the Ho-Chunk "seem more loth to leave this region than any of the other tribes," he wrote to his friend Charles H. Marsh on October 4, 1894.

Henry had first photographed Ho-Chunk in the spring of 1873, a few months prior to his initial outing with Metcalf. On May 24 the *Wisconsin Mirror* reported, "Henry H. Bennett, the artist, has taken some fine views of the Indian Camp." One of the most compelling of these early views was a portrait of Yellow Thunder himself. Sitting comfortably in front of a traditional wigwam, he looks directly into the camera lens, holding a wooden warclub in his hand. The wigwam of the chief was covered with rush matting, which the Ho-Chunk wove so tightly that it could not be penetrated by rain. According to later accounts, Henry had to persuade Yellow Thunder to pose for him.

Wah-con-ja-z-gah died only a few months after Henry and Metcalf visited his encampment. The chief was allegedly 120 years old. After the chief's death a few of the younger men of the tribe suggested that Henry's mysterious black box, which had somehow captured Yellow Thunder's likeness, might have played a part in causing his demise.

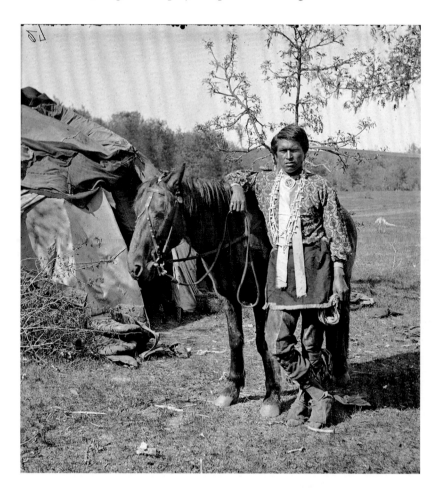

"Ha-Noo-Gah Chun-Hut-Ah-Rah (or Second Boy and Pony)." Between 1878 and 1881 Bennett made six photographing expeditions to Ho-Chunk encampments. This young man wears traditional clothing and stands before a *chipoteke*, a traditional Ho-Chunk dwelling. (WHi-7277)

Henry's Ho-Chunk views, as he called them, were marketed as a series titled *Among the Winnebago* and soon became some of his best-selling stereo images. In subsequent years Henry made additional stereos of Ho-Chunk in their natural settings and also created formal portraits of individual Ho-Chunk, who posed for him in the open air or in his studio. But Ho-Chunk leaders refused to let him photograph their daily life or ceremonies at summer encampments. Although tourists demanded group photographs of the Ho-Chunk, the tribe refused, maintaining their right to define the appropriate use and dissemination of information about their cultural activities. During his lifetime Henry produced only about twenty-five "authentic" Ho-Chunk stereos. The significance of these images to Henry's reputation and his business, however, far exceeded their number.[6]

The rugged adventures shared by the two men undoubtedly encouraged Metcalf, twenty years Henry's senior, to forge an even stronger relationship with the young photographer, who in 1873 was still struggling to make ends meet. Between 1874 and 1890 they communicated frequently about photographic technique and artistic composition. Metcalf eventually suggested an increase in Henry's charges for stereos and sent him a checkbook with sample entries to instruct him in its use.[7] The men's voluminous correspondence reveals the development of a deep and trusted friendship. Henry's written exchanges with Metcalf were more intimate and detailed than his letters to anyone else.

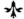

Charles Darwin's *Origin of Species* had been published in 1859 and promoted the study of nature in its purest form. A cultivated reverence for nature in the mid-nineteenth century, enhanced by the popular Hudson Valley school of painters, encouraged photographers who preferred to work outdoors to look at the landscape with a romantic vision, to gaze upon the landscape and share an inspirational moment. The genteel charm of Henry's landscapes would invoke notions of a place where inspirational nature could be encountered within the middle-class terms of control, safety, and uplifting recreation.

Romantic landscape painters had a persuasive influence on William Metcalf, judging by his own collection of art and his photographs. He in turn found a ready pupil in Henry Bennett. Henry was as fascinated by the geological formations along the riverbanks of the Dells as he was by the play of light and shadow upon those contours. He often made two exposures of a scene, once with the stereographic lens and once with a full plate. He returned to photograph the same spots again and again, motivated by Metcalf's recommendations for achieving increased depth and perspective in his stereos:

> August 25, 1876
>
> The "boss" view is the one opposite Coldwater Canyon—though there are no clouds to help out the sky, I hardly want to quarrel with it on that score—the rocks and water of the middle distance are done to a turn and there is fine detail in the foreground—the picture would be greatly helped in effect, if the left hand corner of the foreground, say, all the oak foliage, were in the deepest shadow—& if there was a way out of the picture, in the distance, showing fields beyond, it would be almost perfect.

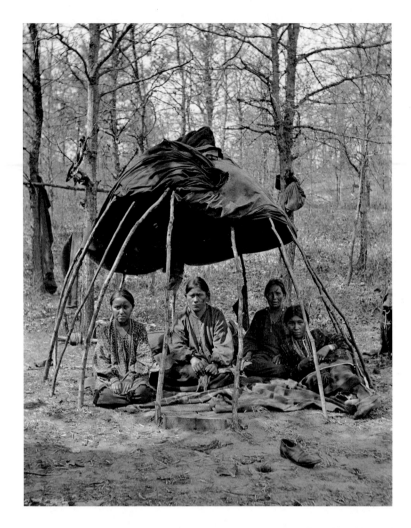

"Wona-chia-ah Chea-da (Indian Tent and Ho-Chunk Women)," 1880. If this is a menstrual lodge, it indicates how much the Ho-Chunk trusted Bennett; such locations were inaccessible to unworthy men. Bennett usually made small payments to the Ho-Chunk for the privilege of photographing them. (WHi-7273)

Under Metcalf's tutelage Henry's artistry began to excel as he created compositions that would be most effective when seen in three dimensions via stereoscope. His scenes began to feature a striking foreground element that seemed to leap out at a viewer combined with an angular element, usually at forty-five degrees, that would cause the background of the picture to recede. Henry's mentor approved of his progress but encouraged him to strive for perfection:

November 27, 1876

 I am much obliged for the views you sent—I liked them all very much, especially the one showing islands through the pine trees—it would improve that picture vastly if the distance between the rock in the right foreground and the surface of the water could in some way be made apparent—a boat or branch of a tree stuck out from the shore would do it if such a thing could be accomplished. . . . As a composition and massing light and shadow the view of rocks and river with little boy standing in right foreground is the best of all—it is a very rich picture.

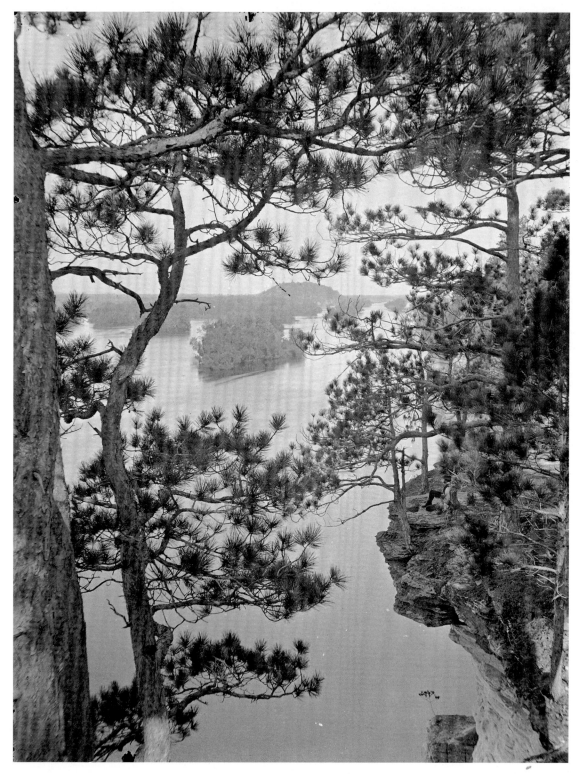

"Upstream from the Mouth of Witches Gulch," a favorite photograph of Bennett's Milwaukee friend, William Metcalf. With his background as a photographer and art collector, Metcalf often helpfully critiqued Bennett's work. (WHi-7515)

Surely Metcalf realized before long that Henry could never achieve technical excellence in the cramped and drafty gallery he was renting from Leroy Gates. In 1875 William Metcalf loaned Henry and Frankie the funds to purchase a lot in the 200 block of Broadway, a much better location than the Gates studio, which was a block and a half east and on the opposite side of the street. The spacious new gallery would be up to date and easily accessible to patrons in Kilbourn's main business area. Henry's specifications were requested and considered, but Metcalf's detailed correspondence contained exacting proposals for everything from roof shingles and sewer pipes to the proper length of wood screws.

The new studio was a twenty-foot-wide brick building with eight rooms. A grassy vacant lot stood to the west. Several tall elms shaded the entrance on Broadway. The salesroom had oak and walnut fittings, and the floor covering was a "wood carpet" of inlaid oak and black walnut. A northward-sloping skylight illuminated the large operating room. Shelves and cupboards lined the workroom, which housed a gasoline engine and burnisher that gave the final high gloss to the finished prints. A well and windmill supplied water for the operations.

But the most unusual part of the new studio was the revolving printing house.[8] Accessible by an open stairway, the garage-sized wooden structure stood behind the studio building atop the woodshed. Henry talked of patenting his unique solar darkroom, which was rotated by a winch on a circular rail. He turned the crank every half hour so the assortment of clear and opaque window panes across the bottom of one side of the room were aimed at the sun throughout the day. Other photographers moved their equipment from one stationary room to another to develop their photographs as the sun crossed the sky, and their hours of operation were restricted. There was only one other revolving solar printing house like this in the United States. Metcalf wrote, rather nervously, that he hoped the extra cost of the printing house was justified. A confident Henry explained to Metcalf that it would eventually be necessary for producing stereo views in profitable quantities.

The exciting exploits of photographers Charles Roscoe Savage and Andrew Russell, who documented the national project of constructing a transcontinental railroad for the Union Pacific, were well known to anyone interested in the expansion of photography following the Civil War. Their photographic records satisfied the economic agenda of the railroad and captured a visual story of places as yet unpictured. Photographs of the linking of the Union Pacific and Central Pacific on Promontory Summit at Promontory, Utah, in 1869 became iconic. Images of the two engines, head to head, and the large crowd in attendance—"East meets West shaking hands, May 10, 1869"—were much sought after by collectors.

While the new studio was under construction, Henry had an idea that initiated a long and mutually beneficial relationship with the Chicago, Milwaukee and St. Paul Railway. The success of his business depended on a steady stream of tourists to Kilbourn, so in 1875 he sought out the railroad's agents with an offer to sell them photographs of the Dells. Railroad officials balked at first, but Henry persevered. After numerous letters and personal visits the railroad agreed and accepted his proposals. Soon the Kilbourn paper reported, "H. H. Bennett completed six

thousand of his unexcelled stereographs for the Chicago, Milwaukee & St. Paul Railway, which will be distributed by this enterprising company in all the principal cities of the South. They will be deposited in libraries, so that they will not be destroyed, and no doubt will be the means for attracting many people to this place for the purpose of viewing the most beautiful scenery in the Northwest."

Henry Bennett was at work in his new studio by the winter of 1875–76. Construction had cost $2,321.02. Metcalf considered the loan an investment and charged the Bennetts $19.33 per month as rent. In his spacious new surroundings Henry was able to refine his customary techniques and improvise further improvements.

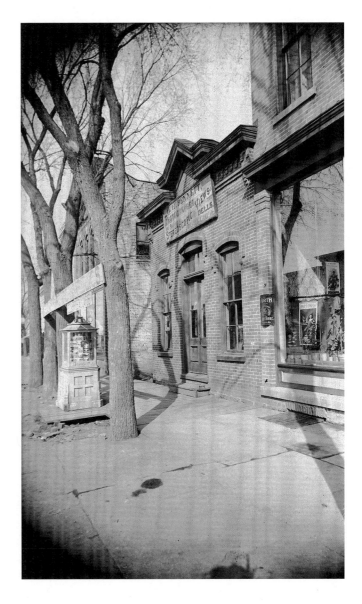

The Bennett Studio. William Metcalf saw great promise in H. H. Bennett, and in 1875 he loaned the photographer the money to purchase a lot on Broadway and to build a new studio. Metcalf then provided exhaustive suggestions regarding all aspects of construction. (WHi-8048)

Henry's son, Ashley, often boasted that his father constructed his first camera from cigar boxes.[9] The cigar box conjecture was never actually confirmed, but Henry assuredly did construct his own cameras, and as soon as possible he acquired a pair of Globe lenses. Henry joked about a wandering photographer of the early days who, he claimed, disappeared with his Globe lenses right about this time.

The innovations created in his new studio reflected Henry's skill at his earlier carpentry trade. He began by constructing a camera with a tilting back for perspective control. He then built a machine for washing prints. Next he built a machine run by a small oil-powered engine for lubricating prints before they were burnished. To print titles on stereo cards there was a small printing press powered by a foot treadle. (Pictures needed titles, and Henry was responsible for naming many of the popular spots in the Dells such as Stand Rock, Witches Gulch, Demon's Anvil, Sugar Bowl, Devil's Elbow, Chapel Gorge, Twin Sisters, Steamboat Rock, and Cold Water Canyon.) With ordinary contact printing Bennett had been creating images the same

A typical family scene, carefully posed in the new studio. A rug was laid over the plank floor, and household items were brought in to create a homey atmosphere. Nellie, age six, leans against her father; Hattie, eight, pretends to be interested in a book. Frankie is crocheting, and Ashley appears thoroughly bored. (WHi-68190)

size as the original glass negatives, but in the revolving printing house a separate window was allotted to a solar camera that used reflected sunlight to make enlargements from negatives.

Some of the equipment and printing processes Henry developed were strictly secret, and he worried about his techniques being stolen. Everyone who worked for him was required to sign an oath of secrecy. The workroom doors had "No Admittance" signs posted on them. There is no record today concerning most of the methods Henry kept so hush-hush, but his novel technique for trimming and mounting stereos is known. The negatives produced by stereo cameras were reversed, so when the negatives were printed, the right side appeared on the left and vice versa. Some photographers solved this problem by cutting the glass negatives in two and then creating the print with the halves reversed. However, with this method there was always a risk the glass would break while being cut, thus destroying the negatives.

Henry solved the problem by focusing on the mounting process rather than the printing process. He made reversed-image paper prints by traditional methods. His genius was in constructing a machine that cut the paper prints with a die and reversed the two sides while mounting the prints on cardboard. The machine was operated by a simple foot lever. Although the process was kept highly secret at the time, recent scholarship has revealed techniques used by Henry to produce stereo views in such volume.

> The rear of the studio building housed the print washing operation on the east side and the print mounting operation on the west side. . . . [Henry] designed die-cutting and mounting fixtures (for each stereograph size) that allowed operators to quickly mount large quantities of prints. The mounting process began after fixing and washing, when the prints were placed, face down and still uncut, in a holder similar to a picture frame. Paste was applied to the back of the print before sliding the frame into the mounting fixture between the punch and die. A blank stereograph card, also face down, was slipped into the top of the fixture, above the die. By kicking a foot-operated treadle, a punch was driven up through the print, cutting and pressing the pasted left print to the right side of the stereo card. Since the print and the card could slide separately in the fixture, both were indexed to the opposite sides for then properly transposing and mounting the *right* print to the *left* side of the card. The mounting fixtures included adjustments to allow print movement relative to the cutting die for alignment of distant objects in the two images.[10]

Years later Henry replied by letter to a friend about his stereo mounting machine and said it was his original design. "[I have seen] three of my help take from the wash and get onto the mounts three hundred and twenty views in forty-five minutes," he wrote. He said he knew of no other stereo mounter like it, but he left no records about the inspiration for his design or the amount of time it took him to construct the machine.

To catch the eye of tourists, Henry erected a revolving showcase on Broadway in front of his new studio. The *Kilbourn City Guard* called the showcase "quite a topic" and explained, "The cylinder, on which are placed the pictures, is made to revolve by means of clock work, and persons can now stand on the sidewalk and see all the pictures in the case as the cylinder slowly revolves."

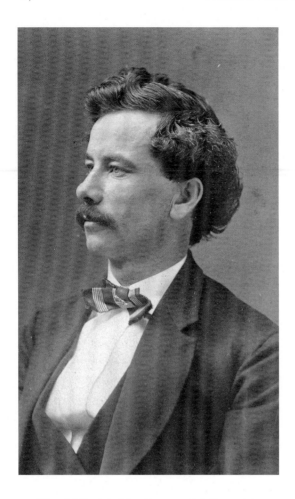

Bennett's ingenuity and his isolation in a rural community led to the creation of necessary devices and techniques. In 1876 employees were asked to sign secrecy oaths that dealt mostly with his methods of stereo manufacture. By 1905 an employee had to promise on his "word of honor as a man" that he would not reveal any aspect of Bennett's business or manufacturing processes. (WHi-68831)

The Philadelphia Centennial Exposition was held in the spring of 1876, and H. H. Bennett sent twenty-four dozen stereo views by order of the Wisconsin State Board of Managers. The editor of the Kilbourn paper deemed Henry's gallery of views an "institution." He added, "Bennett has been most influential in bringing our scenery into repute. If climbing break-neck precipices, wading swamps and swimming ice cold streams in our canyons and carrying, pulling, tugging and hauling all the apparatus necessary to his trade don't deserve success we don't know who is deserving."

Apparently, Henry was not letting all the praise go to his head; he still had time for other pursuits. Taking up an equal amount of space in a succeeding issue of the Kilbourn paper was an article extolling his proficiency as a fisherman. It read: "H. H. Bennett, the Dells photographer, is the champion fisherman of the season, having caught the largest pickerel or muskellunge taken in the river. Weight 28½ lbs, length 4 feet, width 8 in, depth 6 in. On Friday last, Mr. Bennett with his wife and another lady took fifteen wall-eyed pike at the mouth of Hurlbut Creek."

In the aftermath of Commodore Matthew C. Perry's "cannonball diplomacy" in the 1850s, Japan's emperor opened his country to trade with the United States. This set off a wave of travel by wealthy American intellectuals who were drawn by Japan's aesthetic ideals and spiritual culture. Metcalf was informed in 1877 that his dear friend Professor Edward S. Morse of Salem, Massachusetts, was planning a trip to Japan in search of fossils. With only short notice, he decided to join in the journey. This proved to be the most fascinating trip that Metcalf ever made.

At that time Japan had not yet been opened up to tourists and was still mostly untouched by foreign influence. Morse, a zoologist who had recently been made a fellow of the National Academy of Science, intended to search for coastal brachiopods. Metcalf asked Henry to build him a camera that was compact enough for travel and could photograph both in stereo and in individual five-by-eight-inch negatives.

Henry worked with several designs and finally came up with one that Metcalf pronounced to be as fine and efficient as possible. Henry then made one for himself that he judged to be just a shade better. He considered this camera the most versatile of his collection and used it, with box and fittings, for the rest of his career.

Metcalf and Morse steamed into the harbor at Yokohama on June 18, 1877. The letters Metcalf sent back home to his family were filled with exclamation points. Everything was a surprise for him, startling and interesting. Metcalf put his new camera to good use and created hundreds of negatives, mostly of Yokohama, Kamakura, Nikko, and the Fuji-Hakone region. He also brought home an exquisite collection of the very best Japanese bronze, lacquer, pottery, temple vases, fine painted jars, and embroideries to delight his wife and daughter. Most amazing of all, Metcalf was also able to secure a piece of rare Satsuma pottery, a treasure unattainable anywhere else and usually found only in museums.

Once back in Wisconsin, Metcalf turned his negatives of Japan over to Henry, who printed a selection and mounted them on stereo cards.[11] Henry included the Japanese scenes in his list of stereos and marketed the series of twenty-six views under the title *A Summer in Japan*. Metcalf had photographed temples, Buddhas, countryside landscapes, and villages. Henry was careful to attribute the work to Metcalf, however, by printing the notation "negative by W.H.M." on the cards.[12]

Impressed by Henry's invention of the stereo mounting machine and the mounting process itself, Metcalf wrote, "It would be impolite to say that I do not believe your cock and bull story of a trimmer and mounter, so I will not say it, but . . . I recently rec. a letter from a photographic friend in England to whom I had sent some Japan views; he says, 'I like and am much interested in the views, but I admire the beautiful style in which they are mounted and finished; so much that I exhibited them to the members of the Liverpool Photographic Society at a recent meeting and they elicited much admiration.' Pretty hard on *me*, I think."[13]

For years Metcalf and Henry carried on a good-natured debate on a number of photographic topics, including the advantages and disadvantages of wet versus dry plates. Metcalf (who made his own dry plates) was convinced of the advantages of that method: "The slow and sure I am better satisfied with than ever and am convinced are the best to travel with." Henry was resistant to switching over to the dry-plate process even though he realized it would probably be more

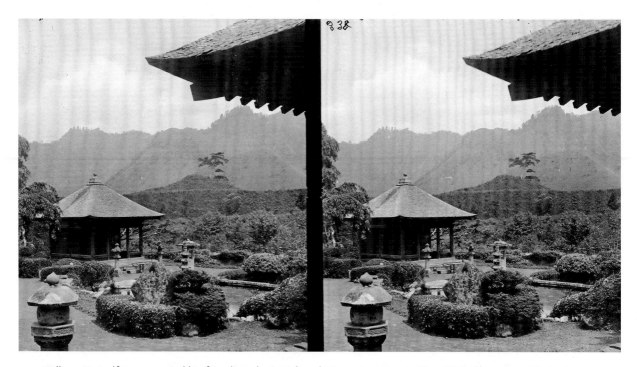

William Metcalf accompanied his friend, zoologist Edward Morse, to Japan in 1877. Metcalf requested Bennett to construct a camera specifically for his use on this trip and upon his return sent Bennett a list of thirty Japanese views. Bennett published the stereo series as *A Summer in Japan*. (WHi-68830)

efficient. With the new technique, a series of photographs could be taken in relatively quick succession and held for developing at a later time.[14]

Metcalf sent Henry an advertisement from the November 7, 1879, issue of the *British Journal of Photography* promoting Cussons & Company's Rapid and Extra Rapid Bromo-Gelatine Plates. "To those Photographers who have not hitherto adopted this form of Plate," the advertisement stated, "or who have failed in their experiments with others, we would say *try them fairly*; and if the accompanying instructions are carefully followed, we can guarantee the most satisfactory and pleasing results." The plates were claimed to be "The Process of the Future."

Metcalf's accompanying letter suggested, "For real artistic work, (and by that I mean the *natural* modulation of light and shadow) I believe slow plates to be the best—and of slow plates I think the *Colodio-bromide* the better—the time required for No. 3 opening from 40 to 60 seconds. I know all the disadvantages of *slow* plates so you needn't say anything about *wind* and sun going behind clouds or butcher wagons stopping before the camera and this and that. Rapidity is a great thing but not *everything*."

The dry process was not fully accepted in America until 1880. Henry initially found the new technique difficult to manipulate and never gave it his unqualified approval. When experimenting with dry plates, his greatest trouble resulted from overexposure because the action of

the gelatin was very quick. It was that very quickness, however, and the resulting practicality that eventually convinced Henry he would have to adopt the dry-plate process to maintain a professional business. While Henry was fiddling with his "snapper," Metcalf wrote to him in the spring of 1878: "I want, if possible, to do some instantaneous work this summer. What do you say to my sending you a plate or two (dry) to expose and send back to me for development? I shouldn't want you to fool away any time in so doing, but . . . it would be fun some bright, still day to go out for an hour or so and no great, big elephant thing of a developing box and chemicals to carry!"

In the summer of that year Metcalf ruefully admitted, "I have made several lots of gelatine emulsion but 'skinning off' is the rule this hot weather." But several months later he offered, "I will fill your holders with gelatine plates and lend you a pair of the quickest lenses you ever saw (my Dallmeyer #1B.) They are awful hasty."

By the spring of 1879 the Bennett Studio listed more than twenty-five hundred negatives in a variety of categories. Disasters were big sellers, and Henry commented that flood pictures were an especially good item. Customers' tastes also bent toward the fine arts, and his photographs of the interior of the Chicago Art Institute's Statuary Hall were popular. Henry's traveling agent, D. A. Kennedy, urged the photographer to produce some comic scenes, but Henry declined: "I don't think my taste runs in the directions of comic views, at least cannot see what I could find for subjects here." Still, he attempted a few of them, including models posed as Vikings in little caves and a cardboard cutout of a cute little girl placed in some Dells-like rock formations. They were obvious fakes.

In 1879 Henry guided J. C. Iverson, a Milwaukee purveyor of stereos, and a reporter from the *St. Louis Post-Dispatch* on personal tours through the Dells. He made a point of accommodating reporters and other members of the press who could help bring his photographs to the attention of a wider audience.

In 1880 Henry took Frank H. Taylor, an illustrator for *Harper's* magazine, on a viewing excursion along the Mississippi River. His investment paid off handsomely when Taylor—in a book he authored for the Chicago, Milwaukee and St. Paul Railway in 1883—gave Henry major credit for shaping the public's perception of the Dells. "Year after year, Mr. Bennett had almost lived in his light boat, paddling into the Dells and exploring the hitherto inaccessible gulches and canyons, by swimming, wading, and climbing," Taylor wrote, "giving most of the points of note the pretty and fitting titles they now bear."[15]

Each spring around the second of May the bank swallows returned to the rocks along the Wisconsin River at Kilbourn. An early arrival of the swallows indicated an early spring and a long summer. Although most tourists were happy with their vacations near the Dells, a skeptical reporter for the *Chicago Times* saw a more sober side of resort life there during the early 1880s:

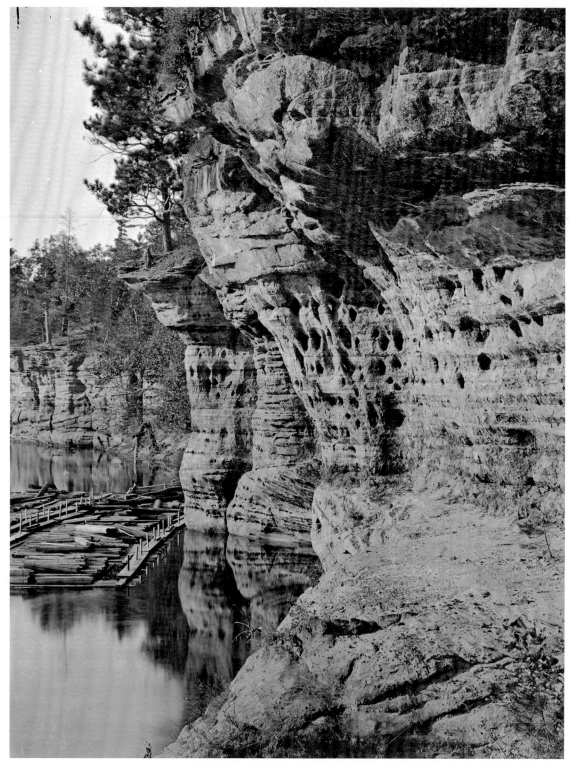

Bank swallows make a punctual arrival each spring and nest in the sandstone rocks along the Wisconsin River. Between Angel Rock and High Rock, Bennett photographed swallows' nests and captured a typical lumber raft drifting by. (WHi-7517)

There can be no more disagreeable city in the whole world than this little country place during these alternations of dull, cloudy days, high raw winds and coquettish suns. The roads are bottomless and there is not a horse or vehicle to be hired for love or money. Visitors are bundled up in rubbers and waterproof cloaks and use their umbrellas to pilot them through muddy streets . . . to the post office in search of letter or paper with which to relieve the monotony of hotel life. The result is a succession of colds, wet noses, influenza, malarial fever and all the ills flesh is heir to.

The little steamers leave the docks three times daily to carry people up the Dells, the latter sit around on decks with white lips, blue noses and chattering teeth, asking questions of the loquacious guides between convulsive shivers. . . . The severe storms have washed the bridges leading to the gulches, chambers and grottos in and about the Dells so that men are as fearful as the women. People come here year after year expecting to find an interesting watering place where they can spend the dog days without being prostrated by heat, devoured by mosquitoes, poisoned by malaria, deranged by bad food or starved by an insufficient quantity of it.

After complaining further about boredom and Kilbourn's inadequate hotels, the writer offered some fashion tips for the ladies:

The very best people appear in check or drab traveling dresses, and their baggage is limited to a small hand satchel containing six collars, as many handkerchiefs, some drab neckwear and a toilet case. The journey up the river costs .25, is made in a steamer and cannot be satisfactory if encumbered by the restraints of dress. White flannel or black satin skirts, lace edged, are as charming as red ones are hideous. The shapeliness of a pretty foot may be enhanced by a broad, common sense shoe. Hoop skirts are an abomination. They hinder grace and oppose agility, but the demi-bustles are prevalent. The chief amusement for Kilbourn is at the depot at 7:30 pm. The train from Chicago arrives then, bringing the daily papers and the evening mail. The good people begin to appear at seven o'clock, a little prudent flirting is carried on and choice bits of gossip are rolled from one tongue to another.

The reporter neglected to mention that a favorite gathering spot for tourists in Kilbourn, no matter the weather, was the Bennett Studio under the elms on the north side of Broadway. There the photographer acted as an unofficial chamber of commerce as he told stories, recited the charms of the Dells, and dispensed rates for board and room at local establishments. Henry's family noticed that he often suffered from what he called "stomach trouble" after groups of visitors left the studio, and he would have to retire to the back part of the building and recline on a table. The distress was the result of Henry's courteous attention to his guests. He refrained from spitting tobacco juice in their presence and consequently had to swallow it, eventually suffering the consequences.

When he needed a break from the tourist trade, Henry loaded up his camping gear and camera and drove a horse and buggy up among the rocks of Adams and Juneau counties. One day when he was up there with his dark-tent and camera he saw a rattlesnake, which he caught and had his assistant hold in place with a forked stick. He had always heard that certain of the chemicals he carried with him were very deadly, so he pried open the jaws of the rattler, poured

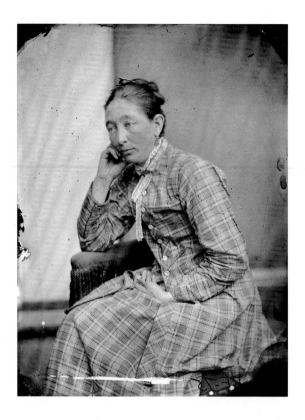

Perhaps another example of "trying on the dog," this portrait of Frankie may have been intended to try out a new lens, a new camera, or the newfangled dry plates that Bennett distrusted. (WHi-68829)

the chemicals down its throat, and watched the snake die a horrible death. At least that's the gruesome story he told his children when he got home.

Assignments also took Henry away from Kilbourn from time to time. He journeyed by train to photograph St. Paul and Minneapolis, Lake Pepin, and Minnehaha Falls for the Chicago, Milwaukee and St. Paul Railway. He spent some time in Milwaukee, hired to obtain views of that city's streets and stately homes for Simon L. Stein, a Milwaukee portrait photographer. In Madison, the capital of Wisconsin, he took stereo views of Old Abe, the famed eagle that had served as the mascot of the Eighth Wisconsin Infantry Division during the Civil War. Shortly after Henry had photographed the eagle, Metcalf wrote that he, too, had been to Madison to visit with Old Abe.

> He is looking well and eats his rations with great promptitude. He whispered to me privately and which he hoped I would not make public, that he was very much annoyed about a month ago by a country fellow who kept dancing around him and cutting up monkey shines and looking into a little box with two big eyes, set up on thin legs. He excused him because he thought the fellow was crazy; 'But', says he, and he dropped his voice and stuck his bill clear into my left ear, 'if that chap comes around me any more with his cheap traps, I'll show him what a battle eagle can do. I think', says he, 'I saw the same fellow at Vicksburg hanging around the suttler's wagon eating pie.' I shook hands with the old bird, he dropped a tear as he said good-bye and we parted.

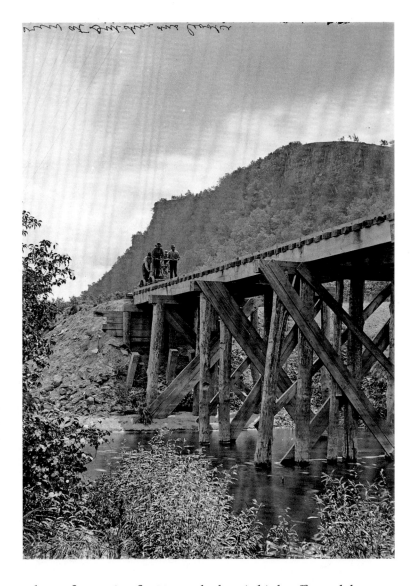

"View at Riley's Coolie." In 1880 Bennett escorted an illustrator for *Harper's* magazine on a viewing excursion to the Mississippi River along the Chicago, Milwaukee and St. Paul Railway line. In Waubesha, Minnesota, he caught a railroad crew crossing a bridge in a handcar. (WHi-7731)

Old Abe survived the war, but not long after posing for Henry the heroic bird suffocated during a fire in the Wisconsin State Capitol in 1881. After his death Old Abe was stuffed, only to go up in flames when the capitol burned again in 1904.

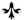

Many photographers were still producing and selling stereo views of the same locations in the Dells. The competition was affable. Henry had especially cordial acquaintance with Simon L. Stein, the prominent portrait photographer whose studio in downtown Milwaukee was lavish even by Victorian standards. He also had a pleasant friendship with Truman Ward Ingersoll and Charles A. Zimmerman in St. Paul. Their correspondence was warm and personal and included

"Old Quarry Road at Frontenac," another Minnesota view. Frontenac overlooks the Mississippi between Lake City and Red Wing. (WHi-7736)

exchanges of practical opinions and advice. In spring, when trailing arbutus was blooming in the evergreen forests near Kilbourn City, Henry sent his colleagues boxes of the fragrant wild-flowers by express.

As for William Metcalf, the ongoing genial argument over the wisdom of dry versus wet plates continued between the two men. Early in 1881 Metcalf wrote to Henry about an account in the *British Journal of Photography* that described the experiments of the Belgian chemist, physicist, and photographic researcher Désiré Charles Emanuel van Monckhoven, who had invented the dry-plate process. Metcalf called him "an impractical fellow" but mentioned an English parson, an enthusiast in gelatin emulsion who had given up glass wet plates entirely.[16] Henry agreed that dry plates might be lighter than a wet-plate outfit on a hot day, but he would never give up his belief that wet plates provided superior quality prints.

Henry Bennett and William Metcalf had a uniquely beneficial and warm personal friendship. Metcalf's daughter, Julia, later wrote, "Among the many acquaintances whom we naturally had in Milwaukee, it is rather sad to think how few . . . really contributed to my father's intellectual pleasure. There was hardly anyone there who understood art in any of its branches; at least, not as he understood it. It was a barren field." In Henry Bennett of Kilbourn, however, William Metcalf found a pal he could camp outdoors with and who shared his sense of humor, who would introduce him to the Indians, who understood the art of photography, and who was able to appreciate and capture what was still left of the Wisconsin frontier.

In the summer of 1881 Henry and Frankie Bennett received a letter from William Metcalf that helped erase forever the painful memory of the early years when the young photographer had despaired that Fate was against him:

> Milwaukee, July 19, 1881
>
> Friend Bennett,
>
> Today is the anniversary of my sixtieth birthday, and I am casting about in divers directions for ways and means of celebrating it and to express my gratitude for the blessing of having been allowed to live to such a good old age and to have been so comfortable as I have always been.
>
> One way that I have chosen is, to make you a present of the gallery and the lot on which it stands. It gives me as much pleasure to give it as it possibly can you to receive it, and I sincerely hope it may prove a benefit to you in its true sense. I do not wish to take away from its true value as a *free gift* by imposing conditions of any kind, and I will not do so. I will only say that it would grieve me much, if the property should ever be taken from you through any means which you had not first carefully considered.
>
> I do not fear it, for I am sure that you have already felt the grip of debt too strongly to ever venture rashly within its grasp . . .
>
> With kindest regards for Mrs. Bennett I am as ever,
>
> Yours very truly,
>
> [signed] W. H. Metcalf

"Looking Out from Boat Cave." The birchbark canoe with Henry's brother John in the bow was purchased in September 1882 from Ojibwe in northern Wisconsin. Bennett whitewashed the walls of the cave to allow for a faster exposure. (WHi-7566)

5

Developments
1882–1883

The life of the landscape photographer is assuredly an enviable one. . . . [T]he pursuit of his favorite art leads him to pleasant places, and brings him face to face with whatever is most lovely and enjoyable in Nature's fair domain; but it is not a life of unmixed content. . . . I do verily believe that no member of the community is so sorely tried as he is.

—Francis Bedford, "Landscape Photography and Its Trials"

WILLIAM METCALF'S GIFT OF THE STUDIO IN 1881 set the tone for the busiest decade in Henry Bennett's career. But the coming years were not without deep sorrows as well as momentous achievements.

As Henry matured as a photographer, his range of contacts expanded. He subscribed to a number of professional journals, including the most influential of the day, Edward L. Wilson's *Philadelphia Photographer*, a technical magazine that published articles about composition and methods to utilize in landscape photography. Among Henry's correspondents was British-born photographer Eadweard Muybridge, who contributed articles to Wilson's journal and had established his reputation with the views he made in Yosemite in 1867 and 1872.

In July 1882 Henry yielded to Metcalf's constant urging to at least give the new gelatin plates a test during a trip to Minnesota. Afterward he wrote that "out of two dozen plates exposed only one good result." Perhaps, he concluded with tongue firmly in cheek, the factory (Metcalf) had sent defective plates. However, Henry was willing to give them another try.

That same summer Henry invested in a stereopticon, a Magic Lantern, which was illuminated by small oil lamps to project photographs onto a screen. Magic Lantern slides of famous landmarks, foreign lands, and personages were available by mail order. Henry made and sold his own three-by-three-inch slides with black-and-white positives on thin glass at the studio. This early version of a slide show provided a kind of home entertainment different from the stereoscope, and for Henry it was an easy way to promote the Chicago, Milwaukee and St. Paul Railway along with the visual delights of the Dells.

When he presented a Magic Lantern show, the Dells photographer accompanied it with a colorful lecture to help flesh out the evening's entertainment. As a special treat he would

sometimes borrow Metcalf's lantern and thrill his audiences by dissolving from one view into another on the screen. In an advertising promotion for the Magic Lantern, Oliver Wendell Holmes enthusiastically praised a show he had witnessed in Milwaukee (perhaps a William Metcalf production): "To sit in the darkness and have these visions of strange cities, of stately edifices, of lovely scenery, of noble statues, steal out upon the consciousness and melt away with one another, is like dreaming a long beautiful dream with eyes wide open."

A famous visitor to the Dells provided another kind of amusement that was perhaps even more thrilling. The local newspaper said a local Indian known as White Beaver (actually Dr. Frank Powell) was a companion to Buffalo Bill: "And what I am working around to is the fact that William (Buffalo Bill) Cody, White Beaver and others of the company of scouts and stage performers will pitch their tent in a few days near the Winnebagos and will form a picturesque setting for the wild scenery of the Dells. I think they are attracted by Bennett, the man who shoots with a camera as well as Buffalo Bill does with a rifle."[1] Indeed, Cody toured the Dells on the *Dell Queen* and later called at the Bennett Studio, where he spent quite a while trading

Diamond Grotto, where, it was said, a visitor must have his or her portrait taken to prove that he or she had been to the Dells. The diamond-shaped rocks had framed Bennett's Ho-Chunk friend Hoonch-Shad-e-gah (Big Bear), William Metcalf, and William "Buffalo Bill" Cody. This was another beloved landmark eventually submerged by the Kilbourn dam. (WHi-68828)

stories with the proprietor. The two men actually had quite a bit in common. Cody's show depicted the triumph of white civilization over Native American culture, but it also featured scenes of Indian encampments and other aspects of Indian life and dress that were both accurate and reminiscent of Henry's photographic depictions of Ho-Chunk camps a decade earlier. Cody employed Indians for his show on terms that were quite good by standards of the time. And like Henry, Cody made an effort to learn the language of his Native American employees. The Kilbourn newspaper noted: "Bennett got the scouts in the Diamond Grotto. . . . The process of being 'taken' by Bennett at the Grotto—one of the most striking points in the Gulch—is now looked upon as a necessary part of a trip up the river. One of these pictures tells more about the Dells than an hour of talk."

One day in August 1882 Henry escorted a party of ladies down a path at Cold Water Canyon and called them to follow, assuring them, "It's easier going this way." Just then a ledge of rock broke out from beneath his feet, and he plunged headfirst into the river—in plain sight of every passenger on a steamboat that happened to be moored nearby. Henry wrote to Metcalf about the incident on the eighteenth of that month:

> Of course my plunge at the Canyon was source of amusement to those on the boat. . . . I was very much annoyed, however put as good a face on the matter as possible. My clothes did not show it in a little while so I hoped a reporter for *The Chicago Times* that was here would not learn of it, but an article in last Saturday's issue of that paper shows that I did not succeed in concealing it from her. I do remember my first circus act at the mouth of the Canyon—wondered if you remembered it. Maybe I had best keep away from there.

Autumn of 1882 found Henry Bennett planning a trip east. He wanted to check out the latest photographic developments in Boston and New York and "get off a little rust." He was now thirty-nine and had not returned to Brattleboro since leaving there twenty-five years before.

The Vermont branch of the trip he found somewhat disappointing. "The same old knife with several new blades and handles," he wrote home. "All distances are only about ¼ what I remembered. Our house has been somewhat changed; ½ story higher."

After leaving Vermont, Henry came home by way of New York, Philadelphia, Cincinnati, Louisville, Nashville, and St. Louis. While in New York he met on November 20 with a representative of the Schoville Manufacturing Company, a large distributor of stereographs. After the meeting he noted in his diary, "[Stereo] business now running into cab [cabinet] and larger sizes with printed-in skies, on heavy beveled gilt mounts. I *must* do some of it *sure.*"

The day after visiting Schoville Henry had a personal meeting with Eadweard Muybridge, whose recent work with instantaneous shutters was of great interest. Muybridge had begun photographic analysis of movement in 1872 when California governor Leland Stanford commissioned him to settle a wager: Do horses at full gallop have all four feet in the air simultaneously at any point in their stride? Stanford thought they did and provided his trotting horse, Occident, as a test subject. But Muybridge's motion experiments were interrupted when he was arrested for murdering his wife's lover.

Of course, Henry would have been aware of the Muybridge scandal and of the photographer's prudent escape to Central America following the jury's verdict of "justifiable homicide." Muybridge returned to California in 1875, giving up landscape photography for motion studies. Only days before his meeting with Henry he had addressed the Turf Club in New York City to demonstrate his zoopraxiscope, an instrument that paved the way for cinematography.

Henry's visit with Muybridge was the highlight of his trip out east. Vermont had been a letdown, and attempts to peddle his stereo views had not met with success. "The little I have been able to sell here," he wrote in his diary of his efforts in Boston, "is not an entire surprise. Cheap views and scopes have about killed the trade and those who make them. As I supposed, too, the stereo view trade is becoming more local, all dealers here have Boston views and sell hardly anything else. I think I shall find trade better as I get back towards the west." He was disappointed in Philadelphia and for the same reasons. "Leave Philadelphia more than ever satisfied that the stereo view trade is in very poor shape. No business east, only local and limited sales in a very cheap grade of views."

One bright spot was the Pennsylvania Railroad, which, he said, was the best railroad he had encountered in his travels. "A new feature to me is burning gas to light cars which they do on this road," he noted. He had also been pleased to meet up with quite a number of former Confederate soldiers when he went through Tennessee and Kentucky: "All expressed themselves in most cordial terms on learning I was an old 'Yank.' One of the most pleasant was one of Forrest's old command that was at Paducah the same time we were."

Back in Kilbourn Henry wrote to his brother Charlie on December 1, 1882: "I got home safe and well last night. The trip was not as immediately successful as I had hoped for . . . though I am glad I went. Got off a little rust, I think, and opened a way for more trade in the future, I hope. Besides, gave me a chance to learn some of the peculiarities of the Trade. . . . Frank I find about half sick with a cough she had when I left home."

Much of that winter and spring of 1883 were spent at his wife's bedside or very near. Henry did the portrait work, caught up on his correspondence, and made plans for a new catalog. He filled orders for stereo views that had piled up during his absence, and on January 5, 1883, he penned a courteous thank-you note to Eadweard Muybridge:

> Dear Sir,
>
> I enclose with this some unmounted views as per my promise to you while in New York. I am mortified that they are no better and more of them, but my attention has been given almost wholly to stereo work, there being no sale here for any other class of views up to the present time. I wish to make an apology for so long a delay in the fulfillment of my promise. I trust the views will please you a little, as yours have me a great deal. I hope for the pleasure of meeting you again, and many times.

Henry was preoccupied with Frankie's illness and greatly concerned with the general decline in business he knew firsthand was now sweeping from east to west. Meanwhile, he updated his stock and was specific in orders for stereo mounts. Among the number of assorted sizes and types he purchased were some handsome pink mounts with beveled and gilded edges in the

As 1882 drew to a close, Henry's wife Frankie became ill. While she rested, he dealt with the portrait work and planned a new catalog of his stereo views. Occasionally, he ventured outdoors, most likely still experimenting with the new dry plates. (WHi-68827)

four-by-seven-inch Promenade size. But as Frankie's cough and cold lingered, he became more absorbed with her decline. He wrote to brother Edmund in January 1883: "[The gift of the gallery] has made things a wonderful sight easier on both Frank and myself. Whatever success I may attain, financial or otherwise, a great deal of credit is due Frank for aid and cooperation with me. Her health is not good this winter, a cold on her lungs for the past two months has confined her to the house most of the time."

Henry published his first real catalog of stereo views in 1883. He had spent time during Frankie's illness working on its organization. The catalog was an elaborate undertaking and required explicit letters of explanation to the designer and printer. Henry wished the cover to

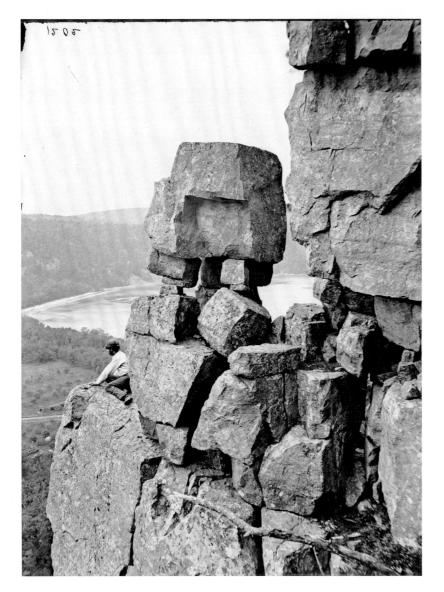

Wanderings among the Wonders and Beauties of Western Scenery, Bennett's new catalog, was published in 1883. It listed his complete series of stereos, and he wanted the cover to illustrate his most notable and exciting experiences. Prominent were scenes of Bennett and his assistant struggling up the cliffs at Devil's Lake. Here an assistant checks out the view below the Devil's Doorway. (WHi-7572)

be illustrated with engraved cartoons depicting—with poetic and promotional liberty—events from his career. He wrote to the artist, "The incidents I have in mind to use . . . are photographer and assistant climbing at Devil's Lake with packs on backs and camera; photographer and assistant . . . meet a big black bear; photo. and asst. insist on making views of Indian camp, Indians appear armed with guns and bows and arrows insisting they don't want camp pictured; photo. gets a tumble into the Dells camera and all."

In previous years Henry had prepared simple lists of his stereos, but he wrote to Metcalf that this time he hoped to get out something more attractive and interesting than a mere catalog. He also mentioned the possibility of reprinting a long humorous article from the *Milwaukee Sentinel* of January 28, 1883, written by a reporter named John Kaine. The catalog, the only major one Henry ever published that listed all his stereo views, was entitled *Wanderings among the Wonders and Beauties of Western Scenery*. Kaine's article was given a prominent place:

> The Man with the Camera is known to every stranger who visits the wonderful scenery of Wisconsin, and there are few characters in the state more deserving of acquaintance or who have undergone as many dangers and trying experiences in the pursuit of the beautiful and wonderful. Mr. H. H. Bennett, the "Man with the Camera," has done everything to advertise the remarkable features of Wisconsin Natural scenery. Twenty years ago the raftsmen knew and cursed the Dells of the Wisconsin River, but nobody except Bennett seemed to know of the deep ravines and dark gulches and rocky mountains back from the river's edge. Today they are known the world over—they are painted on canvas, pictured in magazines and described in verse, all from Bennett's prints. When Harper's or The Century sends its own artists to picture nature in Wisconsin or along the Upper Mississippi, they take a set of Bennett's views and pass them over to the engraver. "Bennett has left us nothing," as one of them frankly confessed . . .
>
> Whoever has gone over a part of the region pictured by Bennett (nobody has gone over it all) must have been astounded that certain points above a yawning chasm could have been pictured so closely. To see Bennett plant his apparatus a hundred feet above the water on the perpendicular side of a cliff, without appearing to consider that the fingernail by which he clings may break, is enough to turn one gray. It is not easy for the visitor to understand at first, that the modest man who passes views over the counter at Kilbourn is the man who has risked his life scores of times to get these pictures. And, looking at the pictures, one can form no conception of the many weary miles over an unsettled country the artist has walked, the dizzy heights he has climbed, the perseverance he exercised. In short, the pictures do not fairly indicate the qualities a photographer must possess in this wild region . . .
>
> There are two events in Bennett's life about which he cannot speak without emotion. One took place near Camp Douglas before the railroads were known there. He had just fixed a plate to take Fort Danger when a black bear came out of the bushes. He turned the machine on the bear, guessed at the focus and drew the slide, when the bear made a dash at him and he grabbed his instruments and fled. "If he had only waited two seconds longer," Bennett says sadly, "I would have had him."
>
> The other incident was on the river. One of the ambitions of Bennett's life is a series of views representing the life of the raftsmen. He had taken his place on a raft, intending to take a picture of the raft as it moved over the dam, sometimes a thrilling sight. Just as the raft approached the fall it showed

signs of breaking, which was just what Bennett wanted. The raftsmen were excited by the danger and just as Bennett had drawn the cap, a bucket of beans struck the camera along with the shout of a half-drunken oarsman to "Take that _____ thing out of the way."

In addition to the entertaining (if somewhat embellished) article from the Sentinel, the catalog listed between four hundred and five hundred stereoscopic views. Most were pictures of the Dells, but there was also a good selection from Devil's Lake and Adams and Juneau counties. A series titled *Wayside Gems* included such views as "A Cowboy's Success as a Fisherman," "Among the Pines on a Frosty Morning," and "Old Abe, the Wisconsin War Eagle." A selection of scenes made from William Metcalf's negatives were listed under the title *A Summer in Japan*. Thirty-eight views of Minnesota were represented by a series called *Among the Bluff Scenery of the Upper Mississippi*. This last series was prefaced by the following tale, evidently penned by the photographer himself:

One day he had planted his camera on the railroad track in one of the deep cuts and was waiting for a cloud to pass over in order to get the best view of a beautiful bluff, when the whistle of the Flying Dutchman was heard at Lake City, just above. "The sunlight and that train will get here just about the same time," said Bennett. Just as the shadow began to move off the bluff the noise of the Flying Dutchman tearing along at forty miles an hour, was heard. It was a trying situation for Bennett, for another cloud was chasing the first and if he missed this opportunity to take the picture he might wait

Bennett's 1883 catalog listed a series titled *Wayside Gems*, an eclectic collection of views, including this eerie spectacle of Jack Frost's Aquarium. (WHi-68826)

Minnehaha Falls, in autumn and winter, where Minnehaha Creek takes a fifty-three-foot plunge near its confluence with the Mississippi River. This became a top tourist attraction in Minneapolis after William Wadsworth Longfellow (who never saw the falls) immortalized it in *The Song of Hiawatha.* (WHi-68825, WHi-68824)

weeks for another. Bennett stood at his post on the track. He grew pale as the rumbling of the fast express grew more distinct, but he drew the slide and began the exposure—one second, and the train was close. The hand-car men implored him to get off the track, but he went on with his exposure. Two seconds, and it was almost upon him, when he threw his hat over the tubes and leaped from the track, the engine catching a leg of his tripod as it passed.

The catalog was a success, and readers enjoyed the tales, tall as they might have grown. To a customer who inquired, Henry wrote, "The article which you referred to was written by a friend, one of the editors of the *Sentinel* who has been out with me on some of my viewing trips and the incidents are, in substance, correct."

After all that effort Henry's satisfaction with his new catalog must have been severely curtailed by Frankie's dire condition. Her illness had been diagnosed as a bronchial infection, and her absence from the studio was conspicuous, particularly in the darkroom, where she had attained enough proficiency through the years to be trusted by her perfectionist husband with the finishing of prints.

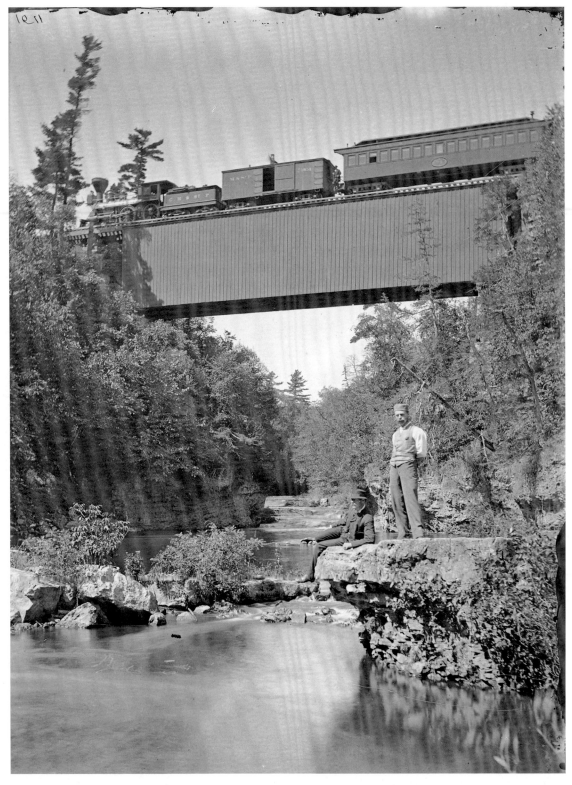

"Railroad Bridge over the Vermillion River in Minnesota." Near Hastings the train paused to allow Bennett to take this photograph. A man atop the freight car seems to be hollering "Hurry up!" (WHi-7727)

When Frankie's health had not improved by late spring, William Metcalf insisted that she be brought to see a physician in Milwaukee. He made all the arrangements. Frankie's health had declined to the point where she suffered from unbearable fatigue, and constant coughing made her so weak that she was unable to rise from her sickbed. Henry secretly feared that the long hours his wife had spent in the cold, dark atmosphere of the darkroom may have been responsible for her decline. The Milwaukee doctor said it was tuberculosis.

The slightest change in Frankie's condition became an obsession with Henry. He wrote several letters a week to the Milwaukee physician during that summer of 1883, reporting her symptoms in exhaustive detail—letters reflecting his desperation in seeking the slightest reason for optimism:

Barn Bluff near Red Wing, where Bennett climbed the bluff to obtain views of the village and the Mississippi River downstream. (WHi-68823)

July 27, 1883

Dr. A. J. Heare:

. . . Mrs. Bennett kept the bed most all of yesterday and today is very weak though sitting up. Had no movement of bowels for three days until this morning which was effected by taking some tincture of rhubarb. She has but little fever yesterday or today, up to now, 3 o'clock p.m. Tongue is heavily coated white.

For several days and nights past she sweats profusely when asleep, more the limbs and head than the body, in fact last night her body about the chest and stomach was hot and dry while the legs and arms and head would be wet with perspiration.

Yesterday and today all food or medicine taken gives her great distress and the stomach is somewhat sore to the touch . . . Coughing also distresses her a great deal . . . whooping and gagging before she can raise. Today she complains of faintness and a sinking sensation succeeding a hard coughing spell.

Down the river from the bluff at Reed's Landing, Upper Mississippi River. (WHi-69033)

"Train Depot at Buena Vista, Iowa." Bennett had been traveling by train and taking photographs for nearly three weeks. Now he was heading home. (WHi-8129)

Ashley Bennett turned fourteen in 1883. He helped his father haul bulky photographic equipment in the Dells, but it was much more enjoyable to master his high-wheeled bicycle on Kilbourn City's unpaved streets. (WHi-68822)

Henry clung to hope for his wife's eventual recovery. Because Frankie was restricted to their bedroom, Henry attempted to share his time with the children so they would not worry or feel neglected. Ashley was now old enough to serve as his father's assistant. He helped carry the photo equipment when they went out on the river.

In the summer of 1883 Henry organized a broom brigade, the Dell Rangers, for the benefit of Nellie, then age twelve, and Hattie, who was sixteen. The brigade consisted of teenaged girls from Kilbourn City who dressed alike in snappy military uniforms and carried out a series of military drills as outlined in the booklet *Broom Tactics, or Calisthenics in a New Form for Young Ladies*. Henry was the drill instructor. It reminded him of his Civil War days, though his charges were female and carried brooms instead of muskets.[2]

Frankie showed little progress in her recovery. "I feel sometimes that my load is a heavy one," Henry wrote to his old friend Metcalf, "when I can only sit powerless to help and see her I love so well in such agony as she suffers at times. I assure you the charming words from you and our many friends are a great comfort."

Henry Bennett's daughters Nellie and Hattie pose with kittens. (WHi-68821)

Popular "remedies" for consumption included sea voyages, horseback riding, walking, and changes of climate. In the autumn of 1883 Henry and Frankie, with their eldest daughter, Hattie, started west with the hope that a milder and drier climate would prove to be a panacea. Frankie was encouraged to eat an apple daily, before breakfast, and to take a cold sponge bath each morning and night. The journey was rather loosely planned. A note to Metcalf on September 17 revealed that Henry would take a camera along. "I shall take an outfit with me and hope on my return or perhaps while away to send you something in exchange for the excellent pictures you have sent me. In stating that I take with me only a gelatin outfit, have to acknowledge more confidence in it than in the past."

The family traveled by train, and their initial goal was Denver, although Henry thought they might go as far south as Texas. After reaching Kansas City, he decided to head for New Mexico instead. Henry's brother Albert took over the business at the gallery for the winter. Letters written between them tell the story of the family's unusual trek through Kansas. In a move that must have seemed like a good idea at the time, Henry rented a team and a covered wagon so Frankie would have the benefit of fresh air:

Hattie was sixteen in the autumn of 1883 when her father decided a change of climate might boost her mother's health, and she went along for the trip. Bennett eventually rented a team and wagon and headed south across Kansas so Frankie would get plenty of fresh air. (WHi-68731)

October 7—Washington, Kansas

Dear Brother Al,

. . . During the past week we have been out three days with our emigrant wagon, making over 40 miles in that time. Of course she was tired each night, but having a good appetite and sleeping pretty well has, I think, done her good. We shall leave here for good day after tomorrow if the weather is favorable, so don't send any more letters here. On the road I will write you where to send letters ahead of us.

November 10—Lecompton, Kansas

Been having pleasant weather to travel most of the time . . . and no faculties for writing if laid up. I think I can report that Frank is slowly on the mend. A doctor we saw a few days ago at Topeka says it would be suicide for her to return to Wis. this winter and suggests Santa Fe and vicinity as a good place for her. We have been on the road most of the time since I wrote you last and most all the time she has a good appetite which is strongly in her favor. Won't try to tell you all the experiences we have had, only to say that few have been other than pleasant. . . . I am uncertain as yet whether we will go to New Mexico; shall consult other doctors before deciding.

November 25—Kansas City, Missouri

. . . We did not reach this place as early as I expected when I wrote you last . . . No "Jay-hawker" molested us. I had to sleep but one night with an ex Confed. soldier, but he had no gun, or I either, so we got along nicely together. I have sold our team and abandoned that mode of life as Frank had become tired and I was afraid of being caught in some uncomfortable place in stormy or bad weather.

December 3—Kansas City, Missouri

. . . Frank is quite low just now, I think that as soon as she rallys sufficiently for her to make the journey we shall return home. I wish you would ascertain if the girl Hannah Gregerson that used to work for us can be got and engage her against our return. . . . Tell Ashley and Nellie we have their pictures and Mama was pleased with them. You will please excuse the brevity in this, my time is closely occupied with Frank just now.

They arrived back in Kilbourn by train in December 1883. Frankie's illness had demanded nearly all of Henry's attention during the trip, so his dry plates had not been given much of a test, and he returned with only a few negatives of Kansas scenes. Henry was clearly distracted. Compared with his photographs of Dells-area rock formations, the Kansas scenes are uninspired. Near Christmas Henry sent a desperate letter to his friend William Metcalf:

December 21, 1883

Dear Friend Metcalf,

I have got to borrow money of someone to carry me through to the time in the spring that I can get at something that pays, and Mrs. Bennett gets better. I am much lighter hearted than when we reached home [from Kansas City], for she is most surely better, though improvement is very slow. The doctor also feels much encouraged so far and for some time to come I shall be able to leave her but very little, for I feel that no one can take quite as good care of her as I.

But to return to business, I had much rather owe you than anyone else, if you are willing to take such security as I can offer, a mortgage on the gallery which I will keep insured. The amount I shall need will be from $500 to $700 to carry me through and go into a scheme I have in view of making large views of residences in Milwaukee before our season opens here. But I would rather . . . have only $200 at a time, as I may require because something might transpire to prevent doing the Milwaukee scheme and besides, I would rather not pay interest on money until I can use it. . . . I have not forgotten how happy I have been while out of debt, but I don't see now how I can avoid shouldering such a burden again.

I will only say this, if you should feel I am an unlucky one I shan't disagree with you.

I shall send you some unmounted prints from gel plates in a few days, and I am humbled to confess that a few of them are reasonably good. So far I have not done much towards fixing your camera, but I hope to be situated so I can before a great while. If you should want it to use the lens before I can fix it, I will gladly send it attached to my 8 × 10 box which is so arranged that you can work 5 × 8 plates in a dry holder.

With kindest regards for both you and Mrs. Metcalf, in which I am joined by Mrs. Bennett, I remain, vty, HHB

Metcalf sent the two hundred dollars Henry had requested by return mail.

Henry took a camera along on the journey west, but he was preoccupied with Frankie's health. He did not take many photographs, and this one seems to unconsciously convey his sense of despair. (WHi-68729)

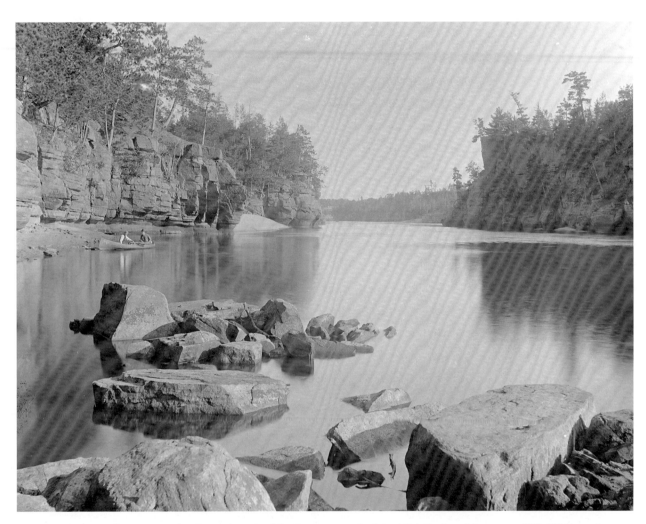

"Lower Jaws, from Stone Pile," located south of the Narrows not far from High Rock and Romance Cliff. (WHi-7792)

6

The Snapper

1883–1888

Arbutus is about in the prime or will be by Sunday. The river is up a booming and the narrows are wild enough to make some interesting views.

—Henry Bennett, April 20, 1886

As 1883 DREW TO A CLOSE, THE BENNETT STUDIO was advertising the "New Rapid Dry Process" for portrait work. Apparently, Henry and Frankie were not in agreement regarding the wet versus dry process, and Metcalf egged them on. In January 1884 Metcalf wrote to thank Henry for lengthening the focus on his own camera: "It seems to be just the thing needed, and I believe the slight projection of the cap will not prevent the box from slipping down into its proper place in its traveling case though as yet I have not tried it. I notice you say 'No bill'—I say *Noble* which is very much the same in sentiment though quite different in spelling. I accept your present with pleasure." Then Metcalf added, "I sent today by Express, packages of instantaneous photos for Mrs. Bennett's inspection which I hope will gratify her sense of what is good in photography. Tell her that they are all taken on *Gelatine* plates which she and I both admire so much, but which her old fogy husband has not yet climbed up to. I shall be glad to know her opinion of them. Please keep a weight on them to keep them straight, when you are not examining them, and do not hurry to return them."

Metcalf was negotiating a big contract between Henry and Chapman's Department Store in Milwaukee. Timothy Appleton Chapman and Company was founded in 1857. The company's second store, built in 1872, was one of the largest dry goods houses in the country at that time, and in 1883 Chapman doubled the store's size and capacity. Having spent $100,000 to enlarge and decorate his store, Chapman wanted the world to see how really splendid it was. "He wants good work or none. I took pleasure in saying that you were a man of excellent judgment in your business and that you would not promise to do anything until you had looked the ground over and even then, you might decide that the subject was not promising enough for you to attempt it."

Metcalf offered Henry the use of his ten-inch lens, which he'd used before. Lighting conditions had to be optimum, which probably meant photographing the interior early in the morning. "If he [Chapman] can get views of it which are satisfactory to him, he will want a good many

of them. He is a very liberal man and the job is worth your attention. I would advise your coming in soon, on a bright day, to get a good idea of what is required of you." It was decided to photograph Chapman's store on Sunday, February 3, with all the necessary materials brought in on Saturday and the camera locations determined ahead of time so nothing would be left to be done on Sunday morning except exposing the negatives when the sun was at the right angle.

Henry had inquired what to charge for his work, and Metcalf replied, "Why not adopt a plan like this: *If only 1 print* of each be taken, charge for all materials, expenses and a round sum for your time. If only 50 prints from each negative—so much apiece. If only 100 prints from each negative—so much apiece, but less. After that a still smaller sum for each print but enough to pay you well for the work. But I think you ought to charge for the two days work and expenses to begin with. Let me know what the prints look like whenever you can."

By the first of April Metcalf was worried because he'd asked Chapman if he could see a set of the photos, and Chapman said "he was afraid 'the little fellow' had gone back on him," as Henry had only sent him a few, "and those were already disposed of."[1] Metcalf also thanked Henry because "the postman surprised me today by handing me a half bushel or less of checkerberries. Mrs. M. and I are still eating and enjoying them—They brought vividly to mind the time when we were top of Witches Gulch where the berries were so plenty, and where I ate all the toast. You must have been there to get those you sent me, which is a sign that you have had some good weather out in the country."

Frankie's health had improved slightly, but she was not yet well enough to work in the studio, nor could she speak above a whisper. They were now selling five-by-eight-inch and eight-by-ten-inch photographs as well as two sizes of stereos.

Henry wished to experiment with an even larger format. In March 1884 he ordered a Blair Reversible box made by the Blair Tourograph and Dry Plate Company for $82.50 from Smith and Patterson in Chicago.[2] The camera was able to produce negatives in a size that was aptly called "mammoth"—eighteen by twenty-two inches. Henry sent his lens specifications along with the order and added, "I desire [the camera] as light and compact as consistent with strength and firmness and with it a tripod and top that are large and strong enough for such a box." He had earlier commented, "My experience has been that it does not pay for a Photographer to make his own equipment unless he cannot get *what* he wants from the dealers." He planned to try two or three lenses with the new, larger camera and anxiously awaited its arrival. But when Henry tested the new camera, the Blair Reversible was a letdown. It was not as strong and rigid as he had specified and was disturbed by the slightest breeze. He promptly sent the camera back and began plans for building one of his own that would meet his exact requirements. By the beginning of May he had a design under construction.

The incentive for owning such a camera may be found in his apology for having only stereos to send to Eadweard Muybridge (the stereo bore the stigma of commercialism and was not considered "art"). Further motivation may have been an editorial in a recent issue of the *Photographic Times and American Photographer,* where Mr. H. H. Bennett was praised for studying the glorious scenery of Wisconsin and Minnesota through the mediumship of the camera, using the three requisites—"energy, taste and manipulative skill." The editors reviewed several of Henry's stereos,

the "Ink Stand and Sugar Bowl" in particular, with raptures for the "excellent and effective bit of composition; indeed, there is a knowledge of art principles which pervades the whole of the series. Each picture is 4 × 3 inches barely, and is cut to a dome shape. The tone is a brownish violet."[3]

Construction of the new camera was completed by June 1884, and Henry used it to photograph a group that included Wisconsin governor Jeremiah Rusk and some army officers in Madison. Few studio portraits were ever made with the mammoth camera; it had purposely been designed for landscape work, even though moving such a monster was exceptionally difficult. The metal-bound box enclosing the camera was the size of a small trunk. Holders for six or eight glass plates created another large and heavy package. The wooden tripod Henry built for the camera was sturdy enough to support the camera without vibration, but he could not transport the equipment on viewing trips through the Dells without the help of an assistant, usually a young man or older boy who worked in the studio. Nevertheless, the colossal camera proved to be one of the most valuable in Henry's collection. Its eighteen-by-twenty-two-inch negatives yielded fine, clear detail, and contact prints made from the negatives were finer than any enlargements made by projections in an enlarger.[4]

By the summer of 1884 Henry had to accept the painful fact that his dear wife Frankie's health was in jeopardy again. There was very little hint in her wide-set blue eyes of the happy, carefree girl who had run off to Tomah with Henry only seventeen years before. She had become emaciated and now was consumed by a heart-wrenching cough. Her distraught husband was helpless to save his wife from her affliction. Francis Irene Douty Bennett died on August 28, 1884, at the age of thirty-six.

The Kilbourn newspaper printed a lavish obituary, praising her courage and lamenting:

> Mortal skill could not stay the fatal progress of the disease, and the husband, with an aching heart, could only watch the gathering of the shadow which was so soon to fall around his life and over their happy home. Just when the reward of their combined efforts in the profession which they honored seemed near at hand, she was called away. Her death occasioned a feeling of universal sorrow throughout the community, and when her remains were taken through the quiet streets to their last resting place in the village cemetery, they were accompanied by a large number of friends who had known, loved, and admired her.

When early portraits taken at the Bennett Studio are viewed, it is impossible to know which ones were taken by Frankie and which ones by her husband. She must have possessed a talent for portraiture and the supreme patience (a quality her husband lacked) to pose men, women, and children at the various turning points in their lives. It was obviously important for these people to have their portraits taken, usually in their finery, and it often cost them dearly to pay the photographer's bill. In those early years a portrait photograph possessed almost the same significance as a painted portrait and was undertaken with the same sense of destiny. Henry had entrusted his wife to capture the pride, the dignity, and, with tenderness, the grief of their customers, with photographs that bore the imprint of their shared place of business. At the same time she was running the household and raising three active children.

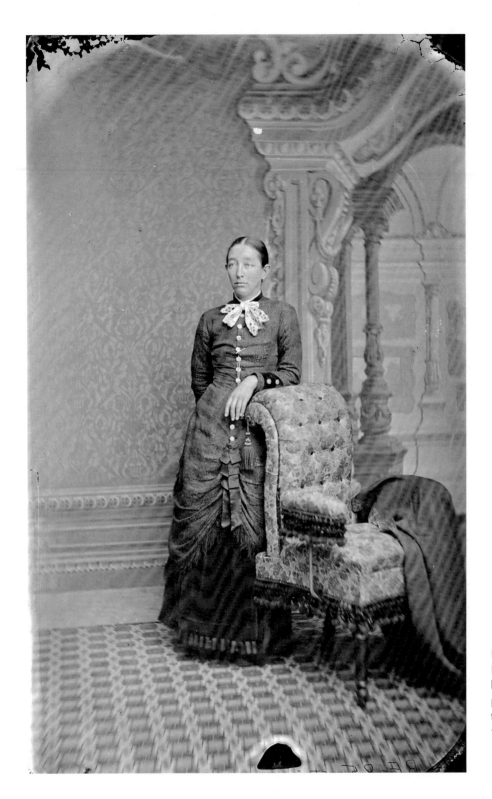

Francis Irene Douty Bennett, her husband's helpmate and loving partner, died at age thirty-six on August 28, 1884. (WHi-68724)

In William Metcalf's letter of condolence he strove mightily to support his friend.

> The greatest of the losses that can possibly come to us is the loss of a husband or wife. Where the relations are true and tender as I know yours have always been, the blow is a keen one, and one that will always leave its mark. There are some mitigating circumstances which in your case will soften the blow—it was not an unexpected event—you have always been loving and tender, so that you have not to bear, in addition to the sorrow, any self reproaches—you have three affectionate children to share the burden of grief. All these are and will ever be sources of comfort to you.

Following Frankie's death, Henry suffered a recurrence of the old familiar "Bennett blues." In time he threw himself into his work with what must have been a healing urge. He now found the new gelatin dry-plate method much more convenient for his use and informed another photographer, "I too have become a partial convert though not as successful as these views show you to be. Still enough so that occasionally the later part of this season have taken the Steamboat with gelatin. As I remember your work on wet plates these are quite equal to it, which I am afraid cannot be said of mine." To another photographer he wrote, "I have found the Cramer plates most rapid and uniform. . . . I have done but little instantaneous work."[5] Studio records indicate rather frequent orders that year for the Cramer plates, made by the Cramer Dry Plate Works in St. Louis, Missouri. But Henry never gave up his conviction that wet plates were superior for the quality of their images.

By December 1884 Henry had several new eighteen-by-twenty-two-inch views ready for an exhibit in Milwaukee. He sent along some of his distinctive panoramic photographs for display.

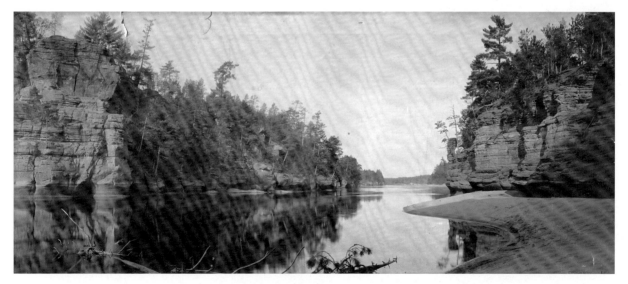

"Jaws of the Wisconsin Dells," an early panorama made from two eighteen-by-twenty-two-inch negatives. Each negative was printed separately in diffused light. (WHi-64331)

In the past Henry had experimented with smaller panoramic views by joining three eight-by-ten-inch negatives and printing them on albumen paper. The final result was achieved by double printing where the negatives were joined. Each negative was printed separately in diffused light. Utilizing this technique, it took him about a day and a half to make a single panorama.[6] The larger panoramas, made with photographs taken by the eighteen-by-twenty-two-inch camera, had to be printed from three matched negatives and printed on a single sheet of paper five feet long and eighteen inches wide. These were the largest direct-contact prints ever made. Henry's panoramic photographs were so perfectly executed that it was difficult for even the most critical observer to find where the negatives were joined in printing. It was exacting work, but Henry's craftsmanship was apparent, and the finished panoramas were (and remain) impressive.[7]

A bird's-eye view from the dome high atop Milwaukee's Exposition Hall. In the distance can be seen the Best and Company Brewery, which became the Pabst Brewing Company in 1889. (WHi-68719)

In an April 1885 letter to his brother Charlie, Henry confessed that he was still depressed. "This spring finds me more hundreds of dollars in debt than I dare tell, and with less ambition and health to lift the burden than ever before. You see Charlie, the inspiration has gone and I cannot feel the same interest that my work once had."

Despite his dejection, on warm summer Kilbourn evenings in 1885 the most popular place for tourists was still the Bennett Studio. There the photographer, now age forty-two, found comfort in projecting lantern slides on the screen and recounting his experiences with his audience. His favorite stories were still about his service in the Civil War. He loved to get out the oak leaf from Vicksburg along with other war relics and tell about the battle, the hanging of the copperhead, or the escaped slave Tom Allen, who had joined up with Company E, survived the war, and lived out the rest of his life right there in Kilbourn City. Allen's grave was in the Kilbourn cemetery.

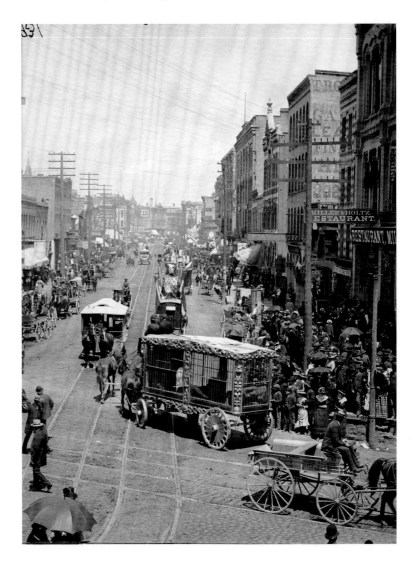

Wisconsin was the birthplace of several circuses, and two had homes in Baraboo near Kilbourn City: Gollmar Brothers' Great United Shows and Ringling Brothers, whose Milwaukee parade drew enormous crowds. This is the corner of West Water Street and Grand Avenue (now Wisconsin Avenue), where the parade shared the street with horse-drawn streetcars. (WHi-7492)

In March 1885 Henry's views were exhibited at the New Orleans Exposition and in September at the Milwaukee Exposition. By 1887 the business began to generate impressive figures. The studio was producing about thirty thousand stereo prints each month and offered for sale some six hundred subjects in five different sizes. One of these sizes was the "Budoir." At five by eight inches, Budoirs were quite large and, Henry noted, particularly popular with customers. Later he added the even larger "Imperial," which measured approximately seven by ten inches. But even with more than six hundred views to choose among, customers demanded more variety. Henry advised his travel agent in October that he did not have time to work up any more comic subjects, and no, he could not obtain negatives of New York City or Washington, D.C., at present.

Milwaukee portrait photographer Simon Leonard Stein contracted with Bennett to provide a series of photographs for his Milwaukee album in 1887. Stein provided the list of images, which included the Milwaukee County Courthouse. (WHi-68184)

Milwaukee, one of the fastest-growing cities in the Midwest, was well represented in Henry's work. While he was in Milwaukee in 1885 he tried an exciting experiment. He was in his hotel room with his camera and a set of dry plates when a furious thunderstorm broke over the city. Henry set his camera in a window and opened the shutter as lightning flashed. He closed the shutter, developed the plate, and found he had captured the streak of lightning on his negative. In the nineteenth century a photograph of lightning was extremely rare.

In 1887 and 1888 Henry returned to Milwaukee to work on views for a photogravure book to be published under the auspices of his colleague Simon L. Stein, the Milwaukee portrait photographer who appreciated Henry's exquisite workmanship.[8] In Henry's journal for May 1888 he listed major public buildings in Milwaukee that he had photographed for Stein; they included the museum, chamber of commerce, opera house, old city hall, post office, armory, new insurance building, and jail. Penciled comments in Henry's notebook revealed a common problem:

Milwaukee's tanneries were also on Stein's list of images. Henry Bennett kept meticulous records of the date and weather and made careful notes for each of his exposures. (WHi-68185)

Three stereos of Chamber of Commerce
no good. Hat blew off the lens.
4 × 5 stereo same subject
3 six seconds light
cloudy 5 o'clock
flat thin and underexposed.

Two decades after the Civil War, Milwaukee had become a commercial capital with an increasingly diverse ethnic mix. In 1881 an article in *Harper's Monthly* gave Milwaukee some national publicity, but its description of the Milwaukee River, which divided the city, was unpleasant to be sure: "It is a narrow, tortuous stream, hemmed in by the unsightly rear ends

"New Passenger Station, Fourth Ward Park," photographed by Bennett for what he called "the book job." But when Stein's distinctive Milwaukee album—with a leather cover embossed in gold—was published in 1889, each of the thirty-five photogravure images inside was identified as "Photographed and Published by S. L. Stein, Milwaukee." (WHi-69577)

While he was in Milwaukee, Bennett photographed additional images such as men unloading coal from boats on the Milwaukee River. (WHi-7495)

of street buildings and all sorts of waste places; it is a currentless and yellowish murky stream, with water like oil, and an odor combined of the effluvia of a hundred sewers. Nothing could better illustrate the contaminations of city life than the terrible change its waters undergo in a mile from their sparkling and rural cleanliness, up above, into this vile and noxious compound here among the wharves."[9]

Henry dutifully recorded the river and the busy thoroughfares of the Milwaukee business district, especially on Grand Avenue. The noise and other distractions of the city disturbed him, but he was intrigued by the variety of nationalities, and he represented the city's German influence with photographs of open-air markets and breweries. Perhaps Henry's finest Milwaukee views are those of the city's Lake Michigan waterfront. His photographs of the harbor and its commercial sailing ships are superb; here he manipulated light and shadow with the same originality he employed along the Dells.

S. L. Stein wished to have industries included in his Milwaukee album. Reliance Iron Works on Walker's Point turned out equipment for flour milling, small steam engines, and heating plants. Owned by Edward P. Allis, the company then employed fifteen hundred men. (WHi-2102)

"Joseph Schlitz Brewing Company." "The beer that made Milwaukee famous" was only one of many breweries in the city. (WHi-7023)

William Metcalf must have been extremely proud of Henry's photographic innovations and development as an artist with a camera, but he continued to urge his friend to work on developing a device for an instantaneous shutter.

The earliest exposure of photographic plates to light—removing the cap or cover of the lens and then replacing it when the photographer wished to complete the exposure—was an inexact procedure, and the action frequently jarred the camera. For stereo work with two lenses, a pair of covers were fastened together with a hinged arrangement so that both could be raised together. Now with gelatin plates and faster chemical coatings, quick exposures were essential for outdoor work, since mere fractions of seconds were required where the light was often quite strong.

"Down River from Grand Avenue Bridge." This graceful schooner was obviously built to sail the Great Lakes. Note the men near the schooner's bow, perhaps to help indicate scale. (WHi-2082)

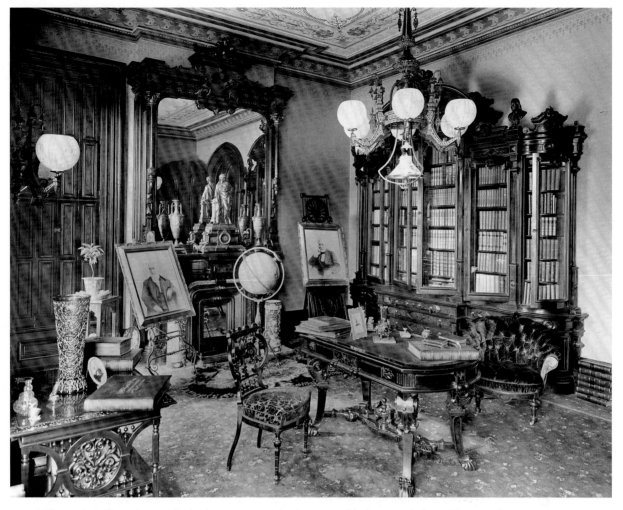

William Metcalf may have pulled some strings so that Henry could photograph the residences of prominent Milwaukeeans. This is the library of Metcalf's business partner, Charles Bradley. (WHi-69024)

Henry had been interested in faster exposures ever since 1879, when Metcalf had first described a "snapper." He had halfheartedly experimented with some designs since then but never found one that worked to his satisfaction. Metcalf was insistent on this topic. In his 1879 letter Metcalf had written, "While in New York I saw at Scoville's an exposing shutter exactly on the same principle as the one you made me—only it is placed inside the camera and just behind the lens and operates by a brass pin attached to the shutter sticking up through the top of the camera." He attached a small sketch and continued, "Of course, it is not to be spoken of in respect to quickness with the one you made for me; but it is out of the way, inside of the camera and can be used with any pair of lenses or with only a single lens. The camera would have to be just so much larger. If the rubber band be attached or not I can't say. It was in a Philadelphia box." Metcalf referred Henry to an issue of the *British Journal of Photography* for an article about instantaneous shutters the following year.

This stereo of a home on Milwaukee's Prospect Avenue is reminiscent of some of Bennett's stereo images at the Dells. By framing the home with a porte cochere across the street, the stereo acquired a three-dimensional effect. (WHi-68720)

In 1886 Henry finally came up with a workable design for a stop-action shutter. It was a complex contraption fastened in front of the lenses of a stereo camera. Across the lens openings a slide of thin, hard rubber with two holes was moved from side to side by an arrangement of springs and levers to which one or more rubber bands could be fastened to speed the action of the shutter. Except for Metcalf's letters, nothing in the studio records indicates where Henry got the idea for this design. Like most of Henry's inventions, it was something he needed, so he built it. In later years Henry would purchase commercially made shutters, but in 1898 he would write that he had discarded many of them and that the commercial shutter he was currently using was "intricate, delicate and faulty." He added that he was purchasing a Thornton Pickard for use "behind the lens."

With his very first successful homemade "rubber band" instantaneous shutter, exciting new photographic vistas opened for Henry. One well-known view shows his son, young Ashley Bennett, suspended in midair, leaping across the chasm at Stand Rock, a distance of only five

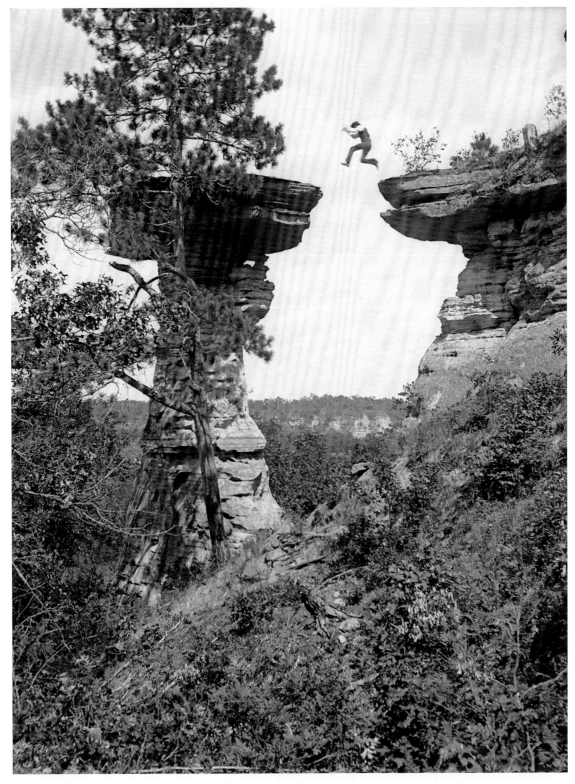

"Leaping the Chasm," the famous scene of son Ashley jumping to Stand Rock in 1886, caught with Bennett's rubber band "snapper," or "instantaneous shutter." Skeptics called the picture a fake. (WHi-2101)

feet and ten inches but seemingly much farther when viewed from below. Henry must have known the stereo would be extraordinarily remarkable: that afternoon in 1886 he asked Ashley to jump many times so that several negatives would be available for multiple printing. The photo, "Leaping the Chasm at Stand Rock, Instantaneous," became one of Henry's most famous, despite initial skepticism. Unfortunately, earlier in his career Henry had doctored some of his photographs by scratching in moons to simulate "moonlight effects" or—encouraged by his agent—posing miniature Indian figures inside rock "caves" for picturesque stereo views. Naturally, the first photographs he made with his instantaneous shutter were dismissed as merely more of Henry's fakes.

For many years Henry had been thinking of doing a series of lumber rafts and their crews on the Wisconsin River. Henry's 1883 catalog listed two stereo views of rafts going over the Kilbourn dam. These were probably taken with previous shutter designs and from a distance too great to depict any interesting detail. Henry was dissatisfied with the photographs but was unable to improve on them until 1886.

"Handspiking Off a Bar. A Heavy Lift." The raftsman's life had always enticed Henry Bennett, and by 1886 the days of the lumber rafts were numbered. He and son Ashley got permission to join the Arpin fleet from a point north of Kilbourn to Boscobel, a distance of over a hundred miles. (WHi-4269)

Wisconsin's pine forests contained an estimated 130 billion board feet of high-grade pine and millions more of hemlock, spruce, cedar, and other hardwoods. Logging began with the earliest French traders or even earlier with the Indians. The first sawmills of record were built in 1809. Because the growing state and nation needed lumber, within one lifetime much of Wisconsin's north woods had been reduced to stumps. The state's rivers were utilized for transportation, and the Wisconsin River—which stretches the length of the state and empties into the Mississippi—carried the most lumber of all.

The shipping of lumber each spring when the river rose was of enormous interest. In 1857, during Henry's first spring in Wisconsin, the river rose five feet, and rafts were running. The exciting scene became emblazoned in his memory. When the water rose higher, perhaps twenty feet above the normal level, very few raftsmen dared venture through the Dells, but that year it was estimated that one hundred million feet of lumber would pass by.

It was customary for the raftsman to build his own raft, for which he was paid by the day. Typical Wisconsin lumber rafts were not made of logs but of sawed pine lumber pegged together in "cribs" sixteen feet square. The average crib contained about five thousand feet of lumber. The cribs were fastened, one behind the other, in strings up to seven cribs long called "rapids pieces." The first crib was connected to the one behind it by two long saplings called "spring poles" in such a way as to lift the leading edge of the first crib a little bit. At the end of the string a long heavy steering sweep was placed.

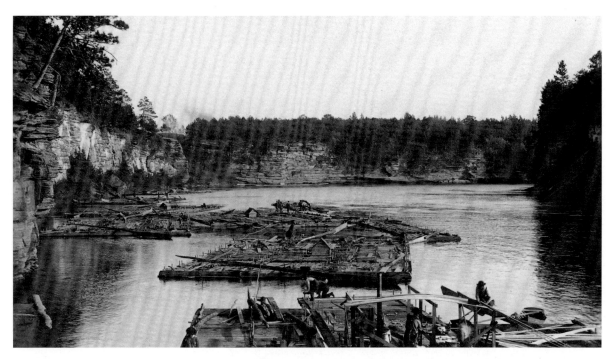

Rafts, or "cribs," were sixteen feet square and fastened one behind the other in strings of up to seven, called "rapids pieces." (WHi-69570)

When a fleet of rafts was completely equipped, the crew was organized and the long journey begun. The decks of the rafts carried cargo of laths and shingles, together with sleeping quarters for the crew and a shelter for the cook and his stove. A rope, called a "sucker line," could be rigged down the center of the raft so the crew could hold on and not be swept overboard in rough water, which happened often enough.

If a fleet started north of Wausau, it could figure on reaching St. Louis in twenty-four days, but the trip often took longer if the rafts encountered problems. No trouble was likely to occur until they reached the head of the rapids. Where the river was wide and had no difficult spots to navigate, rafts might drift downstream fastened three strings wide, held together by wooden strips called bridles. At the head of the Dells, however, near the entrance to Witches Gulch, the river narrowed, and navigation became challenging. Here the rafts would usually be separated into individual rapids pieces, and each would run the Dells with a full crew aboard.

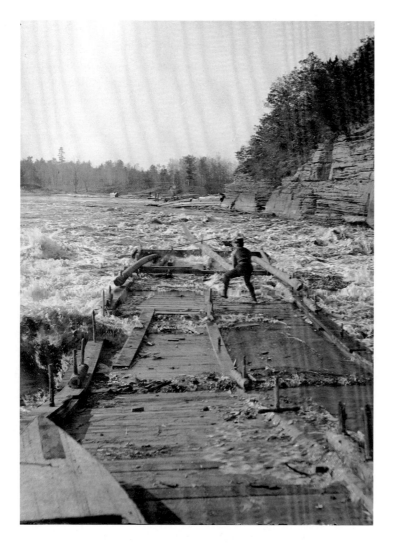

"Running the Kilbourn Dam, on Board the Raft." Bennett's "instantaneous shutter" helped to capture the action in this daring photo. (WHi-4270)

The toughest spots in the Dells were the sharp right-angled turn at the Devil's Elbow in the Narrows and the dam at Kilbourn City, especially when the Wisconsin River was at flood stage. At such times, when the river pouring through the Narrows was wildly turbulent, fleets of rafts would stay tied up at the head of the Dells until the water level subsided to a safe point. Sometimes the dam at Kilbourn would be equally impassable, and there would be so many rafts tied up between the Jaws and Kilbourn that a person could walk across the river all the way from town to High Rock by stepping from raft to raft. Below the dam rapids pieces were again joined together for the rest of the trip.

Raft crews consisted of about twenty men. The visits of rafting crews to Kilbourn City were often raucous. One section of Superior Street was known as Bloody Run and was the scene of many revels. It was rumored that during boisterous activities the town marshal often found himself tied up and deposited in a safe place "so he wouldn't get hurt."

After the dangers of the Dells passage were behind them, the pleasures of the inn called the Dell House were a welcome diversion. The Dell House, erected in the 1840s by Robert V. Allen, grew into an imposing three-story structure with a large fireplace at one end of the main room and sleeping chambers upstairs where balconies overlooked the river. For a quarter-century, rivermen snubbed their rafts at Dells' Eddy to enjoy Allen's "concentrated river water" (also

The Dell House had seen better days by this time. It had been erected by the first white settler in the area, and raftsmen paused there to relax and find reason for celebration. Its history was rowdy, rioutous, and bawdy. (WHi-40729)

known as "devil's eyewater," a vile concoction made with cheap whiskey), food, gambling, and a place to rest. Although the hostelry gained a reputation as a hell-raising "house of ill-repute," over a hundred men were known to sleep there at one time, even on the floors and benches.[10]

By 1886 the profitability of shipping lumber by means of rafts was in decline due to dams on the river and the prevalence of railroads. An editorial writer suggested the railroads should transport lumber and leave the navigable streams to generate power for factories. Henry, who had long wanted to capture a series of stereo views of lumber rafts and their crews, now found that he must document them before they died out altogether.

Ever since he had come to Kilbourn City as a boy, Henry had wanted to join the rugged raftsmen for a trip downriver. Now in 1886, at the age of forty-three, with his instantaneous shutter and reliable Cramer dry plates, Henry was at last able to board the Arpin family fleet when it arrived at Kilbourn City. Henry's son, Ashley, then seventeen, signed on as his assistant. Henry and Ashley journeyed downstream with the rafting crew for well over one hundred miles, from somewhere near Louie's Bluff (north of Kilbourn City) to Boscobel, at which point Henry ran out of plates.

Henry reported back to the Arpins after the eight-day trip, "We had a glorious time and made lots of pictures, how good they will be I cannot say as I have not yet developed the plates. Most all I done was illustrative of rafting or raftsman's life, leaving the scenery along the river for another trip, which I hope to make another season."

About thirty good views resulted from the expedition, and Henry promised to send some to the Arpin brothers, Antoine and John, "in return for favors to myself and my son." In the two pictures of the fleet's cook Ashley is serving as the "cookee" (cook's helper). But the most startling photograph, and one that caused quite a stir at the time, is entitled "We Are Broke Up. Take Our Line!" It shows a rope, thrown by a raftsman, paused in midair. Again, skeptical photographers implied the rope had been frozen or somehow hung up—another one of Henry's fakes. But it was definitely Henry's new instantaneous shutter at work. He got another unusual action shot from the rear of a raft just as it plunged over the dam at Kilbourn with the steersman hanging on to his oar and water boiling up among the planks of the raft.

The raftsmen series was promptly added to the list of available stereos.

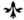

A few months later Henry took the train north to Minnesota, where the St. Paul Ice Carnival was being celebrated for the very first time in response to a New York reporter's remark the year before that St. Paul was "another Siberia, unfit for human habitation" in winter. The Ice Carnival featured an enormous, elaborate castle built of ice from Minnesota lakes, and there were other exciting activities such as bobsledding and ice horse racing to prove that in winter St. Paul was very much alive and festive, and so were its inhabitants.

Henry printed the stereos he took there on specially designed commemorative mounts and adapted the technique he had used to photograph lightning in Milwaukee to capture the Ice Carnival's fireworks. To get these extraordinary images he first focused the plate on the Ice Palace while it was illuminated by electric floodlights. After an exposure of eight minutes he closed the

shutter, leaving the camera in the same position until the fireworks display lit up the night sky behind the palace; then he made a very slow exposure, giving ample time for the fireworks to reach their peak. He was the first person on record to photograph fireworks, and the stereos made from these negatives caused quite a sensation.

Henry cheerfully returned to the St. Paul Ice Carnival twice more, in 1887 and 1888, working day and night to reproduce the glitter of frost, ice, and snow. He wrote to his friend and fellow photographer Charles Zimmerman, recalling the good times: "How much St. Paul beer did I have to drink to keep on the good side of the Ice Saloon Man, and even then my fingers would get cold. Also, my daring feat of balancing while trying to get views from a tower on a dray sled, and all the other jolly features."

"We Are Broke Up—Take Our Line." This was the most controversial of Bennett's series *The Camera's Story of Raftman's Life on the Wisconsin*. His instantaneous shutter captured the rope in the air, but critics insisted the picture, like Ashley's leap at Stand Rock, must be another of Bennett's fakes. (WHi-7632)

"Storming of Ice Palace by Fire King," the climax of the Ice Carnival in St. Paul. Bennett was the first person on record to photograph fireworks. (WHi-7744)

Henry spent a short time in Chicago taking photographs during in the spring of 1887. In October he went to Milwaukee to photograph President Grover Cleveland and his party. Henry's photograph of the presidential parade was unspectacular, but the Kilbourn City paper expressed the belief that "if Gabriel should come out to blow the final trumpet Bennett would be on hand to make a picture of him!"

A few days later a crowd gathered at the Kilbourn City depot to see the presidential train pass through town. The newspaper described the historic scene:

> There was a little cheering, and, because Kilbourn is not given to such demonstrations on any occasion, there was not much enthusiasm. The President and lady were standing on the rear platform both graciously bowing and smiling to the crowd as they passed. This was an unexpected favor to the crowd as all supposed the train would shoot by like an arrow and only a possible view through a window would be obtained. . . . Little Anna Dixon threw a bouquet at the feet of the First Lady . . . eliciting a pleased smile from Mrs. Cleveland. H. H. Bennett threw a bundle of his excellent views of the Dells, thereby bringing our resort to the notice of a distinguished party who might never have heard of it in any other way. The train slowed up on the bridge and the party had a splendid view of the river and dam.

During this decade Henry's work had become ever more refined. But the public was eager to capture scenes on film, too, and in 1888 George Eastman introduced his Kodak box camera, filled with a one-hundred-frame roll of film. The entire Kodak outfit cost twenty-five dollars. "You Press the Button, We Do the Rest" was Eastman's slogan. After you exposed all one hundred frames, you sent the camera back to the Eastman plant, where the pictures were developed, printed, and mounted. A new roll of film was inserted in the box, which was then mailed back to you—all for ten dollars more.

It was the beginning of a new era in photography. The once-mysterious art was now within the reach of everyone.

"Ink Stand and Sugar Bowl." In October 1888 Bennett wrote of this outing in his journal, "It was an enjoyable day to me, Nell and Hattie were so happy. . . . John and Nell went trolling without success, however, which was aggravating as when we got home we learned that lots of fish had been caught upriver." (WHi-7758)

7

Personal Views

1888–1890

Why, I have been whistling today and although it has been cloudy and hazy, the old inspiration has returned that brings out artistic beauties in bits of woodland and streams that could not be seen before, or, if seen, not appreciated.

—Henry Bennett to Evaline Marshall, October 30, 1889

AFTER A DAY OF "VIEWING" IN EARLY OCTOBER 1888, Bennett wrote the following in his journal. His daughters, Hattie and Nellie, were now twenty-one and sixteen, respectively. A typical notebook entry for him includes technical data as well as personal details:

Yesterday I got brother John to go down to the Lower Dells with me taking Hattie and Nellie along for a days outing. The trip resulted in photographic failures in the cave down the Old Channel from Sugar Bowl because of too great contrast in light. . . . Two 18 × 22 and two 8 × 10 negatives of Ink Stand and Sugar Bowl were good, the former were made with the back lens only of an 8 × 10 Darlot Rapid Hemispherical lens smallest dia. exposed 5 and 8 seconds, the shortest was enough but I developed an equally good negative on the one exposed 8 seconds by using Bromide. The 8 × 10 were done with a Morrison wide angle on Cramer 30 plates.

It was an enjoyable day to me, Nell and Hattie were so happy. After spreading and eating lunch just below Ink Stand they posed with Uncle John in the pictures mentioned, then we went over to the cave spoken of before and Hattie stayed with me while John and Nell went trolling without success, however, which was aggravating as when we got home we learned that lots of fish had been caught up the river.

The photographs made that idyllic autumn afternoon depict the Ink Stand, framed by the gracefully drooping branches of a tree in the foreground. Nellie is seated beneath the tree. John's boat is moored to the bank, with John at the oars and Hattie holding a fishing pole. The Sugar Bowl is in the distance. A serene light illuminates the landscape, and the wind and water are calm.

Other journal entries for 1888 denote the variety of work Henry was engaged in at that time. They also convey his exacting standards for his photography, his devotion to his children, and his burning desire to do more fishing.

On September 9 he attended a reunion of Civil War regiments in Milwaukee and made photographs for all who were present, but he was not completely satisfied with the results because "a few of the boys did not keep quite still," so the negatives indicated some blurred movement.

He traveled to La Crosse later in September to photograph the spacious three-story home of prominent La Crosse businessman F. Lucian Easton and his wife, Mary. The couple had just completed the Queen Anne–style mansion in 1886 and commissioned Henry to record their luxurious new residence. On October 7 he noted: "Last Friday finished up the printing and mailing of the pictures that were ordered from the reunions, rifle range and Mr. Easton's home and grounds. Most of the Negs. are reasonably good though none perfect in my estimation. Probably I shall never get a picture that I shall regard as all right in all respects. However, I shall always try for the best results attainable."

During October 1888 Bennett was juggling lantern slides and widemouthed bass:

> Not very successful so far from not getting the proper exposure but I like the color or tone which is on the chocolate order and am confident of making some excellent ones after a little more practice. Some that I have done are good, but there are more failures, or partially so, than I like.
>
> Yesterday I went out trolling with Nell and her young friend, Lilly. Ten fine bass were the result of the afternoon's fishing. They had good sport and so, of course, I did. I have rather got the fishing fever which I am afraid can only be cured by indulgence in more of that sport.

Henry was in southeastern Wisconsin in early November 1888, taking views for the Chicago, Milwaukee and St. Paul Railway. In Oconomowoc he stayed with Henry H. Shufeldt, a wealthy distiller from Chicago who maintained a summer home in the resort community.

Kilbourn was not a classic Victorian resort like Oconomowoc, Lake Geneva, or Waukesha where elegant ladies rocked on hotel verandas in refined idleness, with one eye on the children and another on the constant fashion parade. Wives might stay for a month, with their husbands (most likely from Chicago) joining them by train on weekends. A travel guide issued by the railway in 1883 called Oconomowoc "a fashionable, genuine gem" whose streets and lakeshores were lined with "beautiful cottages" and "delightful villas owned by prominent Chicago gentlemen." The guidebook singled out Shufeldt's residence, Anchorage, on the shore of Lac La Belle as particularly elegant, with a four-story tower, acres of manicured gardens, a spring, and a statue of a majestic bull elk.

Shufeldt also happened to have a stuffed deer, which he and his son dragged out into the woods and marsh along the lakeshore so Henry could stage some fake hunting scenes:

> At 12 M I make three stereos dia. 2 in. Cramer 40 plates with Dallmeyer RR 5½ dia. looking through the bushes out onto the lake, all of which have developed into good negatives. After the above we move the deer onto an oak ridge running out onto the marsh where I made at about one p.m. four 8 × 10

At Oconomowoc

From *Wanderings by a Wanderer*, an album Bennett published in 1890 after a quarter-century as a landscape photographer. In all he selected a total of twenty images, including a few composites like these scenes from Oconomowoc. (WHi-69561)

Cramer plates Darlot lens dia. 12 inst. and two stereos Cramer 40 plates Dallmeyer 5½ dia. 2 inst. At this point the light was well to one side so I got quite strong contrast but the negatives will do pretty well. In all the above Mr. Shufeldt Jr. fires at the deer at the time of exposing the plate and the smoke shows very nicely.

Waukesha County was famous for its numerous mineral springs, believed to be beneficial for the restoration of health. "Taking the waters" was a popular pastime in the nineteenth century, and visitors hoped to soothe body and soul at the springs. Whether or not the spas were actually responsible for any healing, most visitors came away fulfilled. The water in Waukesha was proclaimed providential for its mineral content—the principal ingredient was bicarbonate of magnesium, which was antacid and mildly laxative after continuous use. Ornate pavilions

enclosed each bubbling spring, and fashionable guests such as Mrs. Lincoln, Horace Greeley, and President Grant came there to relax and be amused. Eleven hotels and more than forty boardinghouses served the "Western Saratoga" when Henry Bennett photographed in Waukesha. The Fountain Spring House was the largest and could serve eight hundred guests.

Henry's notes for November 3, 1888, indicate his arrival by train from Oconomowoc at 9:15 a.m.

> After a short delay I get a team and boy to show me around. I first expose two 8 × 10 Cramer 40 plates on the Fountain House from the SE using Darlot lenses dia. 12 inst expose which is not satisfactory though perhaps I can use one of them. From there I go to Bethesda Spring where I expose two stereo plates, Cramer 40 dia. 5½ dia. 5½ secs. These come up fogged slightly . . . wind bothered me very much at this place, having to wait quite a time. From there I drove to the Spring City House and

Colonel Richard Dunbar drank twelve glasses of water from a spring at Bethesda in 1868 and declared himself cured of diabetes. Afterward this area west of Milwaukee beckoned visitors who wished to be restored to health by drinking Waukesha's springwaters. (WHi-68726)

exposed two 8 × 10 Cramer 40 plates using Morrison lenses dia. 50 inches . . . Salurian Spring . . . Arcadian Spring . . . As a whole the Waukesha work is not all satisfactory for me and I shall hope for some good weather and shall try for something better before winter.

He returned later that month, as he explained in his journal dated November 15:

Negatives made at Waukesha on the 3rd of this month not being satisfactory to me and last Sunday promising fine weather I got ready . . . and started for the above place on Monday morning at 3 o'clock and arrive about 7:30 a.m. Got breakfast at the Spring City House and then got a one horse rig from the stable I patronized there before. The boy to show me where to go I get along with. . . . First we went to Bethesda Spring about 9:30 a.m. Expose one 8 × 10 Cramer 40 plate with Morrison lens smallest dia. ½ sec which I find was not quite enough to bring out detail in big tree in the foreground as I would like to have. Still will make good vigorous prints. I am getting to rather like Waukesha and feel that in the proper season quite a number of pretty and interesting views can be found here.

Bethesda Springs, where the waters provided a mildly laxative effect. The tranquil Waukesha locale was referred to as the "Western Saratoga" when Bennett photographed there in 1888. (WHi-68718)

At 5:15 p.m. leave there for Oconomowoc which I reach about 6:30. Have a fine supper at the Jones House and spend the evening at the City Hall seeing and hearing "Burr Oaks," interesting but not very well handled, or so it seems to me. This visit to Oconomowoc is for the sole purpose of getting a better negative of the Jones House which I do, both 8 × 10 and 5 × 8 at about 12 M of the 13th.

Tired a little and am glad this job is done.

The Chicago, Milwaukee and St. Paul Railway was still striving to promote the Dells as well as other places along the line, and the Kilbourn paper said in December 1888, "The rail-way intends to do its share of booming the Dells next season. H. H. Bennett is getting out a large lot of views of the Dells. The views are mammoth pictures of the Dells with smaller pictures set in the large view. Now if Kilbourn will invest some of the money that was voted to beautify the town . . . we will see a speedy return on our investment."

That same month Henry went to Chicago to photograph the reunion of ex-prisoners of the Civil War. The reunion was held at the former Libby Prison, which had been converted into a Civil War museum. An entry in his journal toward the end of 1888 said:

Since the last writing in this I have been very busy in printing on the railroad order, doing some portrait work incident to the holiday, made and making transparencies mostly 8 × 10 though today have finished three 11 × 14 transparencies on Cramer 40 plates using the 8 × 10 Darlot rapid hemispherical lens—so far no indication of the ghost that troubled me with the Voigtlander. . . . I'm feeling well and enjoy this lively work but have a realization of the fact that it is a tax on one's self that cannot be other than harmful. Hay must be made, though, before the season is over for doing so.

During the day learned there is . . . a request from Mr. Stein to do some work for him in Milwaukee . . . and a letter asking me to assist in making some 18 × 22 and 8 × 10 on iso plates of some of the paintings at the Layton Gallery, [which] makes the outlook favorable for a busy time for me for awhile at least.

But matters other than travel and studio income were occupying Henry's mind.

Not too far from Henry's studio in Kilbourn and only a block from the railroad station, George Marshall owned and operated a machine shop. Marshall was the machinist and inventor who in 1875 had cast the gears for Henry's revolving printing house, built the track and wheel, and engineered its installation. George McIntyre Marshall and his wife, Julia Hoyt Marshall, had a son named Frank and two daughters, Evaline and Ruth. Evaline, born in Hinesburg, Vermont, was close in age to Hattie, Henry's oldest daughter. The Marshalls had moved from Vermont to Big Spring in Adams County in 1865 and from there to Kilbourn in 1879.

Evaline had spent 1888 in Chicago, learning hairdressing and wig making, but she returned to Kilbourn in the winter of 1889 and before long came to the attention of the local photographer. Despite the considerable difference in their ages, Henry began to court her. Frank Marshall, who worked in the machine shop for his father, kept an unusually close account of his sister's love life in his own daily journal. On February 15, for instance, Frank and Evaline visited the Rourks, where they met Nellie and Hattie. They all stayed there and played Authors until nine o'clock.

Evaline Helen Marshall Bennett with her parents, Julia and George Marshall, and siblings, Frank and Ruth. Evaline is holding her daughter, Miriam Bennett. (WHi-68717)

When they started for home, Frank and Evaline and the girls met Mr. Bennett, who took them back to the gallery, made some flash pictures of them, and entertained them with stereo views. They were there until midnight and had to walk home in the rain.

That winter Frank seemed obsessed about recording Evaline's encounters with Henry. On February 17 Henry and Evaline went sleighing together. The next evening Henry came to visit the Marshalls at home.

Clearly, now that Evaline was on his mind, Henry did not favor being away from Kilbourn so often. He made the following entries in his own diary while in Milwaukee in March 1889:

March 11

I leave home at 3:13 this a.m. in response to a message from Mr. Paul who called to meet him at the Pabst Hotel early today for the making of some Negs for the Cramer Dry Plate Company at the Layton Gallery on both ordinary and isochromatic plates for the purpose of demonstrating the iso plates and rendering color values. This call he made on me after getting a letter from me in which I wrote him that I would do the work for $10 per day and all expenses while away from home. Thus accepting my terms, I find him as per his message and as he desires, register and am quartered at the Pabst Hotel. . . .

Neuralgia head and earache has pestered me some all day but this evening being the close of an engagement of Fanny Davenport in Cleopatra . . . I brace up and go and am very glad I did for I think it the best thing of the kind I have ever seen, both in scenic effects and acting, the storm in the last act being awfully grand and realistic. I wish someone had been with me. In the early evening I write to Eva and in the same ask Ashley to send the other two 18 × 22 holders.

He returned to Kilbourn after only a day or so in order to be present for the Paper Fair, held at the Grand Army of the Republic Hall on March 14. It was the first project of the Cemetery Improvement Association. Visitors to the cemetery were faced with a long walk from town, and flowers planted there dried out quickly in the sandy soil, so funds raised at the fair would be used for a well and a windmill or for a sidewalk to the cemetery from the town. Women made sale articles out of colored tissue papers. Nellie and Hattie Bennett participated, dressed—as

Evaline Marshall moved to Kilbourn City at the age of sixteen. Henry hired her father to build the mechanical assembly of his revolving printing house. (WHi-68667)

were other women—in flower costumes made of paper. Evaline and a friend made a quantity of sunflowers of various sizes. She wore a matching dress made of yellow and black tissue paper and was amazed that it held together as well as it did. The Paper Fair brought in enough money to build well, windmill, *and* sidewalk.

Henry attended the fair, admired Evaline in her sunflower dress, and was attracted by her big brown eyes. He walked her home. The next day Evaline and her brother, Frank, went up to the gallery to see Henry's new photographs of cycloramas.[1] The most famous cycloramas traveled from city to city, and Henry had encountered and photographed a number of them.

Shortly after the Paper Fair Henry had to return to Milwaukee to photograph the Layton Gallery. His journal entry for March 17 shows that his heart remained in Kilbourn:

> Late hours last night and up at six a.m. brings conviction that this bed will be acceptable as soon as I repair damages to my suspenders that broke down today. . . . This is a good hotel and my work has been pleasant, but the prospect of being at home tomorrow is even more pleasant. A letter from Eva today brought a breath of home life at the Dells, the dearest spot on this earth. Straws serve to show the direction of the wind, and a needle, ready threaded in my satchel, is a valued proof of someone's care and thoughtfulness and love, too, that I prize very much.

Cyclorama featuring the Battle of Gettysburg, photographed in Chicago. (WHi-25718)

While in Milwaukee Henry took the opportunity to photograph more cycloramas of Civil War battles and the cyclorama painters, too. He had previously photographed the fight between the *Merrimac* and the *Monitor* when he was in St. Paul, had made stereo views of the Missionary Ridge battle while visiting Kansas City, and had photographed the Shiloh and Gettysburg cycloramas in Chicago. The Gettysburg painting was the first of four cyclorama versions of the legendary battle. Created by French artist Paul Philippoteaux, it was roughly eight feet high and nearly one hundred yards long, and it weighed six tons. When displayed, the painting was supplemented by stone walls, trees, and artifacts, including cannons. The impact was so realistic that Civil War veterans reportedly wept upon viewing it. The stereo series Bennett made from all these cycloramas was quite successful.

Back in Kilbourn Henry's courtship of Evaline was meeting with less success, as her brother's compulsive diary records:

Friday, March 22

Mother has palpitation a great deal. Came near having a fit. Evaline and Nell Berg off with Bennett, upriver taking pictures. Went to gallery in eve.

Monday, March 25

Up to gallery eve and talked with Bennett until about eleven. He has fallen in love with Evaline and the whole family, I guess. Evaline and I over to train at 11:30 eve and met sister Ruth, home for a week or so.

Tuesday, March 26

Evaline, Ruth and I to the LCIA [Ladies' Cemetery Improvement Association] Sociable and Supper at Hall. Bennett home with Evaline. Looked like rain.

Thursday, April 4

Bennett wants Jones and I and our girls to take trip with him to Camp Douglas. Evaline and I up to Ice Cream Supper for Reverend Brown.

Saturday, April 6

Went to Bellringer Concert evening at GAR [Grand Army of the Republic] Hall. Took Edith Rourk. Bennett took Evaline. It was a humbug. They had a lady whistler that was pretty good.

Tuesday, April 23

Bennett here eve and sat up with Evaline until about midnight. Guess he is desperate now and said what he wanted to. Rained hard, and windy eve.

Monday, April 29

Bennett up from Milwaukee eve to get Evaline's answer about marrying him. Guess she won't. Still talking.

Tuesday, April 30

Centennial of George Washington's inauguration. A general holiday today throughout the country. We dressed up and went to GAR Hall. I helped to sing. I did not like the addresses. Evaline fixed me up with a costume. Had a big crowd Mostly tableaux of events in G. Washington's time. Bennett off to Milwaukee p.m. He feels pretty bad about his rejection and I pity him.

Sunday, May 19

Took a walk up to cemetery to see the new walk. They have begun the well. Advised Evaline to let Bennett alone.

Thursday, May 23

Went to gallery eve, take Bennett's papers home. Could hardly get away. Stayed until most eleven. Wanted to talk with me about Evaline but I didn't give him a chance. He is badly mashed.

On Friday, May 24, Henry left for Milwaukee on the afternoon train but before boarding confessed to Frank that he was terribly in love with Evaline. Frank, of course, advised him that it was of no use. Henry returned a week later, "alive and hanging around Evaline," according to Frank, but "did not take her home."

In courting Evaline, Bennett drove her by horse and buggy to visit Giant's Tomb, a massive rock formation near the border of Adams and Juneau counties. (WHi-68668)

The courting continued; Henry was persistent. He gave Evaline a kitten; he took her riding. On Wednesday, June 19, Frank noted: "Jones and Bennett at me again to go to Camp Douglas with them. Said I would, so over and asked May Stroud to go with me. Did several jobs, went up for May and to train. Our party consisted of Jones and wife, Bennett, Evaline and Hattie, May and I. Train late. Off about 4:15. We drove over to Giant's Castle and all climbed to the top but Jones and wife. Over to Camp of 3rd Regiment Militia. Saw Dress Parade, rifle range, had supper at hotel. Home 11:45. Had some fun, also, with 'Pigs in Clover.'"[2]

On June 23 Henry took everyone for a late-afternoon outing in his new boat. A few days later he took Evaline to the Orchestra Festival, where they enjoyed lemonade and ice cream. On the Fourth of July Evaline joined the group as they went upriver to fire off rockets.

On July 6 Henry took the afternoon train to spend a month in Portage and Pine River, but when he returned Evaline joined him for an all-day trip to Devil's Lake in late August. Her brother, Frank, was concerned and made a note in his journal that she did not arrive home until ten in the evening.

September 3
 Evaline off on Fast Mail morning to St. Paul. Let her have $20.

Evaline's brother, Frank, was worried when Bennett took Evaline on an all-day journey to Devil's Lake and she did not return until ten o'clock at night. (WHi-68664)

"Dalles of the St. Louis River, at the Bridge." In the autumn of 1889 the Wisconsin Central Railroad offered Bennett a commission to photograph attractions along its line from Duluth, Minnesota, to Fox Lake, Illinois. (WHi-7369)

During the autumn of 1889 the Wisconsin Central Railroad, having admired the success of the Chicago, Milwaukee and St. Paul Railway's use of Bennett's photographs to promote rail travel, commissioned him to take a series of photographs along its line. The Wisconsin Central, just then uniting with the Minneapolis and Pacific and the Canadian Pacific to form the Minneapolis, St. Paul and Sault Ste. Marie Railway (nicknamed Soo Line), provided the photographer with a wood-burning locomotive, an engineer, a special car for darkroom and printing, and a writer—Charles Rollin Brainard—to prepare copy for the booklet the railroad planned to publish.

Evaline had gone to Duluth to work at a shop where she constructed women's hairpieces. Henry deftly manipulated his schedule in order to spend time in that region, taking yet more photographs of Minnehaha Falls and the Dells of the St. Louis River. He deliberately spent a day in Duluth before he began the Wisconsin Central Railroad trip and demanded from Evaline the answer he so craved—that she could love him as he loved her. Frightened by his intensity, Evaline said she thought she could. She agreed to give his question further thought and send him confirmation of her feelings by mail.

Henry left for Ashland by train, hoping to hear from her and to see the words "I love you" written in her own hand. Almost at once he began expressing his deepest feelings to Evaline in letters written aboard the train but before he had even received her response:

> Late Tuesday, October 29, and early the 30th 1889 (on train from Ashland) . . . The enclosed elaborate sketch represents the ground plan of our moveable home. I can hardly call the representations of the occupants perfect likenesses or artistic reproductions, but perhaps will serve the double purpose of giving you the idea of the arrangement of our car and keeping me occupied.
>
> Eva, I did not mean to write a word only in cheerfulness, but without the note I so much hoped for I am so lonely. I cannot sleep and it is nearly morning. Have done the developing of the plates exposed at Duluth, walked the car and tried to wait patiently. So many nights without sleep and yet I am weary and that boon will not come.
>
> How is all this to end? This night in such violent contrast with last, such tender, holy and happy memories of how you gave yourself to me and how good you were today, always, so you let me see more joy in your face. But the stark curtain of uncertainty depresses me to a degree I cannot describe. I will put it aside and try to be patient. I am certain the next mail will bring the coveted assurance and perhaps it will contain the word *do* instead of *think*.
>
> I know, Eva, I ought to be happy and not importune. I will try, but it has been so long for me, only moments at a time, that I feel sometimes that I should not realize it if it comes. I will try and wait. Goodnight, and may only joy and sunshine be over you.

He wrote to her again the very next day:

> October 30 at the end of the table where I was last evening only earlier.
>
> Eva, my more than friend,
>
> Courage has been with me today because of the conviction that all is well and you are happy. To be sure I have missed the letter I hoped for, but feel almost a certainty that when it does come it will

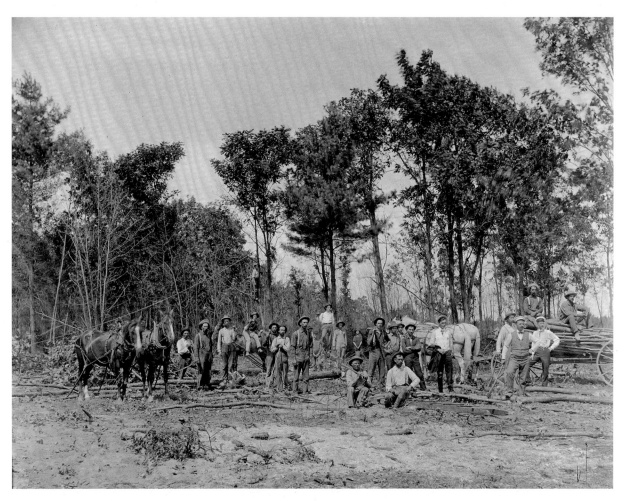

Loggers working near the St. Louis River, Duluth, Minnesota. (WHi-68662)

contain all I crave, and I hope it may be very soon. Why, I have been whistling today and although it has been cloudy and hazy, the old inspiration has returned that brings out artistic beauties in bits of woodland and streams that could not be seen before, or, if seen, not appreciated. Idealism has crept into the titles of the pictures I have made, and suggestions for other subjects that will have artistic merit, I think, all because hope is strong that to win is to win for another who will be proud of my success or sorry if I fail. With such an incentive there is no such word as fail.

My companion is busy with his typewriter which sits on the table where I am writing, so if there is any improvement in my penmanship it can be credited to that. He is no less odd with further acquaintance. He has just two profane expressions, "Wichy Worm" and "Chickery Me," which come with a frequency that it would seem almost a relief if he would let out a good round oath. But he is wonderfully good, too, and careful of me, so I hope to be able to get along with his peculiarities while we must be together.

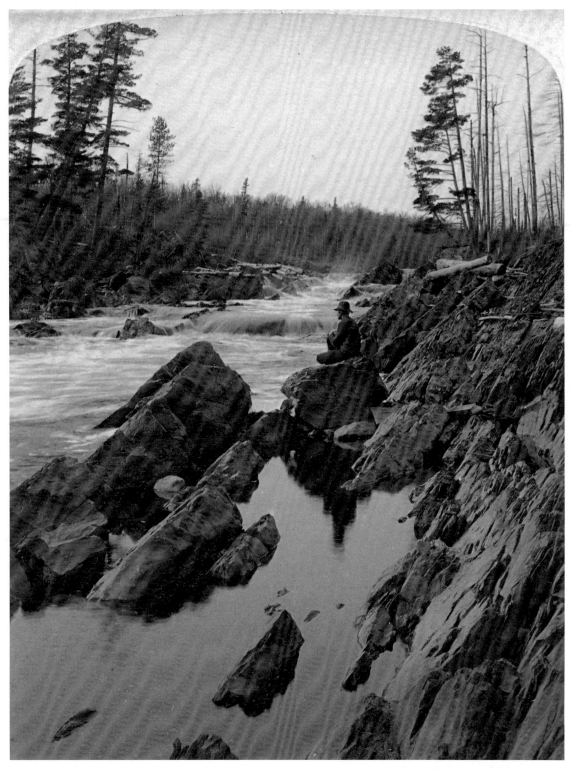

Charles Rollin Brainard, the writer who accompanied Bennett on his Wisconsin Central trip, typed with a flourish and a flurry of words. Bennett soon tired of Brainard's two favorite oaths, "Wichy Worm" and "Chickery Me." As Brainard sat for a frenzied view of the Dalles of the St. Louis River, he may have uttered both. (WHi-68657)

Meanwhile, Ashley Bennett, now twenty years old, was taking care of his father's studio. Henry Bennett's letters to his family gave no indication of his own emotional distress:

In our car leaving Ashland 1:30 p.m., November 4
Dear Son,
. . . The gallery roof will have to hold until I get home, meantime you might go down onto the gravel bar opposite Eggleston's and if there's plenty of gravel, set Mr. Marsdon to getting out and hauling up about 80 bushels which should be done by the job at 20¢ per bushel or less. Give the job to the one who will do it for the least, of course the sand must be sifted out. . . .
Bad weather and lately snow has prevented doing but little and now we are on the way south expecting to go as far as Waupaca tonight.
My companion is rather eccentric but I get along very nicely with him.
With a father's love for you all,
P.S. Understand 20¢ per bushel should get out and deliver the gravel at the gallery. It should be put in dry goods boxes or barrels.

"Wisconsin Central Ore Dock, Ashland, Wisconsin." Bennett had never been this far north in Wisconsin. Brainard described this view as "monster docks stretching out below the great, red bluff that overlooks the cold, gray waters of the bay." (from Wisconsin Central Railroad, *Pen and Camera*)

"Trout Bay, Bear Island, of the Apostle Group." The Apostle Islands, comprised of twenty-two islands, are located just off the tip of the Bayfield Peninsula in the waters of western Lake Superior. This is the northernmost location in Wisconsin and drew tourists even in Bennett's day. (from Wisconsin Central Railroad, *Pen and Camera*)

Henry finally received the longed-for response from Evaline, written on October 31:

> My poor dear friend,
>
> Your note came last night but not until after I had gone home, so I did not get it til this morning. I did not write Tuesday night for I gave you the message you wished when I met you on the street, and last night I was not in the letter writing mood. Am very busy as usual and am writing this at noon, hope it will reach you tonight. And so you are unhappy. Yet I had hoped my answer would make you happy. I cannot give you any different one yet, but be patient. You are in my mind constantly and they all here in the store think me very absentminded, I guess. I never did so little thinking in connection with my work.

A woman of that day was advised to be coy, to test the true strength of her suitor's affections. Eva, however, seemed to be playing unusually hard to get. Meanwhile, Henry had no choice but to continue with his labors. He duly noted the reception given him and his companion in Waupaca, although Henry may have resented the November 1, 1889, issue of the *Waupaca Republican*'s claim that he occupied a "good soft position":

"In the Wildwood of Northern Wisconsin." A view of the forest near Stevens Point, which Brainard called "the threshold of the great pine region." (from Wisconsin Central Railroad, *Pen and Camera*)

Chas. Rollin Brainard and a photographer named Bennett from Milwaukee have a good soft position picturing and writing of summer resorts and points of interest on the Wis. Central Line. The Central Company has fitted up [a] special car in the highest style for editorial sanctum, parlor and sleeping berths; also a photographer's developing room. Mr. Brainard is a ready writer and will undoubtedly do justice to the famous places of interest along the popular Central line for her guidebook to be issued in 1890. He should not forget Waupaca, her charming lakes and rivers, Veteran's Home, granite quarry, etc.

The *Daily Northwestern* in Oshkosh tracked their progress as they traversed the Fox River Valley:

Neenah, November 6, 1889.
 Messr's Charles Rollin Brainard and Bennett, the two men who are getting material for a tourist's book for the Wisconsin Central RR arrived in this city today having decided to postpone work until the melting of the snow which fell last night to a depth of about four inches between Ashland and Stevens Point. Messrs Brainard and Bennett expect to go to Oshkosh tonight.

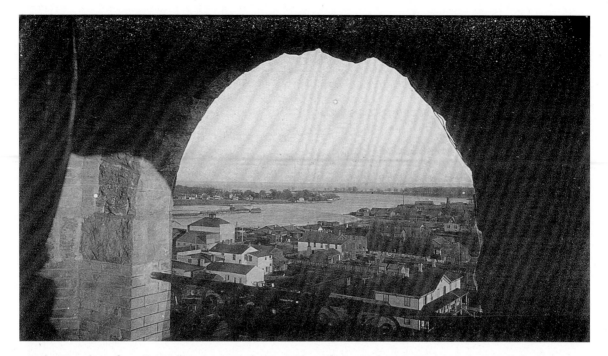

"Lake Winnebago from City Hall Tower, Neenah, Wis." When they arrived on November 6, the Brainard and Bennett expedition found four inches of snow had fallen here. (from Wisconsin Central Railroad, *Pen and Camera*)

Despite hearing very little else from Evaline, Henry continued to write her long, detailed letters. Perhaps it helped him feel closer to her:

> November 7, on the same track as last evening, Oshkosh, Wisconsin.
> . . . Tuesday I paraded the streets of Waupaca between the car and hotel, just enough times to get breakfast and supper. Meantime visited the Chain of Lakes on the shore of . . . which is located the Veteran's Home, pleasantly situated and consisting of quite a village of little cottages in connection with the larger buildings. Some of the cottages have been built by individuals as memorials, others by posts of the GAR in the same spirit. The region is full of small lakes abounding in fish such as the angler is fond of taking and in summer must be delightful country to wander in. While the day we spent there was clear and bright, it was too cold for any sort of purpose connected with our work unless perhaps it would be to accustom me to the temperature I will be likely to encounter at the Ice Carnival (if there is one this winter.)
> Mr. Brainard has been in his element hunting up facts and figures to combine with what he dissertates as Gush.

> November 10, on our way from FonduLac by freight train.
> . . . [A]bout two miles from here two shots came through the window of the caboose just over my head, scattering glass all over the floor and creating surprise, not to say consternation, and panic

among all its occupants, 6 or 7 men. A group of boys at the side of the track with a gun told the story, except insofar as it was maliciousness or accidental. A policeman went out on a train to look the matter up, but with what result I have not learned.

November 11

. . . In my letter mailed yesterday I referred to the car we came in from FonduLac being shot into just out of the suburbs of Oshkosh. As illustrative of how much capital can sometimes be made from nothing, an incident caught my attention when we stopped at South Oshkosh, which was perhaps a mile from where the shot was fired. Brainard's desire for notoriety was manifested by his calling the attention of everyone in earshot to our miraculous escape, which soon brought a crowd around to see the marks and count the shot holes. The ever-present knife displayed in his belt and the rifle, together with his wearing a strong leather sack slung over his shoulder, I suppose, was sufficient cause . . . for the statement I heard from one of the crowd before our train pulled ahead that we were "carrying an immense amount of money," and there "had been an effort to kill and rob us." Brainard had not a cent at that time, which would practically apply to the condition of my exchequer.

"Scene on Chain O'Lakes, Waupaca, Wis." This bucolic scene in central Wisconsin again demonstrates Bennett's artistic eye by incorporating an element in the foreground. (from Wisconsin Central Railroad, *Pen and Camera*)

An article published by Brainard during the course of the trip said: "We did famously well. Wherever we went the agent had announced our coming and we found scores of people ready to show us the wonders of the universe, or their portion of it, at least." The piece also reveals that another of his eccentricities was his insistence on referring to his companion as "Kilbourn Bennett":

> Kilbourn Bennett—God bless him for the memory of the experiences of our trip together—and I had been constituted a committee of two to portray in proper and attractive form the beauty of the region along the line of the Wisconsin Central Railway. Kilbourn was to carry his double-barreled camera and capture all the game in the shape of beautiful views of natural scenery, waterfalls, cascades, ruins, ravines, gorges, headlands, hunting scenes, night scenes, everything but commercial tables and advertising statistics. The latter were likely to be too fishy and photographs never lie. The photographic, then, was his department. Mine was to do the writing, the word painting, the effulgent that would, on a perusal of the work, knock weariness into the next generation.

Things may have been going "famously" for the two adventurers on their railroad trip through the central part of the state, but then Evaline sat down to write a letter that would crush Henry Bennett's fondest hopes. The letter confessed her profound concerns over his tendency to drink. In his anguish about the uncertainty of their relationship he must have imbibed heavily, with her knowledge, and she worried that his eventual ruin would be "laid at [her] door," despite his sincere pledge to remain abstemious and sober if she would only give him her heart.

> November 10
>
> My friend, how shall I write to you? I have debated with myself all day, yes, for the last week. I cannot write such a letter as you want, and I do not take the pleasure in your letters that I should. I have tried so hard to do so, but it seems as if I almost dread to receive them. I have tried to think that my regard for you is love, as I hoped it was, but something always says no. It is cruel, I know, to write to you in this way, after raising the hopes I have, and you will have just cause for hating me for the misery I have caused you, but I must tell you the truth. I have felt so dreadfully ever since you first told me of your trying to drown your sorrow. It has seemed as if I was to blame for it, but I was glad when you gave me your promise not to drink again, and thought I could depend on your keeping it.
>
> After I came up here and was a little homesick and tired, and lonely, I could not help thinking once in awhile, prompted by love of ease, if it would not have been better to let you take care of me and saved you that fall. So, when you threatened while here the first time to break your promise to me, you frightened me into giving you the hope that I did. After it was given, my conscience upbraided me for it. I doubted everything, except your sincere love for me.
>
> You came back for your answer before I expected you. I did not know what answer I should give you . . . but I was tired with this long struggle and cowardly lest your ruin be laid at my door, and so you persuaded me to think perhaps I did care for you more than I knew. But as you know I could not say that I loved you, only that I hoped I did, and would try, but oh, my friend, I have been so unhappy these two weeks past, and I know you would never wish me to marry you feeling as I do.

Charles Rollin Brainard and the photographer he called "Kilbourn Bennett" in their private car on the Wisconsin Central Railroad. The booklet published by the railroad in 1890 was entitled *Pen and Camera*. It spoke of the men's "recent tour of exploration and adventure" but never mentioned them by name. (WHi-68540)

Sometimes these last two weeks thoughts of the bitter disappointment this will bring you and your possible ruin have made me resolve to keep my promise anyway. . . . I know what you have told me before: if I do not love you I will not care. But I cannot agree with you. And although I cannot marry you, to save you, yet it will always grieve me if you make a ruin of your life.

Oh my friend, if you do indeed love me, do not give me that cause for sorrow. . . . Try to forgive and forget me, or, if you cannot, think as kindly as you can of the foolish girl who has caused you so much unhappiness, and whose heart aches for you although she cannot love you.

I am, very sincerely, your friend,

Evaline Marshall

Although she expressed herself with confidence in her letter, Evaline was not entirely sure of herself, as her brother Frank's entries for the same period in the fall of 1889 disclose:

November 7

Got letter from Evaline, she is almost distracted because Bennett insists that she must decide the question of marrying him at once.

November 9

[W]rote to Evaline about the Bennett affair. Told her she must not be in a hurry and need not decide the matter now.

By the time Eva received Frank's letter, however, she had already made the decision that she could not marry Henry to "save him" and had dispatched her disappointing missive to him. But her letter did not catch up with him until shortly after Henry had returned to Kilbourn. In his November 14 diary entry Frank noted Henry's devastation at Eva's rejection: "Bennett back from his northern trip. He thinks Evaline has gone back on him and he is wild. I went up to gallery eve and stayed til 12. He is almost crazy."

Indeed, Henry wandered about in his gallery, unable to do anything but think of Evaline and what was happening in his life. He wrote one last letter to her, pouring out his grief:

In the gallery, almost morning of the 15th of November.

Dear Eva,

My soul is crying out in anguish that almost curses the god that created it. I have walked the floor trying to think and make myself believe that I am in some horrible dream and will wake soon in the bright light that will bring the memories of our last hours together. Of the glad light in your eye when you saw how happy I was and gave assurance of your happiness. How cheerfully I took up the work which was no longer a burden, of the kind encouragement of your first letter after my return to Ashland, how I had hoped for more but cherished every word of it in its kindly solicitude for my happiness and appeal to be patient. How that I was certainly in your thoughts. But why should I refer to that happy part which is lost to me. . . .

I reached home . . . Wednesday night. And yesterday afternoon called to see your mother as you desired. And from her learned the purport of your letter of November 10th to me. God bless her for efforts to bring cheer and some trace of hope to a heart that had sunk and lay heavier and colder than lead. I do not remember now much that was said, only how kind and considerate she was and I left her with resolve to be worthy of all her goodness and bear manfully all that which I knew I should soon receive from your hand.

I dared not go to the post office or gallery for some hours, knowing or feeling it would await me. . . . Your good father was with me here all the early evening [and] your brother, Frank, until after midnight with kind, kind words . . . in this hour of darkness. But why, Eva, do I write you all this I don't know, after that letter it surely can be no moment to you how I feel, and yet I know you are suffering, too. But, my friend, (God grant I could once more say "My Eva,") if the writing of it has brought relief to you from the doubts and troubles that you say are with you after you said you thought you loved me and I know, did, and do now, I am glad for your sake, and will try ever so hard never to trouble you more.

I do not mean in this writing to utter one word of reproach as I do not and never shall feel one little trace in the heart whose heartbeat will be the utterance of prayers for your welfare and happiness. I am sorry and crave forgiveness if what I said was construed as a threat to so cause you to give a promise you could not keep, as I . . . ask forgiveness for everything that has caused you one moment of suffering.

Yes, Eva, the feeling is with me that I am a trouble to everyone I come in contact with. I left Nell, crying. She knew not what for, only that I was in trouble. Your good people are all surely distressed at my distraction. I wish it was not so. I could not help it but perhaps I can hereafter. Oh, Eva, why is it you must tear out of your own heart that love which I know you feel and it hurts you as much to do as it does me?

Eva's reply was cool. She asked Henry not to send any more flowers, please, or write to her anymore. She planned to come back to Kilbourn for Christmas.

As 1889 drew to a close, Frank revealed that Henry continued to long for Evaline's love:

December 1
Bennett in shop and house. I went out walking with him, then to the gallery. He still broods over his disappointment. I told him he must brace up.

December 2
Bennett hanging to me tight. Wants to give Evaline a present but we advised him not to. Evaline home from Duluth on 11:45 train.

December 27
Evaline and I to dance at GAR Hall, eve. An invited dance. Blissland, Portage, played. About 30 couples out. Had a fine time. Bennett there and payed about as much attention to Evaline as he could.

Henry Hamilton Bennett *literally* "trying on the dog." (WHi-68646)

December 29

 Up to Bennett's gallery, evening, to please him. He is awfully anxious to get Evaline yet.

On January 15, 1890, Henry Bennett celebrated his forty-seventh birthday. He had been a widower for almost six years, and now even Nellie, his youngest child, was a young woman of seventeen.

There is no indication as to what might have changed Evaline Marshall's mind about Henry Bennett, but almost at once her feelings underwent an astonishing transformation. He wrote to her from Milwaukee on February 4 of that year; they were to be married in March:

> I need not tell you where my thoughts are and how truly I hope for most perfect joy and happiness for you, neither need I tell you, Dear Eva, how dearly I prize every line you might find time and inclination to send, if I can know the writing is not an added burden to the much you have to do just now. Say my kind regards, please, to all your people and tell to yourself that which you know I will never tire of whispering in your ear, and please let me know at once if you are a bit troubled and I will come. My place is to shield you from all that can make you unhappy. Counting the hours until I can again be with you, I am, as ever, and truly yours,
>
> Henry H. Bennett.

"Board of Trade District." In his diary Bennett wrote that he got up at five o'clock on June 11 to picture this scene with a crowd of people, but "it was smoky and some cloudy until too late." The weather finally cooperated on Sunday, June 26, but the streets were empty. The composition of this city scene echoes the archetype he used for some of his Dells scenes. (WHi-69602)

8

Urban Landscapes
1890–1899

The summer is not for the summer hotel, it is for the closest possible association with nature.

—*Ladies' Home Journal*, quoted in Michael J. Goc, *Others Before You*

ON MARCH 20, 1890, HENRY PLACED AN ORDER with a Chicago florist for a ten-dollar box of flowers, mostly roses, to be delivered to Evaline Helen Marshall on the morning of the twenty-fifth of that month. They were married later that day at the Marshall home in Kilbourn, and invitations were confined to the immediate relatives. The bride, born on February 1, 1863, was twenty years younger than Henry. On that day Henry had written in his Civil War diary, "Nothing of importance happened," an entry that would become a subject of mock indignation when Eva read his diaries. Of the wedding itself the Kilbourn paper remarked:

> The rooms were arranged with admirable taste, without the slightest suggestion of display, yet appearing so pleasant as to excite admiration. . . . The bride is a lady of rare mental capabilities, noted for her intellectual accomplishments and the most admirable qualities of heart and mind. . . . Mr. Bennett's reputation is as wide as the state, and as an artist his work is seen all over the union. Among the many people who have visited the Dells he has made many friends by as affable and gentlemanly a temperament as ever graced a man.

William Metcalf's wedding gift to Henry and Eva was a remarkable music box that played twelve songs, including "When the Leaves Begin to Turn" and "Auld Lang Syne."

The couple visited Niagara Falls, New York City, and Boston on their honeymoon. A *New York Times* article on March 31, 1890, mentioned: "This evening H. H. Bennett of Kilbourn, Wisconsin; a member of the Chicago Lantern Slide Club, will exhibit between 70 and 80 slides of the picturesque scenery of the northwest. The collection includes pictures of the Indians of that region. Mr. Bennett will speak informally of the character of the country and its inhabitants." Henry gave another slide show in Boston. Eva would always recall that audiences at these gatherings gasped audibly when the view of Ashley leaping the chasm at Stand Rock flashed on the screen.

Evaline Helen Marshall and Henry Hamilton Bennett on their wedding day, March 25, 1890. (WHi-68186, WHi-69020)

The newlyweds planned to stop over in Chicago for a couple of months after their return from the East so Henry could complete a series of one hundred views of that city for Simon L. Stein, who had the idea of publishing a photogravure collection similar to the Milwaukee project that the men had collaborated on a few years earlier. Stein may have hoped to sell them as souvenirs during the world's fair to be held in 1893. Or perhaps it was a way of documenting, for Chicago residents, the city's miraculous comeback after the disastrous fire that had taken place twenty years before, as many felt Chicago's "resurrection" was as remarkable as its destruction.

Urban landscape photographs, which often depicted people busily involved inside the structures of the town or city, were becoming popular in Europe.[1] Concentrating on *structures* rather than on *people* would be another purely commercial enterprise for Henry, but as usual he would apply his strict photographic standards. He and Eva looked for a room to rent in Chicago and bought new furnishings for the house in Kilbourn, sending them on ahead by train. Hattie, Henry's oldest child, insisted that everything be especially nice for their return home.

Henry encountered a number of problems in creating the Chicago photographs, so the couple moved up to Milwaukee, where Henry did some work instead. He photographed the Chicago

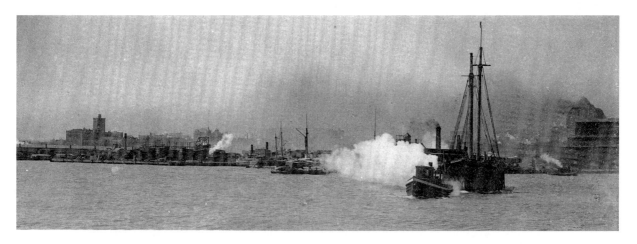

"Mouth of the Harbor." Bennett's Milwaukee friend, photographer S. L. Stein, commissioned him to make one hundred photographs of Chicago for a photogravure book similar to the one he had published for Milwaukee. (WHi-69581)

"Lake Street, East from Clark." Stein promised Bennett six dollars for each satisfactory plate. The urban landscape far from the serenity of the Dells was still treated with Bennett's typical strict photographic standards. (WHi-69595)

and North Western Railway depot, the view from the top of the courthouse, and the bronze statue of Solomon Juneau, which had recently been commissioned at a cost of $25,000 by William H. Metcalf and Charles T. Bradley to honor Milwaukee's founder and first mayor.[2]

During this time Eva wrote optimistic letters to her mother:

April 8

 Yes, I am very happy and I am sure I shall continue to be, and I am only sorry I made you so much trouble by my doubts and fears. Henry often speaks of the good you did him last fall, and says he has tried to thank you for it and wishes me to again tell you how much he appreciated your kindness. . . . It is just two weeks today since we were married, it seems longer and yet the time has passed like a dream, and a very happy one.

The Layton Gallery in Milwaukee, where William Metcalf was a trustee and to which he had donated several of his choicest works of art. (WHi-68579)

Henry again photographed the interior and exterior of the new Layton Art Gallery, to which William Metcalf had loaned several pieces from his own private collection when the gallery was dedicated in 1888. Metcalf was also a trustee. Inside the dim museum one of Henry's negatives had to be exposed for forty-five minutes.

Henry had also been invited to demonstrate a French invention, something new in photography: a panoramic camera that photographed a complete half-circle. He was to demonstrate the camera for all of June 1890 in both Milwaukee and Chicago.

When the couple returned to Kilbourn, they found that the first few months and even the first few years of their marriage were far from serene. Hattie and Nellie, young women now, had been in charge of the household since the death of their mother, Frankie. Naturally, they were reluctant to share their home and their father's love with a stepmother who was practically their own age. (Eva was, in fact, only four years older than Hattie.) Ashley felt no such jealousy, however, and easily welcomed his stepmother into the family.

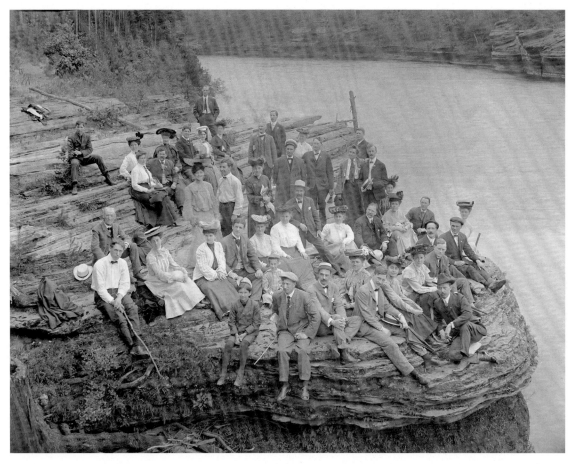

"A Group of Tourists at the Bird's Nest." Bennett would take their photograph, then have prints available at his studio when they returned to Kilbourn City. (WHi-7919)

Tension existed on the business front as well. Studio trade began to fall off in 1890. Henry did not attribute the decline to George Eastman's do-it-yourself Kodak camera (he privately believed that amateur photography would never amount to much); instead, he blamed the slump on the many tourists who came to the Dells on hurried, one-day excursions and did not take the time to visit the studio and purchase photographs. He was fully aware that the success of his business depended on increasing the flow of visitors, particularly those who would linger for more than just a few hours. To help promote travel to the area from afar he provided the railroad with lantern slides and information for use by a lecturer at more distant locales.

The Bennett Studio was an informal chamber of commerce. People often wrote to inquire about tourist accommodations in Kilbourn City. There were seven hotels—the largest housed one hundred guests, the smallest could handle twenty. Boardinghouses also welcomed visitors and "put them up."

In 1890 the best hotels in Kilbourn City charged from $2 to $2.50 per day, or $10 to $15 by the week. A seven-day stay in a good boardinghouse would cost a tourist $6 to $8. There was nothing Henry was willing to recommend at $5 or less per week, however. To one inquirer who wanted to bring along his "wheel," Henry explained that bicycling was possible, although the roads were rutted and streets were still unpaved.

Compared to other resort cities in Wisconsin (Lake Geneva, Oconomowoc, Waukesha), Kilbourn City made no effort to pass itself off as anything but middle class and unpretentious. The Finch House was proud of its reputation as "one of the rightest, freshest, home-likest houses we ever saw." Women had no need to dress in the latest fashions, and a travel writer cautioned them: "The journey up the river . . . is made in a steamer and can not be satisfactory if encumbered by the restraints of dress." Men often accompanied their wives and children. Families spent their days exploring the river's natural beauties, picnicking, hiking, or fishing. This kind of pastoral retreat was becoming popular across the nation. Visitors sought the revitalization of nature, the refreshment of wholesome food and clean country air. One guidebook suggested: "One important consideration of a summer at the Dells is economy. . . . A season here costs no more than it does in ordinary homes or boarding houses." To respond to the requirements of this new down-to-earth tourist, Kilbourn City promised "pure, sweet, holy rest and recreation—at ordinary prices."[3]

Henry took additional steps to bolster business in 1890 by publishing another guide to the Dells entitled *Wanderings Among the Wonders and Beauties of Northwestern Scenery*. The guidebook included photographs of the Dells, Indians, and nearby scenic places plus a dreadful long poem credited to John Clerke (probably a nom de plume for Frank Wisner, local newspaper editor), with repetitive stanzas mentioning "a beautiful maiden from Baraboo / With eyes like violets bathed in dew."[4]

The booklet was a dismal failure. One buyer who had ordered a thousand copies returned most of them at the end of the season.

The card stock at the studio was upgraded when Henry added two more sizes of stereo mounts, the "Petite" and the "Milieu," similar to mounts he had seen in New York. He also came

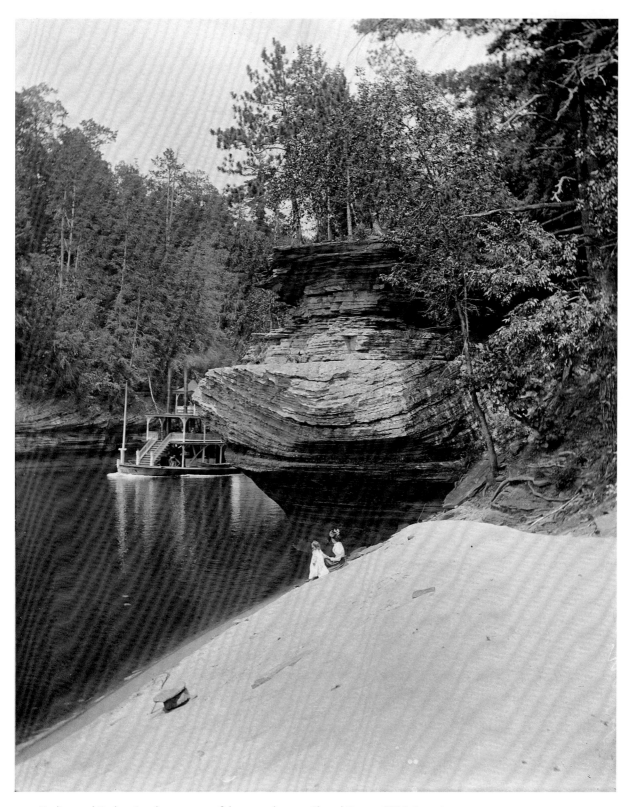

Evaline and Ruth enjoy the passage of the steamboat at Chapel Gorge. (WHi-69019)

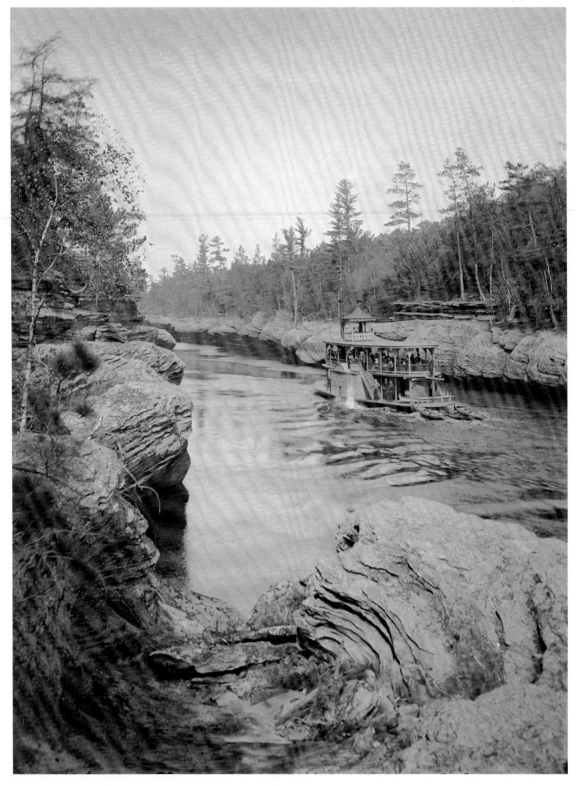

In 1874, a year after the introduction of the steamboats, over six thousand sightseers visited the Dells. By 1900 this number would reach at least sixty thousand. (WHi-7552)

up with another invention, which the Kilbourn paper called "about the most ingenious of labor saving schemes yet invented by and adapted by H. H. Bennett: a little water power designed to rock a shelf on which trays for negatives are placed. . . . Ask to see this little curiosity when in the Studio."

Both amateur and professional photographers who visited the village wrote to Henry for information about cameras and lenses. He usually recommended the Zeiss Anastigmat lens or the Dallmeyer Rapid Rectilinear lens, and on one occasion he said he preferred Cramer's Rapid Plates. But he was fond of saying his favorite cameras were those he had made himself.

Tour boats still accounted for the majority of the tourist trade in the Dells. That same year, 1890, the excursion boat company with which Henry had nurtured close ties for more than fifteen years went up for sale. Concerned about losing an important source of income, Henry wrote to the general passenger agent of the Chicago, Milwaukee and St. Paul Railway in October and proposed a scheme to purchase all or part of the steamboat business in the Dells. "My means are all tied up in my own business and I cannot put any money into this," he wrote, "but I would be glad to take the care and management for a small percentage of the profits because of the benefit an increase in travel to this point would be to my photo view business. My work during the tourist season as you perhaps know is almost entirely on the boats and river and has been for many years, and it naturally follows that I have both an extended acquaintance throughout the northwest and a knowledge of what is for the best interest of the Dells and the boat business on them."

He explained that the steamboat business had taken in over three thousand dollars the previous season with expenses of less than sixteen hundred. "With better facilities and different methods of handling it I am confident it can be made to pay nearly as large a profit on an investment of eight thousand dollars which amount, I would think, would put it in proper shape which would include a new and better boat to do the principal part of the work, leaving the present ones to be used in case of larger excursions." He even suggested that the landings should be improved, made more attractive and comfortable; "in fact make this like other resorts in its artificial attractions." But the railroad was not interested in getting involved in the steamboat business, and Henry's request for a meeting with further discussion apparently never took place.

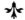

In October 1890 William Metcalf wrote with a proposition.

> I am about to publish a catalogue of the pictures in my gallery, and for a special, small edition of, say, 10 copies (which I wish to give away *only* to members of my family and my wife's) I wish to have illustrated by photographs of every one of the paintings described in the catalogue. The negatives for this purpose, I have about completed—say 60 altogether, big and little, but all on 5½ × 4¼ plates. For 10 catalogues, would require 600 photographs. I would like to have you do the job; *not* that it would be done at less cost to me, for I mean to pay you as much as you would charge anybody for the same work; *but* for reasons which I will tell you when I shall have the pleasure of seeing you in Milwaukee.

The art project for Metcalf eventually involved the entire Bennett family, many months of work, and a great deal of correspondence between the two men. "I am proud to know I can do something that a Man with 11 Millions (how it does grow) can't," Henry remarked to Metcalf, "I.E. find time to stick a few pictures in a book, and as proof of the statement I would say that you may send them along and do the best I can."

Henry wished to do the work for nothing "because it has been a pleasure to me to do it for you," and "Mrs. Bennett has seen your letter and is delighted that she is to have one of the books." But Metcalf sent a check for $50 to Henry at the end of March 1891. "I accept it because I know you wish me to," Henry then acknowledged, "and I want to say my sincere thanks to you not only for the payment but for the big hearted Motive which has prompted you to insist on this. But my good friend I have not and shall not forget how much I am indebted to you and like to be of some service to you as a slight return. The fact of your being pleased with the work is a gratification to me more than anything else could be."

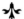

Unperturbed by the lackluster performance of the guidebook he had published the year before, Henry was preparing to publish another in 1891. He placed an order for only five hundred copies from the printer "to demonstrate whether it is going to be a catchy affair; I hope much for it." Later he doubled the order. The booklet was entitled *The Wisconsin Dells* and was designed especially to be sold on the boats, with a clever sort of fabrication that would allow the studio to add another leaf and insert a photograph of the boat and its passengers. "Please make a clean job of this that will not offset onto the backs of the pages," Henry wrote to the printer.

That spring the Bennett family moved from the house they had rented for eleven years because the owner had sold it. Moving was quite an event for the girls, Henry told Metcalf, but "in fact I don't look at it as particularly enjoyable." The move took place in April and was soon followed by another change for the family. On September 9, 1891, Henry wrote to William Metcalf: "A young lady came to our house early this morning and seems inclined to stay with us." Henry and Eva named their daughter Miriam Eva.

Their new home was on Oak Street at the corner of Wisconsin Avenue. It would be the first home Henry had ever owned, having rented living quarters until that time. He paid five hundred dollars down and borrowed the rest on a mortgage. "I want the place for a home and am satisfied the time has come when Kilbourn property will be a better investment than heretofore," he wrote to a friend. The house had been built in 1863 by Jacob Weber, the postmaster of Kilbourn. It was designed in the Greek Revival style, with two stories in the main part and two single-story wings. The house was ideally situated for the Civil War veteran turned photographer, since it was just around the corner from his studio and next door to the GAR Hall. When Henry moved in, he placed his portrait of Lincoln on one wall of the foyer and his Civil War swords and framed memorabilia on the other.

Henry was correct that property values would rise in Kilbourn, and he was not alone in that view. In 1891 real-estate developer John E. Godding and his brother, T. F. Godding, from Rocky Ford, Colorado, arrived on the Kilbourn scene flush with capital for resort development. An

article in the May 1886 issue of *Prairie Farmer* described one of John Godding's savvy real-estate ventures. When a railroad wanted to establish a stop between Rocky Ford and Garden City, the railroad's attorney formed a company to develop a town, which he named Lamar. Godding was one of the incorporators, and his investment in Lamar paid off handsomely, as the article describes:

> Only five short weeks ago, there was not a sign of human habitation . . . save a single log building down by . . . the stream. . . . Today there are five and twenty buildings completed or nearly so. . . . Tens of thousands of dollars worth of lots have been sold, $400 to $600 . . . being paid for a . . . 25-foot frontage on the principal street. The land on all sides is held at a premium of $500 to $1,000 per quarter section, which the owners "filed upon" within a month. Twenty-five-foot lots in town are jumping up a hundred dollars a day. . . . He who owns property in Lamar has "old wheat in the mill."

The Larks Hotel, constructed by the Godding brothers of Colorado. (WHi-69105)

Henry welcomed the Goddings with the same goodwill he exhibited toward other entrepreneurs in the tourist business. "I am cordially in sympathy with such plans as may result in putting the Dells where they should be among the resorts of the Northwest," he wrote. He was particularly pleased because the Goddings, unlike the railroad, seemed to be interested in taking over the tour boat operations. He had been desperately trying to salvage the steamboat business in association with F. A. Field, who had built the *New Dell Queen*, but in December 1891 Henry released Field from his option on the boats and wrote to Metcalf, "I think I told you something about a scheme of mine in relation to the steamboat business here in the Dells. Well I have given it up for the present because I find that another party who seems to have lots of scheckles is trying to boom the Dells. . . . He has bought a part of Witch's Gulch, a part of Cold Water Canyon and is trying to buy other property along the Dells, and I did not want my scheme to stand in the way of others on a larger scale."

"North Clark Street." Bennett ran into a great many obstacles in his attempts to complete the Chicago commission and capture the list of subjects desired by Stein. Wet weather and smoke often hindered his progress. (WHi-69604)

Ever cooperative, Henry wrote to John Godding several times over the next few months with offers of assistance in resort promotion. He described a plan to give lantern slide shows and lectures about the Dells in southern resorts during the winter and in northern resorts during the summer, relating his success with such lantern shows in New York City, Boston, and Chicago.

But the Goddings were unimpressed. They did not share Henry's devotion to the long-term well-being of the Dells. Instead, in a move reminiscent of the development of Lamar, Colorado, they formed the Wisconsin Dells Company and set about beefing up the resort and steamboat business as quickly as possible. Their goal seemed to be to swiftly sell off their land and business ventures at a tidy profit. Among their initial undertakings was a resort complex on the crest of a bluff near the Narrows between Cold Water Canyon and Artist's Glen. The complex included the Larks Hotel, from which a long, winding, white staircase led down to a steamboat landing at the river. Nearby was Camp Welcome, a campground that featured tents and hammocks artistically arranged for the relief of tourists who arrived by boat or on foot.

"Fountain in South Park," "Lake Front, South of Randolph Street Viaduct." Stein hoped to have the Chicago album completed in time for the 1893 World's Columbian Exposition. (WHi-69605, WHi-69586)

The Goddings also built a frame structure at the landing in Kilbourn. It had a street-level ticket office and an "elegant reception room." A long, enclosed stairway led to the pier eighty feet below from which passengers boarded the steamers for the river trip. The Goddings brought the first stern-wheeler to Kilbourn, the *Germania*, built in Osceola, Wisconsin, in 1887.

With a new boat and boat landing, the railroad reconsidered Henry's enthusiastic idea and decided to invest in its approach to the Dells. The railroad landscaped the depot with grass, shrubs, and trees. A gravel path led down the embankment to the new landing building. Excursions were arranged with tickets to Kilbourn and return at the price of a one-way fare plus fifty cents for a boat ticket. A five-piece orchestra from Milwaukee made the trips even more festive.[5]

Henry, assiduously trying to complete the photogravure collection he had started for Stein in 1890, went back to Chicago in early 1892 to take more pictures. In all, Henry made several trips to Chicago that winter and spring. Stein had commissioned him to make one hundred views at six dollars each, so, wearisome or not, the job was an important source of income. But the project seemed jinxed. The weather was often cloudy and rainy, and smoke and wind delayed his work. Henry grew impatient. On January 29 he wrote to his son:

> I can't see now when I shall get home; if there should come quite a large box or piece of furniture before I get there, have Mr. Arnty take it over to the house. It is for Eva's birthday so I wish you would not mention it at home for I wish to surprise her. There is fruit inside, so ask Mr. Arnty to deliver it and get it into the house as early as possible, especially if it is very cold weather. I hope to get home before it does but may not, and so write you these instructions.

Henry was in Chicago again in April, and while he was there his old friend William Metcalf died on April 8, 1892, at the age of seventy-one. Metcalf's health had begun to fail several years before because of a kidney ailment, and the final period of his life had been one of confinement to his home. His daughter had said that after "he could no longer continue the pleasure of travel, [Metcalf] was obliged to content himself with looking at the beloved pictures he had already gathered about him."

The obituary that appeared in the *Milwaukee Sentinel* on April 9 said the gallery in Metcalf's home was the "largest private gallery in the state" and added that he "was one of the patrons of the Layton Art gallery, to which he contributed some of the most valuable paintings in that choice collection, and was one of its trustees." He was said to have visited the countries of Europe more than once, and the obituary writer described the six months Metcalf had spent in Japan in 1877. His only survivors were his wife and one daughter, Julia Cary of New York City.

> [Metcalf's] love for art was most sincere. He loved it for its own sake, for the pure delight to be derived for it. . . . For one who lived so far from the art center of the world he was remarkably well informed. His judgment of a work of art was slow and deliberate. . . . He would never accord praise if he could not conscientiously do so, no matter what the reputation of the artist. . . . Fond of his joke and inclined quickly to see what was absurd or ridiculous in a picture, his sarcasm put an edge upon his criticism that caused it to be felt and remembered.

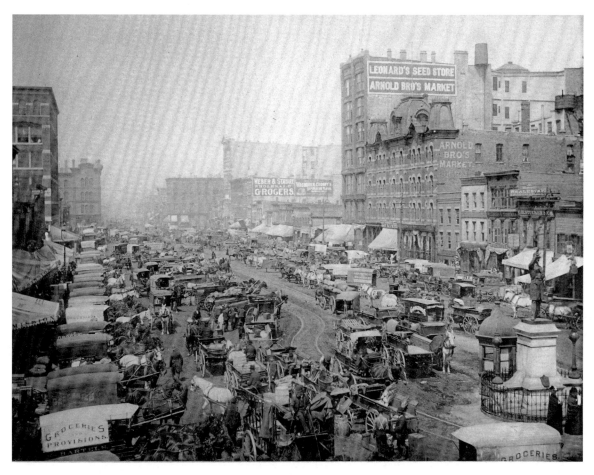

"Haymarket Square." During this visit to Chicago Bennett learned of his friend William Metcalf's death on April 8, 1892. He took time out to travel to Milwaukee for Metcalf's funeral on April 12. (WHi-69598)

In reviewing her father's life, Metcalf's daughter Julia recalled him as "open-eyed with interest and curiosity, never content with superficial knowledge, but really mastering whatever came before him in his chosen line of endeavor. Early advantages he had not, such as many another enjoyed; but at the close of life, how few could equal him in positive achievement, cultivation and elegance."[6]

Henry's friendship with his mentor and benefactor had spanned twenty years. They had shared the same wry sense of humor, and their common love of photography bound them with unyielding ties. Perhaps of even more magnitude was Henry's knowledge that Metcalf had always been solidly behind his endeavors, personal and professional. Metcalf's critical artistry had been essential to Henry's perfection of his craft in the early days, and without the financial gift of the studio and the occasional crucial loan from Metcalf, Henry might have had to return to carpentry and rely on making a living rowing tourists around, like his brothers.

Not long after Metcalf's death the Milwaukee businessman's vast collection of artworks was cataloged. Mrs. Metcalf asked Henry to help her sort out photographic supplies, cameras, lenses, and pictures. She returned to Henry the camera he had built for his friend's historic journey to Japan.

In May Henry finally handed over a selection of Chicago negatives to Stein in Milwaukee and recorded the following in his journal:

> May 7
>
> Deliver 8 negatives to Mr. Stein. Received from Mr. Stein, $125. At six p.m. take train for home in the full belief that tomorrow will be cloudy and perhaps stormy. Unpromising weather all week permits my having a good visit at home until May 16 when I again start for Chicago at 9:30 a.m. staying over in Milwaukee from one to 7:30 p.m. I see Mrs. Metcalf, Mr. Stein and Mr. Pratt.
>
> Flowers for cemetery $3
>
> Expenses $2.5

Some of Henry's photographs in Chicago and Milwaukee—especially those on the largest glass plates—were made by agreement for the Cramer Dry Plate Works. He was still trying to complete the exasperating Chicago project in June 1892, but the going was as difficult as ever. He detailed his frustration in his journal:

> June 11
>
> It's been oh, such a hot day, and though I got up at five o'clock this morning . . . only have done one subject, the boats and the crowd at the lakefront near the auditorium, two plates. My early rising was in the hope of getting the Board of Trade building but it was smoky and some cloudy until too late. I also hoped to get a view south on Dearborn from just north of Adams which must be made on a Sunday morning before many people are stirring. After finding conditions would not allow making those subjects I went over to Canal Street . . . but could not find anything. Then took a car to South Halsted Street bridge and walked over to 22nd Street on the South side of the river. There took car to State Street and down onto 29th where I hoped to get a view but there was too much wind.
>
> . . . From there to the Ashland block where I climbed the stairs to the top, 16 stories, but found it too smoky for birdseye views but seeing a tug out in the lake and two lumber vessels coming in I went over to Fifth Ave. bridge, 4 or 5 blocks, hoping to get them but they did not make a good picture so I packed up the outfit without exposing a plate and went over to the lakefront with result as above stated.
>
> The atmosphere has been clear enough here in the business center to allow making some views, only those street views should be done when the weekday crowd is on them. Besides, all places being closed on Sunday, I could not get to the elevated points I have selected to make them from but I am hoping tomorrow will be favorable for those subjects so I will stay over instead of going home tonight as I had intended to do.
>
> Car fare and meals $1.25

"Grand Boulevard." Bennett completed his Chicago assignment and the final photographs were delivered to Stein on July 9. (WHi-69603)

Henry had taken along the camera that allowed him to use eighteen-by-twenty-two-inch plates, but weather conditions provided erratic opportunities. Under the circumstances, he found his guide more compelling than the photographic opportunities:

> I have ridden about over much of the city today in search of subjects for the 18 × 22 negatives. A north wind has kept the air clear . . . but it has been too strong to allow of making pictures with foliage in. . . . The party who has driven for me today interests me. Evidently a waif who has seen much of the world, traveled for years with circuses, is about 38 years old, intelligent looking but without education—only such as has come with a roving life, quiet . . . and yet answering all inquiries about himself that I felt at liberty to make, telling me that he is without a relative in the world. If I had only seen him just enough to notice him, would have thought him a "rough," an ugly upright scar on the left side of his face passing close to the corner of his eye perhaps having some influence in forming such an opinion.

When he got home, Henry admitted to being tired and enormously glad that part of his Chicago commission had been completed. He had a new project to consider: the Wisconsin State Board of Control of Reformatory, Charitable and Penal Institutions had hired Milwaukee photographer Paul G. Lecher to provide images of the state institutions it managed for display at the World's Fair, and Lecher in turn wanted to hire Henry to provide the negatives. This project would involve winter travel and associated photographic quandaries that Henry felt ought to be considered when negotiating their agreement. The institutions to be photographed included the State Public School in Sparta for homeless, dependent, and neglected children; the school for the blind in Janesville; the school for the deaf in Delavan; hospitals for the insane at Madison and Oshkosh; the state prison in Waupun; and the Wisconsin Industrial School for Boys in Waukesha. Lecher would print the images and retain the negatives.

"Woodworking Class at the State School for the Deaf, Delavan." The Wisconsin State Board of Control of Reformatory, Charitable and Penal Institutions wished to display examples of its institutions at the World's Columbian Exposition. It hired Milwaukee photographer Paul Lecher to provide the photographs. In turn, Lecher hired Bennett to make the negatives. (WHi-25781)

In his letter of agreement for this commission Henry specified his conditions: "I will do the work referred to, furnishing camera, for $10 (ten dollars) per day, you to furnish everything, plates and all material necessary for developing the plates, you to pay all traveling expenses, hotels and RR fare, and wherever the pictures are used and credit given anyone, I am to have the credit of having made the negatives. . . . I also think the time you mention in which to get 100 negatives in seven different cities is considerably less than it can be done in."

Evidently, a problem arose regarding the compensation Henry required. In a succeeding letter the photographer made it clear he was not willing to sacrifice the quality of his work:

> Your estimate for cost of plates is only half or one third enough, for at least ten plates should be exposed on each subject because no one can take 100 good negatives on only 100 plates where good

or creditable work is expected. . . . Another point in which you are in error I am afraid is in the number of negatives to be made each day. . . . Many interiors require lots of minutes and often hours of exposure. . . . With 6 or possibly 8 hours of photo daylight and the time required to change the camera from one subject to another and the many little things that are necessary to success [this will] take time and if one desires excellence, must be given consideration.

An agreement on terms and the number of negatives was finally reached, and in February Henry began his task. It was an intriguing assignment for him because he felt compassion for the residents at all the institutions, and he recorded his sympathies in his journal. On February 20, after leaving the state prison in Waupun, he wrote:

"Art Class at the State School for the Deaf, Delavan." The school had been incorporated in 1852 by the Wisconsin Legislature in order to provide a free education for "all deaf and dumb residents" except those considered "imbecile, idiotic, or feeble-minded." (WHi-25774)

The warden gave me a few pointers and turned me over to a gentleman he called Dr. who is an amateur Photo. who also made some suggestions and put Mr. Clinton Walsh at my disposal. He had helped the Dr. in his photo work and made a set of views 5 × 8 of the prison which he offers for sale to visitors. He was very kind to me in rendering assistance, seemingly pretty well informed and withal a companionable fellow, notwithstanding he has served 17 years of a life sentence for murder.

On leaving I could not help shaking his hand and wishing him a brighter, better life. . . . Maybe my sympathies would not admit of being a good warden of that institution or I would grow to feel that every man sent there is of necessity bad. I don't know. Certainly my friend of today was not very bad or he would not have been given the liberty he has had in the work with me.

Henry left the Sparta school on the evening of February 27 in heavy rain and found himself waiting at the depot until midnight as the train was almost two and a half hours late.

"Wisconsin State Prison Cell Blocks." Bennett was given a tour of the prison by one of the inmates who had a life sentence for murder and an interest in photography. (WHi-25635)

Students outside the Wisconsin Industrial School for Boys, a reform school in Waukesha. After twelve days' work Bennett was paid $148.07 and expenses for the institutional photos, but—in conflict with their previous agreement—Lecher claimed credit for all of them. (WHi-25741)

So I did not get to Portage until about 2 a.m. and then could not get a bed at the Fox House so slept in a chair until 5:30 a.m. when I had a good breakfast and took train for Madison at 6:15 a.m., reaching Madison about 7:15 a.m. Not being able to get a train to the hospital, I hunt for a livery barn and finding it, find my old army comrade James I. Bowman keeping the stable. The drive across the lake [Mendota] with him for company made the biting west wind more bearable than it would have been with most anyone else.

Before leaving Portage he had checked with the express office in Madison to see if there were any Cramer plates awaiting him. He then tried to purchase some when he arrived in Madison, but there were none in town. Due to some confusion, Lecher had sent the plates to the Park Hotel in care of Mr. W. H. Graebner of Milwaukee, a member of the State Board of Control

recently appointed to the position by Governor Peck. The hotel was more than five miles away from where Henry had completed the number of views contracted for at the Mendota Hospital for the Insane across the lake. After some deliberation Henry decided to walk the five miles over ice and a slushy road "with a gale of wind at my right side and a little in front." It took him over an hour to get to the hotel. In all, the Madison photography work was tedious and hampered by delays. Graebner insisted on having pictures taken of the Board of Control Office in the capitol, preventing Henry from leaving for Delavan before Thursday evening.

Henry was paid $148.07 and expenses for twelve days' work.

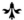

Anticipation was growing over the World's Columbian Exposition soon to open in Chicago. Henry's traveling agent, D. A. Kennedy of Minneapolis, encouraged him to get some stereos of the distinguished event, the last and most spectacular of the nineteenth century's world's fairs, which would open to the public on May 1, 1893. Kennedy felt such photos would give a boost to sagging sales of Henry's stereo views.

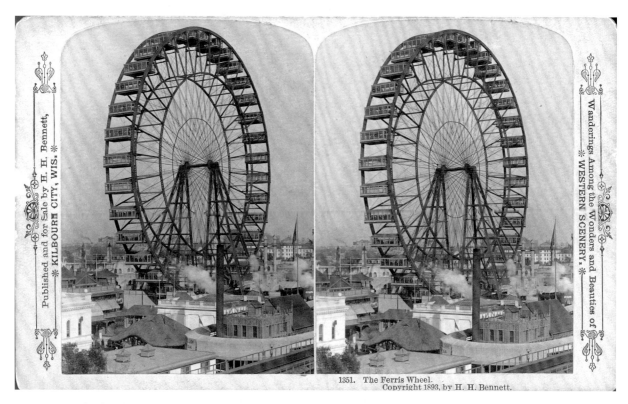

"Ferris Wheel at the World's Columbian Exposition, Chicago. 1893." The photo concession had been sold to another photographer, and Bennett was able to obtain only a few views. This scene of the Ferris wheel was taken from outside the grounds. (WHi-68616)

CHICAGO AND VICINITY.
313. Looking through the Ferris Wheel, near the top.

"Ferris Wheel, Interior." The Ferris wheel was twenty-six stories high, and passengers were given two revolutions for fifty cents. When full, it carried 2,160 passengers. (WHi-68576)

"The Midway or Plaisance, as seen from the Ferris Wheel." This was obviously taken after the fair closed, as few people remain on the grounds. (WHi-68573)

Indeed, more than 27 million people—roughly half the population of America at the time—visited the exposition during its six-month run, including such notables as Henry's colleague Eadweard Muybridge, Helen Keller, Annie Oakley, and President Grover Cleveland. But the photo concession was sold to another photographer, and Henry was able to get only two good views. Both were of the famous Ferris wheel, one by day and one by night, and both were taken from outside the grounds.[7]

Henry was not alone in being barred from the fair. Buffalo Bill Cody was denied permission to put on his Wild West Show at the exposition, so he staged the show successfully nearby and didn't have to share a penny with exposition organizers. Late in the season Henry finally gained admittance, but his exposition work was not profitable.

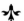

In 1893 Henry took out the first of several copyrights. It was for one of his eighteen-by-twenty-two-inch panoramas. It seemed that customers were becoming bored with mere scenic views; they were more interested in buying comic subjects and series that told sentimental stories. Henry tried to adjust by rephotographing many of his familiar Dells landscapes. In some of his new scenes he added people in the foreground, often family members. In others he featured a canoe. "I have a real Chippewa Indian birch canoe," he explained in a letter to his agent dated October 1, 1892, "that I got a few days ago from the northern part of the state, which I will use in some pictures that I will make at Boat Cave and perhaps other points." He also issued and copyrighted a set of hunting scenes. Though never enthusiastic about comic subjects, he nevertheless published three novelty stereo views that were taken on studio tabletops arranged with rocks, moss, ferns, and miniature plaster and cardboard figures.

The ability of the Bennett Studio to produce stereo views of exceptional quality was now at its height, but public taste was undergoing a transition. Nationwide, most of the stereo views on the market were declining in subject matter, workmanship, and cost. Some stereos were being reproduced by lithography, which reduced prices but yielded poor-quality images. Henry might construct fake little arrangements with moss and ferns and paper dolls, but he could not bring himself to sacrifice the overall quality of his craft. He continually explained to canvassers and would-be canvassers—traveling salesmen who marketed stereos in towns across the country—that he simply could not make cheaper views and maintain his standards. To one correspondent he pointed out that because his stereos were more expensive than average, canvassers could make up to 150 percent of their normal profit by selling his views.

Henry was convinced that the "amateur photo craze" would eventually pass, but he could not deny the effect that Kodaks in the hands of tourists and the availability of cheap, lithographically printed views were having on sales. To offset declining income, he continued promoting the Dells, and he accepted even more commissions. At the February 1896 convention of the Northwestern Photographers Association in Minneapolis, for example, Henry presented an evening of lantern slides. The Minneapolis paper commented, "Mr. Bennett is a most entertaining lecturer having the rare faculty of investing even the most prosaic facts with a touch of humor and drollery that keeps an audience continually on the alert."

The Chicago, Milwaukee and St. Paul Railway hired Henry to make more photographs of the upper Mississippi River. While working on the river views, Henry—still fit in his midfifties—walked five miles one day, carrying his eight-by-ten camera and gear.

Not every commission was attractive, however. Henry declined a proposal to undertake a round-the-world photographic journey. The trip would have lasted two years. He did not think there would be enough profit from such a trip, and the devoted husband and father simply did not want to leave his family, his studio, or the Dells for such a long time.

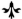

When the Bennett children grew old enough, they were expected to help with the work of the studio. Nellie, the second daughter born to Henry and his first wife, Frankie, developed a special aptitude for making and mounting prints. When Nellie was old enough to begin working in the studio, her father was using wet plates, and printing paper still had to be coated with a silver-containing emulsion. She had a gift for applying the emulsion deftly and without air

"Upper Mississippi." Chosen by Bennett to be included in *Wanderings by a Wanderer*, his album of twenty favorite photographs. (WHi-69563)

bubbles. Hattie, Henry and Frankie's first child, was also gifted with artistic talent. She learned portrait retouching in Milwaukee and applied that expertise when she returned to the studio. Working with oil paints, she colored some of her father's landscape photographs. Henry and Frankie's son, Ashley, did a multitude of jobs in the studio and out in the field. He often amused himself with trick printing in the darkroom, although he occasionally did some serious work as well.

In the late 1880s, as his children grew up and began their own independent lives, it became more difficult to find a regular assistant to work in the studio every season. Henry wrote to other photographers detailing the kinds of things with which he needed help, but none of the outsiders he was able to hire seemed to last very long. One worked only a week before absconding with thirty dollars' worth of cash and supplies.

The 1890s were a time of beginnings and endings in the Bennett family. Henry Bennett's family was growing up and moving away. Hattie and Nellie both married in 1893. Hattie wedded Fred Snider but was widowed the very next year.[8] She moved back into the Bennett home, where she and Eva finally became fast friends. Nellie became the bride of George H. Crandall, who had arrived in Kilbourn City in 1892. He was then earning $45 a month as the station agent at the railroad depot. The couple ventured into the resort business in 1895, when they converted a rented house into a small hotel. In 1898 they were hired to manage the Larks Hotel, which had been erected at the head of the Narrows by the Goddings' Wisconsin Dells Company.

The first small powered tour boat, the *Wisconsin*, owned by Ben Olson, appeared in the Dells in 1894.[9] It could hold twelve passengers and looked like a miniature stern-wheel steamer. Now guide-powered rowboats used for personal tours were threatened with obsolescence. The Bennett brothers—John, Albert, and Clarence, carpenters like their father—had perfected the designs of their rowboats and given the boats sharp prows like canoes so they moved easily through the water and provided stability for several passengers. The brothers also served as river guides, and one has to marvel at the strength required for their feats. The oars may have appeared long and cumbersome, but they were fashioned with a spoon at the end to provide additional power.

In 1894 a woman writer, Annie Turner Preston, described a trip up the Dells for a magazine article in *The American Angler*. She chose to ignore the steamboats, opting for a tour by rowboat with H. H. Bennett, "a man of innate courtesy of manner and thoroughly acquainted with each bit of scenery for miles around." They left about 4:30 in the afternoon in Henry's "comfortably cushioned" boat. "Imagine a perfect summer afternoon, a hazy, lazy, dreamy summer day, and you are entering the Jaws of the Dells," Miss Preston wrote. She offered elaborate descriptions of various rock formations, suggesting, "To have seen it, to have hung it up in the hall of imaginative memory, is to have become richer forevermore," quoting the English art critic John Ruskin. To further entertain his guest, Henry resorted to a little trick: "Presently our little boat seemed to be surrounded by fire. Flames leaped up on all sides, and we could hardly believe it was just phosphorous we saw, caused by the guide pushing the oar quickly back and forth in the sand just beneath the boat's side."[10]

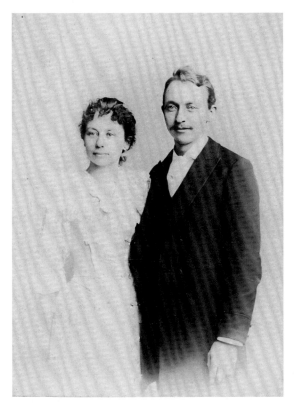

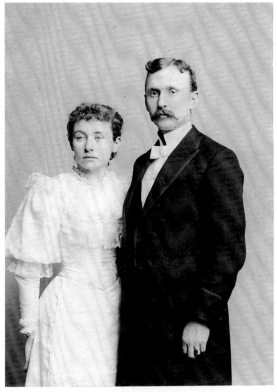

On April 26, 1893, Hattie married Fred Bailey Snider. Fred died within a year of the marriage. (WHi-68572)

On November 28, 1893, Nellie married George Humphrey Crandall, the station agent at the railroad depot. (WHi-68571)

Her first impression of Witches Gulch was disappointing, but Henry docked the boat and she dutifully followed him through a narrow gorge "all the time full of wonderment." Eventually they emerged into an opening and found their intended dinner destination, the Robinsons'.

> It's such a quaint place. A cottage with ample piazza has been erected in the cleared space among and almost under the overhanging rocks, and the little stream we have followed through the gorge rushes along by the very door, as if bent upon some mission which our dull minds could never think of comprehending, even should it pause to explain. We glance up at the rocks on all sides and how forbidding they look. It's not sunset yet, but the sunlight never finds its way in here except for an hour or two at midday, and, tonight, could we have a more sweeping view of the sky above us, we should have due intimation of how our plans for returning to Kilbourn City by moonlight were all to be shattered and laid in ruins.

A violent storm moved in, and Miss Preston and Henry were forced to spend the night with the Robinsons. "They made us very comfortable, even though it was a bit crowded for everybody."

The account of Annie Turner Preston's visit to the Dells was recounted in a chapter of the booklet *Short Journeys on a Long Road*, published that same year by the passenger department of the Chicago, Milwaukee and St. Paul Railway. Both the article and the book included engravings of Henry's photographs.

The Robinsons would soon offer more commodious quarters in The Pines, between Cold Water Canyon and Steamboat Rock, with ten guest rooms, each with a river view.

Ashley left home in 1894 and, in a supreme irony, went to work selling products on the road for the Eastman Kodak Company. He married Esther "Essie" Jones in Columbus, Wisconsin, in 1897 and soon settled in Mankato, Minnesota.

Henry's father, George, died on June 25, 1894, after suffering a series of strokes. The Kilbourn paper said his life was "full of years and honor." He was survived by his wife, Harriet, nine sons, and two daughters, the sons "all capable, popular and prominent business men" and the daughters, "who are honored for pure, noble womanhood—all, without a single exception, a credit to the communities of their citizenship." The funeral was held at home.

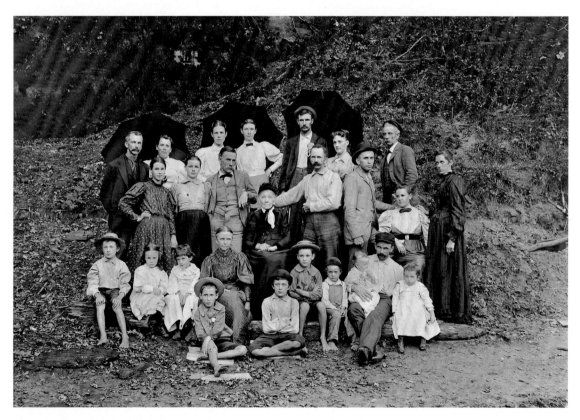

The Bennett family on the banks of the Wisconsin River around 1895. Matriarch Harriet Houghton Bennett is seated in the center. (WHi-68187)

On Christmas Day 1895 a second daughter, Ruth Noel, was born to Henry and Evaline. She and her older sister, Miriam, would soon figure prominently in Henry's landscape photographs along with their mother. One portrait made of little Ruth with her stuffed lamb was especially sweet.[11]

Henry's mother, Harriet, died in 1896 at the age of seventy-seven, less than two years after her husband had passed away. The author of her obituary in the Kilbourn paper said her death "removed the last tie that has for many years bound together one of the notable families of this community."

Perhaps spurred by entering the date of his mother's death in the family Bible, Henry turned to family history records and made a slight modification. His marriage to Francis Irene Douty had originally been noted as taking place on June 22, 1867. Now he blotted out the 7 in the year and changed it to a 6. After that, Hattie (or anyone else who went looking) would think her parents had been married for fifteen months before her birth in Tomah instead of three.

Changes were being made in the area around the Dells as well as within the Bennett family. In October 1895 seven thousand tourists visited the Dells on excursions, and the boats carried

Ruth Noel Bennett and her toy lamb, which her teasing older brother Ashley encouraged her to ride. The broken lamb then became a rug. (WHi-8066)

fifteen thousand passengers who paid fifty cents apiece. The Bennett Studio must have benefited from this, as some excursions lasted until after supper, contributing to the profit of the community.

The Goddings were still pushing their Wisconsin Dells Company, and in an 1896 guide they expressed the philosophy that defined their operations, stating that the changes made in the Dells did not detract from "the sublimity of nature."

> Wherever the beauty of modern adornment, the introduction of modern improvements can be applied without changing the primitive beauty or natural grandeur, these changes will be adopted. Four hundred acres of beautiful park, covering hills, dales, glens and meadows will be cleared up. There are stone walks, terraces, winding walks around precipices, wire suspension bridges over chasms, rustic seats in lovely bowers, incomparable vistas through forest groves, and broad perspectives over river, hill, woods and fields.[12]

The site for a dam in Kilbourn City was originally purchased by the Hydraulic Company in 1855, creating bitterness with residents of nearby Newport who had been assured by glib promoters that the Hydraulic Company would locate there. According to old settlers, "Kilbourn was born in iniquity and can never prosper."[13]

The rapids in the Dells was a dividing line between the Upper and Lower Dells and a natural place to harness the river for milling and manufacturing. The Hydraulic Company built Kilbourn's first dam there between 1855 and 1859. It was generally considered to be the most dangerous dam on the river and was soon torn out by a gang of lumbermen who came down from the pineries in the north and demolished it while helpless citizens watched.

Ultimately, three more dams were built on the site before the century was out. Businessmen interested in starting a woolen mill planned to build a larger, stronger dam in the mid-1890s. Alarmed by this news, Henry feared the scenery of the Dells would suffer if the water level were raised even by ten feet. He wrote letters of concern to Thomas Greene of Milwaukee (Henry had photographed Mr. Greene's home), who wished to purchase the Stand Rock tract in the Dells and had also considered purchasing property below the site of the Dell House. He also wrote to the Milwaukee Road in hopes the railroad could exert some influence to prevent the dam from being built.

The dam was constructed in the winter of 1893–94, but in 1896 its center pier swept downriver so quietly that a man watering his horses just above the dam did not realize what had happened until he noticed the water rapidly subsiding from beneath the noses of his team. The dam and mill were a financial failure, and the property was taken over in 1898 by Kilbourn banker Jonathan Bowman.

As he had done many years before with the Dell Rangers, Hattie and Nellie's broom brigade, Henry now took an interest in drilling a company of thirty high school cadets. They learned drills, including the manual of arms, and marched in Memorial Day parades. During exhibitions

one of the boys might do a bayonet drill with Henry, who was pleased with the organization because the rules were the same for all boys, rich or poor, and each boy had equal opportunities for promotion. The company disbanded prior to the Spanish-American War, and several former cadets joined the army at the time of that conflict. Henry kept up a correspondence with "his boys," and his thoughts were with them even in his dreams, as described in a letter to one of the cadets dated July 22, 1898:

> My dear boy, last night I received a Captain's commission in the Volunteers, of course the first thought was, how I wish I had the boys who went in Co. F. Then I wondered if I had better accept the commission, and debated with myself as to the wisdom of my again becoming a Warrior. But before I had decided the matter, I woke up and found . . . the commission had not materialized in the dream. . . . I watch the papers closely and so far have not seen the names of any of my boys on the hospital list.

"Munger's Mill Dam Construction." Built in 1894 for milling Gold Brand, Roller Gem, and Ruby flours, the dam washed away two years later. (WHi-7831)

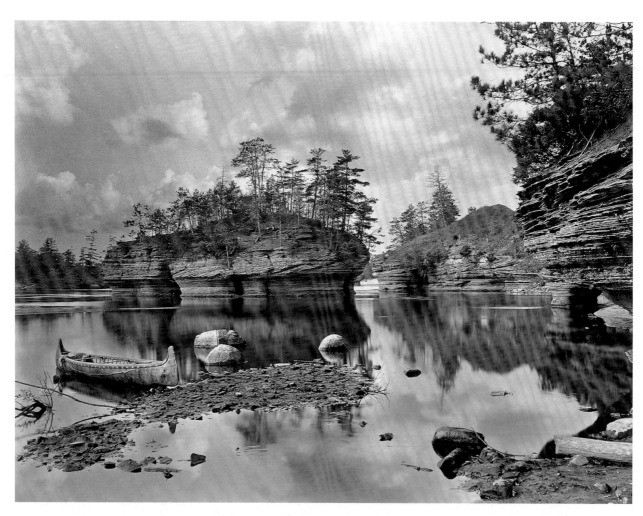

"Lone Rock with Canoe, Wisconsin Dells." Bennett repeatedly photographed this favorite formation. Here he superimposed a cloud mask over a view of Lone Rock with a blank sky, then reversed the cloud image as it was reflected in the water. (gelatin silver printing-out paper; 15½ × 20¼; Milwaukee Art Museum, gift of H. H. Bennett Studio Foundation, Inc., M1993.118; photography by Larry Sanders)

9

Change in the Wind

1899–1904

Hail to thee, O fabled Dells,
Land of pine and rivers and sun
And hawk-eyed merchants, quick to cry
"Here comes another one!"

—Anonymous, in Charles F. Church, *Easygoing: A Comprehensive Guide
to Sauk and Columbia Counties*

HENRY AND EVALINE TOOK THE TRAIN TO CHICAGO late Sunday night, September 17, 1899, and arrived in the Loop in time for breakfast at the new Thompson's cafeteria on Monday morning. It was a treat to sit on a one-arm chair and eat at a lunch counter. The Spanish word *cafetería* had recently been used by a nearby restaurateur from New Mexico to describe his self-service eatery, and the catchy name and style of restaurant were becoming a trend.

After breakfast Evaline went shopping while Henry met with A. F. Merrill of the Chicago and North Western Railway. Merrill wanted some views of the passenger depot near Fox Lake in the far northeastern corner of Illinois. Henry met his wife again for dinner that noon at Thompson's. In the afternoon they accompanied Ned Sherman and "young Mr. Dixon at the 'fair.'"[1] That evening he and Evaline saw *A Stranger in New York* at the Great Northern Theatre, a play with a plot that revolved around a hilarious French ball. It was a demanding day after a mostly sleepless night on the train from Kilbourn City, but Henry found time to write in his journal.

Evaline took the train back to Kilbourn City while Henry spent the next several nights at the Howard House in Fox Lake. The hotel was recommended by the Wisconsin Central Line, which provided omnibuses at the Lake Villa Depot to convey passengers to their lodgings.

On Friday night, September 22, Henry made the following journal entry:

> Opens up with a Northeast wind strong and cloudy, so I spend the morning hunting subjects roads and paths in the woods of which I find several that will be pretty with proper light. In my wandering get caught by the rain and take refuge in the hotel, Nippersink Point. Have a pleasant chat with the

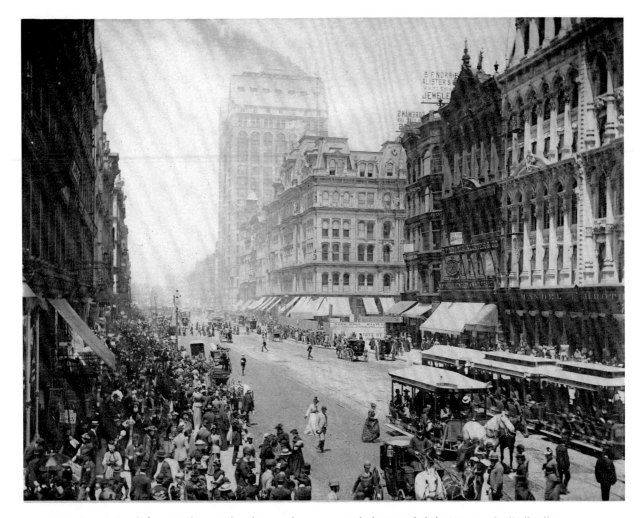

"Stato Street, North from Madison." The Chicago skyscrapers with their steel skeletons were built after the disastrous fire of 1871. That same day Peshtigo, Wisconsin, saw more than 1,100 die in the nation's deadliest wildfire, but it was overlooked due to the dire conflagration in Chicago. (WHi-69592)

proprietor and learn that I was in error when I supposed I was making pictures on Lake Nippersink when I was really on the west shore of Lake Pistakee, though less than half mile below or south of Nippersink. While sitting in the hotel at above place a gentleman came in with twenty-one ducks that he said he had got in an hour or less.

Find the grass and weeds pretty wet in making my way back to the Howard House, which I make just before dinner. At dinner table I am recognized by a gentleman who with his wife are at the same table, they having spent a day at the Dells four or five years ago and seen me on the steamboat. Spend dark, cloudy, windy and rainy afternoon sitting around the hotel in pleasant conversation with several gentlemen. Letter from home and package of plates from Mr. Katz.

The *Pen and Camera* guidebook featured views of Fox Lake, Illinois. During this visit Bennett found the weather mostly cloudy and wet. (WHi-68570)

Henry no doubt intended to photograph the famous lotus beds of Fox Lake. A railroad brochure from the Wisconsin Line said, "Parties daily visit the beds in small row-boats to gather lotus buds. . . . The fragrant odor of the lotus permeates the atmosphere for miles around Fox Lake, and the sweet perfume of myriads of other varieties of beautiful wild flowers of that lovely region, intermingling with that of the lotus, produces a mélange most exquisitely agreeable to the olfactory nerves."

Not long after this, in the fall of 1899, Henry's health began to fail. Evaline noted: "He was finally confined to his bed several weeks during the winter following. The trouble was called hardening of the liver and his physician did not expect him to recover, but his strong constitution and great willpower prevailed. He partially regained his health and again took up his work

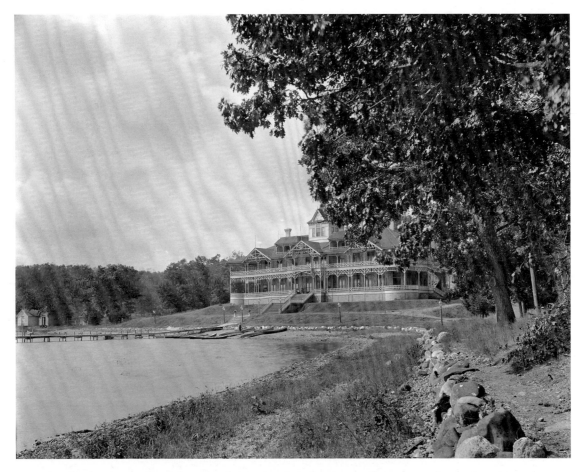

Fox Lake, Illinois, where Bennett mistook Lake Pistakee for Lake Nippersink. In a journal entry from September 22, 1899, Bennett wrote, "While sitting in the hotel at above place a gentleman came in with twenty-one ducks that he said he had got in an hour or less." (WHi-68569)

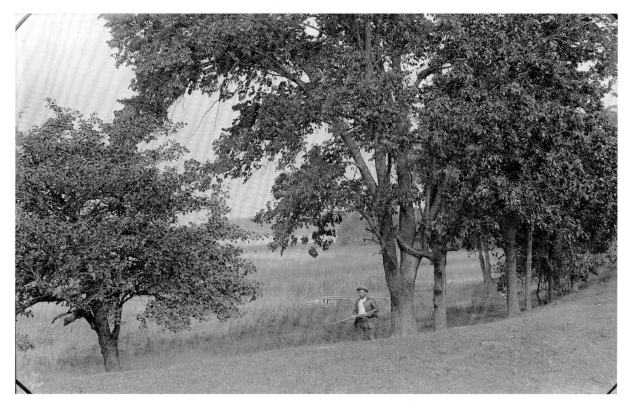

Hunter at the edge of a marsh near Fox Lake, Illinois. Wild rice and wild celery in the area were said to attract waterfowl. (WHi-68567)

that he loved so well, that was henceforth to be done with more or less pressure and because he felt he had not accomplished all he needed to do."[2]

Up until that time Henry had been reluctant to let Evaline help out in the studio. He may still have harbored a deep suspicion that Frankie's health had been endangered by the damp air and chemical fumes in the darkroom, and he did not want to subject Eva to similar risks. Now, however, there seemed no alternative. Evaline had worked in Duluth before her marriage. Now, working with her husband to maintain a business that he loved seemed natural to her.

Fortunately, Henry was strict and meticulous with his work, his records, and his workroom. Rather than leaving everything strewn about, he kept each tool in a special place; he had an exacting sense of order and he knew the cost of carelessness. Negatives used for stock printing were numbered and kept in sturdy wooden cases, each in a slot with a corresponding number.

Eva began working in the studio in 1899. From that time on Evaline Marshall Bennett was a permanent part of the studio's workforce. Like Frankie before her, Eva learned portrait photography and managed the studio's business transactions.

With the turn of the century, changes were occurring everywhere. Henry celebrated his fifty-seventh birthday on January 15. Although his agent, Mr. Kennedy, continued to sell Henry's

stereos on the road, 1900 marked a watershed in the studio's business. For the very first time the studio purchased picture postcards from a printer in Milwaukee. Henry's philosophy about postcards was the same as that for Kodak cameras—they were just a passing fad and would die out at any moment, but one had to acquiesce to the expectations of one's customers.

In July Henry sent twelve of his eighteen-by-twenty-two-inch views to Milwaukee for exhibition at the convention of the National Photographers Association. He stipulated that "a card shall be put up with them stating that the pictures are of 'Scenery on the line of the C.M. and St. Paul R. R. 109 miles northwest of Milwaukee.'" His photographs were highly praised, and he was called "the Wizard of the Dells."

In 1904 Henry had an exhibit at the Chicago Art Institute and then another at the St. Louis World's Fair, which commemorated (a year late) the centennial of Thomas Jefferson's purchase of the Louisiana Territory from France. A group of Bennett panoramas were displayed at the exposition, sponsored by Kilbourn City businessmen. After the fair the photographs were to be donated to the Milwaukee Road for advertising the Dells. Famous visitors who may have seen Henry's photographs were John Philip Sousa, whose band performed several times; Scott Joplin, who wrote "The Cascades" specifically for the fair; and Thomas Edison, whose Edison Studios had recently produced *The Great Train Robbery*.

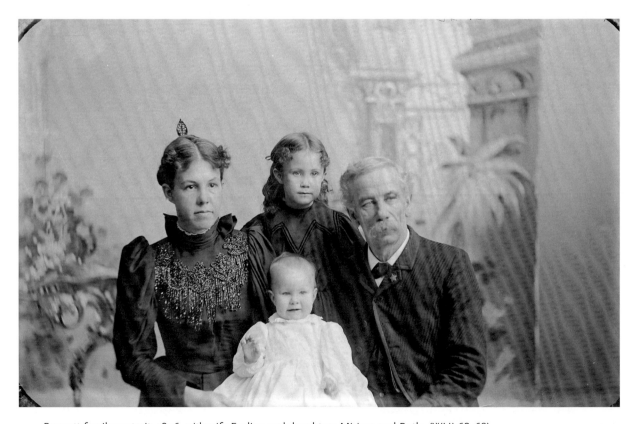

Bennett family portrait, 1896, with wife Evaline and daughters Miriam and Ruth. (WHi-68568)

"Bennett Family, House and Auto." Ashley Bennett was a dealer for the Winton Motor Carriage Company in Mankato, Minnesota. In 1900 he brought his wife, Essie, and daughter, Irene, to Kilbourn City for a visit. (WHi-7998)

Ashley moved to Minnesota and built the first structure specifically designed to be an automotive garage. (WHi-68558)

During the summer of 1900 Ashley Bennett zipped into Kilbourn City in one of the first horseless carriages ever seen in the village. Now the Northwest dealer for the Winton car, Ashley had driven down from Mankato, Minnesota, with his wife, Essie, and their baby daughter. The dusty country roads had not kept them from accomplishing a hundred miles per day. The car terrified everything in its path. Every time Ashley took the Winton out for a spin in Kilbourn City, Henry had to run on ahead and hold any horses along the route so they wouldn't bolt and run away.[3]

Hattie Bennett Snider, Ashley's widowed sister, was still living in Kilbourn City, where she continued to use her artistic skills to color her father's photographs by hand. A new kind of souvenir photograph was being produced in the studio in the form of a blue print on cloth to be used as a sofa pillow cover. The material was a dense kind of cotton called "silkdown," which was washable in cold water without damage to the image.

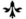

Henry was never able to establish as warm a relationship with the Goddings and their Wisconsin Dells Company as he had developed with the railroads. This may have been because he had little in common with Nat Wetzel, the flamboyant character the Goddings hired to manage their company. The Goddings' interest in the Dells was short-term; they wanted to boost business in order to sell their Dells properties at a profit. For this purpose, Nat Wetzel was the ideal man. Wetzel had gained notoriety as someone who viewed nature for its extractive, not inspirational, potential. This point of view was, unfortunately, fairly widespread in the decades following the Civil War.

As railroads penetrated sparsely settled regions of the country, hunters were able to transport local game swiftly to urban markets. In 1874, shortly after Henry had surveyed the slaughter of passenger pigeons near Kilbourn, a survey revealed that an immense deer kill in Wisconsin had glutted New York markets, driving the price for venison down to the paltry sum of six cents a pound. Even in this environment, however, Wetzel was in a league of his own. In the 1880s, as a young entrepreneur in Kansas, he had employed scores of professional hunters and farmers to supply game for the expanding market in Kansas City. His weaponry normally consisted of five-shot pump guns, but his most remarkable method may have been "threshing" waterfowl—swinging hand-held wire flails at low-flying flocks. Known as "the King of the Market Hunters," Wetzel later turned his attention to Texas, where he grew rich from ventures that included a line in frog meat in Houston.

After his first visit to Kilbourn and the Dells in the late 1890s Wetzel was reported to have said, "That's just fine! Now we need some attractions!"[4] Wetzel promptly introduced the serving of liquor on the steamboats. Another of his improvements took the form of whitewashing the lower trunks of the pine trees on the riverbanks at the Larks, where Nellie and George Crandall managed the hotel. For added excitement, Wetzel brought in a hippopotamus and installed a raccoon in a cage and a sea lion in a tank.

With liquor now sold on the steamboats, one inebriated excursionist reputedly fell into the water and drowned near Gates Ravine. The somewhat exotic animals did not fare well. Jerry,

the sea lion, was sick and coughed from the very beginning; he did not survive the summer. Then someone left the door to the raccoon's cage open one day, and it escaped. The hippopotamus also died in the ravine north of the Birch Cliff Hotel, thus ending the animal attractions for that year.

Henry began to feel better, and he wrote to Wetzel to quote prices for photos the Goddings' Wisconsin Dells Company could use for advertising. He offered to go to St. Louis, where Wetzel and his wife were living, to give a slide show of Dells views. Not only did Wetzel decline the offer, but in 1900 he refused Henry permission to sell his photographs on the excursion boats. This was a serious economic blow. A lucrative portion of Henry's business had consisted of boarding the boats and photographing the tour groups at key stops along the river, then quickly returning to the studio and producing souvenir photographs to sell to the tourists when the boats returned to town. This work had always provided a steady income, earning Henry nearly seven hundred dollars in 1891. Combined with what Henry insisted on calling the "amateur photo craze," Wetzel's action resulted in a real deterioration of business for the studio.

"Apollo Steamboat with Tourists." In 1891 Bennett made nearly seven hundred dollars by taking photographs of tourists on the steamboats, then swiftly racing to the studio before they returned so they could purchase "Keep-sake photographs." In 1900 new owners denied Bennett permission to sell his photographs on the excursion boats. (WHi-69015)

A despondent Eva wrote relatives, "[Henry] is not out on the river much this year—is not picturing the boat at all. The relations with the Dells Company are quite strained and things are very unpleasant this year." Business was so worrisome, in fact, that in 1900 Henry placed his first order for nonphotographic souvenirs. A salesman for Indian-made baskets and curios had been persistent in his attempts to have the studio carry his merchandise. Henry had previously refused to do business with him, but the relentless salesman returned. He had canvassed other shops in Kilbourn City, but all said most of the tourists went to the Bennett Studio, and that was the only place to sell his wares. Eventually, Henry placed a small order for sweetgrass baskets and Indian dolls to get rid of the pesky salesman. Until then, nothing but Henry's well-crafted photographic prints had been sold at the studio. The success of the basket salesman was a foot in the door for the sale of tourist merchandise. When Henry placed a substantial order for one hundred dollars' worth of baskets, Evaline cried all night.

In a sense, H. H. Bennett had always been selling souvenirs. The pictures people bought of scenic landscapes or themselves aboard steamboats were mementos of their journey to the Dells. But now the steamboat keepsakes were a thing of the past, and sales of other photographs were declining so precipitously that by 1903 Henry told relatives he was losing sleep and was "nearly wild" with anxiety. Business prospects looked so dismal that he thought even manual labor might be more lucrative.

Daughter Ruth Noel Bennett recalled making sand bottles for sale with her sister, Miriam. The children would fill little glass bottles with water and then sift different shades of sand inside in layers, poking them down inside the bottle with a straw. When the bottle was filled with sand it was then emptied of water and corked. The careless introduction of even a few grains of sand into the photography workrooms, where they might find their way under the prints, was a serious offense, so the girls' work was done outdoors in an adjoining shed. The proceeds provided the sisters with some pocket money, but they found their work discouraging when the sand bottles became too popular and the girls couldn't keep up with the demand.[5]

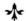

Henry's easy charm made him equally comfortable with a wide variety of people. He enjoyed meeting and talking with the tourists when they came into the studio, and those who met Henry seemed always to remember him.

Through the years members of the Ho-Chunk tribe had sold Henry some valuable pieces. He had purchased his first locally made Ho-Chunk handcrafted item—a bow—in 1883. Slowly he accumulated a number of such cherished objects from Ho-Chunk artisans. He kept them locked away if he knew the tribespeople would not appreciate seeing the precious items on display— things like a scalp lock, an otterskin medicine pouch, or a necklace of eagle and snake bones. But tourists who were interested in Indian artifacts and lore often enjoyed the experience of having these treasured old pieces brought out of hiding while Henry told the stories he'd learned from the Ho-Chunk.

To capitalize on the public's fascination with Native Americans and make up for his economic losses, Henry turned to the local Ho-Chunk, with whom he had a good relationship since

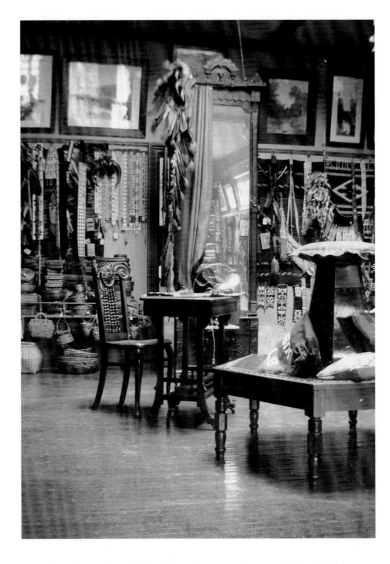

"Interior of Bennett Studio, ca. 1912." Evaline rearranged the studio to highlight their Native American goods and other souvenirs. Many of Bennett's contemporaries in landscape photography also found it necessary to supplement their incomes with other endeavors. (WHi-3998)

1866. He made a concerted effort to acquire more local Ho-Chunk artwork, especially highly prized beadwork and black ash splint basketry. By 1903 hardly a day passed without a Ho-Chunk artisan coming to the studio.

In the winter of 1904 a Ho-Chunk woman named Emma Pettibone sent Henry a package of her beadwork and that of her friend Susie Prettyman, including belts, watch fobs, and chains. He wrote back to her with an order for more belts with exact specifications: the belts should be twenty beads wide by twenty-five inches long, and he would pay one dollar each. He also wanted some watch fobs twenty beads wide and six inches long for which he would pay twenty-five cents each. "Send them before next Saturday," he urged. He made notations in his cashbook and paid the women at the end of the month. He tagged each piece with a name so tourists would know it had been Native-made.

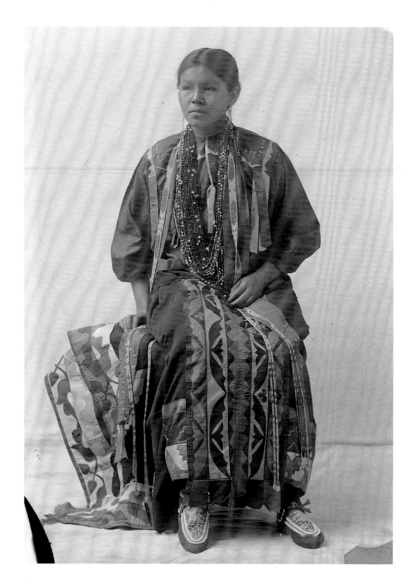

Emma Pettibone wears typical
Ho-chunk moccasins with flaps,
and the beadwork streamers are
pendants and ribbons from the
pajgae tied in her hair.
(WHi-8291)

The beadwork represented "Indianness" to tourists. It was light and inexpensive and could be easily packed to carry back to the cities. It was evocative of a visit to the Dells and its Ho-Chunk past. Henry and Evaline soon realized that selling Indian curios was the only way to keep their studio appealing to the tourist trade. To accumulate enough beadwork for the following summer's business, they began to purchase more abundant supplies in the winter. The women said they could produce more beadwork for Henry if they had better access to the necessary materials, so he began placing orders for seed beads, needles, and thread from a supplier at Fox Lake. He ran into problems with the quality of the beads and subsequently ordered them from Somers and Company in St. Paul, commenting that the beadworkers were "getting out of humor and I am looking what might develop into a good trade if I could get the beads."

The women preferred dealing with Henry, as he had provided them with their beading materials and an occasional loan, but they were becoming shrewd businesswomen and began to sell their work themselves. When they offered their work to a store owner across the street who would pay them higher prices, Henry purchased even more of the work and for more money, even though his inventory already held more than he could use.

To help out Pettibone, Prettyman, and Suzie Red Horn, whom Henry often referred to as one of the best beadworkers, and to disperse the large amount of beadwork he had accumulated, Henry began selling it wholesale to Gimbel Brothers department store in Milwaukee. They asked if one of the women could come to Milwaukee and demonstrate her art. She agreed but wanted her brother to come along—he made bows and arrows of hickory. They would need to be paid $2.50 per day. Henry was specific when he wrote back to Gimbel Brothers and advised them to treat the Ho-Chunk with respect and concern as they had never been in so large a city. Henry's surplus beadwork was also sold to stores in New York.

At least fifty Ho-Chunk families traded with the Bennett Studio. By 1904 beadworkers from all over Wisconsin were sending their work to him by mail. "They are hard up or unusually industrious," Henry wrote to a friend.

To make ends meet the studio was now relying heavily on nonphotographic souvenirs—the Ho-Chunk beadwork, Sioux war clubs from Mandan, South Dakota, and peace pipes, Navajo blankets, Pueblo pottery, model birchbark canoes, and shell trinkets. Henry's brother Ed was a prospector and miner in Cerrillos, New Mexico, and Henry acknowledged to him wistfully, "I am in the souvenir and Indian relic trade quite extensively."[6]

Henry tried to sell ginseng that the Ho-Chunk had gathered and also tried to market some German silver ear bobs. There was a sorry span between authentic Native American crafts and what he called the "cheap stuff that an Indian never saw until he saw it hanging in my place" or "all sorts of ocean shell goods made by the worst kind of Indians in Philadelphia and New York City." But Henry was an economic realist, and although there was strong popular demand for faux-Indian curios, he greatly preferred to deal in "genuine Indian articles" and repeatedly told his suppliers that he only wanted "*real* Indian work." He also insisted that suppliers furnish information about the purpose of each item and the materials of which it was made. Most important, he wanted to know the name of the individual who had created each item. When he sold a dozen items to the director of the Union Railroad Depot in Milwaukee, Henry assured his customer, "The name on each tag is really the name of the squaw of whom I bought the . . . article."[7]

Ashley expressed concern about all the Ho-Chunk individuals his father admitted to the studio, but Henry told his son that his "Ho-Chung-er-rah friends" were welcome and observed that he himself was a bit "Indianish." One of the Ho-Chunk Henry most admired was Thomas Ho-pin-kah, who spoke three languages and had written a book. Ho-pin-kah had attended an Indian boarding school in Tomah, the town where Henry had briefly maintained a photo-tent studio after eloping with Frankie.[8]

Another of Henry's favorite Ho-Chunk friends was Big Bear, or Hoonch-Shad-e-gah, whom Henry had met shortly after returning from the Civil War. The pair had remained close ever since. Hoonch-Shad-e-gah sometimes accompanied Henry on photographic excursions and may

Coo-nu-gah (First Boy) and
Hoonch-Shad-e-gah (Big Bear),
who had a close, forty-year
friendship with photographer
Henry Bennett. (WHi-69018)

have helped the photographer gain access to Ho-Chunk camps by serving as his interpreter. During visits to the studio Hoonch-Shad-e-gah performed medicinal ceremonies for the Bennett family, gave them gifts of artwork, and shared some of his people's spiritual beliefs. An entry in Henry's journal for January 13, 1904, tells of one such visit by Hoonch-Shad-e-gah:

> Big Bear skins a snake here in the back room of the gallery. Before beginning the operation he asks me for tobacco, some of which he sprinkles on the snake's head and asks me to do the same. . . . Then he tells me that snake like tobacco and when he get to see God he tell him Choo-cah-gah [the Ho-Chunk word for "grandfather," a name sometimes applied to Henry] and Hoonch-Shad-e-gah good men to . . . give him tobacco before they skin him. He also said God make snake same as he make men and everything else. He asked me to partake of fried snake with him. When I declined he said snake (wo-con-dah) "better as chicken."

One of Henry's pet projects for many years was to learn the Ho-Chunk language and record its words phonetically in English.[9] Ever the scrupulous record keeper, Henry filled several handwritten notebooks during his sustained study. Although Henry was not entirely accurate in his translations, some Ho-Chunk speakers can still recognize the words he was trying to capture phonetically. As his business increasingly depended on trade with the Ho-Chunk, he accelerated his language-acquisition efforts, as he noted in a letter to his friend Will Holly in 1903:

> Part of the winter now drawing to a close . . . I have given to cultivating our Indians, buying their beadwork . . . and trying to learn to talk with them. I have . . . accumulated a lot of their goods, bows, moccasins and beadwork . . . [but] I have not made the progress in learning to talk with them that I could wish. You see about the time I get it fixed in mind that wah-narf-ink soc-sic-e-rah, mar-shump-peen, means "Bead belt very good," something . . . diverts my thoughts from such an interesting subject and in a few minutes I have forgotten and would be as likely to say something that might mean "Winnebago Indian a rascal," or "Squaw Big Fraud," which of course would not be either polite or political in the presence of these people. But I have made a little advance over the days when you were here and I only knew a few names of Indians and objects.

Even as his studio was beginning to look like an emporium of Native American goods, including "bows and arrows, bead purses, birch canoes up to two feet long, medicine charms of weasel, squirrel and muskrat skin, etc.," Henry remained a photographer. In 1873 he had visited the encampment of Wah-con-ja-z-gah to take stereo pictures. He had photographed the Ho-Chunk at their homesteads on a number of occasions between 1878 and 1881. Now, two decades later and under economic duress, he undertook a series of formal studio portraits of his Ho-Chunk neighbors. Not surprisingly, many of the subjects were individuals he considered friends. These included Ha-Zah-Zoch-Kah (Branching Horns), who may have been among the local Ho-Chunk who performed in Wild West shows, and Chach-Scheb-Nee-Nick-ah (Young Eagle), whom Henry described as "one of our most intelligent men." Henry intended these showy, technically elegant portraits taken in 1904 and 1905 to reach a broad American audience. To this end, he photographed the sitters—who were paid for their efforts—in multiple formats and copyrighted the portraits.

Although he participated in the growing market for all things Native American to supplement his income, Henry never abandoned his love of traditional landscape photography. Around 1900 he started printing in clouds on his larger photographs. As John Szarkowski, curator of photography at the Museum of Modern Art, later noted, "Skies were a thorn in the side of the nineteenth-century photographer; because of the limitations of his blue-sensitive emulsions, the sky was generally either dead or false, and often both."[10] Henry addressed this situation using a technique that incorporated two negatives. He printed the negative of the landscape first. Then he cut a mask roughly the shape of the land forms and placed both the mask and a negative of clouds on the print of the landscape. Finally, he printed the cloud negative in the landscape's sky. For views that featured both water and sky, Henry took this process one step further and printed the reflection of the clouds in the water (for an example, see "Lone Rock with Canoe, Wisconsin

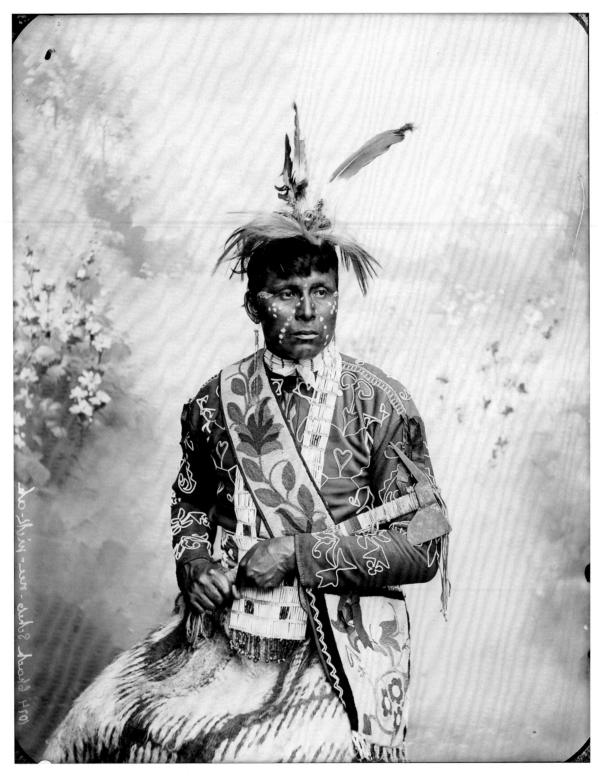

Chach-Scheb-Nee-Nick-ah (Young Eagle) sat for this elegant portrait taken by Bennett in June 1904. It was produced in a variety of formats. The photographer copyrighted the images and forgave a seven-dollar loan he had made to Young Eagle. (WHi-2285)

Dells" at the beginning of this chapter). His fine craftsmanship made this technique effective and allowed him to add drama to many of his views. Several of his glass negatives were specifically of clouds.

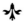

The Grand Army of the Republic (GAR) had chartered the John Gillespie Post #50 in Kilbourn in 1882. Henry, of course, was one of the charter members, and throughout his life he maintained a continuous interest in the organization. Many reunions of his old Civil War company were held in the hall, and old war comrades visiting Kilbourn often stayed at the Bennett home nearby.

In the early 1900s Henry corresponded with many of his buddies from Company E in order to help compile a history of the company and regiment in the Civil War. Hosea Rood, the youngest man in their outfit, wrote the text. Glyde Swain was in charge of printing and binding. Henry collected the photographs of those men who wished to be included in the volume. Five hundred copies were printed and sold by subscription in 1893 under the title *Company E and the 12th Wisconsin Regiment in the War for the Union, 1861–1865. Written for Our Children and Grandchildren.*

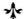

Since switching to dry plates, Henry had enjoyed a close relationship with the Cramer Dry Plate Works of St. Louis. He must have been entertained by a project undertaken by Cramer in 1901: the company was planning to make a photograph plate eight feet long and over four feet wide. The *New York Times* said it would be used by George Lawrence of Chicago, who would make a photograph of the cities of St. Paul and Minneapolis from a hot air balloon.[11]

How far things had come since Henry and his brother Georgie had opened their modest tintype studio in Leroy Gates's dark and drafty little building thirty-seven years before. Georgie had gone on to Texas and New Mexico and then Chihuahua, Mexico. He had gained respect as one of the most important photographers in the West while working with W. Henry Brown in Santa Fe.[12]

Kilbourn City had reached a population of about one thousand citizens in 1901. Streets were unpaved, and sidewalks consisted of planks varied by stretches of sandstone flags. Part of the regular expenses of the village went for oil and wicks for the streetlamps and the wages of the lamplighter, Gus Kaufman. Many corners in Kilbourn were now occupied by saloons. Broadway, west of Superior Street, was mostly a ravine leading down to the river. Homes had little or no inside plumbing or central heating. During 1901 the village board received a petition for a franchise telephone line and poles from Bell and Conway, which was granted: the first public telephone line in the community made its appearance. Four doctors, one dentist, and two lawyers had cards in the newspaper's professional directory. The volunteer fire department had been in existence for a decade; in 1901 it responded to three calls.

Next door to the Bennett house, in the GAR Hall, entertainment consisted of home talent plays, lectures, magic lantern shows, and high school commencement exercises. When *The*

"Popcorn Party," 1894. Obviously posed, but a favorite winter evening pastime nevertheless. Note the photograph of Frankie in the center, flanked by wedding pictures of daughters Hattie and Nellie. (WHi-8285)

Mikado was in rehearsal at the GAR Hall, Henry and Eva frequently stopped to watch and listen after work in the evening.

On winter nights the Bennett family would sometimes let one of the wood fires that heated the house die down to a glowing bed of coals. Then Henry would get out a long-handled wire popper and pop a dishpan full of popcorn. The children would bring him his guitar, which he had taught himself to play, and they would sing songs he had learned during the Civil War: "Marching Through Georgia," "Tenting Tonight on the Old Camp Ground," "Lorena," and "Nickodemus the Slave." His daughter Miriam later remarked, "I do not know how well he played, but it surprises me that a man with so maimed a right hand undertook such a hobby."

The family experienced additional excitement when Ashley left his Irish setter, Jack, with his family for several years in the early 1900s. Ashley may have used Jack for hunting a couple of times, but to the young Bennett girls, Ruth and Miriam, Jack seemed like their dog. Henry himself must have liked him, too, for in one of his letters to his son the photographer penned these words from Jack:

Dear Ashley,

I think the people you left me with think a good deal of me and I think I will of them when I get used to them; but I got a scolding for chasing one of the squirrels in their back yard one day so I won't do that any more unless I forget.

I can't help being lonesome but I have some fun going out with your little sisters and nieces. Once in a while I go out with a white headed man who I mind pretty well and I don't fight with other dogs when he calls me. I wanted to go with your stepmother today when she drove off to Big Spring but the rest wanted me to stay with them, which I did after having a short run in front of the team when she started.

I want you to stay and see me when you go to Chicago in February so you will know how good I have been.

I hope this is a happy New Year.

This is from your own Jack.

His Mark [a pawprint].[13]

"View out Phantom Chamber." A stunning interplay of light and shadow, especially in stereo, lending a mystical quality to this tourist destination near Witches Gulch. The chamber was submerged after the construction of the Kilbourn dam. (WHi-7525)

10

Shadows

1903–1908

Mr. Bennett was often called "The Father of the Dells." . . . A character as firm as the rocks he prided so well, a name that will last while they do.

—*Mirror-Gazette*, Kilbourn, Wisconsin, January 2, 1908

Winter and spring were always quiet times in Kilbourn City and in the Bennett Studio. Daughters Ruth and Miriam recalled a New Year's Day reception held in the Bennett home in 1903 as the most exciting party ever. Invitations were sent to more than 140 guests in the village. The rooms had been lavishly decorated with beautiful palms and bright holly. Punch and refreshments were served, including little cakes from an out-of-town confectioner and crunchy Saratoga chips, an unusual delicacy. Miriam was assigned the responsibility of showing the guests where to put their wraps but enjoyed eavesdropping on gossip regarding the exclusive guest lists. Due to smoldering social and business feuds in the village, guests had to be invited at different times so opposing factions would not accidentally find themselves face-to-face.

> In spite of all precautions there were a few such encounters but without open hostility. And there was also the problem of the rather disreputable son of an important family who, ordinarily, would not have been invited. However, he had recently married a charming lady from another town, and it did not seem kind to slight her, whatever the hostesses thought of her husband. The couple was invited and came. Father behaved in his usual courtly and charming manner and the hostesses were gracious though wondering, no doubt, what she could see in him.[1]

Miriam remembered the Bennett home as being altogether harmonious despite business and health worries and the twenty-year age gap between her parents. Henry was the very opposite of a stern parent, except one time when Miriam spoke disrespectfully to her mother, and then she felt the effects of his discipline. He often brought presents home from his trips. One was a toy woodman who would "saw" when placed above the dining room stove by means of the current of warm air rising from the heater.

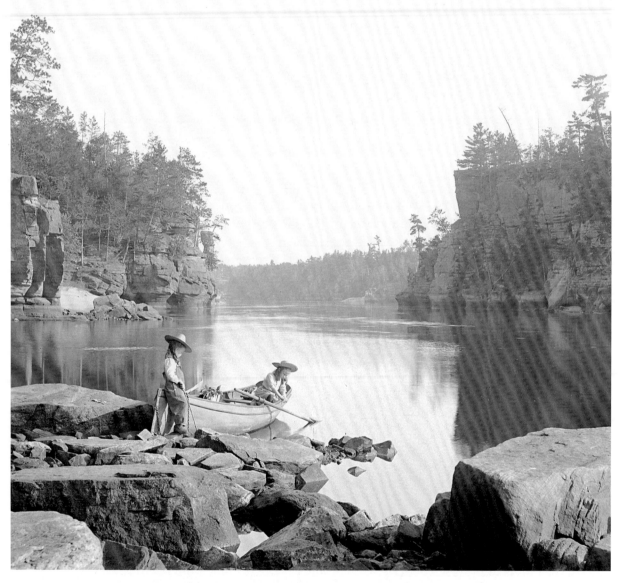

"The recollection of long days on the river is one of the chief prizes of my childhood," daughter Miriam said. (WHi-7337)

Like Hattie, Nellie, and Ashley before them, Miriam and her younger sister, Ruth, often posed for Henry's scenic views, occasionally with their mother and Uncle Frank, dressed in their best clothes. Miriam recalled, "In summer Mother and we two children spent many Sundays with Father in his rowboat or on the beaches of rocky banks of the Dells while Father set up his camera and waited for the best time and light for the view he wanted at the time. We always ate a picnic lunch."

They enjoyed exploring the rocky cliffs as their mother called out warnings not to go too close to the edge; they posed overlooking the river, waiting for the steamboat to pass as Evaline assured them it would come any moment now; they stood beside the water and usually heeded their mother's warnings not to get their best shoes wet.

> Years afterward Mother said that Father complained mildly that it was harder to move his small family on these expeditions than a company of infantry. Just the same, he took us along. When we children had to pose in the picture it was quite tiresome to leave our sand castles or toy boats and stay in one place till the exposure was made. Nevertheless, the recollection of long days on the river is one of the chief prizes of my childhood. Father never pointed out the beauty of the scene he was trying to transfer to his negative—perhaps he thought it obvious.

Often, Miriam said, Henry may have photographed them for the purpose of experimenting with various styles and materials, which she called "trying on the dog." Henry was known to take pictures of himself for the same purpose, using a string to click the shutter. Ruth and Miriam

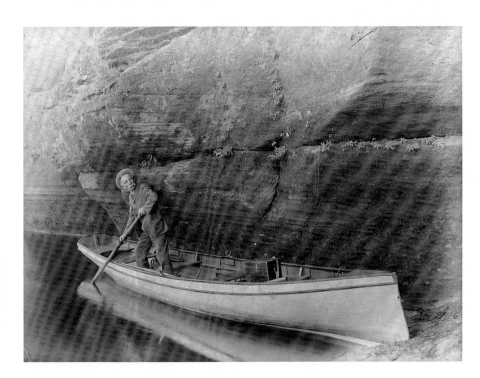

Ruth and Miriam appreciated photographs of their father at various stages in his life. (WHi-38831)

later treasured photographs of their father that had been taken at various ages because eventually they could remember him only as a rather stooped figure with white hair and a moustache, showing the effects of illness, age, and early hardship. His heavy and bent shoulders, Miriam said, may have come from exercise at the oars of his boat.

Both girls prized one last trip into Adams County during their childhood. Due to rutted roads and the lack of motorized vehicles, the rocky bluffs of Adams and Juneau counties were not easy to reach, but Henry never lost his interest in returning to the area. Perhaps he had a sentimental attachment, a bit melancholy, recalling his week-long trip in the wilderness with William Metcalf and the other men at Camp Mosquito Bite. It brought back memories of the adventure of picturing together, the hard-boiled eggs, the rum, the camaraderie, the beginning of a long and highly cherished friendship.

At any rate, one day Henry hired a livery rig and set off with Eva, Ruth, and Miriam for a final drive into Adams County. The roads were thick with sand, and the pace was slow. Ruth was subject to motion sickness and had to walk much of the way. Somewhat piqued, Miriam remarked, "Except for this handicap we might have gone farther than Rocky Rock where we stopped for the night at the home of the farmer who owned the place. We children found the rock fascinating with its nooks for playhouses. I do not remember that Father made any photographs there, at least none were published from this trip. Perhaps he wanted just to see the place."

"Looking Through the Port Hole at Coon Castle." Bennett enjoyed framing stereo images in this fashion to dramatize the separate planes of distance. The rock formations of Adams and Juneau counties were favorite subjects and beloved destinations. (WHi-7457)

Recalling good times in his past was uppermost in Henry's mind during the winter of 1903. He took advantage of the quiet days to write letters, including one to Will Holly, a former employee who now lived in Los Angeles:

March 14

My Dear Will,

. . . I don't know how many moons have been here since I had a letter from you or wrote one to you, but I don't believe . . . there has been a single moon here that I have not thought of you and the many enjoyable hours we used to have. . . . You are often in our memories. . . . I have been trying all this time to meet the world halfway in the matter of being good, with but indifferent success, however, in a financial way.

A little more than three years ago the "Old Fellow" conducted me to the banks of the river we all must cross sometime; but I told him that I would have to see him again later as I had a lot more work to do at the Dells before I quit; but it's been harder work to work hard since then, a disease being fastened to me that some doctors say I will never fully recover from, though I may hold out several years longer. . . .

Prosperity kindly lets me just about hold my own by working diligently with hand and head, that is, just lets me hold my own, can't get ahead and don't fall back much. If I get a dollar that I don't owe must put it into the business to . . . meet the continual changes that are taking place. For instance, the last two seasons . . . we have done more business with souvenir goods than pictures . . .

I have kept busy most of the winter in making prints of various sizes and styles, hoping to sell them next summer. Just now we are printing and finishing a few thousand stereoscopic views, mostly from new Negs that I made last fall. That trade just about holds its own. Neither increasing or decreasing in the past several years. The same old trimming and mounting machine that you knew is putting them onto the cards, the same engine and burnisher standing in the same places is finishing them, and the same press will print the titles though I am using gelatine paper to make the prints on now instead of albumen paper as in the old days.

If you were to look in here now you would hardly see any difference . . . from when you last saw it. I am writing at the same old desk you knew so well. Almost the only changes I can recall are the absence of a tank and windmill, our city well water being so much better than my well that I put [city water] in a little more than a year ago. The only new invention is a washing machine where the tank was. . . .

No, I could not show you much that is new here in the back room unless it might be a more gray head and moustache. But if I should hear your footstep on the walk . . . I would open the side door and shake hands with you cordially and we would have a good smoke and tell stories as of old.

Over at home everything is the same, only the babies are older and the wife shows a few gray hairs. She and Hattie unite with me in expressions of sincerest good wishes for you. Ashley is in Minneapolis, Northwestern agent for the Winton automobile.

I have no unmounted prints of . . . the views you note, but enclose with this a set of 18 unmounted views that have proven quite popular, no bill.

I would like to put on my bonnet and grab the little "Black box" and take it out among the grand mountain scenery of your region but I'm afraid I can't at least in the near future. I am mighty glad to have your letter and to hear from you again as your time and inclination may permit.

By the end of the 1903 season Henry had reported more income but also more expenses. Competition with the Wisconsin Dells Company grew even keener when that company began cutting into Henry's sales by marketing its own postcards. Henry tried to counter the company's move by sending a boy to the railroad station to sell postcards to passengers as they disembarked from the excursion trains. Tourists no longer had an opportunity to visit the studio because they were escorted directly from the railroad depot to the steamboat. So-called train butchers soon drove Henry's boy from the depot grounds, but Henry wrote a letter of protest to his friend in the railroad passenger department and the postcard boy was left alone from then on.

By the middle of September Henry had planned to make some more stereos and, if possible, picture some new scenes at Devil's Lake and Mirror Lake. He believed it was still worthwhile to try to tempt customers with fresh and different views.

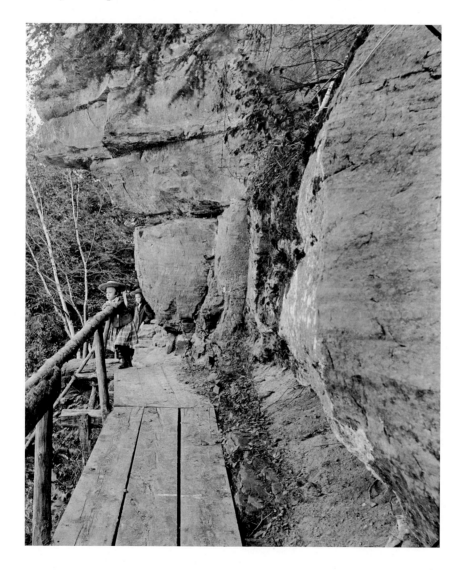

Still searching for different views, Bennett went to nearby Mirror Lake with his daughters Ruth and Miriam in the autumn of 1903. (WHi-68566)

Glossy-surfaced prints had now been replaced with dull-surfaced mounts. Henry rented his stereo mounter to the International View Company of Decatur, Illinois (with detailed operating instructions), and gave the company permission to copy it. However, he added, he knew of no mechanic who could copy the machine at any price. Since its inception Henry had made a few changes from time to time, but the stereo mounter was essentially the same device that had been utilized without mishap for at least twelve years.

When he mounted some stereo views for a Minneapolis amateur the next year Henry complimented the photographer: "A pretty good lot for hand camera work and especially for film negatives. For stereo work I prefer a 5×8 camera, either focal plane shutter or behind the lens shutter with adjustable panels."

Meanwhile, Nat Wetzel had recently moved to the area to more closely manage the Goddings' properties in the Dells. Now, he told reporters, he intended to open up the Wisconsin River to navigation from the Mississippi. The editor of the local paper proposed an electric road between Baraboo and Kilbourn City, claiming better advertising would bring more tourists for an even longer season. "Kilbourn must do something to supplement nature," the editor claimed. "The attraction of mere scenery is no longer all that is expected." In fact, a constant stream of tourists was now visiting the Dells, increasing the business of Kilbourn City hotels and boardinghouses. Many of these tourists arrived in their own automobiles, ignoring the preplanned outings provided by railroads or tour boat operators.[2] These tourists were interested not just in what they could *see* at the Dells but what they could *do* there.

Wetzel, simultaneously promoting hydraulic improvements in Kilbourn as well as coastal Texas, was also talking up a new dam on the Wisconsin River at Kilbourn—no doubt with the idea of selling the Wisconsin Dells Company's riverside real estate to a power company. A low timber dam with an opening in the center to permit the passage of lumber rafts had been built there in the 1870s, but it washed out a few years later with the help of raftsmen who claimed it was a danger to navigation after one of their number drowned on that spot.[3] The small timber dam constructed in 1894 to power a flour mill had washed out in August 1897.

In 1901, when a higher and much stronger dam was being proposed, Henry became truly alarmed. He wrote to John Godding and to his friend Mr. Miller of the railroad passenger department, stating his fear that a dam as high as projected would surely obliterate much of the natural beauty of the Dells. His words fell on deaf ears.

The following year some preliminary planning for the dam was already in progress. Dismissing the argument that the dam would harm the area's scenic appeal, the *Mirror-Gazette* stated, "The Dells is a drawing feature, but can hardly be classed as one of our dependable resources. . . . The revenue [from the Dells] is not inconsiderable but not indispensible." In fact, many citizens were looking forward to Kilbourn becoming a factory town.

Henry remained convinced that the scenery of the Dells would be severely affected if the water level were to be raised even as little as ten feet. He wrote to a friend, "The element in town that don't care about the Dells are sanguine that great things are to come from it (the dam) and that Kilbourn is to become a great manufacturing point. I have always felt that our future is in the Dells."

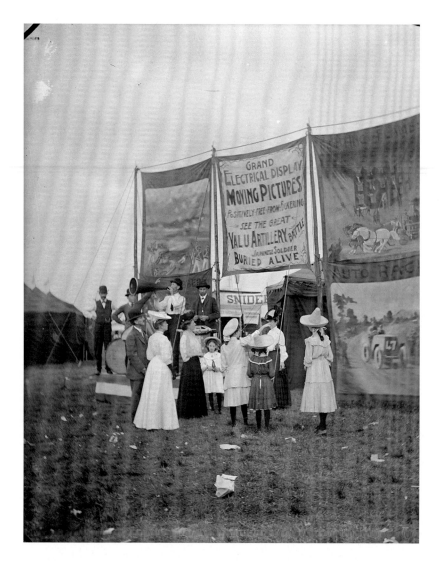

The Bennett women have succumbed to the man with the megaphone and prepare to view the Grand Electrical Display of Moving Pictures at the 1905 Inter-County Fair. (WHi-8135)

Believing that a scenic asset such as the Dells should be the property of the state and preserved in its natural condition, Henry contacted anyone and everyone he thought might be able to help. The Beautiful America Club, a woman's organization, circulated a petition to the governor and legislature of Wisconsin, urging that the Dells and Devil's Lake be made state parks. In 1904 a state commission began investigating both sites.

In 1905 the power and land rights were sold to the Southern Wisconsin Power Company. Almost at once, preparations were made for a modern power plant. Work for the 600 kilowatt hydroelectric development was to begin in 1906 and the entire plant was to be open for business in August 1909.

Henry was feeling well enough by 1905 that he took time out from battling the dam to attend the Thirty-ninth National Grand Army Encampment in Denver, Colorado, on September 7 and 8. There he was reunited with his brother Ed, who had lived in New Mexico for many years. It would be their final visit.[4]

The trip to Denver was the highlight of the decade for Henry. It even surpassed the pleasure he'd had in writing to Ashley, "The phone is installed and everyone who uses it thinks its fine, even the 'Hello Girl' (Miriam) says it is the best ever was. I got our electric light man to put it up and am mighty pleased with the way it works. Eva and I both wonder already how we got along without it and we have only had it going one day. It's going to save us lots of steps."

By early 1906 the Goddings' grand plan for land development in the Narrows had fallen through. Not a single cottage had been built in the subdivisions they had grandly envisioned. In August the local newspaper (perhaps with Wetzel's encouragement) proposed that the river should be made navigable all the way up to Nekoosa. In the Dells cliffs would be crowned with turrets and domes in medieval architecture, "occupied in splendor and ribald gayety by the newly rich."[5]

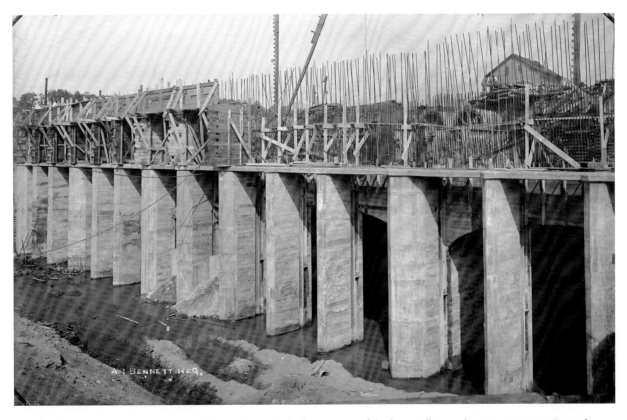

In this photo by Henry's brother, Albert I. Bennett, the beginnings of the huge Kilbourn dam are apparent. Ground had been broken in 1906. Industrial prosperity was eagerly anticipated by most of Kilbourn's citizens, although Bennett was convinced the future lay in preserving the Dells. (WHi-68565)

The reality of the dam was such a devastating threat by early 1906 that Henry became obsessed with the plan. He spent nearly all his time writing letters to people whose influence, he hoped, might help prevent its construction. In January he asked Representative H. C. Adams to try to get the War Department to forbid a dam without a lock, because the Wisconsin River was considered a navigable waterway and under government control. Henry pointed out that tourists were of more benefit to Kilbourn and the state of Wisconsin than any hydroelectric plant could possibly be. He also wrote to Senator Robert LaFollette, asking him to intercede with the War Department. Henry reiterated all his arguments. Raising the water as high as proposed would inundate beautiful scenery; farms above the Dells would be flooded and land taken out of production; there were no businesses in Kilbourn that would use the proposed factories; there was only one railroad to transport any products made in those factories; the Dells would bring in more revenue through its scenic attractions than anything produced by the imagined factories, even if they should materialize one day.

Senator LaFollette replied that the only hope of preventing the construction of the dam lay in the courts. The men's correspondence contains no discussion of ways to meet the prohibitive legal expenses of a lengthy lawsuit. About this time Henry wrote to a Chicago friend who had a summer home in Kilbourn. "I wish I was Czar (not of Russia) for a little while," he said, "just long enough to kill this *damnable* business." (Henry's children remembered that "I wish I was Czar" was one of his favorite remarks.)

The Federated Women's Clubs of Wisconsin had taken an interest in preserving the Dells and Devil's Lake as state parks. Julia Lapham, chairman of the landmarks committee, corresponded frequently with Henry on that subject. On January 1, 1906, he asked Lapham, "Why should such beauty spots [as the Dells] be destroyed or even injured as has been by building dams and cutting trees here for the profit of perhaps a few men when the good God made it that all people for all times might enjoy the beauties?" Later, he addressed the issue of funding for a lawsuit in a plaintive letter dated March 2, 1906:

> I was told of a "fighting lawyer" who holds a deep interest in the preservation of the Dells and was given to understand a move was to be made to collect funds for the purpose; but when this is to be done or how I have no knowledge, and hearing nothing more of it am wondering if that plan has been dropped.
>
> My energies for near a lifetime have been used almost entirely to win such prominence as I could in outdoor photography and in this effort I could not help falling in love with the Dells. There are few people who see them who don't become infatuated in a greater or less degree. Except with me, every rock that is to be hidden from sight is a sacrilege of what the good God has done in carving them into beautiful shapes, but very few of my good Kilbourn neighbors feel this way and most of them believe now that the Dells will be quite as beautiful with fifteen feet of them under water. If I thought the rest of the people of Wisconsin felt as they do I would have to be convinced that I have overestimated their beauty.
>
> Kilbourn was born with the idea of a great water power being generated here, and a mass of our people cannot give up that hope and they will not listen to my statement as to what they have done

(the Dells) for our village. "A prophet has no honor in his own land." Perhaps if someone of some degree of prominence were to come in here, whose heart was in the preservation of the Dells, some of our people at least would be convinced that the Dells are better as they are, and that it is wiser to take care "of the goose" that has already laid many "golden eggs."

My good wife is asking me to sell what I have here (not much) and go away somewhere else, and I assure you, my good friend, it is lonely work trying to pull the Dells away from what I fully believe in the end will mean their destruction. This pull against all my neighbors is tiresome and far from agreeable at times, for some who think they work harder than I do are impatient that my efforts may "prevent their getting more work."

The *Milwaukee Free Press* featured an emotional full-page article in its Sunday magazine section on February 25, 1906, under the headline "Scenery of the Dells Threatened by Development of Kilbourn Water Power." The story was illustrated by several views of the Dells and a photograph of Henry, "whose work," in the words of the newspaper, "as an artist and photographer first advertised the beauty of Wisconsin Dells. He is now fighting for their preservation and is opposing the construction of a dam."

But Henry's desperate efforts were unavailing. Early in December 1906, Nat Wetzel's wife, on behalf of the Wisconsin Dells Company, dug the first shovelful of earth at the site of the 340-foot concrete dam, which was expected to raise the level of the Wisconsin River seventeen feet and generate 8,200 kilowatts of 25-cycle power for the Southern Wisconsin Power Company. "A Great Commercial Center Is Ours!" proclaimed the *Mirror-Gazette*. Henry was heartbroken, but he would not listen to Evaline's suggestion that they sell out the studio and move away.

Evaline said her husband's health began to seriously decline during the following summer, 1907. His brother Arthur, from Minneapolis, and Don, who lived in Cleveland, visited the Bennetts in Kilbourn for a reunion of six brothers. "No man ever made a braver fight for health than he and had he been willing to save himself and shirk a little, he might perhaps have lived longer, but this would not do," Evaline wrote in the family's genealogy.

The studio was now selling more souvenirs than photographs. Daughter Miriam worked in the studio with Evaline and said their "Norse pottery from Rockford, Illinois; sweet grass baskets, Indian dolls, Peter Pan purses, souvenir spoons, photographic cushion covers, lantern slides and other views of the Dells, including ten different colored post cards, were popular."

Henry reported to a friend that there were very few furnished houses for rent because so many workmen had arrived to start on the dam. In the meantime, at least for the season of 1907, the scenery of the Dells was unaffected by construction on the dam, which, Henry greatly hoped, might not be constructed as high as first reported.

On October 21 Henry consulted a noted kidney specialist in Chicago. The diagnosis was an advanced stage of Bright's disease.[6] This was the first he and Evaline knew exactly what was causing his ill health.

Buehler's Sidewalk Machine installed the first sidewalks in Kilbourn City, replacing the town's board walkways. It was the beginning of a new era. (WHi-69016)

Although weak and unable to do much on the river with his camera, Henry managed to get out and take a few pictures. The last photographs he made were of clouds, which he intended to use for masks. He took the cloud scenes from the railroad bridge below Kilbourn City late in the autumn of 1907.

On November 6 Eva wrote to her sister, Ruth Marshall:

> Henry gets no better. [His doctor] seemed very hopeful but I have been fearing lately that all was not as it should be. I have intended to ask [the doctor] for the truth and I have just done it. According to him it's a nearly hopeless case. . . . He says it's a breaking down of the tissues of the kidneys. . . . I will save him! I have once, but oh, I didn't have such a fear at my heart as I do now. I can't lose him—what will I do? . . . Forgive me, I am almost wild and I must keep up and not let Henry know by my

face and I am such a poor one to hide my fears. . . . [Hattie and Nell] went away Monday. I wish they were here this winter. . . .

 Yours with a broken heart,

 Evaline

 Later—have just been talking with [the doctor] again. He tells me of two cases he has had where the wasting had begun and both men recovered and are still living though they are younger. I shall save him if there is any such possibility. If I can only keep up hope and not let him know how serious it is.

Despite Eva's best efforts to shield her husband from medical information, Henry Bennett grasped the gravity of his situation—if not by reading Eva's face, then by the testimony of his own body. On November 14, 1907, he drew up his will.

In 1906 Bennett commented, "It is lonely work trying to pull the Dells away from what I fully believe in the end will mean their destruction. This pull against all my neighbors is tiresome and far from agreeable at times." (WHi-68564)

In December 1907 Evaline took her husband to Madison, where he stayed for two weeks at the home of a kidney specialist. Their children, Miriam and Ruth, then sixteen and twelve, remained in Kilbourn City with neighbors and sent their father daily letters filled with drawings and expressions of concern. Ashley wrote to Eva from Minneapolis, "Don't let Daddie get discouraged, tell him he is better even if you don't think he is. . . . We will have to tell a few little white lies to Daddie, maybe."

When it became obvious Henry would not recover, Eva brought him back home. Nellie was in southern Texas and unable to travel, but Hattie, who was also in Texas, returned to Kilbourn City to be near her father. Ashley drove down from Minneapolis. Miriam, Ruth, and Evaline watched at his bedside.

At 5:20 on the morning of January 1, 1908, Henry told his wife, "I love you," and then died.

The following day the front page of the *Mirror-Gazette* featured its weekly "Dam Notes" on the front page and detailed the pouring of concrete piers for the dam. In the upper left corner of the front page was this prominent headline: "PIONEER PASSES AWAY—Useful Life Ended but Memory Still Lives." The two-column article announcing the death of H. H. Bennett concluded, "The one great consolation of the family and friends will be in the thought of a great work well done, a high ideal placed above all else and followed unerringly, irrespective of and ignoring all

Evaline photographed the new Kilbourn dam after it began operation in August 1909. (WHi-69106)

criticism. A character as firm as the rocks he prided so well, a name that will last while they do. Of the great good he has done we need make no mention. It is obvious to those who know. There will be a short family service at the home tomorrow morning followed by a service in the G.A.R. Hall at 10 o'clock. Rev. R. T. McCutchen of the Episcopal church will officiate."

The Grand Army of the Republic Hall was filled, "about all families in the community being represented," for the ritual service of the Grand Army. Expressions of sympathy poured in to the family from across the nation, according to the *Mirror-Gazette*. Henry's affable character and beautiful photographs had touched so very many people. His old comrades from Company E, Twelfth Wisconsin Volunteer Infantry served as pallbearers. He was buried in the Bennett plot in the Spring Hill Cemetery near the rest of his family.

The newspaper's obituary said, "Mr. Bennett's life bears not one single reproach. He lived as near to the line of moral perfection as is possible in human nature. His most intimate associates never knew him to manifest an impure motive. He was warm-hearted and even affectionate with his friends, and during the active period of his Grand Army relations, and ever with his old comrades of Co. E., no heart was nearer the hand-clasp, no sentiment of loyalty more earnest and sincere than that of Henry Bennett."

In the end Evaline spoke of "the great void that was left when this great-hearted, devoted husband, father and brother was called to his reward." She concluded that no better or more fitting eulogy could be composed for Henry Bennett than the one he had written for his own father. In the family history he had begun compiling on a cold January night eleven years earlier, Henry had said of his father: "His life was one of hard work but done as a brave man does his work. He never shirked or wronged a fellow man. God bless him always. None knew him but to love, honor and respect him. May his rest be perfect."[7]

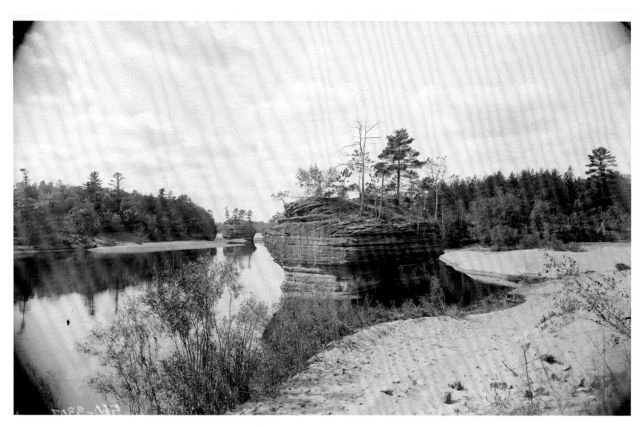

"Ink Stand and Sugar Bowl," seemingly isolated in serenity, with no clue of the railroad embankment nearby. (WHi-68898)

11

Guardian Spirits

1908–2010

No man can own the Dells. He can only be its custodian for a time.

—George Crandall, husband of Nellie Bennett Crandall

T HE BENNETT FAMILY REALIZED HENRY HAD DIED OF A KIDNEY DISEASE, but privately they wanted to believe that he had died of a broken heart. Evaline was only forty-four, with two school-age daughters and a business to deal with.

"My sister Ruth and I were school girls the year father died," Miriam said. "I was a high school sophomore at the time but my recollections of him are dim and incomplete and it seems now that I was not very well acquainted with him. Oddly, the only talk with him that I remember took place in 1907, shortly before his death. He said something about 'not giving up the ship.' I promised I wouldn't."[1] Ruth remarked, "Mother was strong. She always let Father be the forceful one while he was alive, but after he died she took over and went on. There was no sudden break in the business. She had six months to recover from her sorrow before the tourist season began."[2]

Miriam recalled, "Mother ran the studio competently though she was never the aggressive or driving type. She had a family to support and could not give up to grief. Fortunately, she had enough experience in the studio to be able to carry on, although she did little photography except for studio portraits. To her we owe the preservation of so much of Father's work and the records where his story is found."

"The Dells are closed," Nat Wetzel declared in July 1908.[3] Six months after Henry Bennett's death, Wetzel left Kilbourn and returned to Raymondville, Texas, where he was a key supporter of projects to dredge canals and build roads through coastal marshes.

The Larks Hotel did shut down, albeit temporarily.

T. F. Godding, Wetzel's employer, had died in Longmont, Colorado, in 1907, reportedly "highly respected." Fate was not so kind to his brother, John E. Godding. Perhaps overextended by his real-estate ventures, John was convicted of bank fraud in 1908 and sentenced to eight to

Ruth and Miriam Bennett.
"My sister and I were school girls
the year my father died."
(WHi-68563)

ten years in prison. As president of the State Bank of Rocky Ford, Colorado, Godding had continued to accept deposits when he knew his bank was insolvent. According to a January 12, 1909, notice in the *Ogden (Utah) Standard*, when rumors reached Rocky Ford that the governor of Colorado intended to pardon Godding, "a delegation of depositors of the defunct bank appeared before the Governor and made emphatic protest." Instead, Godding's sentence was reduced to two years, which Godding served as inmate 7309 in Colorado's state penitentiary.

The Wisconsin Dells Company was disbanded soon after Wetzel left Kilbourn. It is possible that Wetzel had been promoting and urging the building of the dam so he could sell the Godding property to the Southern Wisconsin Power Company—the best, if not the *only*, prospective buyer.

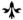

Henry's fear that raising the water in the Upper Dells would discourage tourism was not realized. The dam *did* raise the water seventeen feet at the dam site, a level higher than expected, and few factories were built in Kilbourn to take advantage of the water power produced there. But Henry's family had more to say about the preservation of the Dells. He was an idealistic

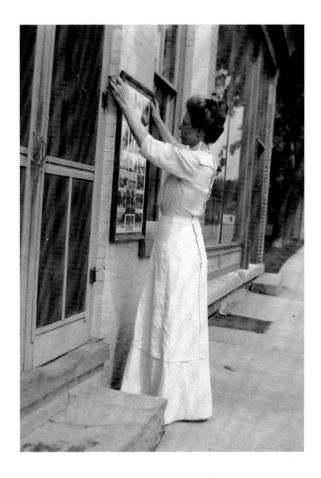

Evaline Bennett in front of the Bennett Studio. This photograph is from about 1916. Daughter Miriam said, "Mother ran the studio competently. . . . She had a family to support and could not give up to grief." (WHi-40710)

conservationist, and until his death he remained dedicated to preserving the Dells scenery in its natural state. Fortunately, his descendants are still carrying on the fight.

Nellie Bennett, Henry's daughter, married George H. Crandall from Milwaukee in 1893. He was the night operator at the Kilbourn City Depot. In 1895 the Crandalls began renting Glen Cottage, a seven-room house built in 1857, and converted it into a small hotel. The cottage was preserved and incorporated into the Crandall Hotel around 1914. In 1898 the new Wisconsin Dells Company asked the Crandalls to manage their Larks Hotel (later the Dells Inn) at the head of the Narrows between Artist's Glen and Cold Water Canyon. Nellie's sister, Harriet Bennett Snider, who had been widowed as a young bride, helped her sister and George in managing the hotel. They had their own cow, pastured up over the hill behind the resort, because it was not practical to bring milk up from town.

In 1905 the Wisconsin Dells Company sold its holdings to the Southern Wisconsin Power Company, which then purchased riverbank property to avoid paying flowage fees for land that would be covered by the water backed up by the new dam. The power company persuaded George Crandall to manage these properties, along with other riverfront land threatened by logging. As Crandall watched the shoreline develop with resorts and hotels, he began to dread

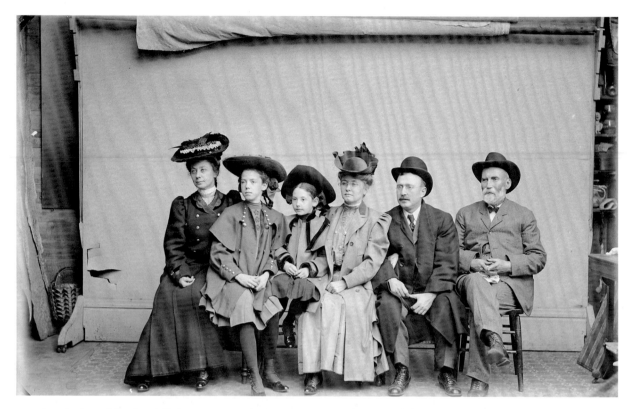

A gathering of the Crandall clan in 1906, with Hattie Bennett Snider on the left. Hattie was helping the Crandalls with the Larks Hotel. The Crandalls and their descendants would be instrumental in the preservation of the Dells. (WHi-68562)

too much "improvement," fearing it would obliterate the beauty that drew people there. He began to buy up river frontage and eventually purchased all of the property formerly owned by the Wisconsin Dells Company. Where trees had been cut, he reforested. His land purchases halted plans for roads, hotels, cottages, and signboards along the river banks. In 1909 Crandall quit the railroad to take over a sight-seeing boat operation on the Upper Dells. He stopped the sale of liquor on the boats and drove off the gamblers. Ever since, the pattern of catering to families has been maintained at the Dells.

By the time George Crandall purchased Stand Rock and the Hotel Crandall in 1914, he was also a partner in the Dells Boat Company and the owner of the steamer *Apollo* and several small launches. In 1929 he bought out most of the Dells Boat Company. In 1934 Crandall purchased a half interest in the boat operations on the Lower Dells, which had been unaffected by the dam. After his death in the winter of 1938 and that of his wife, Nellie, in 1952, the Crandall daughters and their husbands, Phyllis and Ralph Connor and Lois and Howard Musson, transferred hundreds of acres of Dells property to the Wisconsin Alumni Research Foundation. The donation included the Crandall holdings of 1,200 acres of land along the river, the assets of the Dells

"The Giant's Hand." Another of Henry Bennett's favorite photographic landmarks in the Upper Dells, eventually submerged by the dam. In the Lower Dells, landmark sites such as Lone Rock, Ink Stand, Sugar Bowl, Cave of Dark Waters, and Overhanging Rock remained largely unaffected. (WHi-68560)

"Cold Water Canyon." An idyllic setting whose entrance now lies submerged far beneath the water. (WHi-8035)

Boat Company with its three launches, the Hotel Crandall, the Stand Rock amphitheater, and an undivided half interest in the Lower Dells properties. The only buildings to be allowed on the riverbank would support tour boats and their passengers. After that, other gifts were donated to WARF, and the foundation bought further riverbank properties on its own.

Many of today's tourists who visit Wisconsin Dells are unaware that the glorious scenery along the river was the original attraction.[4] Few visitors know of the iconic Bennett locales that were lost forever—the Navy Yard, Boat Cave, Bass Cave, Giant's Hand, Diamond Grotto, Phantom Chamber. After the dam raised the level of the river, boats had to navigate through groves of trees to reach selected areas. Witches Gulch became more accessible. New walks were built, and Stand Rock could be reached by boat instead of on foot.

Thanks to the wisdom and dedication of the Bennett family, the Bennett Studio remains at its old spot on Broadway. After Miriam Bennett graduated from Rockford College she joined her mother in running the studio, and her father's work became her life. She exhibited a love of photography at an early age, and after Evaline's death in 1945 Miriam spent many hours sorting

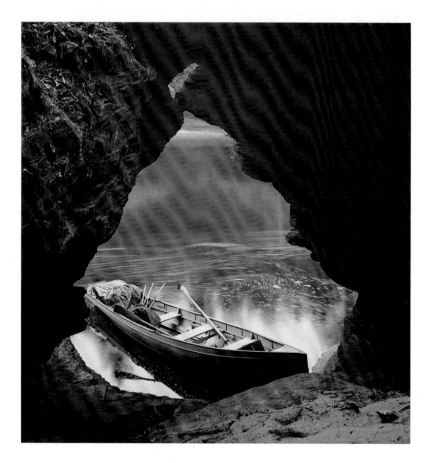

"Bass Cave." Few visitors to the Dells today are aware of the glorious scenes that originally attracted H. H. Bennett. Bass Cave is another, gone forever. (WHi-7344)

and categorizing Henry's negatives.[5] Her writing ability and subtle wit helped to capture forever her father's life stories and his contributions to the Dells in a lengthy, unpublished memoir, "The Camera Man of the Dells," and a shorter, more personal essay, "Postscript: A Daughter's Eye View of the Camera Man," as well as numerous newspaper articles. Miriam died in 1971.

Miriam's sister, Ruth Bennett Dyer, died in 1982 at the age of eighty-six. She had helped Miriam in the studio and was a member of the National Professional Photographers Association.

Ruth's daughter, Jean Dyer, married Oliver Reese in 1945. Oliver had dreamed of becoming a river pilot since boyhood; after World War II his dream finally came true. In 1946 he began his apprenticeship in the studio, which he and Jean eventually operated for over forty years. During the 1950s the family built and gradually expanded a museum of H. H. Bennett's vintage prints, negatives, and equipment. Ollie made and sold prints from the original glass plates. He and Jean became the parents of three daughters, Deborah (Kinder), Betsy (Grant), and Lisa (Henrickson).

In 1976 the Bennett Studio and the antebellum home at 825 Oak Street where Evaline and Henry moved shortly after their marriage were named to the National Register of Historic Places. Founded in 1865, the studio was then the oldest photographic studio in the United States to be continuously operated by members of the same family. In 1978 the Smithsonian Institution removed a few of the negatives from the studio, along with the solar enlarger and the revolving printing house, for restoration and display at the Museum of History and Technology.

Oliver and Jean Reese approached the Wisconsin Historical Society in 1994 with an offer to donate the Bennett Studio building at 213 Broadway, a neighboring building, and the extensive Bennett archive to the society with the condition that the gift would become an Historic Site. The remarkably original condition of the 1875 studio building, the valuable collection of glass

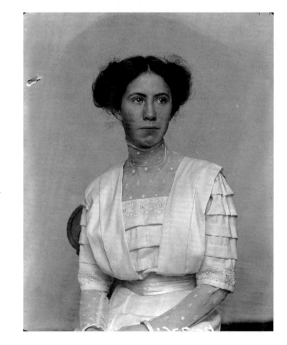

Miriam Bennett created a memoir of her father that is the very heart of this biography. She never married but became a photographer and filmmaker and cared for the family's papers, the studio, and the Bennett negatives until her death in 1971. (WHi-68561)

negatives, and the location and popularity of the current enterprise caused the Wisconsin Historical Society to seriously consider the Reeses' generous offer. The potential of a retail and visitor support space offered by the neighboring building further added to the viability of the complex.

Under the auspices of the State of Wisconsin, the Department of Facilities Development, and the Wisconsin Historical Society, a preliminary master plan was created by Uihlein Wilson Architects of Milwaukee. In 1995 measured drawings and field surveys were taken of the studio and annex, extensive records were made of existing rooms and equipment, and an oral and written history was obtained through interviews with Oliver and Jean Reese.[6]

The Uihlein Wilson Architects' notes indicate the building was a wood-framed, brick veneer structure with wood windows on all four sides and an elaborate integrated sidelight/skylight facing west. The front facade could be characterized as Italianate, with a double leaf center entrance and transom light flanked by flat arched windows and an overhanging cornice above.

The daughter of Ruth Bennett Dyer, Jean married Oliver Reese in 1945. They continued the Bennett Studio for almost fifty years and in 1994 donated the studio and collection to the Wisconsin Historical Society. On June 8, 2000, they cut the ribbon at the dedication of the society's ninth Historic Site. (courtesy of Wisconsin Historical Society)

The interior featured an ornate inlaid wood floor in the reception room where Bennett received his patrons. Through the years various "improvements" had been made. For example, on March 9, 1910, Evaline sold the west half of lot 10, block 46 (the twenty feet of unbuilt area) to Daniel T. O'Neil, who put up a building between the original studio and the building twenty feet to the west, which had been built in 1907 by Evaline's brother Frank and had been used as a post office. O'Neil's building did not extend the full eighty feet of the lot's depth, but it did extend beyond the skylight of Bennett's studio, necessitating its removal. Other remodelings were undertaken at this same time, including the demolition of the wall between the reception room and the operating room and the demolition of the parlor and storeroom. A probable reason for this was the increased tourism in Kilbourn City and consequent opportunities for a souvenir business. Evaline required more space for expanding a business that was to become more lucrative than photography. Where the original skylight opening existed, a new, smaller skylight was built to illuminate the back of the new retail area. The original photo-finishing room was remodeled with a new skylight where three original windows existed. This skylight overlooked a "garden" that was behind O'Neil's building, and the new room was used for continuing the portrait photography business. The original darkroom remained intact but was expanded to accommodate amateur photography development. The plank floor in the operating room was replaced with a narrow strip floor at this time.

The Wisconsin Historical Society's ambitious new project was started in April 1999, with construction commencing in August of that year. Uihlein Wilson Architects executed the project's overall design, and Dells Lumber of Wisconsin Dells served as general contractor. Ollie and Jean had initiated the project with their $1 million donation, including the photo equipment and glass-plate negatives. A coalition of community leaders and interested partners who formed the H. H. Bennett Studio Foundation raised the remainder of the $2.9 million goal. Guided by the H. H. Bennett Advisory Committee, the foundation directed construction of the project. In June 2000 the H. H. Bennett Studio was dedicated as an Historic Site by the Wisconsin Historical Society.

After the June 8 dedication ceremony for the completed museum, the H. H. Bennett Studio opened on June 9, 2000, with Jim Temmer as director. The six-thousand-square-foot site highlights the history of Henry Bennett's career and depicts Bennett's historic studio, including his darkroom, restored to its appearance in 1908, the year of his death. Adjoining buildings display his photographs and provide storage of his glass-plate negatives.

Through a series of interactive exhibits, visitors can walk through the history of the Dells, from a steamboat excursion down the Wisconsin River to a close-up look at a Ho-Chunk camp. One exhibit re-creates the wonder of Bennett's stereo photographs, viewed in three dimensions on specially programmed computers linked with liquid-crystal eyeglasses. Henry would be amazed!

Thanks to funds from a Save America's Treasures grant, a photo archivist in Madison has duplicated all of Henry's glass negatives. Ollie Reese recalled, "Some of these negatives are 150 years old, but they're tough. In summer we put them in the garden in wooden boxes, in the rain and sun. In the winter we'd put them in the studio, which would freeze." Facsimiles of the negatives are used to make copies of Henry's photos, which are available for sale at the studio.

The H. H. Bennett Studio and History Center, with a replica of the Bennett Studio in its original location. (courtesy of Wisconsin Historical Society)

Appropriately, however, a few Bennett mysteries still remain. Commenting on the process Henry used for making his vast panoramas, Dale Williams, the current director of the Bennett Studio, says, "We can't figure out how he masked the lines between the plates. We also don't have his glue recipe, which he used for his stereoscopic images. He made the best glue."

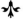

It has now been well over 150 years since Henry Bennett journeyed from Brattleboro to Kilbourn with his father, and more than a century has passed since his death. As Bennett foresaw, the area is a destination more suited to tourism than manufacturing. But it's not likely he would have been able to imagine the Ho-Chunk Casino, the whimsical waterslides, the fudge shops, the day spas, the indoor theme parks, or the incredible crowds. The fifteen miles of shoreline on

the scenic Wisconsin River have been surrounded by nineteen square miles of commercial enterprises that host three million visitors annually—fifty-five thousand visitors per day during peak periods. The Dells region offers eight thousand hotel and motel rooms (more than any other city in the state) and has eighteen campgrounds with 2,780 sites. The economic impact is huge: a one-year total of visitor spending recently topped the $1 billion mark. As the official Water Park Capital of the World, the Dells has more than twenty indoor and outdoor water parks and more than two hundred waterslides that require approximately sixteen million gallons of water.

Meanwhile, threatened by its own popularity, the Dells of the Wisconsin River continue to experience intense pressure from developers just as it did in Henry's time. Henry's great-grand-daughter, Deborah Kinder, is one of the major organizers of Stewards of the Dells of the Wisconsin River, a group formed out of a concern that future development should not be visible from the water. Since April 2006 the conservation organization has sought to protect the fifteen miles of shore frontage along the Upper and Lower Dells, from Nine Eagles to the Rocky Islands, including such famous landmarks as Stand Rock and the Rocky Islands of the Lower Dells.

"Navy Yard from Black Hawk's Leap," where—before the dam was built—residents of Kilbourn City would gather each spring to watch the Wisconsin River rise to the top of the rock walls and roar through the gap. (WHi-7798)

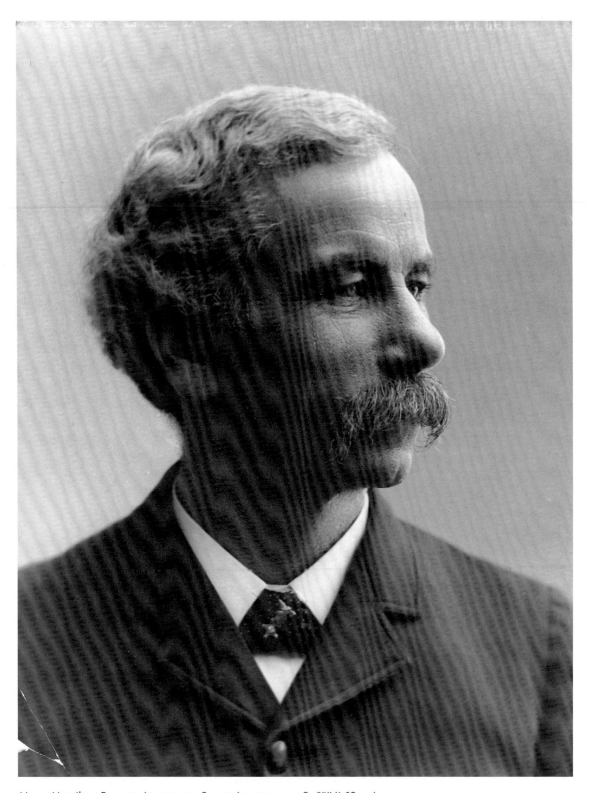

Henry Hamilton Bennett, January 15, 1843, to January 1, 1908. (WHi-68549)

"I feel H. H. and all of my ancestors, and especially my dad, lined up behind me as I work with the amazing group which has formed the Stewards," Debbie Kinder says. "I am lucky to have growing support in the Dells for our mission."[7]

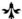

The bank swallows still make a punctual appearance every spring, rediscovering their nesting holes in the sandstone rocks that have been carved out by nature to sculpt the majesty of the Dells.

The first tour boats are ready for launching in mid-April, when observant sightseers along the shore can spot twenty-seven varieties of ferns and the delicate pink blossoms of trailing arbutus—the same fragrant flowers Bennett gathered and shipped to his photographic colleagues.

Across the river from Stand Rock, the craggy banks of Witches Gulch echo with the sound of rushing waters, just as they did in Henry Bennett's day.

"There are few people who see [the Dells] who don't become infatuated in a greater or less degree," Henry Bennett wrote to Julia Lapham in 1906. Through Henry Hamilton Bennett's creative efforts and his family's continued dedication others are able to share his love for a landscape that enchanted and inspired the Dells photographer for almost his entire life.

Notes

1. Oliver and Jean Reese in discussion with the author, August 1991.
2. Kouwenhoven, *The Arts in Modern American Civilization*.
3. Hales, "American Views and the Romance of Modernization," 205.
4. H. H. Bennett to James S. Clark, July 2, 1887, and April 3, 1888, H. H. Bennett Papers, Wisconsin Historical Society (hereafter WHS).
5. Carter and Butcher, *Photographing the American Dream*, 10.
6. Szarkowski, *The Photographer and the American Landscape*, 4.
7. Ralph Waldo Emerson, *Nature; Addresses, and Lectures*, 16.
8. Peter Henry Emerson, *Naturalistic Photography for Students of the Art*, 258.

CHAPTER 1. EARLY DAYS: 1843–1864

1. Bennett's photographs in the MoMA exhibit were selected by John Szarkowski, the museum's newly appointed curator of photography, and included "Among the Crags on Bluff, Wisconsin Dells (1870–73)"; "Canoeists in Boat Cave, Wisconsin Dells (c. 1890–95)"; and "Sugar Bowl with Rowboat, Wisconsin Dells (c. 1889)."
2. Szarkowski, *The Photographer and the American Landscape*, 4.
3. According to a family history compiled by H. H. Bennett in 1897, George Bennett's grandfather (Henry's great-grandfather), Aaron Bennett, was an aide to General George Washington during the Revolutionary War and died at Valley Forge in the winter of 1777. Henry's mother, Harriet Houghton, was the granddaughter of Abraham Houghton, who fought in both the French and Indian War and the Revolutionary War. She was also related to Commodore Oliver Hazard Perry, who commanded American naval forces on Lake Erie during the War of 1812 and, after defeating the British squadron, famously reported to General William Henry Harrison, "We have met the enemy and they are ours." "Bennett Family History," January 2, 1897, Bennett papers, WHS.
4. Henry's siblings: Edmund, October 25, 1844; George, February 1, 1846; Sarah, December 29, 1847; Albert, August 8, 1850; Charles, March 24, 1853; William, April 8, 1855, to August 28, 1855; Clarence, July 26, 1856; John, November 3, 1857; Don, July 12, 1858; Arthur, June 17, 1862; Harriet, July 2, 1865.

5. Kilbourn City was named for the Honorable Byron Kilbourn of Milwaukee, a Wisconsin pioneer and capitalist. Actually, it would have been appropriate to spell the name Kilbourne. His granddaughter Mrs. William Thorndike explained in 1935 that his descendants always spelled the family name with an *e*, but Byron Kilbourn became so tired of correcting those who dropped the *e* from his name that he finally dropped it himself.

6. Byron Kilbourn (1801–70) was born in Granby, Connecticut. He was a surveyor, land speculator, and politician, active in helping to settle and promote Milwaukee. He was twice elected that city's mayor. He was also a pioneer in the promotion of Wisconsin railroads and the principal organizer of the Milwaukee and Waukesha Railroad Company in 1847, the first railroad company in the state to begin actual construction. The line was renamed the Milwaukee and Mississippi, with Kilbourn serving as president. He was forced to resign in 1852 due to alleged fraud and mismanagement. He then became the principal organizer of the rival La Crosse and Milwaukee Railroad and obtained a land grant from the state to aid its construction. Later it was discovered that he and his associates had used $900,000 in railroad bonds to bribe state officials in obtaining the land grant. The subsequent scandal and investigation ruined Kilbourn's public career.

7. *Kilbourn Weekly Illustrated Events*, Kilbourn, Wisconsin, May 1905, bicentennial edition, July 1976.

8. *A Standard History of Sauk County, Wisconsin*, vol. 1, ed. Harry Ellsworth Cole (Chicago: Lewis Publishing, 1918).

9. In Bennett's time the Ho-Chunk were known as the Winnebago. In November 1994 the Wisconsin Winnebago chose to once again be known by the name they had always called themselves—the Ho-Chungra or Ho-Chunk, which means "People of the Big Voice."

10. "Dells of the Wisconsin: Black Hawk's Cave," 298–99.

11. More recent research concludes that Black Hawk found shelter among Ho-Chunk living near Tomah, well north and west of the Dells, and he traveled voluntarily under Ho-Chunk protection to Fort Crawford in Prairie du Chien, where he surrendered to federal authorities.

12. Miriam Bennett, "The Camera Man of the Dells," 5.

13. Unless noted otherwise, all subsequent material about George Houghton in this chapter comes from Donald H. Wickman, *George Houghton: Vermont's Civil War Photographer*.

14. Introduced in 1839, the daguerreotype was named for one of its developers, French artist and chemist Louis Daguerre. In a daguerreotype the image is formed directly on a polished surface of silver coated with particles of silver halide that have been deposited by a vapor of iodine, bromine, or chlorine. A daguerreotype is a one-off negative image, but the mirrorlike surface of the metal plate reflects the image and makes it appear positive in the proper light. Though the daguerreotype was not the first photographic process to be invented, its short exposure time was comparable with portrait photography and made it the first commercially viable type of photograph. The first photograph of Abraham Lincoln was a daguerreotype made in 1846 or 1847.

15. Houghton's first wife had died in 1855, and he remarried that same year. He then abandoned his family for Wisconsin in 1857. His new wife was reputedly shrewish and most likely demanded his return.

16. Austin, *The Wisconsin Story*, 127.

17. H. H. Bennett, "Bennett Family History," January 2, 1897, Bennett papers, WHS.

18. Rood, *Story of the Service of Company E*, 42, 43–44.

19. Ibid., 58–59.

20. Ibid., 105.

21. Ibid., 106.

22. Cordelia Harvey was nicknamed "The Wisconsin Angel" by soldiers. She established several soldiers' hospitals in Wisconsin, and one in Madison, named for her, became a home for soldiers' orphans. It was also where Henry spent time recuperating after the accident to his hand.

23. Downing, *Downing's Civil War Diary*, 142.

24. Miriam Bennett, "The Camera Man of the Dells."

Chapter 2. Discovering the Landscape: 1864–1867

1. Wickman, *George Houghton*.

2. Invented in 1856, tintypes were made by a wet-plate process in which the photographic emulsion was spread on a thin piece of black-enameled iron. The resulting image was a negative, but against the black background it looked like a positive, albeit reversed from left to right. To correct this reversal, some cameras were equipped with mirrors or a prism. A photographer could prepare, expose, develop, and varnish a tintype plate within a few minutes.

3. This was a significant sum, the equivalent of roughly thirty-five dollars today.

4. Georgie Bennett to Henry Bennett, Houghton Collection, Brooks Memorial Library, Brattleboro, Vermont.

5. Current, *The Civil War Era*, 412.

6. The collodion, or wet-plate process is very simple in concept: bromide, iodide, or chloride salts were dissolved in collodion, which is a solution of pyroxylin in alcohol and ether. This mixture was poured onto a cleaned glass plate and allowed to sit for a few seconds. The plate was then placed into a solution of silver nitrate and water, which would convert the iodide, bromide, or chloride salts to silver iodide, bromide, or chloride, respectively. Once this reaction was complete, the plate was removed from the silver nitrate solution and exposed in a camera while still wet. It was developed with a solution of iron sulfate, acetic acid, and alcohol in water.

7. Autograph books were a custom brought to this country by German immigrants, who enjoyed the tradition of having friends sign their names and add reminiscences of common experiences, good wishes for the future, or a favorite passage from literature or poetry.

8. Bennett papers, WHS.

9. Bennett papers, WHS.

10. An advertisement for J. Jolley's picture gallery in Portage appeared in the August 18, 1857, *Wisconsin Mirror*. The accompanying article noted that Jolley, who frequently visited Kilbourn, provided photographic services for daguerreotypes in his Kilbourn hotel room. McIlroy, "Henry Hamilton Bennett (1843–1908)," 39.

11. Black River Falls, located some seventy miles northwest of Kilbourn, was a center of Ho-Chunk settlement at the time. Elsewhere in central Wisconsin, by contrast, families and clans were widely dispersed. The small-scale Ho-Chunk homesteads near Kilbourn were used mainly as headquarters for establishing small gardens and constructing wigwams to store belongings. In the fall families wintered along the Mississippi River near La Crosse, where they hunted and trapped. In the spring they returned to the Dells area, where they tended their crops, worked as farm laborers, and picked wild blueberries, which they sold in small towns like Kilbourn.

12. This may have been the bridge at the Narrows, which was washed out in a freshet soon afterward.

13. Francis Irene Douty, born July 3, 1848, in Elmira, New York, was the daughter of Rufus M. Douty and Nancy Jane Douty. They had four other children: Chancy M., Mattie, Leland, and Jane. The Doutys came to Kilbourn City from Elmira in May 1857 and then moved to Menomonie in 1868. In February 1869 they moved to Eau Claire, Wisconsin, where Rufus, born at Charlton, Massachusetts, died January 29, 1887. Nancy died in Minneapolis on September 10, 1888.

14. The religious ceremony was performed by E. McGurley. Witnesses were Theodore Freer and Matilda Bray. Later in his life Henry Bennett would alter the date of his marriage in the family history to hide from daughter Hattie the fact that her mother had been pregnant with her at the time.

15. Towler, *The Silver Sunbeam*, 131.

16. Daniels was the fellow from Rockford who had purchased the Gates Studio in Kilbourn City.

17. Wickman, *George Houghton*.

CHAPTER 3. PICTURING THE DELLS: 1868–1875

1. Author's interview with Ruth Bennett Dyer, January 24, 1978.

2. Newspaper clipping, unknown source, Bennett papers, WHS.

3. "During the 1860s the number of male photographers increased by a factor of only 1.4 whereas the number of female photographers quadrupled. In other words, while the rate of increase for male photographers declined during the 1860s, the rate of increase for female photographers accelerated rapidly" (Jay, "Women in Photography," 4).

4. The wet-plate process had been perfected by Frederick Scott Archer (1813–57), an Englishman who discovered that he could produce negatives that were sensitive, uniform, transparent, and stable by applying a collodion solution to a polished glass plate. The liquid had a syrupy consistency and could retain its sensitivity only while wet; thus, the method came to be called the "wet process," as the plates had to be kept moist during the exposure to light and developed immediately afterward.

5. The preparation of the glass plate was crucial for success. Towler's chapter titled "Wet Collodion Process" in *The Silver Sunbeam* directed the photographer to proceed as follows: place the piece of glass in a vise to clean and polish; hold the glass in one corner and pour enough of the viscous collodion (often with iodide and a bromide added) over the surface to form a smooth, even coating; soak the coated plate, while still tacky, in a bath of silver nitrate for about five minutes to make it light sensitive, or *excited*. This has to be done in the darkroom. After it has turned a creamy yellow, take it out, drain, and place it, still wet, into a light-tight holder.

Exposed in much the same manner as a tintype, the plate had to be processed immediately. To do so the photographer removed the plate from its holder and poured a solution of pyrogallic acid or protosulphate of iron over the surface. The image appeared as a negative within a matter of seconds, rapidly increasing in brilliance. When the photographer decided the plate had reached the peak of development, he rinsed the glass plate in clean water, poured a hypo of potassium cyanide in a solution over the plate, and washed it once more. To dry the plate, he held it between thumb and forefinger over a gentle flame, rapidly moving it back and forth. Needless to say, there were a lot of opportunities for mistakes.

The next step was to produce a positive image, or print, from the negative fixed on the glass plate. This would take place in the photographer's darkroom (sometimes a tent) using special paper that had been coated with egg white, or albumen, to act as a binder for a silver-nitrate solution in which the paper was then bathed and dried. The coating of albumen and silver nitrate produced a smooth surface that was capable of resolving fine detail. To create a print the photographer placed the paper in close contact with the glass negative in a printing frame and exposed the paper and negative to light, preferably sunlight. Where the light passed through the negative, the paper rapidly darkened to a deep purple. The printing frame had a hinged door at the back that the photographer could open to check how the print was progressing.

When the print had reached the desired density, usually after fifteen to thirty minutes, the photographer took the frame back to the darkroom and removed the paper. The photographer then immersed the print in a neutralizing bath, called a fixing bath, which stopped the darkening and turned the purple image to a reddish brown. Many photographers added a final step, known as gold toning, to give the print a rich sepia tone.

A large photograph made in this manner might require an hour to print, fix, tone, and wash. No mechanization was possible at any step of the process, and no chemical shortcuts had yet been invented. Because there were no artificial sources of heat that would not damage the print, drying had to take place in the air. For a perfectionist like Bennett, a day's work might produce only a few finished prints.

6. Holmes, "The Stereoscope and the Stereograph," 745.

7. Ashley C. Bennett, "A Wisconsin Pioneer in Photography."

8. Wickman, *George Houghton.*

9. Current, *The Civil War Era*, 460.

10. Newspaper clipping from *Wisconsin State Register*, Bennett papers, WHS.

11. *New York Times*, September 17, 1869. The sensational story was closely followed by many large-circulation newspapers.

12. Goc, *Others Before You*; *New York Times*, September 19, 20, 21, 1869.

13. Szarkowski, *The Photographer and the American Landscape*, 3–4.

14. Wickman, *George Houghton*.

15. Newspaper clipping from *Milwaukee Sentinel*, Bennett papers, WHS.

16. Letter from John Muir to Sarah and David Galloway, July 1863, in *John Muir: His Life and Letters and Other Writings*, ed. Terry Gifford (Seattle: Mountaineers, 1996), 66–67.

17. Wisner, *The Tourist's Guide to the Wisconsin Dells*, 11.

Chapter 4. William Metcalf, Friend and Mentor: 1873–1881

1. Unless noted otherwise, all subsequent material about William Henry Metcalf in this chapter comes from Julia Metcalf Cary, *William Henry Metcalf: A Biography by His Daughter*.

2. Robert M. Sandow to the author, February 13, 2009. "I've also seen evidence that Metcalf had a darkroom in his Milwaukee home."

3. Edward George Earle Lytton Bulwer-Lytton (1803–73) was a florid popular writer of his day who coined such phrases as "the great unwashed," "pursuit of the almighty dollar," "the pen is mightier than the sword," and the famous "It was a dark and stormy night."

4. Newspaper clipping, Bennett papers, WHS.

5. Probably Ableman's Gorge on the Baraboo River just west of what is now known as Rock Springs in Sauk County. There, steep cliffs rise about two hundred feet above the river and extend for three-quarters of a mile.

6. See Hoelscher, *Picturing Indians*.

7. Metcalf suggested $2 per dozen for the small size; $2.50 per dozen for the large size; and $4.50 per one hundred in lots of two thousand or more. Hanson, "H. H. Bennett, Portraitist."

8. The revolving solar printing house was donated by the Bennett family to the Smithsonian Institution in 1977. Some of the shed's track had been removed for donation to a World War II scrap drive, but a Smithsonian spokesman said it was "in remarkable shape for its age."

9. "His first landscape camera he constructed out of cigar boxes; as he had only one lens, it was placed on a board which operated from one side to the other for making stereoscopic pictures, which were then becoming popular" (Ashley C. Bennett, "A Wisconsin Pioneer in Photography").

10. Hess, "H. H. Bennett of Wisconsin."

11. Metcalf possessed a stereo mounter and trimmer and may have printed some of the negatives himself. He also used a different color of card stock from that utilized by Henry. The Wisconsin Historical Society has in its collections Metcalf stereos from Bermuda, Norway, and Scotland as well as Japan.

12. In later years St. Paul photographer Truman Ward Ingersoll offered some of the same Japanese views for sale. Unable to compete with giant publishers of stereos, Ingersoll began issuing copy views in about 1898. The quality of his copies was poor, and they were published without attribution to either Metcalf or Henry.

13. Many years later Henry's son, Ashley, went to work for T. W. Ingersoll, a fellow photographer whose studio in St. Paul, Minnesota, employed up to sixty people in its heyday. Though Henry and Ingersoll were colleagues, corresponded regularly, and even went on photographing trips together, on this occasion Ingersoll took advantage of the relationship. He tried to get Ashley to divulge his father's "top secret." Henry expressed annoyance in a letter to Ingersoll: "I have to say I cannot think Ashley will give you my method of printing or that your sense of honor will allow you to expect or try to learn it from him, and I certainly

cannot give my consent to his giving it to you or anyone. . . . The fact of Ashley being in your employ can in no sense entitle you to use the process. Now, Friend Ingersoll, I think I have made myself clear in this matter and if you want the process it will be the cheapest in the long run to get it in a manly legitimate way" (Miriam Bennett, "The Camera Man of the Dells"). There was no further correspondence between Henry and Ingersoll on this subject.

14. The dry process, originating in Britain, involved coating photographic plates with a solution of gelatin, which acted as a vehicle for suspending the silver salts. The quality of the dry plates varied at first, and preparation of the gelatin emulsion was an inconvenience for photographers, like Bennett, who were accustomed to working with wet plates.

15. Taylor, *Reconnaissance of the Golden Northwest*, 48.

16. Miriam Bennett, "The Camera Man of the Dells."

CHAPTER 5. DEVELOPMENTS: 1882–1883

1. Reprinted in *Milwaukee Sentinel*, February 26, 1934, and included in *Wisconsin Dells Events* on February 27, 1936.

2. Ruth Bennett Dyer said the Broom Brigade was formed so Hattie and Nellie could get a sense of regimentation. The girls were once at a contest in Portage where some boys made fun of them, so when the boys were finished with their drilling the girls went after them with their brooms (interview by the author, January 24, 1978).

CHAPTER 6. THE SNAPPER: 1883–1888

1. Chapman's store was remodeled in 1883 but burned down on October 23, 1884. A Milwaukee paper claimed there was so much destruction that "a piece of lace big enough to trim a pair of pantalets couldn't be found in the ruins" ("Remember When," *Milwaukee Journal*, March 9, 1976). The 1883 Bennett photos may have been destroyed in the fire, as they cannot be found.

2. The Blair Tourograph and Dry Plate Company was incorporated in 1881 by Thomas Blair. The Tourograph was an unusual field camera designed and marketed by Blair. This name was in use through 1886. Blair would go on to be a prolific manufacturer of field and detective cameras through 1899, when the company, by then known as the Blair Camera Company, was purchased by Eastman Kodak.

3. Taylor, *Photographic Times and American Photographer*.

4. There were not many cameras as large as this, although W. H. Jackson had one that was even larger with which he photographed some Western scenes.

5. Perhaps a reference to a new, fast shutter that Metcalf was pressing Henry to perfect. He referred this person to Muybridge, who had by then photographed animals in motion.

6. In an autobiography dictated to his son in 1934, Ashley C. Bennett made this claim: "I was first in photography with my father for twenty years; and worked out means and ways for making panoramic photos from two or more separate negatives joined them together [*sic*] in printing the paper. One piece largest panoramic landscape photo in the world, printed from negative which father made. This was 18 in. wide, and 60 in. long, which today is the largest of all direct contact prints ever made." Quoted in a personal letter from Ashley Bennett (son of Ashley C. Bennett) to the author, June 9, 1980.

7. There was not much of a market for photographs of this size, and many were sold to railroads for display in ticket offices as advertisements for scenery along the line. During his tenure as director of the Museum of Modern Art in New York, John Szarkowski displayed the panoramic "Under the Overhanging Rock, Wisconsin Dells." Today, MoMA's holdings include several large-format albumen or gelatin silver prints: "Islands from the Cliff at Gulch" ($13\frac{3}{4} \times 10\frac{3}{4}$), "Layton Art Gallery" ($17\frac{3}{16} \times 21\frac{3}{4}$), and "Canoeists in

a Boat Cave" (13¾ × 10¾). Other Bennett panoramas are in private collections and in the Library of Congress, which, in addition to a few stereos and a panoramic postcard, has two copies of "Under the Overhanging Rock," "The Narrows, Dells of the Wisconsin," "The Wisconsin Dells from Sliding Rock," and "Jaws of the Wisconsin Dells."

8. The photogravure process was developed in England and France in the 1830s, even before the daguerreotype was invented, but it did not become widely used until the 1880s. In photogravure a sensitized copper plate is exposed to sunlight through a photographic transparency. The photographic image becomes etched deeply and permanently into the surface of the plate, from which it can be printed repeatedly. Because photogravure yields prints of exceptionally high quality and richness, many photographers adopted it for portfolio and exhibition work, and many fine art books were printed in photogravure.

Simon L. Stein was included in the "Big Six" group of photographers singled out in *Who's Who in Professional Portraiture in America* for raising the standard of photographic portraiture. Stein also had contacts in the world of publishing through his friend Edward Wilson, who edited and published books and magazines about photography.

9. Ingersoll, "Milwaukee," 702.

10. Durbin, "Two Wisconsin River Stories," 165.

Chapter 7. Personal Views: 1888–1890

1. Introduced in Scotland in 1787, cycloramas were huge cylindrical paintings of scenic places and dramatic historical events. Done on canvas, often by foreign artists, the paintings were displayed in specially constructed circular buildings. Cycloramas became wildly popular in the 1880s, and most major cities in America and Europe had a "theater" for viewing them. Some of the panoramic paintings measured more than forty feet high and nearly four hundred feet in circumference. Standing in the center of the display, viewers had the impression of being present in the middle of the place depicted. To heighten this effect, dioramas were sometimes built in front of the giant paintings, and music or narration was added to the display.

2. Pigs in Clover had just been invented that year and was all the rage, a national preoccupation. President Benjamin Harrison is said to have played the game in the White House instead of tending to politics. The game consisted of a maze constructed in a round box made of wood and cardboard. The purpose was to get all the clay marbles through the maze from the outer ring into the inner "pen" at one time. Within three weeks of its announcement the Waverly Toy Works was producing eight thousand puzzles a day.

Chapter 8. Urban Landscapes: 1890–1899

1. "The enduring power of photography lies in the acceptance of its images as credible documentary records with enduring archival validity. The apparent transparency of the photographic image promotes the idea of comparing photographs of the same subject taken at different times. Through photography, therefore, the urban landscape as it appears today may be compared directly with what it looked like in the past, so providing a new context in which both historical and contemporary images may be viewed and interpreted. Our understanding of history can be divided into two periods: the time before photography and the period following its invention" (London photographer Mike Seaborne, www.urbanlandscape.org.uk/ul-about.htm, accessed February 4, 2010).

2. An elaborate dedication ceremony for the Juneau monument, with profuse gratitude expressed to Bradley and Metcalf, had been held in Milwaukee on July 6, 1887. Juneau is recognized as "the Father of Milwaukee," but Byron Kilbourn, for whom Kilbourn, Wisconsin, was named, had battled with Juneau for control of pioneer Milwaukee and as district surveyor had chosen the site for the city.

3. Goc, *Others Before You*, 167.

4. The poem originally appeared in Wisner, *The Tourist's Guide to the Wisconsin Dells*, 7.

5. The Goddings and their wives led a party of thirty revelers in dedicating Camp Welcome in August 1894. In 1896 John Godding was elected Wisconsin's representative to the National Irrigation Congress. But in September 1897 the *Adams County Press* reported that T. F. Godding was among a party of prairie-chicken hunters involved in a fatal accident. Not long thereafter the Godding brothers hired Nat Wetzel to manage their Wisconsin enterprises and returned to Colorado.

6. Cary, *William Henry Metcalf*, 52–53.

7. The Ferris wheel wasn't actually completed until June, but it drew such huge audiences and reaped such enormous ticket sales that it saved the exposition from bankruptcy.

8. In her memoirs Miriam Bennett said she never remembered Henry expressing any religious views or attending any church, even though—according to their letters—his parents were very devout. "Writing of the death, in 1894, of his son-in-law, Fred Snider, Father's feeling was that he could not accept such a calamity with faith that it was divinely ordered for the best. [But] he continued to believe in a life after death and that the Dells should remain, as he wrote, as God made them" (Bennett, "The Camera Man of the Dells").

9. Goc, *Others Before You*, 144, 145.

10. Preston, "The Dells of the Wisconsin River."

11. Ruth said Ashley teased her and encouraged her to sit on the lamb, and the lamb eventually became a rug on the floor (Ruth Bennett Dyer, interview by the author, January 24, 1978).

12. Goc, *Others Before You*, 145.

13. *Kilbourn Weekly Illustrated Events*, Kilbourn, Wisconsin, May 1905, bicentennial edition, July 1976.

Chapter 9. Change in the Wind: 1899–1904

1. There was not much left at the Columbian Exposition fairgrounds since a massive fire had destroyed almost everything shortly after the fair closed in 1893. Perhaps that's why Henry used quotation marks when he said they visited the fair.

2. "Bennett Family History," entry by Evaline Bennett, Bennett papers, WHS.

3. In 1904 Ashley returned to Kilbourn City with four huge Winton touring cars that dashed through the streets. The cars were greatly admired by the natives but sent the simple farm horses (too many this time for Henry to restrain) galloping out of the way. In the autumn Ashley brought a mechanic and a Winton Bullet to race against time at the Kilbourn Inter-County Fair. The Bullet had set the unofficial land speed record of seventy miles per hour in 1902. The outer shell of the racer had to be removed, and as Ashley's Bullet tore around the small dirt track, the mechanic clung to one side to give it stability. Ashley's time on the five-mile track was nine minutes and twenty seconds. The condition of the track was said to have kept the speed of the car low, but the judge agreed that Ashley had won his race against time. With that achievement behind him, Ashley turned his attention to airplanes, one of which he built with a partner. It actually was able to leave the ground, albeit not for long. Henry wrote to his son, "Be careful about sailing around in that airship!" Essie divorced Ashley not long thereafter. She claimed he was addicted to morphine, chased other women, and was using up her fortune. By 1906 Ashley had married again. This time his bride was Helen Richardson. The couple moved to Minneapolis, where Ashley built the first structure designed especially as an automotive garage and opened a dealership for Winton cars. But the fortunes of the Winton Motor Carriage Company declined as competition mushroomed in the automobile business, and the firm stopped making cars in 1924.

4. Miriam Bennett, "The Camera Man of the Dells."

5. Ruth Bennett Dyer, interview by the author, February 10, 1978.

6. Henry made this comment in 1906. Several of his contemporaries, among the finest landscape photographers of the late nineteenth century, were similarly forced to modify their business focus in order to survive. Frank Jay Haynes, the official photographer for the Northern Pacific Railroad and Yellowstone National

Park, once maintained studios in the park and in the Haynes Palace Studio Car, an adapted Northern Pacific coach. But by the turn of the century his studio car was history and his Yellowstone studio had evolved into a curio emporium. Henry's friend T. W. Ingersoll of St. Paul reinvented himself around 1900 as a major publisher of lithographically reproduced scenes, some of which were used as premiums in Quaker Oats products, and sold rights to his photographs to Sears, Roebuck and Company. Carleton E. Watkins took stunning views of Yosemite in the 1860s that convinced President Lincoln to protect the site. His studio in San Francisco was among the most lavish in the world in the 1870s, but by 1895 he was reduced to living with his wife and children in an abandoned railroad boxcar for eighteen months. And Denver-based William H. Jackson, whose magnificent scenes of the Rocky Mountains almost lived up to the description he gave them ("masterworks of the world's greatest photographic artist"), sold his negatives to large postcard distributors.

7. Jensen, *Calling This Place Home*, 72–79.

8. Ho-pin-kah had also studied at Virginia's Hampton Institute, whose best-known graduate was Booker T. Washington, and at Pennsylvania's Carlisle Indian Industrial School, famous for a football team featuring Jim Thorpe and for its marching band, in which Ho-pin-kah had played.

9. Hoelscher, *Picturing Indians*, 124–26.

10. Szarkowski, *The Photographer's Eye*.

11. "To make the plate it was necessary for the company to procure new apparatus of enlarged dimensions. A great marble slab larger than the plate was the first requirement. Upon this the plate is resting, while the coating is being applied. Large blocks of ice beneath it keep it at a temperature that will cool the emulsion as rapidly as it is applied. The making of such large plates is an experiment, but Emil Cramer says that it can be carried on successfully, and probably will become a new feature of the business" (*New York Times*, August 2, 1901).

12. George Bennett served in the U.S. Army from 1866 to 1869, then operated photography businesses in Texas and New Mexico, where he married Concha Collins in Santa Fe on October 15, 1880. Their three sons were born in Chihuahua, Mexico. By 1889 George's eyesight had become so poor that he gave up photography and left Chihuahua, returning to Kilbourn with two of his sons. He died in Pasadena, California, on March 14, 1915. The New Mexico History Museum calls George C. Bennett one of the most important nineteenth-century photographers of the West and holds quite a few of his images in its collection. The George Eastman House in Rochester, New York, has four of his New Mexico stereos from his series *Among the Ancient and Interesting Scenery of New Mexico*, taken around 1875. He worked for W. Henry Brown in Santa Fe, and although photo cards were issued under the name of Bennett or Brown, scholars at the Museum of New Mexico Photographic Archives believe all photographs were taken by George Bennett.

13. Miriam Bennett, "Post-Script."

Chapter 10. Shadows: 1903–1908

1. All of Miriam Bennett's quotes in this chapter are from her "Post-Script."

2. The railroads would discontinue their excursion trains to the Dells in 1908.

3. Having wrecked the dam in the 1870s, the raftsmen started for Kilbourn with the intention of destroying the village as well. They were met on the way by the man who had engineered the dam. He drew a line across the road, forbidding them to go farther. They didn't.

4. Edmund died suddenly in December 1906, leaving a young widow and baby daughter. Ed's death was a blow from which, Evaline said later, her husband never recovered.

5. Goc, *Others Before You*.

6. Bright's disease was a term used for chronic nephritis, a disease in which the kidneys become inflamed. Prior to this diagnosis it was thought Henry suffered from cirrhosis of the liver.

7. H. H. Bennett, "Bennett Family History," Bennett papers, WHS.

Chapter 11. Guardian Spirits: 1908–2010

1. All of Miriam Bennett's quotes in this chapter are from her "Post-Script."

2. Ruth Bennett Dyer, interview by the author, January 24, 1978.

3. Wetzel's apocalyptic statement—"The Dells are closed"—appeared in the *Kilbourn Weekly Illustrated Events*, July 18, 1908. On September 7, 1906, that same newspaper had predicted that with the changes anticipated by the dam "the class of visitors will [no longer] be confined to mere sight-seers, but will include people who are looking for diversion and recreation."

4. On April 1, 1931, the citizens of Kilbourn City voted to change their town's name to Wisconsin Dells.

5. The negatives were sorted and stored according to advice given to Miriam by the Wisconsin Historical Society.

6. Information from the Wisconsin Historical Society Web site, www.wisconsinhistory.org/hhbennett/studio.asp.

7. Debbie Kinder, note to author, April 20, 2009. For more information see http://www.dellsstewards.org.

Bibliography

Austin, H. Russell. *The Wisconsin Story: The Building of a Vanguard State*. Milwaukee: Milwaukee Journal Company, 1948.

Bamberger, Tom. "A Sense of Place." In Bamberger and Marvel, *H. H. Bennett*, 5–11.

Bamberger, Tom, and Terrence L. Marvel. *H. H. Bennett: A Sense of Place*. Milwaukee: Milwaukee Art Museum, 1992.

The Beautiful Dells of the Wisconsin River. Wisconsin Dells: H. H. Bennett Studio, 1965.

Bedford, Francis. "Landscape Photography and Its Trials." *The Yearbook of Photography and Photographic News Almanac* (1867). Reprinted in *Philadelphia Photographer* 13, no. 148 (1876).

Bennett, Ashley C. "A Wisconsin Pioneer in Photography." *Wisconsin Magazine of History* 22, no. 3 (March 1939): 268–79.

Bennett, H. H. *Wanderings among the Wonders and Beauties of Northwestern Scenery*. Kilbourn City, WI: privately printed, 1890.

———. *Wanderings among the Wonders and Beauties of Western Scenery*. Kilbourn City, WI: privately printed, 1883. Reprint, Wisconsin Dells: H. H. Bennett Studios, 1977.

———. *Wanderings by a Wanderer*. Kilbourn City, WI: privately printed, 1890.

———. *The Wisconsin Dells*. Kilbourn City, WI: privately printed, 1891.

Bennett, Miriam E. "The Camera Man of the Dells." Unpublished manuscript, H. H. Bennett Papers, Wisconsin Historical Society, Madison.

———. "Post-Script. A Daughter's Eye View of the Camera Man." Unpublished manuscript, H. H. Bennett Papers, Wisconsin Historical Society, Madison.

Bennett, Steichen, Metzker: The Wisconsin Heritage in Photography. Milwaukee: Milwaukee Art Center, 1970.

The Biographical Dictionary and Portrait Gallery of Representative Men of Chicago, Wisconsin and the World's Columbian Exposition. Chicago: American Biographical Publishing Company, 1895.

Buenker, John D. *The Progressive Era, 1893–1914*. Vol. 4 of *The History of Wisconsin*, edited by William Fletcher Thompson. Madison: State Historical Society of Wisconsin, 1998.

Carter, John, and Solomon D. Butcher. *Photographing the American Dream*. Lincoln: University of Nebraska Press, 1985.

Cary, Julia Metcalf. *William Henry Metcalf: A Biography by His Daughter*. New York: Press of the Woolly Whale, 1937.

Chicago. Chicago: S. L. Stein, 1892.

Chicago, Milwaukee & St. Paul Railway Company, F. A. Miller for the General Passenger Department. *Kilbourn and the Dells of the Wisconsin with Views En Route, Chicago to St. Paul and Minneapolis*. Chicago: Chicago, Milwaukee & St. Paul Railway, 1901, 1907, 1913.

Church, Charles F. *Easy Going: A Comprehensive Guide to Sauk and Columbia Counties*. Madison, WI: Tamarack Press, 1976.

Coe, Brian. *George Eastman and the Early Photographers*. London: Priory Press, 1973.

Cole, H. E. *Baraboo, Dells, and the Devils Lake Region*. 4th ed. Baraboo, WI, 1929.

Current, Richard N. *The Civil War Era, 1848–1873*. Vol. 2 of *The History of Wisconsin*, edited by William Fletcher Thompson. Madison: State Historical Society of Wisconsin, 1976.

"Dells of the Wisconsin: Black Hawk's Cave." *Wisconsin Historical Collections* 5 (1867).

Dells of the Wisconsin on the Line of the Chicago, Milwaukee & St. Paul R.R. Milwaukee: George Allanson, n.d.

The Dells of the Wisconsin River. Kilbourn City, WI: J. J. Browne, 1885.

Dells of the Wisconsin River. Kilbourn, WI: H. H. Bennett Studio, 1921, 1928, 1936.

"Dells Photographer." *Madison Democrat*, January 3, 1908. In *Wisconsin Necrology* 9 (1907–8): 205.

Derleth, August W. *The Ghost of Black Hawk Island*. New York: Duell, Sloan and Pearce, 1961.

Dobnick, Otto, and Steve Glischinski. *Wisconsin Central, Railroad Success Story*. Waukesha, WI: Kalmbach Books, 1997.

Donan, P. *The Dells of the Wisconsin, Fully Illustrated*. Chicago: Rollins Publishing, 1879.

Downing, Sgt. Alexander G., Company E, Eleventh Iowa Infantry, Third Brigade. *Downing's Civil War Diary*. Des Moines: Historical Department of Iowa, 1916.

Draeger, Jim, and Mark Speltz. *Fill Er Up: The Glory Days of Wisconsin Gas Stations*. Madison: Wisconsin Historical Society Press, 2008.

Durbin, Richard D. "Two Wisconsin River Stories: Part I: Black Hawk Island's Early Structures." *Wisconsin Magazine of History* 77, no. 3 (Spring 1994): 163–78.

Emerson, Peter Henry. *Naturalistic Photography for Students of the Art*. London: Sampson Low, Marston, Searle, & Rivington, 1890.

Emerson, Ralph Waldo. *Nature; Addresses, and Lectures*. Boston: James Munroe and Company, 1849.

Fries, Robert F. *Empire in Pine: The Story of Lumbering in Wisconsin, 1830–1900*. Madison: State Historical Society of Wisconsin, 1951.

Goc, Michael J. *Others Before You: The History of Wisconsin Dells Country*. Friendship, WI: Dells Country Historical Society/New Past Press, 1995.

Gurda, John. *The Making of Milwaukee*. Milwaukee: Milwaukee County Historical Society, 1999.

Haas, Robert Bartlett. *Muybridge, Man in Motion*. Berkeley: University of California Press, 1976.

Hales, Peter Bacon. "American Views and the Romance of Modernization." In *Photography in Nineteenth-Century America*, ed. Martha A. Sandweiss, 204–57. Fort Worth, TX: Amon Carter Museum, 1991.

Hanson, David A. *A Complete Catalogue of the Stereographic Photographs of H. H. Bennett, 1843–1908*. Wisconsin Dells: H. H. Bennett Studio, 1977.

———. "H. H. Bennett, Portraitist to an America Discovering the Poetic Uses of the Wilderness." *American Photographer* (June 1978): 64–72.

Hess, Larry L. "H. H. Bennett of Wisconsin." *Stereo World* (November–December 1991): 4–17.

History of Milwaukee. Chicago: Western Historical Company, 1881.

Hoelscher, Steven D. "The Photographic Construction of Tourist Space in Victorian America." *Geographical Review* 88, no. 4 (October 1998): 548–70.

———. *Picturing Indians: Photographic Encounters and Tourist Fantasies in H. H. Bennett's Wisconsin Dells*. Madison: University of Wisconsin Press, 2008.

———. "A Pretty Strange Place: Nineteenth-Century Scenic Tourism in the Dells." In *Wisconsin Land and Life*, edited by Robert C. Ostergren and Thomas R. Vale, 424–49. Madison: University of Wisconsin Press, 1997.

———. "Viewing Indians: Native Encounters with Power, Tourism, and the Camera in the Wisconsin Dells, 1866–1907." *American Indian Culture and Research Journal* 27, no. 4 (2003): 1–51.

Holmes, Oliver Wendell. "The Stereoscope and the Stereograph." *Atlantic Monthly* 3, no. 20 (June 1859): 738–49.

Ingersoll, Ernest. "Milwaukee." *Harper's New Monthly Magazine* 62, no. 371 (April 1881): 702–718.

Janik, Erika. "Dashing through the Snow: Sleigh Rides in Wisconsin." *Wisconsin Magazine of History* 92, no. 2 (Winter 2008–9): 42–49.

Jay, Bill. "Women in Photography: 1840–1900." www.billjayonphotography.com.

Jensen, Joan M. *Calling This Place Home: Women on the Wisconsin Frontier, 1850–1925.* Minneapolis: Minnesota Historical Society Press, 2006.

Jones, Bernard E., ed. *Encyclopedia of Photography.* New York: Arno Press, 1974.

Jones, George D., and Norman S. McVean, comps. *History of Wood County, Wisconsin.* Minneapolis: H. C. Cooper, Jr., and Company, 1923.

Kilbourn City (Wisconsin Dells) Guard. November 15, 1876, to April 30, 1879.

Kouwenhoven, John A. *The Arts in Modern American Civilization.* New York: W. W. Norton & Company, 1967.

Lambert, Craig. "From Daguerreotype to Photoshop: Robin Kelsey Dissects the 'Hybrid Medium' of Photography." *Harvard Magazine,* January–February 2009. http://harvardmagazine.com/2009/01/daguerreotype-photoshop.

Marvel, Terrence L. "Between Art and Commerce: H. H. Bennett and the Development of Tourism." In Bamberger and Marvel, *H. H. Bennett,* 13–27.

McIlroy, Maida Ewing. "Henry Hamilton Bennett (1843–1908): Pioneer Landscape Photographer of Wisconsin." Master's thesis, University of Wisconsin, 1967.

Mead, Howard, Jill Dean, and Susan Smith. *Portrait of the Past: A Photographic Journey through Wisconsin.* Madison: Wisconsin Tales and Trails, 1971.

Miller, F. A. *Kilbourn and the Dells of the Wisconsin.* Chicago: Chicago, Milwaukee & St. Paul Railroad, 1901, 1907, 1913.

Milwaukee. Milwaukee: S. L. Stein, 1889.

Naef, Weston J., and James N. Wood. *Era of Exploration: The Rise of Landscape Photography in the American West, 1860–1885.* Buffalo, NY: Albright-Knox Art Gallery, 1975.

Nesbit, Robert C. *Urbanization and Industrialization, 1873–1893.* Vol. 3 of *The History of Wisconsin,* edited by William Fletcher Thompson. Madison: State Historical Society of Wisconsin, 1985.

Newhall, Beaumont. *The History of Photography from 1839 to the Present Day.* New York: Museum of Modern Art, 1949.

———. *On Photography: A Source Book of Photo History Facsimile.* Watkins Glen, NY: Century House, 1956.

———. *Latent Image: The Discovery of Photography.* New York: George Eastman House/Doubleday, 1967.

Old Days in the Dells. Kilbourn, WI: H. H. Bennett Studio, 1927.

Palmquist, Peter. *Fine California Views: The Photographs of A. W. Ericson.* Eureka, CA: Interface, 1975.

Peck, George Wilbur. *Peck's Sunshine.* Chicago: Belford, Clarke and Company, 1882.

Preston, Annie Turner. "The Dells of the Wisconsin River." *The American Angler* 25, no. 6 (June 1895): 163–68.

———. *Short Journeys on a Long Road.* Chicago: Passenger Department of the Chicago, Milwaukee, and St. Paul Railway, 1895.

Rath, Sara. *Pioneer Photographer: Wisconsin's H. H. Bennett.* Madison: Tamarack Press, 1979.

Reed, Hugh T. *Broom Tactics, or Calisthenics in a New Form for Young Ladies, Embracing the Schools of the Group and Bevy, Manual of the Broom, etc.* Baltimore, MD: A. W. Reed & Co., 1883.

Reese, Betsy. *The Bennett Story: The Life and Work of Henry Hamilton Bennett.* Wisconsin Dells: H. H. Bennett Studio, 1975.

Richards, John D. "Viewing the Ruins: The Early Documentary History of the Aztalan Site." *Wisconsin Magazine of History* 91, no. 2 (Winter 2007–8): 28–39.

Rood, Hosea W. *Story of the Service of Company E, and of the Twelfth Wisconsin Regiment, Veteran Volunteer Infantry, in the War of the Rebellion: Beginning with September 7th, 1861, and Ending with July 21st, 1865.* Milwaukee: Swain & Tate, 1893.

Sandweiss, Martha A., ed. *Photography in Nineteenth-Century America.* Fort Worth, TX: Amon Carter Museum; New York: Harry N. Abrams, 1991.

———. *Print the Legend: Photography and the American West.* New Haven, CT: Yale University Press, 2002.

Severa, Joan L. *Dressed for the Photographer: Ordinary Americans and Fashion, 1840–1900.* Kent, OH: Kent State University Press, 1995.

———. *My Likeness Taken: Daguerreian Portraits in America.* Kent, OH: Kent State University Press, 2006.

Smith, Alice E. *From Exploration to Statehood.* Vol. 1 of *The History of Wisconsin,* edited by William Fletcher Thompson. Madison: State Historical Society of Wisconsin, 1973.

Standish, B. H. *Among the Dells.* Madison, WI: David Atwood, Printer and Stereotyper, 1885.

Steuber, William F., Jr. *The Landlooker.* Indianapolis: Bobbs-Merrill, 1957.

Szarkowski, John. *American Landscapes: Photographs from the Collection of the Museum of Modern Art.* New York: Museum of Modern Art, 1981.

———. *John Szarkowski: Photographs.* New York: Bulfinch, 2005.

———. *Looking at Photographs: 100 Pictures from the Collection of the Museum of Modern Art.* New York: Museum of Modern Art, 1973, 1999.

———, ed. *The Photographer and the American Landscape.* New York: Museum of Modern Art, 1963.

———. *The Photographer's Eye.* New York: Museum of Modern Art, 1966.

———. *Photography until Now.* Springs of Achievement Series on the Art of Photography. New York: Museum of Modern Art, 1989.

Taft, Robert. *Photography and the American Scene.* New York: Macmillan, 1938.

Taylor, Frank H. *Reconnaissance of the Golden Northwest.* Buffalo, NY: Matthews, Northrup & Co., 1883.

Taylor, J. Traill, ed. *Photographic Times and American Photographer,* vol. 12. New York: Scoville Manufacturing Company, 1883.

Temmer, James D. "A Compelling Vision: H. H. Bennett and the Wisconsin Dells." *Wisconsin Magazine of History* 85, no. 4 (Summer 2002): 12–19.

Towler, J. *The Silver Sunbeam: A Practical and Theoretical Textbook of Sun Drawing and Photographic Printing: Comprehending All the Wet and Dry Processes at Present Known with Collodion, Albumen, Gelatin, Wax, Resin, and Silver . . . Stereography.* New York: Joseph H. Ladd, Publisher, 1864; facsimile, Hastings-on-Hudson, NY: Morgan & Morgan, 1969.

Vestal, David, Bruce Downes, John Durniak, and H. M. Kinzer. "Four Reviews of a Big New Show at the Museum of Modern Art." *Popular Photography,* January 1964, 81–89, 116–22.

"Village of Kilbourn City." In *The History of Columbia County, Wisconsin,* edited by C. W. Butterfield, 807–32. Chicago: Western Historical Society, 1880.

Wadsworth, Nelson B. *Through Camera Eyes.* Provo, UT: Brigham Young University Press, 1975.

Weiss, Margaret E. "The American Landscape—A Time Exposure." *Saturday Review,* September 28, 1963, 29.

Welling, William. *Collector's Guide to Nineteenth Century Photographs.* New York: Macmillan, 1976.

Wickman, Donald H. *George Houghton: Vermont's Civil War Photographer.* Vermont Historical Society, forthcoming.

Wisconsin Central Railroad. *Pen and Camera.* Milwaukee: Louis Eckstein, 1890.

Wisner, Frank O. *The Tourist's Guide to the Wisconsin Dells and an Illustrated Handbook, Embracing the Prose, Romance and Poetry of This Wonderful Region.* Kilbourn City, WI: F. O. Wisner, 1875.

Index

NOTE: *Page references in italics refer to illustrations or captions. Landmarks and locations are in Wisconsin unless otherwise indicated.*

Ableman's Gorge, 73, 253n5
Adams, Ansel, xi–xii
Adams, H. C., 228
Allen, Robert V., 133
Allen, Tom, 119
Allis, Edward P., *124*
American Stereoscopic Company (Philadelphia), 61
Anchorage (Shufeldt home, Oconomowoc), 140
animal attractions, 206–7
Anthony and Company (New York City), 61
Apollo (steamer), *207*, 238
Apostle Islands, *156*
Archer, Frederick Scott, 252n4
Arpin family, 134
autograph books, 251n7

Bailey, Joseph, 7
Barn Bluff, *105*
Bass Cave, 240, *240*
beadwork, Native American, 209–11
Beautiful America Club, 226
Bedford, Francis, 95
Bennett, Aaron (great-grandfather), 18, 249n3 (ch. 1)
Bennett, Albert (uncle), 5, 7
Bennett, Albert Irving (brother), 18, 192, *227*, 249n4 (ch. 1)

Bennett, Arthur (brother), 229, 249n4 (ch. 1)
Bennett, Ashley (son), *xiv*, *82*; as assistant to Henry, *107*, 108, 192; bicycle of, *107*; birth of, 58; car owned by, *205*, 206, 256n3; in charge of the studio, 155; garage built by, 205; on Henry's cigar box camera, 82, 253n9; at Henry's death, 232; and Ingersoll, 253–54n13; as Kodak salesman, 194; lumber rafting by, 134; marriage of, 194; on panoramic photographs, 254n6; photographed leaping Stand Rock chasm, 128, *129*, *130*, *167*; and stepmother Eva, 171; as a Winton car dealer, *205*, 256n3
Bennett, Charles (brother), 249n4 (ch. 1)
Bennett, Clarence (brother), 12, 192, 249n4 (ch. 1)
Bennett, Concha (*née* Collins; sister-in-law), 257n12
Bennett, Don (brother), 249n4 (ch. 1)
Bennett, Edmund ("Ed"; brother): birth/early childhood of, 9, 12, 249n4 (ch. 1); death of, 257n4; last visit with Henry, 227; as a prospector/miner, 211; skating by, 34; as a soldier, 18; on tintypes, 29
Bennett, Esther ("Essie"; *née* Jones; daughter-in-law), 194, *205*, 256n3
Bennett, Evaline ("Eva"; *née* Marshall; second wife), 59, *145–46*, *173*, 204; in Adams County, 222; background of, 144; children of (*see* Bennett, Miriam; Dyer, Ruth Bennett); Henry's

courtship of, xxi, 144–50, *149–50*, 152, 158–60, 162–63, 165; at Henry's death, 232–33, 235; marriage to Henry, 165, 167, *168*, 170–71; in the Paper Fair, 147; studio run by, 203, *232*, 235, *237*, 243

Bennett, Frances Irene ("Frankie"; *née* Douty; first wife), *82*, *90*; birth/background of, 251n13; children of (*see* Bennett, Ashley; Crandall, Nellie; Snider, Harriet); death of, 115, *116*, 117; on dry- vs. wet-plate process, 113; health of, 46, 98, 99, 100, 103, 105–6, 108–10, 114; Henry's courtship of, 39–40, *40*; marriage to Henry, 40–42, *41*, 195, 251n14; as a photographer, 51–52, *52*, 115

Bennett, George (brother): birth/childhood of, 12, *30*, 249n4 (ch. 1); death of, 194, 257n12; joins Henry in photography business, 30, 32, 37; marriage of, 257n12; as photography apprentice to Uncle George, 29, 30, 32; photography expedition with Henry, 73, *74*; reputation as a photographer, 215, 257n12; as a soldier, 257n12

Bennett, George Hamilton (father), 3, 5, 7–9, 15, 233

Bennett, Harriet (daughter). *See* Snider, Harriet Bennett

Bennett, Harriet (sister), 249n4 (ch. 1)

Bennett, Harriet Amanda (*née* Houghton; mother), 3, *12*, *13*, 30, 194, 195

Bennett, Henry Hamilton, *164*, *246*; affability of, 208, 233; birth of, 3; boat tours by, 192–94; cadets taught by, 196–97; cameras constructed by, 82, 85, *86*, 114–15, 253n9; cameras recommended by, 175; as a carpenter, 13–15; children of (*see* Bennett, Ashley; Bennett, Miriam; Crandall, Nellie; Dyer, Ruth Bennett; Snider, Harriet Bennett); collodion process used by, 33; copyrights taken out by, 190, 213, *214*; dams opposed by, 196, 225, 227–29; darkroom innovations by, 175; death/funeral of, xi, 232–33, 235; Denver trip by, 227; depression of, 46–47, 117, 119; disability pension of, 42–43; drinking by, 160; on dry- vs. wet-plate process, 85–87, 90, 93, 113, 117; eastern travels of, 97–98; at Edmund's death, 257n4; education/childhood of, 3, 5; fame of, xiii; financial woes of, 43, 46–47, 111; as a fisherman, 84, 140; hand injury of, *26*, 27, 30, 250n22; health of, 46, 202–3, 229–32, 257n6; Ho-Chunk artwork

bought by, 208–9; Ho-Chunk language learned by, 213; home of, 219; humility of, xxi; lumber rafting by, 134; marriages of (*see* Bennett, Evaline; Bennett, Frances Irene); Oak Street home of, 176, 241; obituary for, 233; parenting style of, 219; perfectionism of, 57, 64; personal journal entries by, 139–40, 199–200; photographic travels of, 90–91; religious views of, 256n8; self-portraits of, *221*, *231*; shutter constructed/used by, 128, *129*, *132*, 134–35, *135*; siblings of, 42, 249n4 (ch. 1) (*see also* Bennett, Albert Irving; Bennett, Arthur; Bennett, Clarence; Bennett, Edmund; Bennett, George; Bennett, John; Bennett, William; McVey, Sarah); skating by, 34; slide shows given by, 167, 190 (*see also* Magic Lantern shows); as a soldier, 18–27, *20*, *23*, 44, 215; western travels of, *109*, 109–10, *111*

—Landscapes: clouds added to, *198*, 213, 215, 230; composition of, 55; early, 38–39, 51–52, *54*; popularity of, 58, 60; portable dark-tent for, *54*, 55; vs. portraits, 51, *52*. *See also* stereographs

—Works: "Across the Lake—Turk's Head in Foreground," *63*; "Apollo Steamboat with Tourists," *207*; "Art Class at the State School for the Deaf, Delavan," *185*; "Bass Cave," *239*; battle scenes, 147, *148*; "Bennett Family, House and Auto," *205*; "Black Hawk's Cave," *11*; "Board of Trade District," *166*; "Camp Ne-Un-Gah Ah-Rue-Chu," *72*; "Canoeists in a Boat Cave," 254–55n7; "Cave of Dark Waters," *64*; Chicago scenes, *166*, *168*, *169*, *170*, 178–79, 180–83, *181*, *183*, *200*; circus scene, *119*; Cold Water Canyon scenes, *xvii*, *239*; Columbian Exposition scenes, 188, *188–89*, 190; *Company E and the 12th Wisconsin Regiment*, 215; copyrighted, 190, 213, *214*; critical reception of, 204; Dalles of the St. Louis River, scenes of, *151*, *154*; "*Dell Queen* Entering the Narrows," *66*; "The Devil's Foot Ball," *38*; "Down River from Grand Avenue Bridge," *126*; exhibits of, 204; faked scenes, 64, *64*, 94, 130, 140–41; "Ferris Wheel, Interior," *189*; "Ferris Wheel at the World's Columbian Exposition, Chicago, 1893," *188*; "Fountain in South Park," *179*; "Giant's Hand," *239*; "Grand Boulevard," *183*; "A Group of Tourists at the Bird's Nest," *171*; "H. H. Bennett and Dark Tent

at Gates Ravine," 54; "Handspiking Off a Bar. A Heavy Lift," 130; "Ha-Noo-Gah Chun-Hut-Ah-Rah," 76; "Haymarket Square," 181; "High Rock," 4; "High Rock from Romance Cliff," 10; Ho-Chunk portraits/views, 53, 75–76, 76–77, 78, 213, 214; hunting scenes, 140–41; "Ink Stand and Sugar Bowl," 114–15, 138, 234; "In the Wildwood of Northern Wisconsin," 157; "Islands from the Cliff at Gulch," 254n7; "Jaws of the Wisconsin Dells," 117, 255n7; "Joseph Schlitz Brewing Company," 125; "Kilbourn, Railroad Bridge," 14; "Kilbourn, Superior Street Bridge," 6; "Kilbourn Fire Aftermath," 35; "Lake Street, East from Clark," 169; "Lake Winnebago from City Hall Tower, Neenah, Wis.," 158; "Layton Art Gallery," 254n7; Layton Gallery scenes, 170, 171; "Leaping the Chasm," 128, 129, 130, 167; "Lone Rock with Canoe, Wisconsin Dells," 198, 213; "Looking Down into Rood's Glen from the East End," 48; "Looking Out from Boat Cave," 94; "Looking Through the Port Hole at Coon Castle," 222; "Lower Jaws, from Stone Pile," 112; "Luncheon Hall, east of Stand Rock," 59; "Men Spearing Sturgeon," 5; "The Midway or Plaisance, as seen from the Ferris Wheel," 189; Milwaukee scenes, 118–28, 121; "Mirror Lake Dam and Mill," xviii; Mississippi River scenes, 191, 191; "Mouth of the Harbor," 169; "Munger's Mill Dam Construction," 197; "The Narrows, Dells of the Wisconsin," 255n7; "The Narrows at Black Hawk's Leap," 31; "Navy Yard from Black Hawk's Leap," 245; "New Passenger Station, Fourth Ward Park," 122; "North Clark Street," 178; "Old Quarry Road at Frontenac," 92; "On a Sunday Afternoon—Dells Guides—Rowboat Fleet," 51; "Overhanging Rock at Black Hawk's Leap," 2; photogravure, 121–22, 122; Pillar Rock/Fort Danger scene, 74; "Popcorn Party," 216; "Railroad Bridge over the Vermillion River in Minnesota," 104; "Rowboat in Eaton Grotto," 28; "Running the Kilbourn Dam, on Board the Raft," 132; "Scene on Chain O'Lakes, Waupaca, Wis.," 159; "Self-Portrait with son Ashley and daughters Harriet and Nellie," xiv; "Sights at High Rock, Down the River," 62, 62; "Skylight Cave," 40; "State Street, North from Madison," 200; "Steamboat Rock," 70; "Storming of Ice Palace by Fire King," 136; Sugar Bowl scene, 55; swallows' nest scenes, 88; "Train Depot at Buena Vista, Iowa," 107; "Trout Bay, Bear Island, of the Apostle Group," 156; "Under the Overhanging Rock," xi, xii–xiii, xiii, xvi, 255n7; "Upper Mississippi," 191; "Upstream from the Mouth of Witches Gulch," 79; "View at Riley's Coolie," 91; "View out Phantom Chamber," 218; Wanderings Among the Wonders and Beauties of Northwestern Scenery, 172; Wanderings Among the Wonders and Beauties of Western Scenery, xviii; Wanderings by a Wanderer, 141, 191; Waukesha mineral springs scenes, 141–43, 142–43; "We Are Broke Up. Take Our Line!" 134, 135; "Wisconsin Central Ore Dock, Ashland, Wisconsin," 155; Wisconsin Central Railroad tour, 151, 152, 153–59, 156–60, 161; The Wisconsin Dells, 176; "The Wisconsin Dells from Sliding Rock," 255n7; Wisconsin State Board of Control of Reformatory, Charitable and Penal Institutions project, 183–88, 184–87; "Wisconsin State Prison Cell Blocks," 186; Witches Gulch scene, 65; "Wona-chia-ah Chea-da," 78; "Woodworking Class at the School for the Deaf, Delavan," 184

Bennett, Irene (granddaughter), 205
Bennett, John (brother), 59, 192, 249n4 (ch. 1)
Bennett, Miriam (daughter), 145; in Adams County, 222; birth/childhood of, 176, 204, 219, 220, 221; death of, 241; at Henry's death, 232, 235, 236; in Henry's landscapes, 59, 195, 221; Henry's memoirs compiled by, xxi, 241, 241; on Henry's religious views, 256n8; photographs of Henry treasured by, 221, 221–22; sand bottles made by, 208; studio run by, 240–41
Bennett, Nellie. See Crandall, Nellie
Bennett, Ruth. See Dyer, Ruth Bennett
Bennett, Sarah. See McVey, Sarah
Bennett, William (brother), 42, 249n4 (ch. 1)
Bennett family: cemetery plot of, 233; home in Kilbourn City, 18; move to Wisconsin, 5–9, 12–13, 15; photograph of, 194
Bennett Studio: architectural description of, 242–43; Ashley left in charge of, 155; decline in business at, 172, 207, 207–8; as family-run after Henry's death, 232, 235, 240–41; growth of, 50, 60; as a Historic Site, 241–43, 242;

improvements to the building, 243; inventory of equipment/supplies at, 67; in Kilbourn, 49, 50; as a museum, 243, 244; negatives preserved at, 243; new, 80–81, 81; opening/early days of, 30, 30, 32–34; props in, 82; remodeling of, 243; revolving printing house in, 80, 82–83, 144, 241, 253n8; revolving showcase in front of, 83; souvenirs sold in, 208–11, 209, 213, 229; success of, 120; in Tomah, 37, 41, 41; as a tourist attraction, 89, 119, 172; traveling, 43, 45; variety of scenes offered at, 87, 120

Best and Company Brewery (later named Pabst Brewing Company), 118

Bethesda Springs, 142–43

Black Hawk, Chief, 2, 11, 12, 73, 250n11

Black Hawk War, 2, 11, 12

Black River Falls, 251n11

Blair, Thomas, 254n2 (ch. 6)

Blair Reversible box camera, 114

Blair Tourograph and Dry Plate (later named Blair Camera), 114, 254n2 (ch. 6)

Boat Cave, 94, 240, 254–55n7

Bouguereau, William-Adolphe: L'étoile perdue, 71–72

Bowman Jonathan, 49, 196

Bradley, Charles, 127, 170, 255n2 (ch. 8)

Brainard, Charles Rollin, 152, 153, 154–55, 157–60, 161

Brattleboro (Vermont), 5, 7, 8

Bright's disease (chronic nephritis), 229, 257n6

Britt, Barney, 58

Broom Brigade, 108, 254n2 (ch. 5)

Brown, W. Henry, 215, 257n12

Buehler's Sidewalk Machine, 230

Buffalo Bill (William Cody), 96–97, 190

Bulwer-Lytton, Edward George Earle Lytton, 253n3

cafeterias, 199

Callahan, Harry, xvii

Camp Randall, 19–21

Camp Welcome, 179, 256n5 (ch. 8)

Carlisle Indian Industrial School (Pennsylvania), 257n8

cars, 205–6

Cary, Julia (née Metcalf), 72, 93, 181

Cave of Dark Waters, 239

Cemetery Improvement Association (Kilbourn), 146–47

Central Pacific Railroad, 80

Chach-Scheb-Nee-Nick-ah (Young Eagle), 213, 214

Champion (sightseeing boat), 69

Chapman (Timothy Appleton) and Company, 113–14, 254n1 (ch. 6)

Chicago: fire in, 168, 200; scenes of, 166, 168, 169, 170, 178–79, 180–83, 181, 183, 200

Chicago, Milwaukee and St. Paul Railway, 7, 68, 69, 80–81, 144, 180

Chicago and North Western Railway, 199

Chicago Art Institute, 204

Chippewa people, forced removal of, 73, 75

cigar box camera, 82, 253n9

cinematography, 98

circuses, 119

Civil War: end of, 32; Gettysburg victory as a turning point in, 22–23; soldiers' reunions after, 144, 215; soldiers' tintypes during, 29; start of/Union recruits for, 18–20; support for/protests against, 19; Vicksburg victory as a turning point in, 22–25, 23

Clerke, John, 71, 172

Cleveland, Grover, 137

clouds, 198, 213, 215, 230

Cody, William ("Buffalo Bill"), 96–97, 190

Cold Water Canyon, xvii, 239

Collins, Concha (sister-in-law), 257n12

collodion. See wet-plate process

Columbian Exposition (Chicago, 1893), 188, 188–89, 190, 256n1, 256n7 (ch. 8)

Company E (Twelfth Wisconsin Volunteer Infantry), 18–22, 215, 233

Connor, Phyllis (née Crandall; granddaughter) and Ralph, 238

Coo-nu-gah (First Boy), 212

Cotillion Band (Brattleboro, Vt.), 7

courtship traditions, 39–40, 156

Cramer Dry Plate Works, 117, 134, 175, 182, 215, 257n11

Crandall, George H. (son-in-law), 192, 193, 235, 237–38

Crandall, Nellie (née Bennett; daughter), xiv, 82, 108; as assistant to Henry, 191–92; birth of, 60; in the Broom Brigade, 108, 254n2 (ch. 5); death of, 238; at Henry's death, 232; Henry's journal

entries about, 139; marriage of, 192, *193*, 237; in the Paper Fair, 146–47; and stepmother Eva, 171

Crandall family, 238, *238*, 240

Crandall Hotel (*formerly* Glen Cottage; Kilbourn), 69, 237–38, 240

cycloramas, 147, *147*–48, 255n1 (ch. 7)

Daguerre, Louis, 250n14

daguerreotypes, 15–17, 250n14

Daily Northwestern, 157

Dallmeyer Rapid Rectilinear lens, 175

Darwin, Charles: *On the Origin of Species*, xiv–xv, 77

Davis, Jack, 73

Davis, Jefferson, *11*, 12

deer hunting, 206

Dell House (Kilbourn), *133*, 133–34

Dell Queen (sightseeing boat), 61, 65–66, *66*, 69

Dell Rangers, 108

the Dells: activities for tourists in, 225, 244–45, 258n3; boat tours of, *51*, 60, *174*, 175–80, 192, 195–96, 238, 247; as "closed," 235, 258n3; commercial development of, 244–45; criticism of, 87, 89; geology of, 11; Henry's first impressions of, 37; Henry's photographs used to promote, 58, 60–62, 87, 144; landmarks/scenery affected by dams, *239–40*, 240; map of, *68*; naming of, 9, 11–12; number of visitors to, *174*, 195–96, 245; preservation of, 225–26, *227*, 228–29, *231*, 236–38, *238*, 240; rapids in, 196; resort complex in, 179; scope of Henry's work in, xviii–xix; tourism in, xv, *51*, 172; as a trade route, 9; train excursions to, 257n2; water parks in, 245; Wisconsin River's route through, 9, 11

Dells Boat Company, 238, 240

Dells Inn. *See* Larks Hotel

Dells Lumber, 243

depression (1857), 7, 15

Devil's Doorway, *100*

Devil's Elbow, 133

Devil's Lake, *100*, 226, 228

Diamond Grotto, *96*, 240

Dixon's Canada Store (Kilbourn), *35*, 36

Douty, Frankie. *See* Bennett, Frances Irene

Douty, Nancy Jane (mother-in-law), 251n13

Douty, Rufus M. (father-in-law), 251n13

dry-plate (gelatin) process, 85–87, 90, 93, 95, 113, 117, 254n14

Dunbar, Richard, *142*

Dyer, Ruth Bennett (daughter): in Adams County, 222; birth/childhood of, xxii, 195, *195*, 204; on the Broom Brigade, 254n2 (ch. 5); death of, 241; at Henry's death, 232, 235, *236*; in Henry's landscapes, *59*, *173*, 195, 221; photographs of Henry treasured by, *221*, 221–22; sand bottles made by, 208; and toy lamb, *195*, 256n11

Eastman Kodak, 137, 194. *See also* Kodak cameras

Easton (F. Lucian and Mary) home (La Crosse), 140

Edison, Thomas, 204

Emerson, Peter H., xix

Emerson, Ralph Waldo, xix, 71

Esty Organ Works (Brattleboro, Vt.), 7

Exposition Hall (Milwaukee), *118*

exposures, fast, 97, 126–27. *See also* shutters, instantaneous

Fairchild, Lucius, 32

Federated Women's Clubs of Wisconsin, 228

ferrotypes. *See* tintypes

Field, F. A., 178

film cameras, 137

Finch House (Kilbourn), 69, *172*

fireworks photographs, 134–35, *136*

Foster, Stephen, 9

Fountain Spring House (Waukesha), 142–43

Fox Lake (Illinois), 199, *201*–3, 202

Gates, Leroy, 30–32, *31*, 36, 49, 56

Gates, Mary Ann, 57

Gates, Schuyler, 56–58

Gates' Gallery (Kilbourn), *50*

gelatin plates. *See* dry-plate process

Germania (stern-wheeler boat), 180

Gettysburg, battle of (1863), 22–23, 147, 148

Giant's Hand, *239*, 240

Giant's Tomb, *149*

Gillispie, John, 18

Gimbel Brothers, 211

Glen Cottage (*later named* Crandall Hotel; Kilbourn), 69, 237–38, 240

Godding, John E., 176–80, *177*, 206, 225, 227, 235–36, 256n5 (ch. 8). *See also* Wisconsin Dells Company

Godding, T. F., 176–80, *177*, 206, 227, 235, 256n5 (ch. 8). *See also* Wisconsin Dells Company

Golden Gate Bridge, 51

Gollmar Brothers' Great United Shows, *119*

Graebner, W. H., 187–88

Grand Army of the Republic (GAR), 215, 217

Grand Electrical Display of Moving Pictures, *226*

Grant, Betsy (great-granddaughter), 241

Grant, Ulysses S., 22–23, 32

The Great Train Robbery, 204

Greene, Thomas, 196

H. H. Bennett Advisory Committee, 243

H. H. Bennett Studio. *See* Bennett Studio

H. H. Bennett Studio Foundation, 243

Hales, Peter B., xvi

Hampton Institute (Virginia), 257n8

Harper's Monthly, 122–23

Harrison, Benjamin, 255n2 (ch. 7)

harvest time, 56

Harvey, Cordelia, 22, 250n22

Harvey, Louis P., 22

Haynes, Frank Jay, 256–57n6

Ha-Zah-Zoch-Kah (Branching Horns), 213

Henrickson, Lisa (great-granddaughter), 241

Ho-Chunk people (*formerly* Winnebagos), 11, 250n9, 250n11; artwork of, 208–11, *210*; forced removals of, 73, 75; Henry's first impressions of, 38; Henry's friendship with, 211–13; hop picking by, 56; photographs of (*see under* Bennett, Henry Hamilton—Works); settlements of, 38, 251n11; summer encampment near Kilbourn, 75, *76*, 213

Ho-Con-Ja-Gah Moche-He (Thunder Cloud), 53

Holly, Will, 223

Holmes, Oliver Wendell, Sr., 52, 71, 96

Hoonch-Shad-e-gah (Big Bear), *96*, 211–12, *212*

Ho-pin-kah, Thomas, 211, 257n8

hops, 55–56

horse, motion photography of, 97

Houghton, Abraham (great-grandfather), 249n3 (ch. 1)

Houghton, Fred (cousin), 17

Houghton, George (uncle), 6–7, *8*; daguerreotype galleries of, 15–17, *17*; death of, 58; financial woes of, 47; on Henry's photography business, 32, 34; marriages of, 16, 250n15; returns to Kilbourn, 53; soldiers photographed by, 29

Houghton, Harriet Amanda. *See* Bennett, Harriet Amanda

Houghton, Henry (grandfather), 3

Houghton's Photographic Hall (Brattleboro, Vt.), 17, *17*

Howard House (Fox Lake, Ill.), 199

Hudson Valley school, 77

hunting, 59–60, 206

Hydraulic Company, 196

hydroelectric development, 226, 228–29, 236

Ingersoll, Truman Ward, 91, 93, 253–54nn12–13, 257n6

Ink Stand, 114–15, 138, *234*, *239*

Internal Revenue Act, 34

International View (Decatur, Ill.), 225

Iverson, J. C., 87

Jack (family dog), 217

Jackson, W. H., 254n4, 257n6

Japan, U.S. trade with, 85

Jefferson, Thomas, 204

John Gillespie Post #50 (GAR Hall; Kilbourn), 215, 217

Jolley, J., 37, 251n10

Jones, Esther ("Essie"; daughter-in-law), 194, *205*, 256n3

Joplin, Scott: "The Cascades," 204

Juneau, Solomon, statue of, 168, *170*, 255n2 (ch. 8)

Kaine, John, 101–2

Kennedy, D. A., 87, 188, 203–4

Kilbourn, Byron, 7, 14, 250nn5–6, 255n2 (ch. 8)

Kilbourn City, 7, 250n5. *See also* Wisconsin Dells

Kinder, Deborah (great-granddaughter), 241, 245, 247

Kodak cameras, 137, 172, 190

La Crosse and Milwaukee Railroad, 250n6

LaFollette, Robert, 228

Lamar (Colorado), 177, 179

Land, J. C., 62, 64

landscape photography, xvi, 39, 77. *See also*
 Bennett, Henry Hamilton—Landscapes
Lapham, Julia, 228
large-format cameras, 114–15, 254n4
Larks Hotel (*later named* Dells Inn), 177, 179, 192,
 206, 235
Lawrence, George, 215
Layton Gallery (Milwaukee), 170, 171, 254n7
Lecher, Paul G., 183, 187, 187–88
Lee, Robert E., 23, 32
Libby Prison (Chicago), 144
Lighthouse Rock, 73
lightning, photographs of, 121
Lincoln, Abraham, 11, 12, 18, 32, 250n14, 257n6
Lincoln, Mary Todd, 60
logging, 131, 153
Lone Rock, 198, 213, 239
Longfellow, William Wadsworth: *The Song of
 Hiawatha*, 103
Louisiana Territory, 204
Lovell, J. L., 15–16; "Brattleboro, Vermont—Main
 Street, looking south from Elliot Street," 8
lumber rafts/raftsmen, 130–32, 130–34, 135, 225,
 257n3
Lyell, Charles, xv

Magic Lantern (stereopticon) shows, 95–96, 119,
 215
marriage traditions, 40
Marshall, Evaline. *See* Bennett, Evaline
Marshall, Frank (brother-in-law), xxi, 144–45, 145,
 148–50, 150, 162–63, 165
Marshall, George (father-in-law), 144, 145–46
Marshall, Julia Hoyt (mother-in-law), 144, 145
Marshall, Ruth (sister-in-law), 144, 145
Mayo, W. W., 58
McVey, James (brother-in-law), 20
McVey, Sarah (*née* Bennett; sister), 20, 44–45,
 249n4 (ch. 1)
Mendota Hospital for the Insane, 188
Menominee people, 75–76
Merrill, A. F., 199
Metcalf, Eliab, 71
Metcalf, Julia, 72, 93, 181
Metcalf, William, 127; as art patron, xiv, 71–72,
 170, 171, 180–81; Chapman contract negotiated
 for Henry, 113–14; commissions Henry to

photograph paintings, 175–76; condolence
 letter to Henry, 117; death/obituary of, 180–82,
 181; on dry- vs. wet-plate process, 85–87, 93, 113;
 friendship with Henry, xiv, 72, 77, 93, 181;
 health of, 180; helps Henry open new studio,
 80–81, *81*, 181; hobbies/interests of, 71; on
 instantaneous shutters, 126–27; in Japan, 85,
 86, 182; Juneau statue commissioned by,
 170, 255n2 (ch. 8); loans to Henry, 111, 181; as
 mentor to Henry, 77–78, 79, 181, 253n7; on
 Old Abe, 90; as a photographer, 72, 85, 253n2;
 photography expedition with Henry, 73; as a
 shoe manufacturer, 71–72; stereographs by,
 253nn11–12; wedding gift to Henry and Eva, 167
military draft, 19
Milwaukee: breweries in, 125; as a commercial
 capital, 122; ethnic diversity in, 122–23;
 industry in, 124; scenes of, 118–28, 121
Milwaukee and Mississippi (*formerly* Waukesha)
 Railroad, 250n6
Milwaukee County Courthouse, 120
Milwaukee Exposition (1885), 120
Milwaukee Free Press, 229
Milwaukee River, 122–23
Milwaukee Sentinel, 101–2
mineral springs, 141–43, 142–43
Minneapolis, St. Paul and Sault Ste. Marie Railway
 (Soo Line), 152
Minnehaha Falls, 103
Mirror-Gazette, 225, 229, 232–33
Mirror Lake, 224
Mississippi River scenes, 191, 191
Modocawanda (sightseeing boat), 61
Monckhoven, Désiré Charles Emanuel van, 93
Morse, Edward S., 71, 85, 86
motion studies, 97, 254n5
Mould, Matthew, 62
Muir, John, 60–61
Musson, Lois (*née* Crandall; granddaughter) and
 Howard, 238
Muybridge, Eadweard, xiii, 39, 95, 97–98, 254n5

Nah-Ju-Ze-Gah (Brown Eyes), 53
National Photographers Association, 204
Native Americans: depicted in Buffalo Bill's shows,
 96–97; forced removals of, 73, 75; government
 attempts to eradicate culture of (*see* Black Hawk

War); public's fascination with, 208–10, *209*. *See also* Ho-Chunk people
Navy Yard, 240, *245*
New Dell Queen (sightseeing boat), 178
New Orleans Exposition (1885), 120
New Year's Day reception (1903), 219
New York Times, 215, 257n11
Northern Pacific Railroad, 256–57n6

Oconomowoc, 140
Ojibwe people, 75–76
Old Abe (eagle), 90–91
Olson, Ben, 192
O'Neil, Daniel T., 243
On the Origin of Species (Darwin), xiv–xv, 77
Overhanging Rock, xi, *xii–xiii*, xiii, xvi, *2, 239*, 255n7

Pabst Brewing Company (*formerly* Best and Company Brewery), *118*
panoramic photographs, 114–15, *117*, 117–18, 171, 204, 254–55nn6–7
Paper Fair (Kilbourn), 146–47
passenger pigeons, 59–60, 206
Pemberton, John C., 22–23
Pen and Camera, *201*. *See also* Wisconsin Central Railroad photography expedition
Pennsylvania Railroad, 98
Perry, Matthew C., 85
Perry, Oliver Hazard, 249n3 (ch. 1)
Peshtigo, *200*
Pettibone, Emma, 209, *210*, 211
Phantom Chamber, *218*, 240
Philadelphia Centennial Exposition (1876), 84
Philadelphia Photographer, 95
Philippoteaux, Paul, *147*, 148
The Photographer and the American Landscape (MoMA), xi–xii, 3, 249n1 (ch. 1)
photographers: female, 51, 252n3; financial woes of, 256–57n6; male, 252n3; number/concentration of, 30
Photographic Times and American Photographer, 114–15
photographs/photography: amateur craze in, 190, 207; documentary nature of, 255n1 (ch. 8); on fabric, 206; hand-colored, 192, 206; landscape, xvi, 39, 77 (*see also* Bennett, Henry Hamilton—

Landscapes); and science, xiv–xv; and sightseeing, xv; traveling vs. at home, xvi–xvii. *See also* panoramic photographs; stereographs
photogravure process, 121–22, 255n8
Pigs in Clover (game), 150, 255n2 (ch. 7)
pine forests, 131, *157*
The Pines, 194
popcorn parties, *216*, 217
postcards, 204, 224
powered tour boats, 192
Prairie Farmer, 177
Preston, Annie Turner, 192–94
Prettyman, Susie, 209, 211
printmaking, xiii

rafts. *See* lumber rafts/raftsmen
railroads, xv, 5, 7, 250n6, 257n2. *See also specific railroads*
Randall, Alexander W., 18
Red Horn, Suzie, 211
Reed's Landing, *106*
Reese, Jean (granddaughter), xxi, 241–43, *242*
Reese, Oliver ("Ollie"), xxi, 241–43, *242*
Reliance Iron Works (Milwaukee), *124*
Richards, Freeman, 69
Ringling Brothers, *119*
Robinson family, 193–94
Roche a Cri, 73
rocks, photographs of, xiv–xv
Rocky Islands, *245*
Rocky Rock, 73, *222*
Rood, Hosea, 215
rowboat races, 69
Rusk, Jeremiah, 115
Ruskin, John, 192
Russell, Andrew Joseph, 50–51, 80

St. Paul Ice Carnival, 134–35, *136*
sand bottles, 208
Savage, Charles Roscoe, 80
sawmills, 131
Schlitz (Joseph) Brewing Company, *125*
School for the Deaf (Delavan), 183, *184*, 185
Seaborne, Mike, 255n1 (ch. 8)
Sherman, Ned, 199
Shiloh, battle of (1862), 22
Short Journeys on a Long Road, 194

Shufeldt, Henry H., 140
shutters, instantaneous, 97, 126–28, *129*, *132*,
 134–35, *135*
The Silver Sunbeam, 45, 252n5
slaves, fugitive, 18
Smithsonian Institution, 241
Snider, Fred (son-in-law), 192, *193*, 256n8
Snider, Harriet Bennett ("Hattie"; daughter), *xiv*,
 82, 108, 237, *238*; as assistant to Henry, 192,
 206; birth of, 44, 251n14; in the Broom
 Brigade, 108, 254n2 (ch. 5); at Henry's death,
 232; Henry's journal entries about, 139;
 marriage of, 192, *193*; in the Paper Fair, 146–
 47; and stepmother Eva, 171; western travels of,
 109, 109–10
solar camera/enlarger, 60, 241
The Song of Hiawatha (Longfellow), *103*
Sousa, John Philip, 204
Southern Wisconsin Power, 226, 236–37
Spain, William, 58
Spanish-American War, 197
Stand Rock, 38, 238, 240, 245
Stanford, Leland, 97
State Bank of Rocky Ford (Colorado), 236
State Public School (Sparta), 183
steamboats, xv, 61, *66*, 69, *174*, 175–80, 206, *207*
Stein, Simon L., 90–91, *120*, *121*, *124*, 168, *169*,
 255n8
stereographs: commercialism of, 114; competition
 in, 62, 63, 64, 91, 93, 98; critical reception of,
 114–15; of cycloramas, 147, *147*–48; Dells
 tourism fostered by, 58, 60–62, 87; framing
 within, *222*; Henry's innovations/trade secrets,
 83, *84*, *85*, 244, 253–54n13; Japanese scenes, *85*,
 86, 253n12; lithograph reproductions of, 190;
 marketing of, 61, 66, 80–81, 87, 190, 203–4;
 mounts for, 83, 85, 98, 100, 172, 225; popularity
 of, xvi, xviii, 52, 66; on the St. Paul Ice
 Carnival, 134–35; tabletop arrangements, 190;
 *Wanderings among the Wonders and Beauties of
 Western Scenery*, 99–100, *100*–103, *102*
stereopticon (Magic Lantern) shows, 95–96, 119,
 215
stereoscope, 52–53
Stewards of the Dells of the Wisconsin River, 245,
 247
Stieglitz, Alfred, xvii

Stowe, Harriet Beecher: *Uncle Tom's Cabin*, 19
Stroud, Perry, 43
Sugar Bowl, 55, 114–15, 138, *234*, *239*
Swain, Glyde, 215
swallows, 87, *88*, 247
Szarkowski, John, xi–xii, xvi, 55, 249n1 (ch. 1),
 254n7

Talbot, William Henry Fox, xiii
Tanner House (Kilbourn), 50, 69
tax stamps, 34, 36
Taylor, Frank H., 87
telephones, 215, 227
Tenney, Charles A., 62, 64
Thompson's cafeteria (Chicago), 199
Thoreau, Henry David, xix
Thorpe, Jim, 257n8
tintypes, 29–33, 251n2
The Tourist's Guide to the Wisconsin Dells, 69, 71
transcontinental railroad, 80
transportation, advances in, xv
tuberculosis (consumption), 109
Twelfth Wisconsin Volunteer Infantry, 18, 22. *See
 also* Company E

Uihlein Wilson Architects (Milwaukee), 242–43
Uncle Tom's Cabin (Stowe), 19
Underground Railroad, 18
Union Pacific Railroad, 50–51, 80
Unitarian Church (Milwaukee), 71
urban landscape photography, 168, 255n1 (ch. 8).
 See also Chicago, scenes of; Milwaukee,
 scenes of

Vanderpoel, Abraham, 18
Vermont Daguerrian Gallery (Brattleboro), 15–16
Vertunni, Achille: *Bay of Naples*, 71–72
Vicksburg (Miss.), 22–25, *23*
vigilantes, 56

Wah-con-ja-z-Gah (Chief Yellow Thunder), *75*,
 75–76, 213
Washington, Booker T., 257n8
Watkins, Carleton, 39, 51, 257n6
Waukesha County mineral springs, 141–43,
 142–43
Waupaca Republican, 156–57

Waverly Toy Works, 255n2 (ch. 7)
Weber, Jacob, 176
Weston, Edward, xvii
wet-plate (collodion) process, 33, 52–53, 85–86,
 251n6, 252nn4–5
Wetzel, Nat, 206–7, 225, 235–36, 256n5 (ch. 8),
 258n3
White Beaver (Frank Powell), 96
wilderness, xv, 39, 58, 59
Wildrick, Pat, 56–58
Williams, Dale, 244
Wilson, Edward L., 95, 255n8
Winnebagos. *See* Ho-Chunk people
Winton cars, 205
Wisconsin: economic prosperity in, 18; farming in,
 18; Native American resistance to white settle-
 ment in, 2, 11, 12; population of, 6
Wisconsin (powered tour boat), 192
Wisconsin Alumni Research Foundation (WARF),
 238, 240
Wisconsin Central Railroad photography
 expedition, 151, 152, 153–59, 156–60, 161
Wisconsin Dells (*formerly* Kilbourn City): dams at,
 196, 197, 227, 227–29, 232, 232–33, 236, 257n3;
 early days of, 7; hotels/boardinghouses in,
 172, 225; life in, 215, 216, 217; name change of,
 xi, 258n4; passenger pigeons in, 59–60;
 population of, 215; property values in, 176;
 rafting crews in, 133, 133–34; railroad bridge,
 14, 14–15; as a resort town, 69, 140, 172;
 sidewalks in, 230; steamboat landing in, 180;
 telephone lines in, 215; tourism in, xi, xv–xvi,
 xix, 49–50, 240
Wisconsin Dells Company, 179, 192, 196, 206–8,
 224–25, 229, 236–38
Wisconsin Historical Society, 241–43, 242
Wisconsin Industrial School for Boys (Waukesha),
 183, 187
Wisconsin River, 131; dams on, 196, 197, 225, 227,
 227–29, 232, 232–33, 236, 257n3
Wisconsin River Volunteers, 18
Wisconsin State Board of Control of Reformatory,
 Charitable and Penal Institutions project,
 183–88, 184–87
Wisconsin State Prison, 185–86, 186
Wisner, Frank O., 69, 172
Witches Gulch, 65, 65, 79, 240, 247
women: as hop pickers, 56; as photographers, 51,
 252n3
work, 62
World's Fair (St. Louis, 1904), 204

Yellowstone National Park, 256–57n6
Yosemite, 39, 52, 95, 257n6

Zeiss Anastigmat lens, 175
Zimmerman, Charles A., 62, 64, 91, 93
zoopraxiscope, 98